ADAY.ORG

EARTH AWARE
EDITIONS

PO Box 3088
San Rafael, CA 94912

FOR WEB EXCLUSIVE CONTENT!

Find us on Facebook: www.facebook.com/insighteditions

Find us on Twitter: @insighteditions

First published in the United States in 2012 by Earth Aware Editions,
an imprint of Insight Editions.
Originally published in Sweden in 2012 by Max Ström.

In agreement with Aday.org and
Expressions of Humankind Foundation,
Stockholm, Sweden.

Library of Congress Cataloging-in-Publication Data available.

ISBN 978-1-60887-146-9

ROOTS of PEACE REPLANTED PAPER

Insight Editions, in association with Roots of Peace, will plant two trees
for each tree used in the manufacturing of this book. Roots of Peace is
an internationally renowned humanitarian organization dedicated to
eradicating land mines worldwide and converting war-torn lands into
productive farms and wildlife habitats. Roots of Peace will plant two
million fruit and nut trees in Afghanistan and provide farmers there
with the skills and support necessary for sustainable land use.

Colour reproduction by Linjepunkt, Falun, Sweden
Printed by Imago in Singapore 2012

Max Ström
Kyrkslingan 11
SE-111 49 Stockholm
Sweden
www.maxstrom.se

Creative director
Jeppe Wikström

Art director
Patric Leo

Captions
Johan Erséus, Kim Loughran,
Nancy Pick, Christopher Westhorp

Editor
Christopher Westhorp

Head of picture research
Marcus Erixson

Picture assistants
Madeleine Halvarsson, Johan Jeppsson

Layout
Patric Leo, Cornelia Waldersten

Artwork
Maja Zetterberg with
Rewir (Astrid Woggart, Oscar Dybeck,
Carl Danielsson, Magnus Klintström,
Johannes Schäfer, Agneta Nyholm)

Editorial coordinator
Anna Sanner

Editorial assistants
Marianne Lindgren,
Susanna Huldt, Tina Johnsson

A DAY IN THE WORLD

A thousand photographs selected by Daphné Anglès, Walter Astrada, Ayperi Karabuda Ecer, Hideko Kataoka, Brigitte Lardinois, Paul Weinberg and Jeppe Wikström

Foreword by Richard Branson
Introduction by Desmond Tutu

EARTH AWARE
EDITIONS
San Rafael, California

THIS PROJECT HAS BEEN MADE POSSIBLE THROUGH THE SUPPORT OF

ERICSSON

Posterscope Worldwide

snapfish by hp

THOMSON REUTERS
FOUNDATION

FOTOLOG

THE BONNIER FAMILY FOUNDATION THE MARCUS AND AMALIA WALLENBERG FOUNDATION
SVEN HAGSTRÖMER PER JOSEFSSON PELLE LYDMAR P O SÖDERBERG

MEDIA PARTNERS

Metro, American Photo, Australian Photography, Camera Pixo, Capture, Dagens Nyheter, Dagens Industri,
Digital Photography, Digital SLR, Emphas.is, Jeune Afrique, Kamera-lehti, National Geographic Hungary, Newsweek Japan,
Photo Net, Popular Photography, Veckans Affärer, Zoom Magazine

SUPPORTERS

Aegis Group, The Chimney Pot, Collateral Creations, Falun Copper Mine, Forsman & Bodenfors, Im Media,
JJP, MyHeritage, Rewir, Translations.com, Vinge

FOREWORD

For the last 30 years I have been constantly travelling. Whether flying in a plane or a balloon I have always been struck by one thing – from that perspective, I can't see any boundaries; all the walls, fences and barbed wire that separate us fade and disappear. All of a sudden the world becomes more beautiful.

On 15 May 2012 people all over the world joined in a global effort to document humankind. Using the power of photography they shared their lives and experiences, helping to tear down a few barriers. The directness and honesty of the participants makes this project truly unique.

For the last two years I have been involved with Aday.org as a member of the Global Advisory Council, together with Archbishop Desmond Tutu, former president Mary Robinson, former prime minister Gro Harlem Brundtland, former president Martti Ahtisaari, Deputy Secretary-General of the United Nations Jan Eliasson and the singer Robyn.

We have all supported this extraordinary project that merges people from every corner of the world. It has been exciting, and it is with joy and great interest that I now explore this selection of images from that normal but special Tuesday – an historical document but also a great narrative for the overwhelming diversity of life, captured in one single day.

Richard Branson

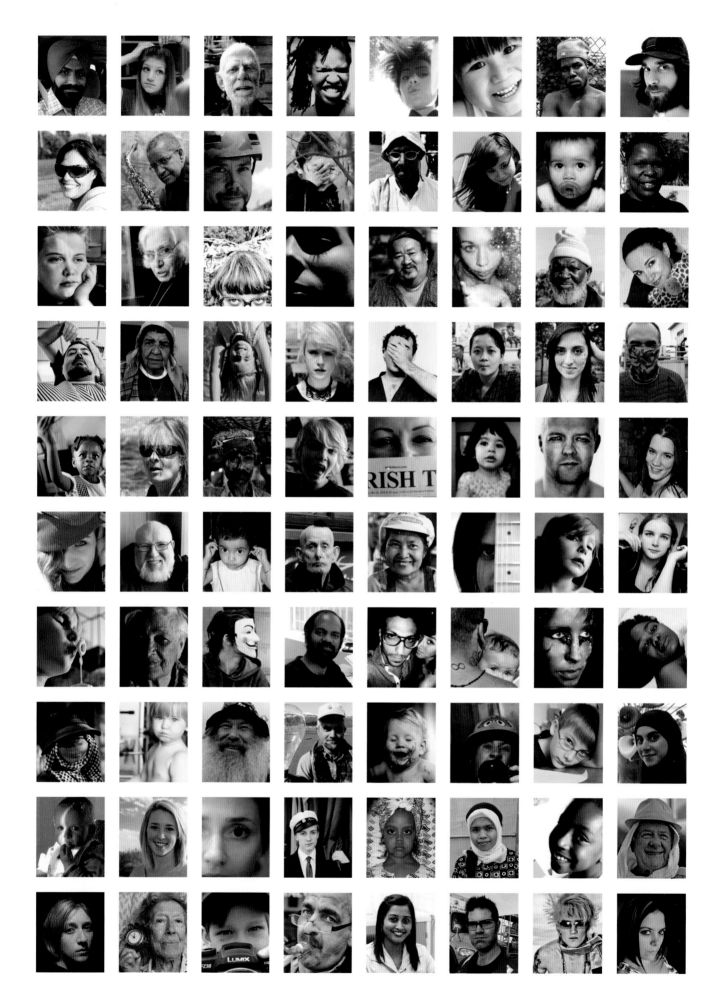

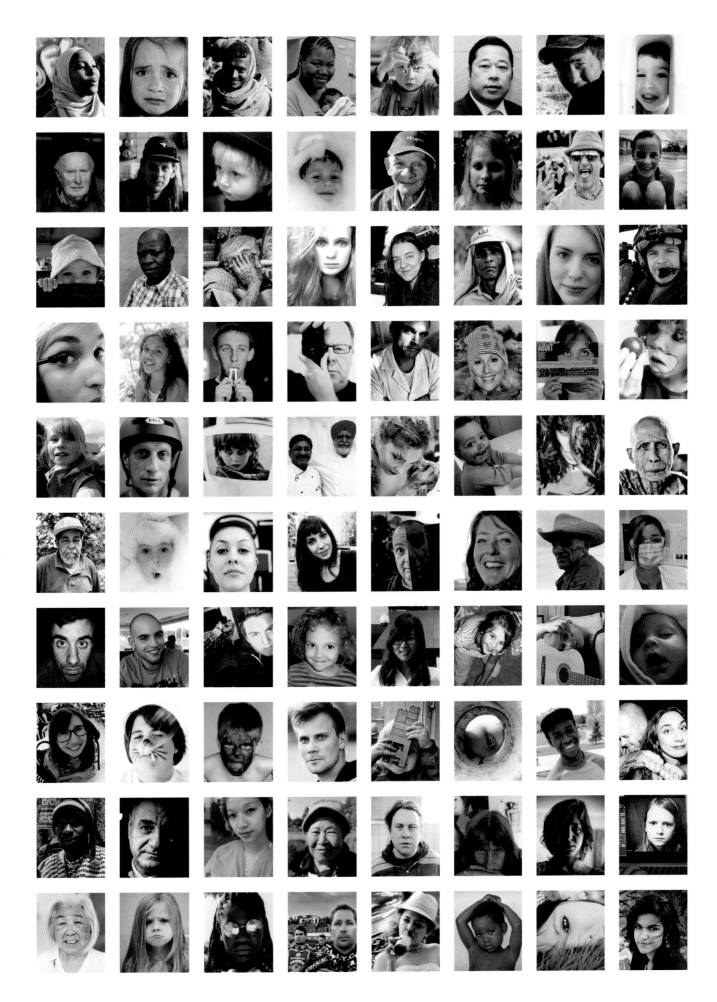

INTRODUCTION

I once studied to be a teacher – and was struck by the way images captured children's imagination. Regardless of what the teacher was saying, the children's attention was first and foremost on any pictures being shown.

At that time, photographs were not widely used. Newspaper printing was poor and the papers used relatively few pictures; the Internet and digital cameras were still unheard of and cameras were largely restricted to professional photographers or the well-off.

All this has changed. Cameras are everywhere, not least in mobile phones, and we use the Internet to share pictures with family and friends. Mass media showers us with pictures from news events across the globe, often in real time, and celebrity reporting is exhaustive. There is no lack of images in our world.

But it is vital to see beyond isolated news events, to try to understand context and learn about each other. And photography is a wonderful communication tool, transcending the barriers of age, language, culture and gender. Photography connects – showing pictures of your loved ones, your children or grandchildren instantly brings you closer to each other. Photography educates us – we see things from other parts of the world and learn about the lives of our brothers and sisters. Photography captures history – our stories deserve to be told.

Air travel, the Internet and global TV have shrunk the world. Conversely, our need to see and understand each other is greater than ever before. A hundred years ago, it was

enough to relate to our immediate sphere: the village, town or country. We knew the people in our immediate circle, or at least knew of their lives. Now we need to relate to an entire world.

But depictions of everyday life are a type of narrative seldom afforded place in the media and in our frantic information flow. Yet it is precisely each other's daily lives that can teach us so much, through seeing how others live and work.

Looking at the photograph from Yunnan Province in China and seeing the way the woman uses a rope to cross a swollen river, I see the ability people have to surmount obstacles.

Looking at the picture from Greenland of a fisherman navigating his small boat between icebergs, I see the urge of man to provide for his family and I see the need for man to live in harmony with nature.

When I see an Egyptian home set up in an ancient cemetery, I understand how humankind has learned to adapt to harsh conditions.

The wonderful picture of a new-born baby in the Philippines shows me life renewing itself.

And I smile when I look at one of my favourite pictures in this project: the boy diving into the river from the back of a water buffalo. No one looking at that picture thinks about the boy's race or skin colour – white or black, yellow or brown. All we see is the invincible joy of youth.

Every picture has added to my experience – my comprehension of life is suddenly richer.

The photograph is an important component of collective memory, of history and the documentation of life. But the photograph is also a story of life here and now, a tool for seeing each other, understanding each other, and thereby creating the potential for a better world.

Desmond Tutu

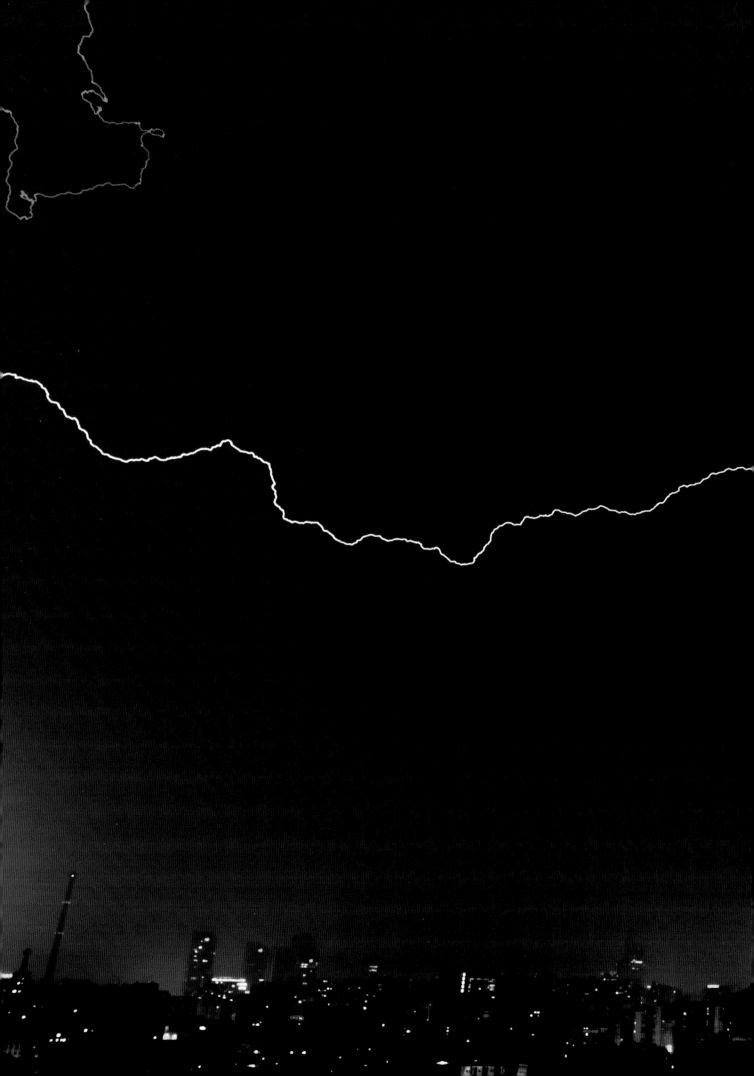

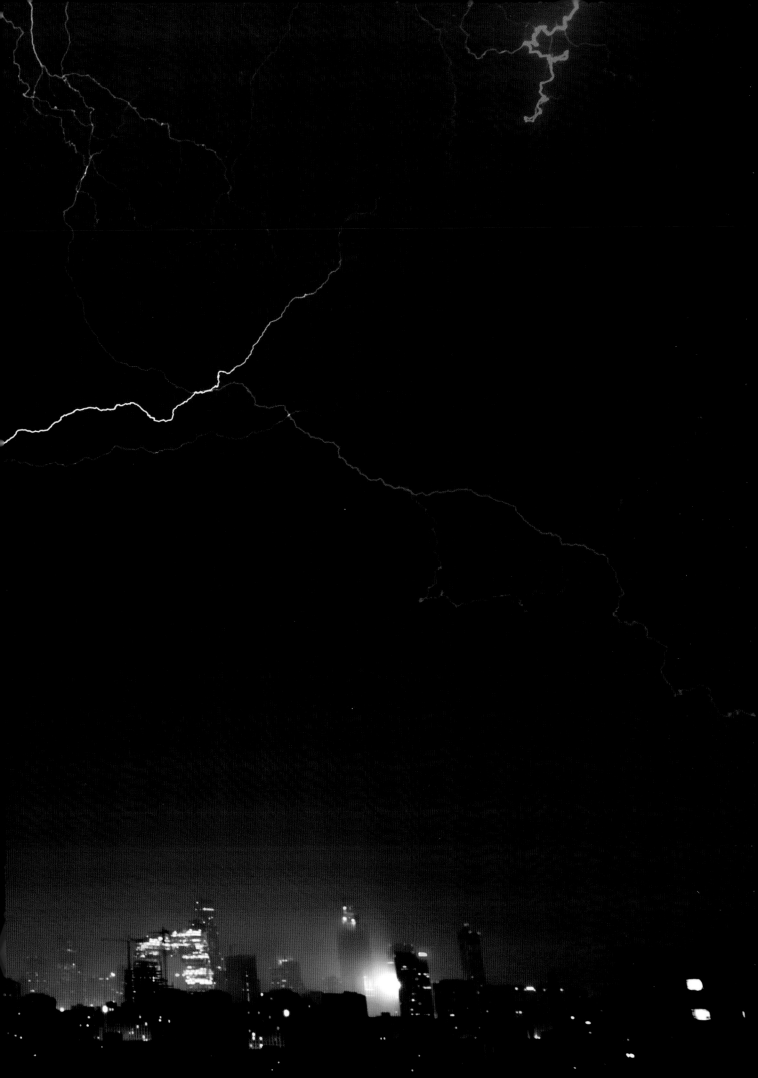

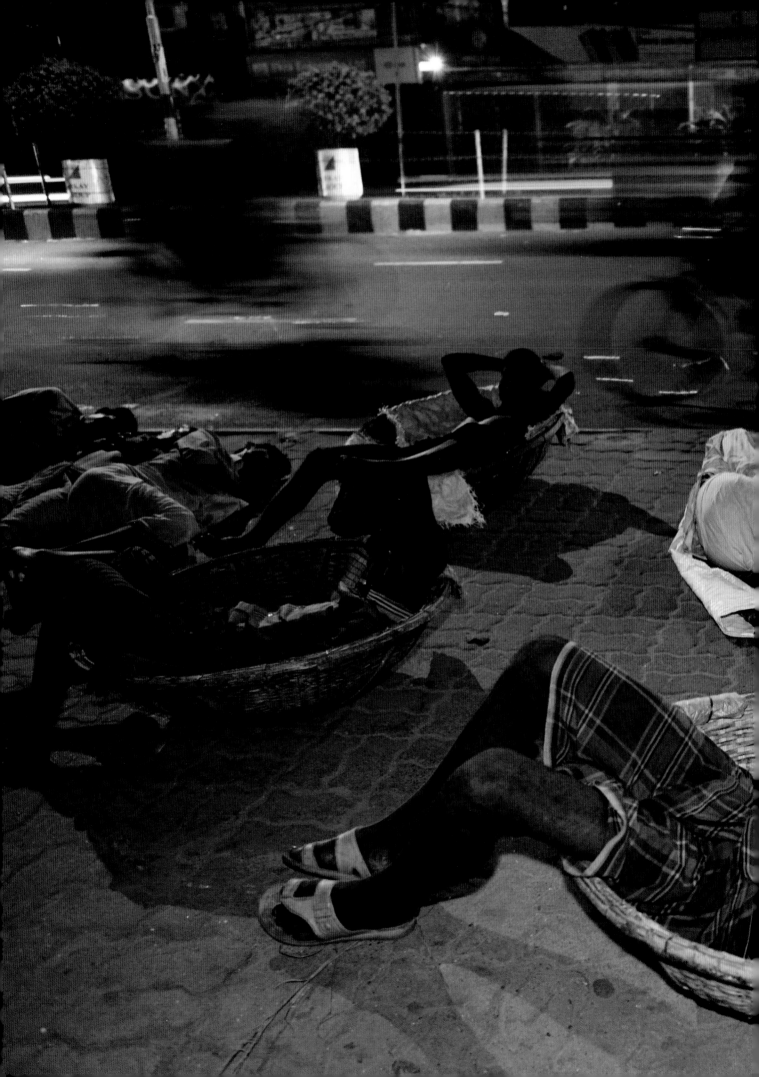

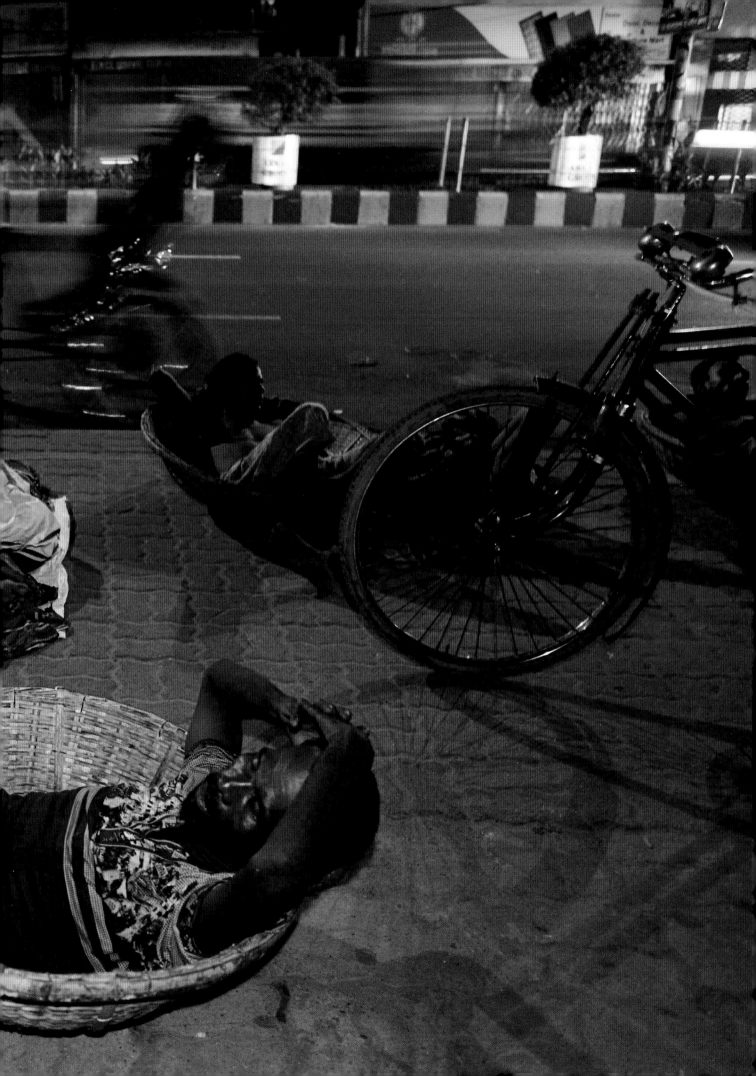

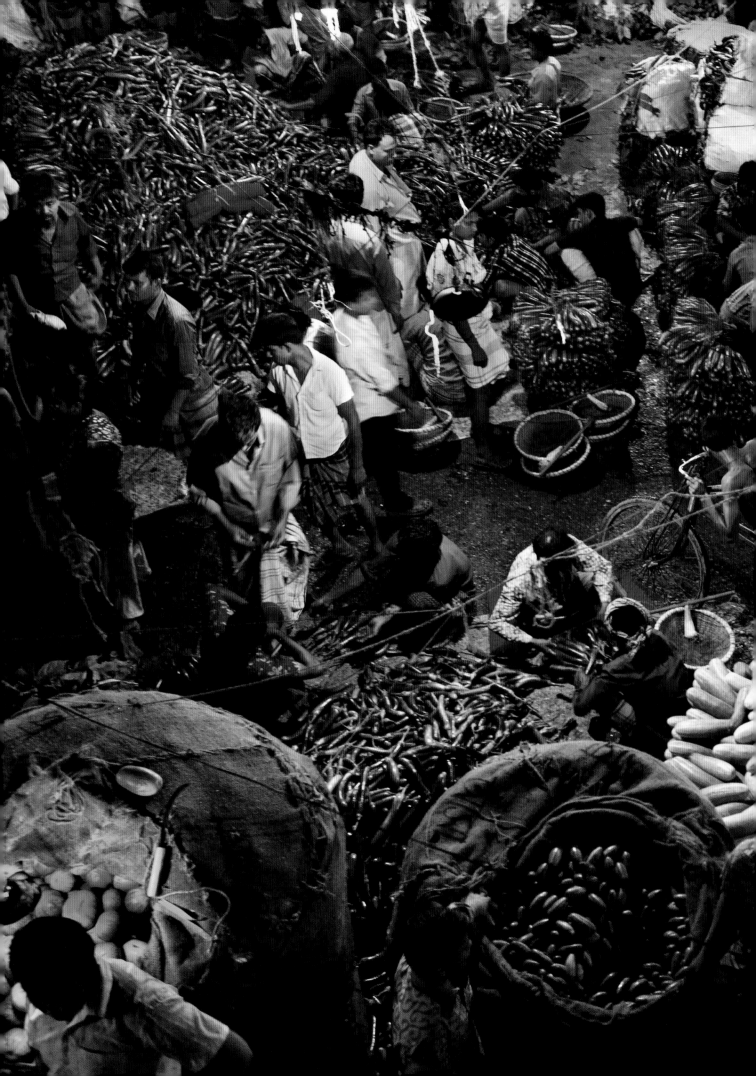

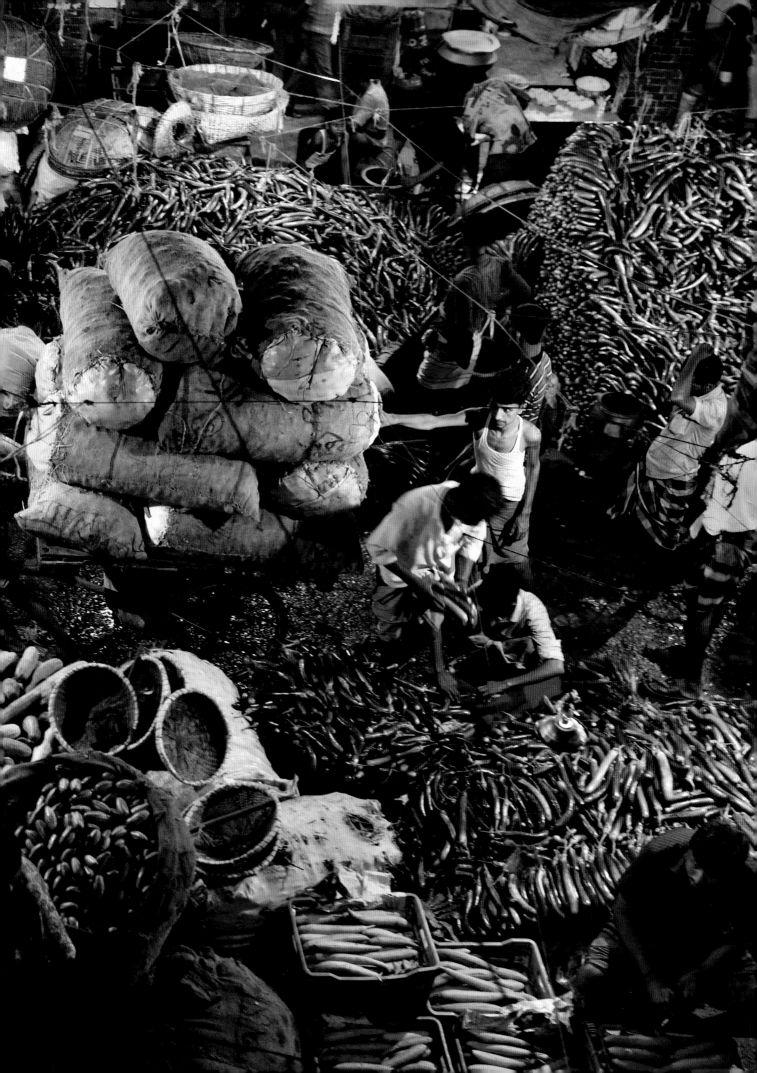

◀◀◀ Beijing, China, 01:00.
Lightning over Beijing. The city is
generally dry and windy in spring,
with occasional sandstorms
from the Mongolian steppe. The
Beijing Weather Modification Office
sometimes induces rain to offset the
effect. The city's population is inching
towards twenty million people.
Photo: Yun Pang.

◀◀ Dhaka, Bangladesh, 04:14.
Daily-wage workers sleep on the
roadside by the Kawran Bazar, a
24-hour, wholesale food market
complex in Dhaka. They dare not
leave their baskets unattended for
fear of having them stolen. Dhaka
is one of the world's most densely
populated mega-cities, where
thousands of homeless people,
many of them rural migrants,
sleep on the streets.
Photo: Probal Rashid.

◀ Dhaka, Bangladesh, 00:53.
Only at midnight does the enormous
Kawran Bazar wholesale vegetable
market swing into high gear, as
merchants start selling to shops and
restaurants. Dhaka is a large and
busy place, with many skyscrapers,
and if the trucks entered the city
during the afternoon the result would
be chaos. The trucks carry in produce
from different districts all over the
country. Dozens of different vegeta-
bles are for sale, including potatoes,
peas, *parwal*, aubergines, cucumbers,
okra and more.
Photo: Noor Ahmed Gelal.

Madrid, Spain, 03:35.
Prostitutes hiding in a store during
a confrontation between police
and activists on the Puerta del
Sol to mark the anniversary of the
Indignados movement in Spain.
The country has also been caught
up in the uncertainty surrounding
the European single currency.
Photo: Alberto Di Lolli.

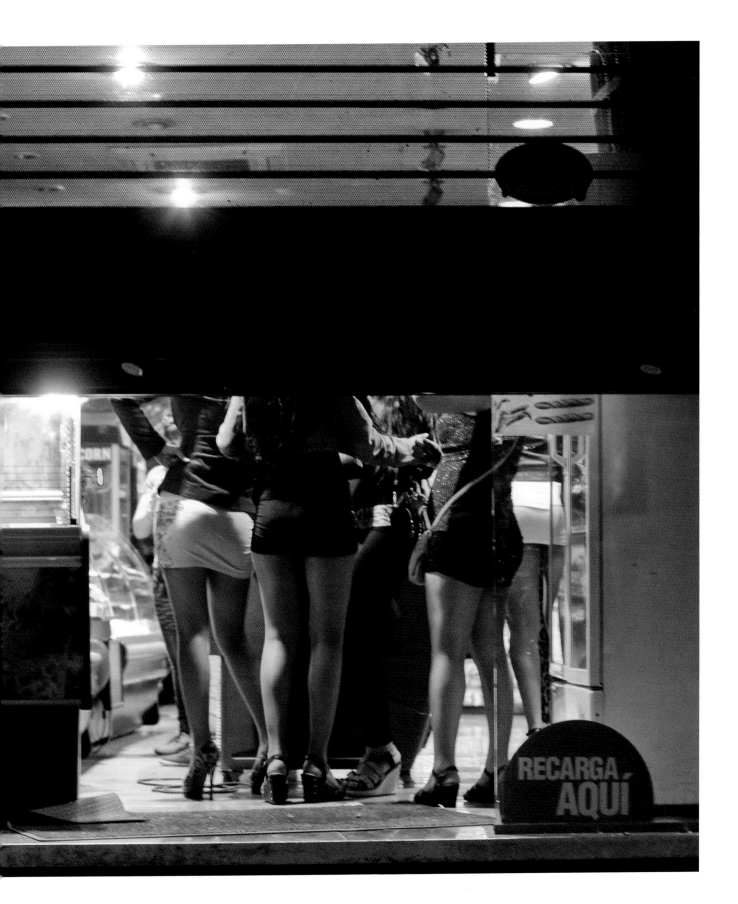

New Delhi, India, 05:15.
As rural jobs disappear, villagers
flock to the cities where, like here,
they work – and sleep – at the
markets and other places of work.
Photo: Saurabh Das.

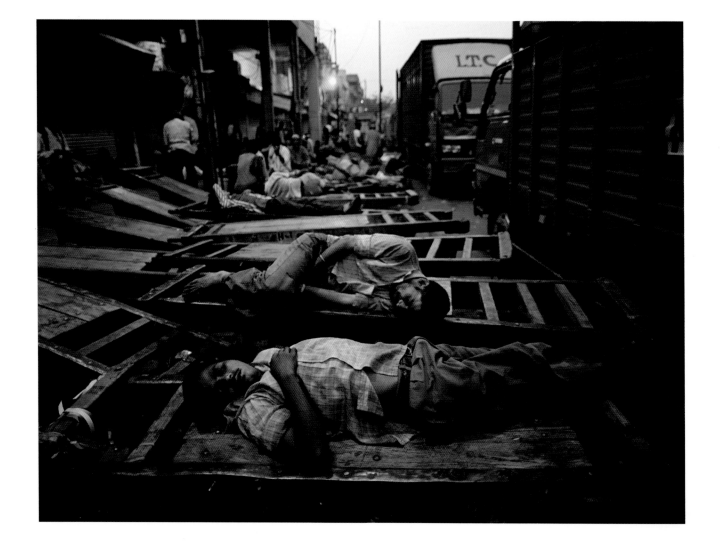

Florence, Italy, 07:00.
"Matteo is eight years old. Some-
times at night, he comes to the bed
in his parents' room asking, 'Can I
stay a little while?'"
Photo: Alberto Ianiro.

Bouar, Central African
Republic, 05:30.
Nadia, the youngest of 10 orphans
housed in an SOS Children's Village,
will soon be waking up.
Photo: Joey Abrait.

Dhaka, Bangladesh, 04:45.
Dhaka is growing so fast that
thousands have to sleep on the
pavements. In spring and summer
the night temperature is often
27 degrees C.
Photo: M. Yousuf Tushar.

Vancouver, Canada, 06:15.
"Like so many others, I sleep with my
iPad and iPhone within easy reach."
Photo: Min-Kuang Lee.

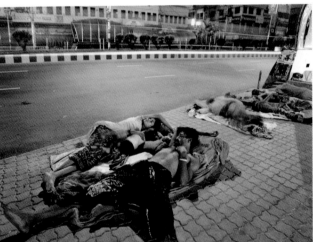

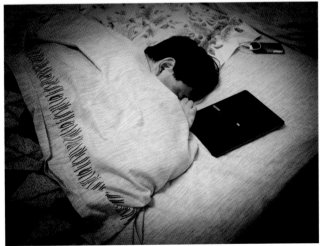

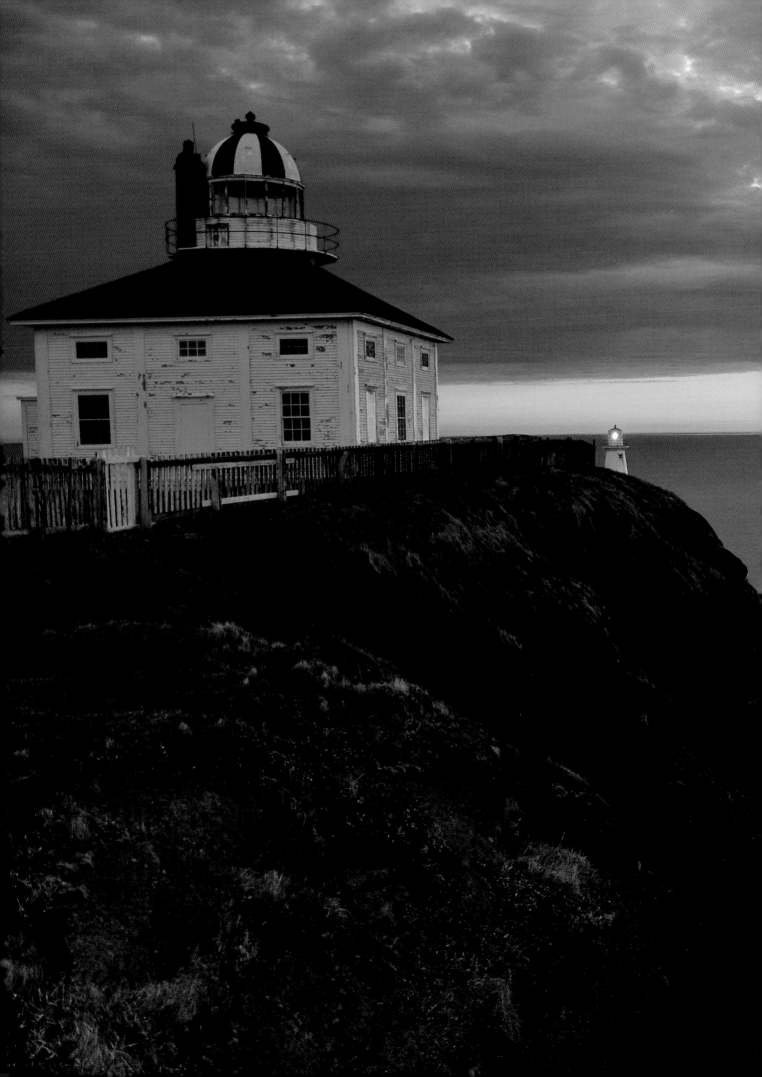

◀ Cape Spear, Newfoundland, Canada, 05:45.
This is the easternmost point in continental North America. "We see the first rays of sunlight before anyone else on this coastline", says the photographer. The lighthouse in the foreground is the oldest in Newfoundland, built in 1834 and used until 1955, when the newer lighthouse – whose light is visible in the background – replaced it.
Photo: Dave Armstrong.

Santiago, Chile, 02:07.
"I was at the Rockas Bar in central Santiago with one of my best friends until the small hours of the morning. Those are his hands. As usual, we talked about literature, art, music bands and life."
Photo: Patricio Saavedra.

Örebro, Sweden, 04:59.
"I just want to show how it is early in the morning. Lonely and quiet. People are waiting in their houses for the newspaper." Delivery of newspapers is a typical entry job for immigrants to Sweden.
Photo: Stefan Moberg.

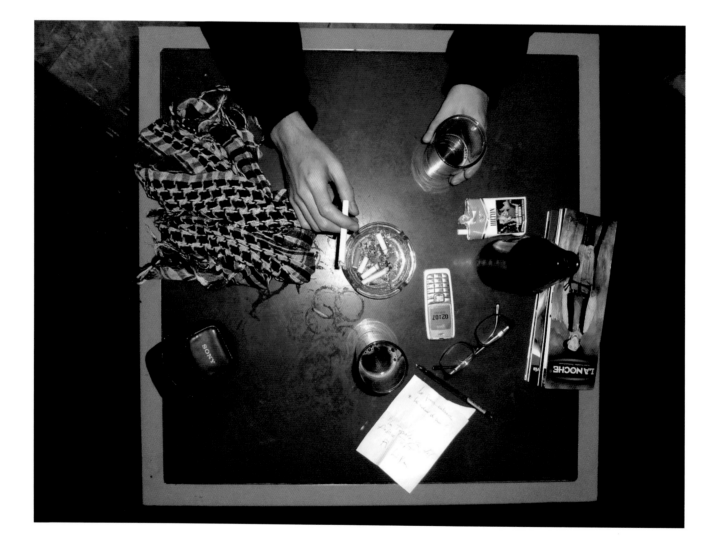

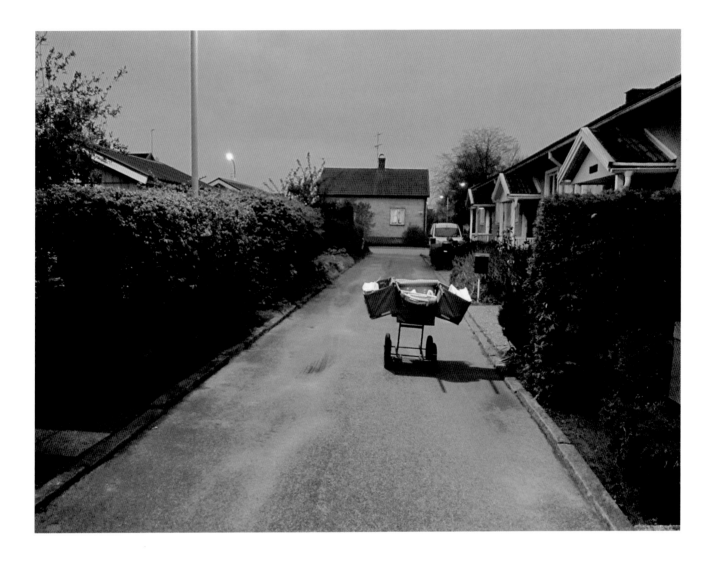

Wilbraham, Massachusetts,
USA, 06:28.
"My son must comply with the dress
code at his school, Wilbraham and
Monson Academy, which requires
a blazer and tie. He learned how
to tie his tie from a YouTube video.
Every morning, he comes downstairs
looking pretty dishevelled, with
his tie tied too tight and his collar
puckered around his neck, so I have
to straighten it. My son likes his
school but dislikes the dress code
immensely."
Photo: Rebecca Laflam.

Vallentuna, Sweden, 06:47.
"The day's first photo of me and
my boyfriend Johan. I'm 19, and he's
20, and we went to the same school.
I used to check him out, and it turned
out that he read my blog. We started
emailing and texting each other, and
we've been together for two and a
half years. We take turns in living
with my parents and his. I have just
graduated from secondary school,
and he is a web designer."
Photo: Sara Edström.

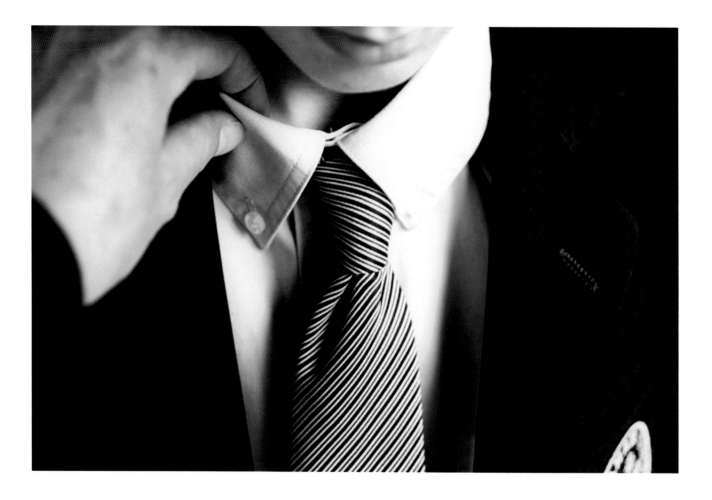

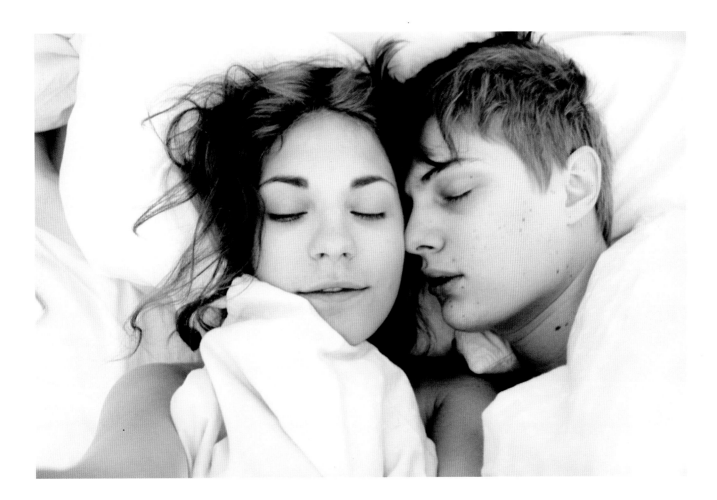

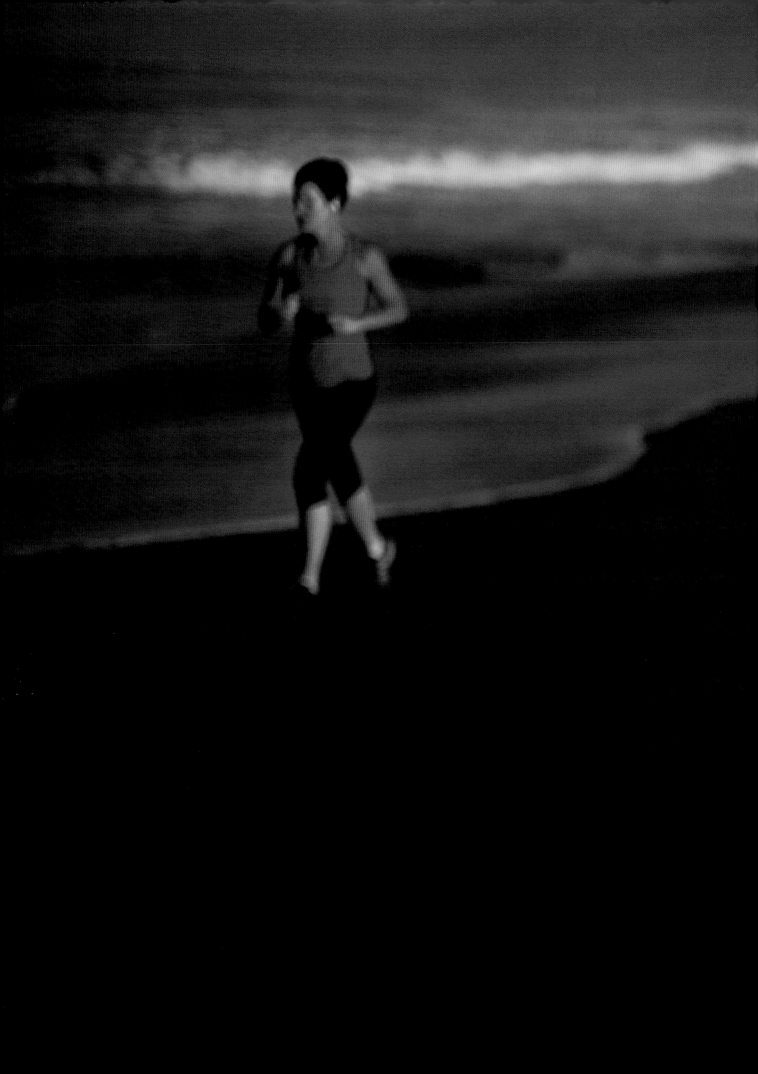

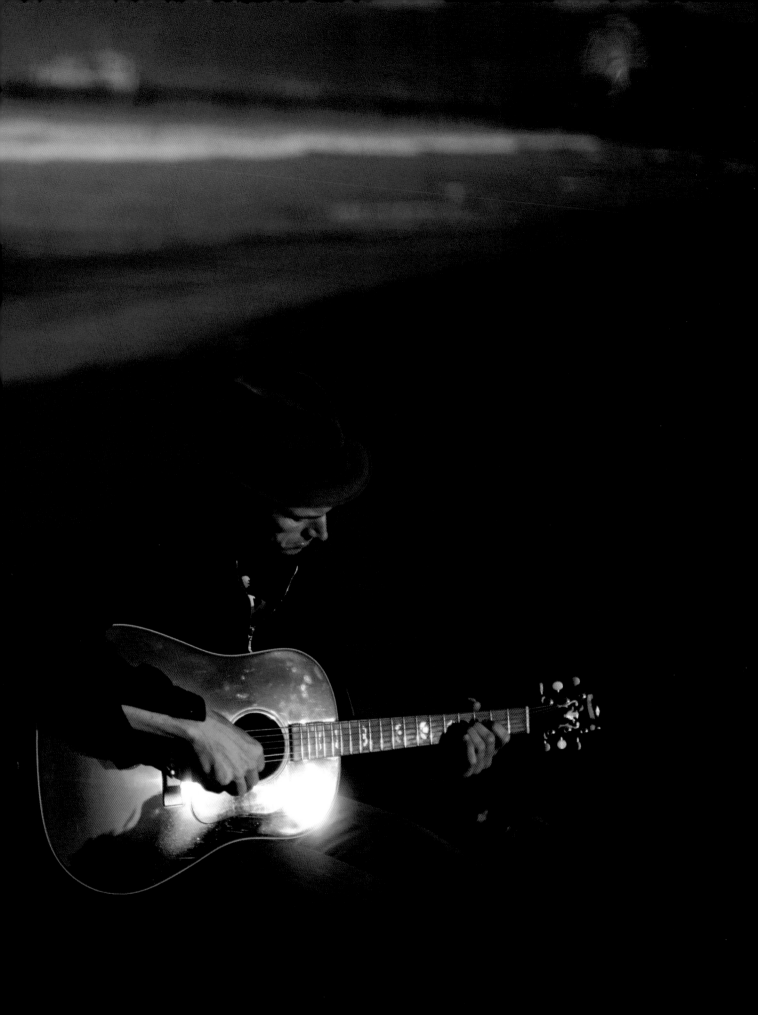

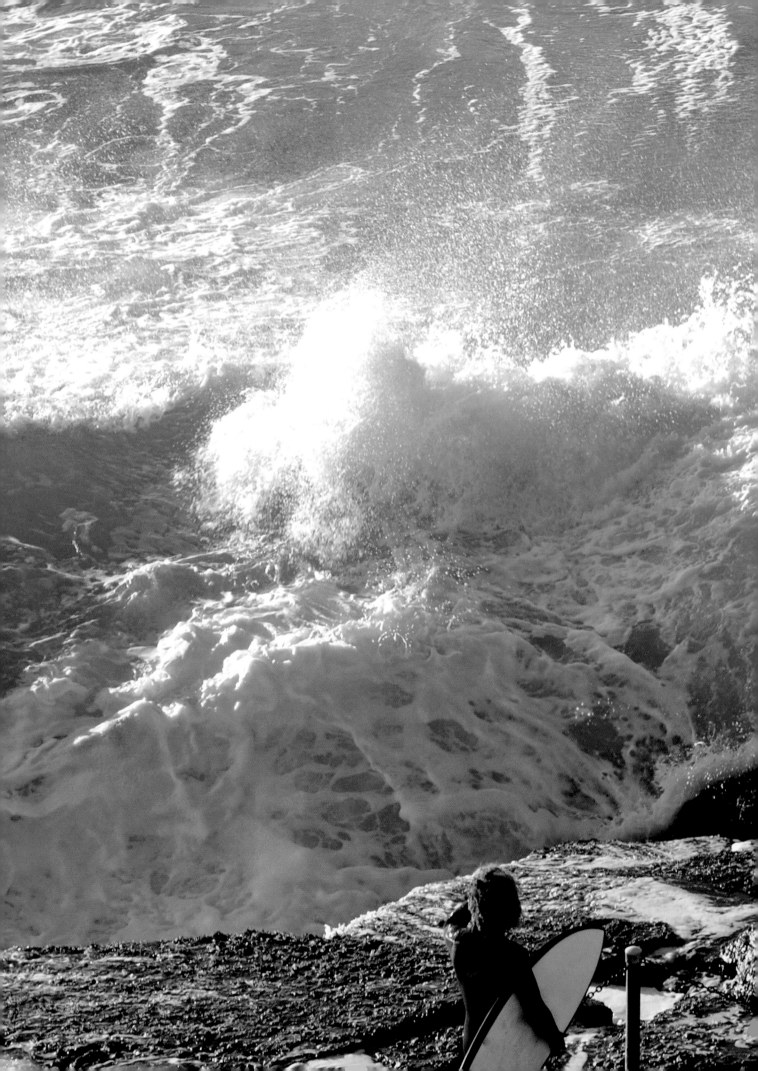

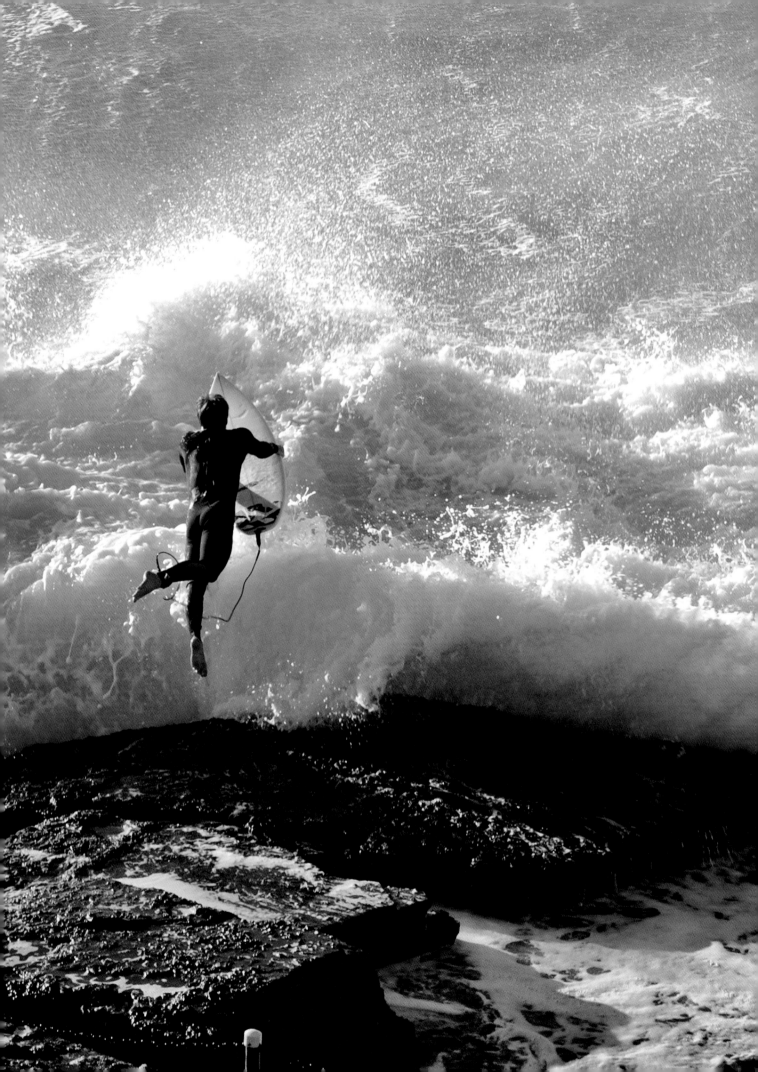

◀◀ Santa Monica, California,
USA, 06:30.
Lucy and her boyfriend Brian often
sit on the beach while he plays guitar.
When she was given a photographic
assignment in Afghanistan in 2009,
Brian was going to be on holiday for
a week in the Grand Canyon, incom-
municado. "He took his guitar to the
beach, and other beautiful places
near to where we live, and recorded
me a series of songs. He put them
on YouTube and set his email
to automatically send me one for
every day he was away. I sat in
the Reuters office in Kabul, with a
massive satellite dish in the garden.
Through music, video, and technol-
ogy, I felt very connected to home."
Picturing Brian by the sea reminded
her of those serenades from afar.
Photo: Lucy Nicholson.

◀ Sydney, Australia, 07:59.
"Big surf today. I took my camera
down to the local beach to watch
the guys picking the right moment
to leap off the end of the rock pool,
timing it so they don't get flung back,
painfully, onto the rocks. This surfer
didn't. I got a clear sense of this guy's
anticipation amidst the sound of
the waves crashing."
Photo: Helen Tracey.

Denver, Colorado, USA, 10:37.
"My breakfast and the pug that
coveted it. The dog's name is
Buella, and she belongs to my
boyfriend's cousin, Jenni. Buella
was right there, wanting my
breakfast, though I don't think that
Cinnamon Toast Crunch and a bagel
with strawberry cream cheese
particularly whet a dog's appetite."
Photo: Rebbecca Romine.

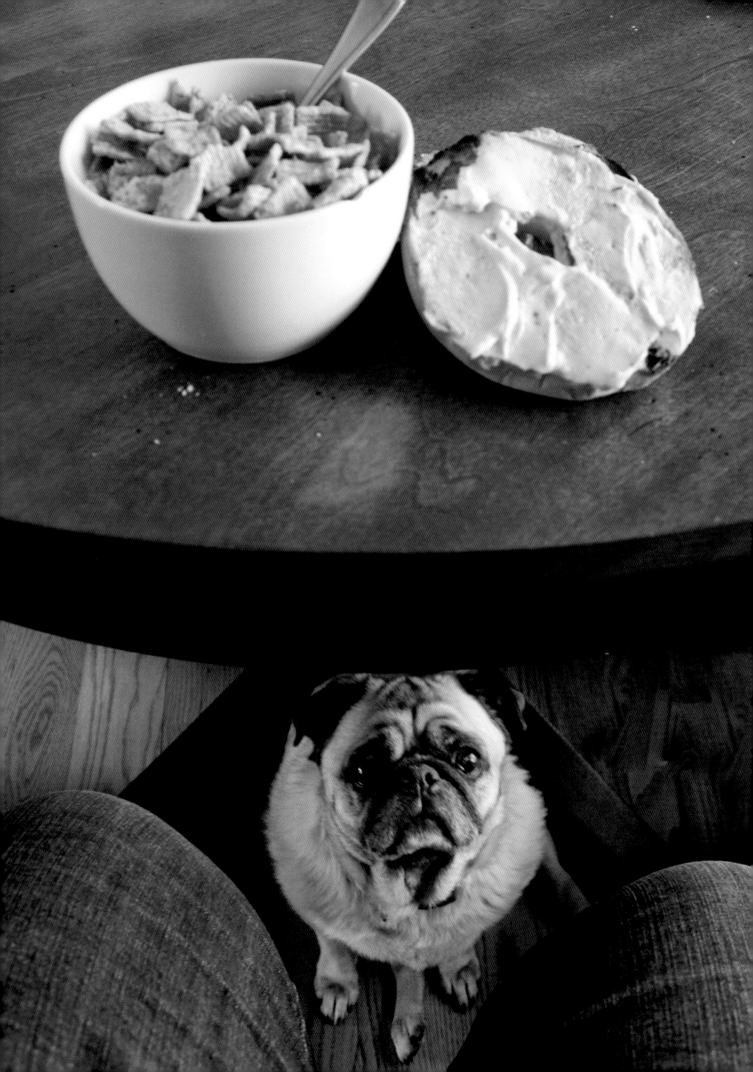

Manila, the Philippines, 14:30.
Street children sleeping in a busy
train station in the heat of the
afternoon. *Photo: Candice Reyes.*

Rochdale, UK, 17:36.
"A dull rainy day at home. Perfect for
a snooze, according to my husband
and the cat!" *Photo: Janet Ellis.*

Tokyo, Japan, 15:00.
"Walking in a cemetery, I came
across a group of sleeping taxi
drivers."
Photo: Leonie Hampton.

Ouagadougou, Burkina Faso, 13:00.
Moussa takes a nap.
Photo: Warren Sare.

Raumo, Finland, 17:02.
"After school, my son is tired enough
to let dad do the shopping in peace."
Photo: Teemu Laulajainen.

Sylhet, Bangladesh, 17:14.
One of many who left their villages
for the city and wound up begging.
Photo: Fakrul Islam.

Lisbon, Portugal, 14:58.
Resting on a park bench.
Photo: Robert Adrian Scurtu.

Johannesburg, South Africa, 13:45.
Cleaners at the HeronBridge Retreat
after the morning shift.
Photo: David Klein.

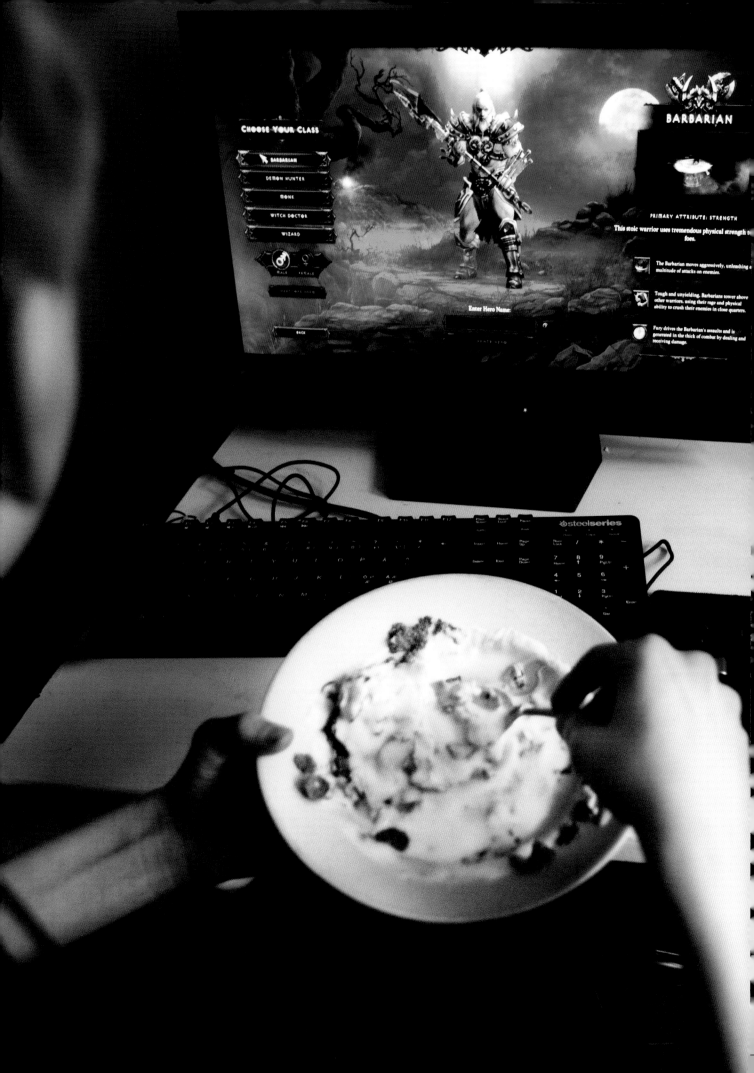

Stockholm, Sweden, 08:15. Sixteen-year-old Valter Turesson had been pining three years for the release of the Diablo III fantasy/horror game. At midnight, he could start downloading his pre-ordered copy. By breakfast, he was playing. Valter was not happy about a planned trip to relatives in the country that day. The compromise was to delay departure by 24 hours.
Photo: Roger Turesson.

Funan Centre, Singapore, 15:07. The release of Diablo III was a major global event in the gaming world; presales broke records, and a new record was set for sales within the first 24 hours. "I am a devoted fan of Diablo. After a wait of 11 years, I eagerly joined the Diablo III launch with 6,000 other fans trying to get a copy of the game. The queue went at snail's pace. There was hardly any breathing space and everyone was packed like sardines. The crowd was angry at how badly the event was organized. I finally received mine after five hours."
Photo: Dereth Tang.

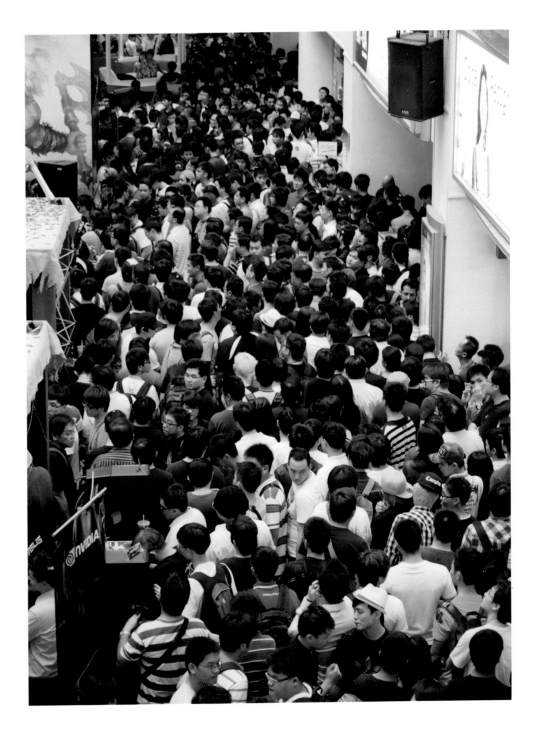

Beijing, China, 08:45.
Even beyond rush hour, the bus
remains crowded.
Photo: Binny Hu.

Mexico City, Mexico, 16:00.
A fan helps, in the sweltering heat.
Photo: Vanesa A. Zmud Jiménez.

Guangzhou, China, 18:45.
"Passengers need to walk at least
10 minutes to transfer between
lines, but the metro is still the most
efficient way to move between home
and office in such a big city."
Photo: Zhou Zongyi.

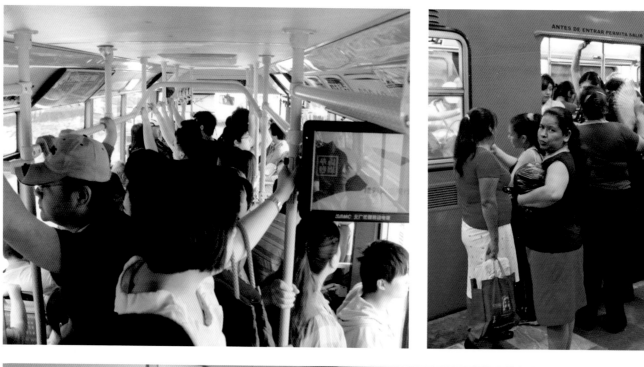

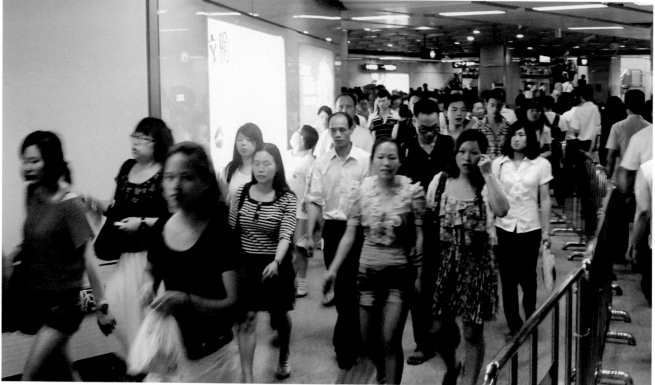

Bangkok, Thailand, 11:45.
My blue shoes. "On my way
to the city centre, riding in an
air-conditioned bus."
Photo: Hon Keong Soo.

Bangalore, India, 12:15.
"Sitting at the back of the bus doesn't
give you the smoothest ride, but it
does give you the best view!"
Photo: Tina Nandi.

Dhaka, Bangladesh, 18:30.
Office workers can face a severe
transport crisis getting back home
in a city where the population of the
greater metropolitan area is more
than sixteen million.
Photo: Abir Abdullah.

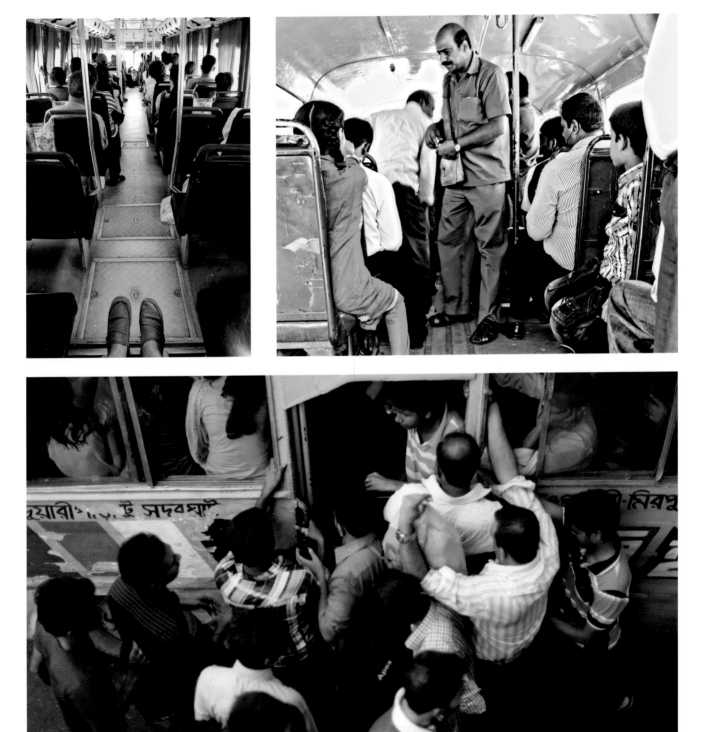

Lancaster, Pennsylvania, USA, 09:38. "I look like I just rolled out of bed. I did. But mornings consist of getting the babe's oatmeal out of the fridge and the puréed prunes from the freezer to defrost a bit. Jude likes his oatmeal cold. At least he doesn't seem to mind it. I think that with teething (he just popped two teeth) it feels good on his gums. He's such a good eater."
Photo: Trinity King.

Dhaka, Bangladesh, 06:30.
A family living by the railway line.
Mother is preparing breakfast
before her son wakes up. Breakfast
in Bangladesh often consists of rice
soaked in water, with green and red
chillies, salt and onion. Sometimes
there will be *roti* bread.
Photo: Tobias Nørgaard Pedersen.

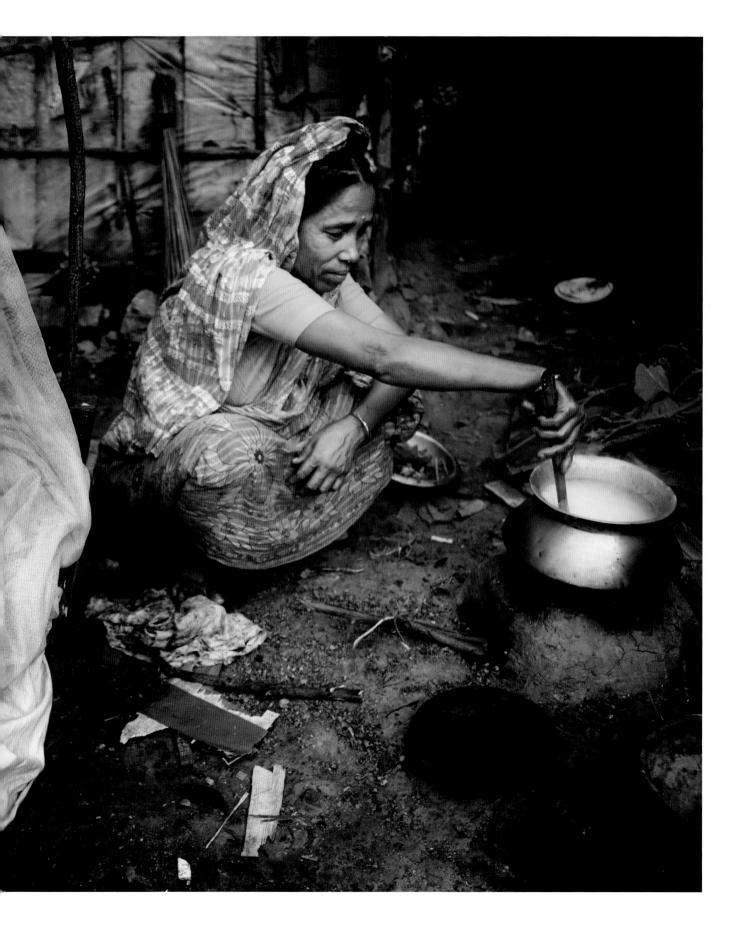

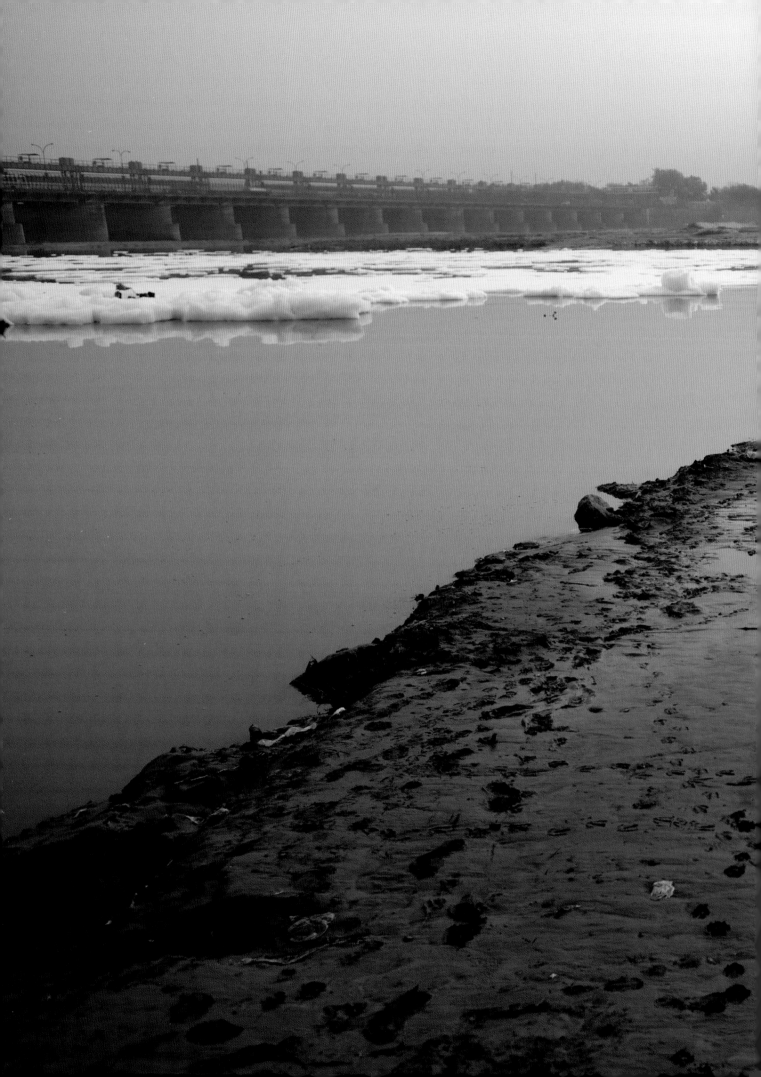

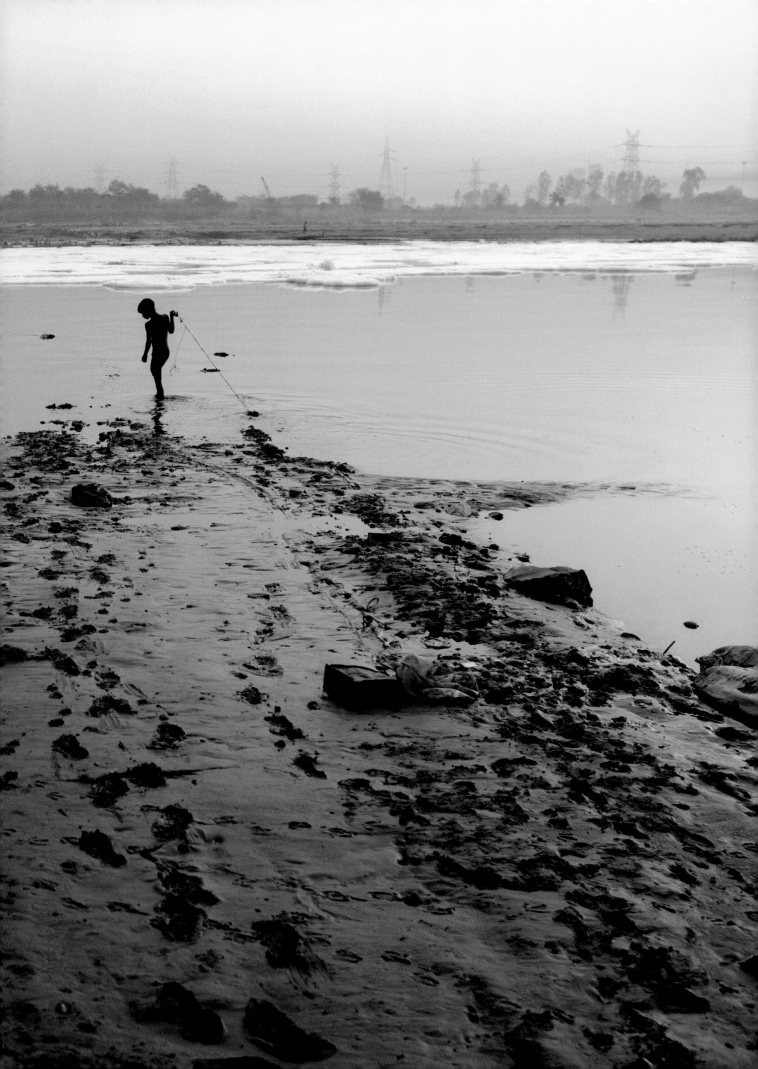

◄ New Delhi, India, 05:12.
At dawn, a boy searches for coins thrown by Hindu devotees in the waters of the River Yamuna. The river has religious significance for Hindus, who toss in coconuts and coins as offerings. The nearby villagers use a magnet attached to a string to pick the coins from the water, or jump into the river to collect the coconuts. Unfortunately for those who use the river, here what looks like ice is actually pollution.
Photo: Ahmad Masood.

Yaoundé, Cameroon, 06:37.
Aurelienne's daily job is to get the children ready for school. She is the oldest of her siblings and is scrubbing the youngest, Nguewou Michel Arthur. "He is a good boy but often quick to take offence", says his father, the photographer.
Photo: Jean Pierre Kepseu.

Natick, Massachusetts, USA, 05:56.
"Tuesday mornings before school, I wash, blow-dry and set my daughter's hair in a bun for her afternoon ballet class. It is one of the best moments of the day."
Photo: David Di Iulio.

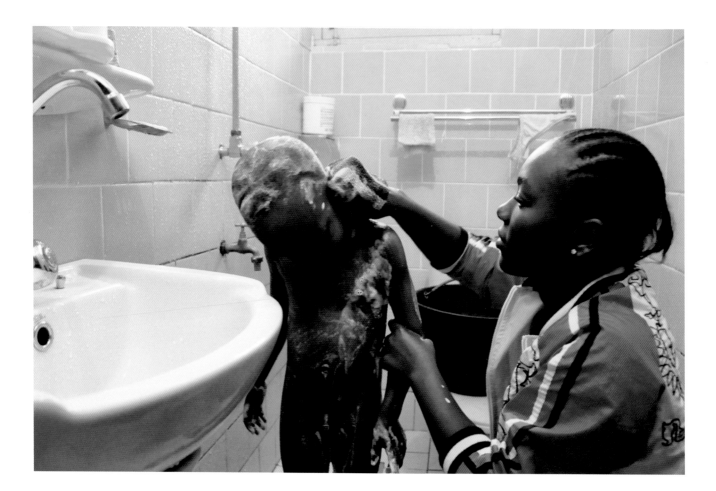

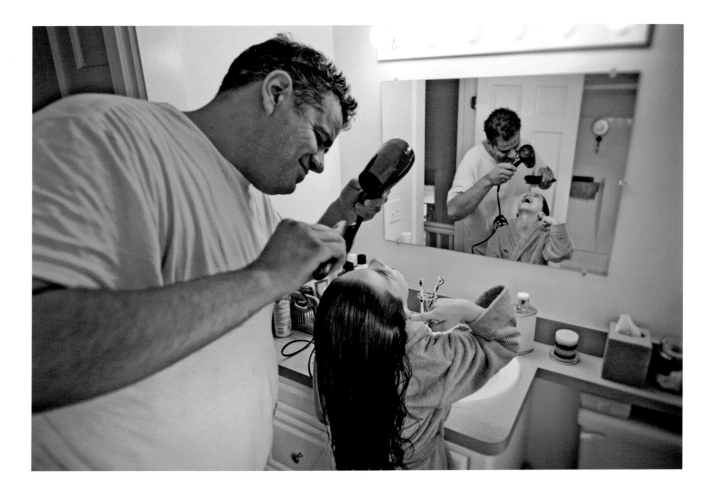

Oslo, Norway, 08:09.
"Changing the stinky diaper of my 13-month-old son, Jan, I hold him in the only grip that keeps him from escaping. He's surprisingly strong. Less surprising is that he needs to be changed during breakfast, given the regularity of his poops." In Scandinavia, childcare responsibilities are often equally shared between mother and father. Norway offers a full year of paid parental leave, with 12 weeks reserved exclusively for fathers. Most of them take advantage of it.
Photo: Chris Maluszynski.

Kuusamo Alakitkalla, Finland, 07:37.
A Finnish study suggests that
individuals who exercise at least two
to three times a week experience
significantly less depression, anger,
cynical distrust and stress than those
who exercise less frequently or not
at all. The photographer observes:
"In the mornings we usually do
stretching exercises for 45 minutes.
This keeps us old folk going for the
rest of the day."
Photo: Esko Alamaunu.

Kuusamo Alakitkalla, Finland, 08:36.
"Tasting our birch sap – a delicious
morning drink. Tapping birch sap is
one of our routine jobs. It's quickly
done: you drill a hole in the tree trunk
and tap the sap through a pipe. When
the leaves sprout, the sap dries up.
The birches grow along a brook
filled with spring thaw water. It runs
into Alakitka Lake in northeastern
Finland, where the calls of the diver
birds can be heard at some distance.
There is still ice on the lake."
Photo: Esko Alamaunu.

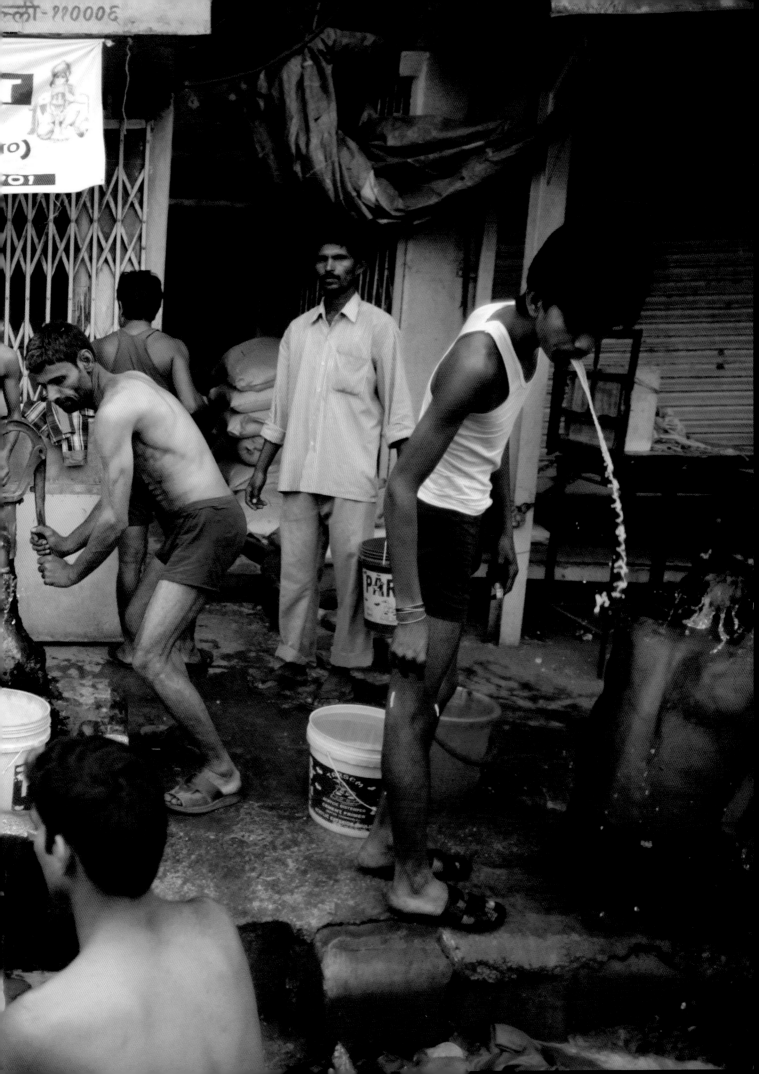

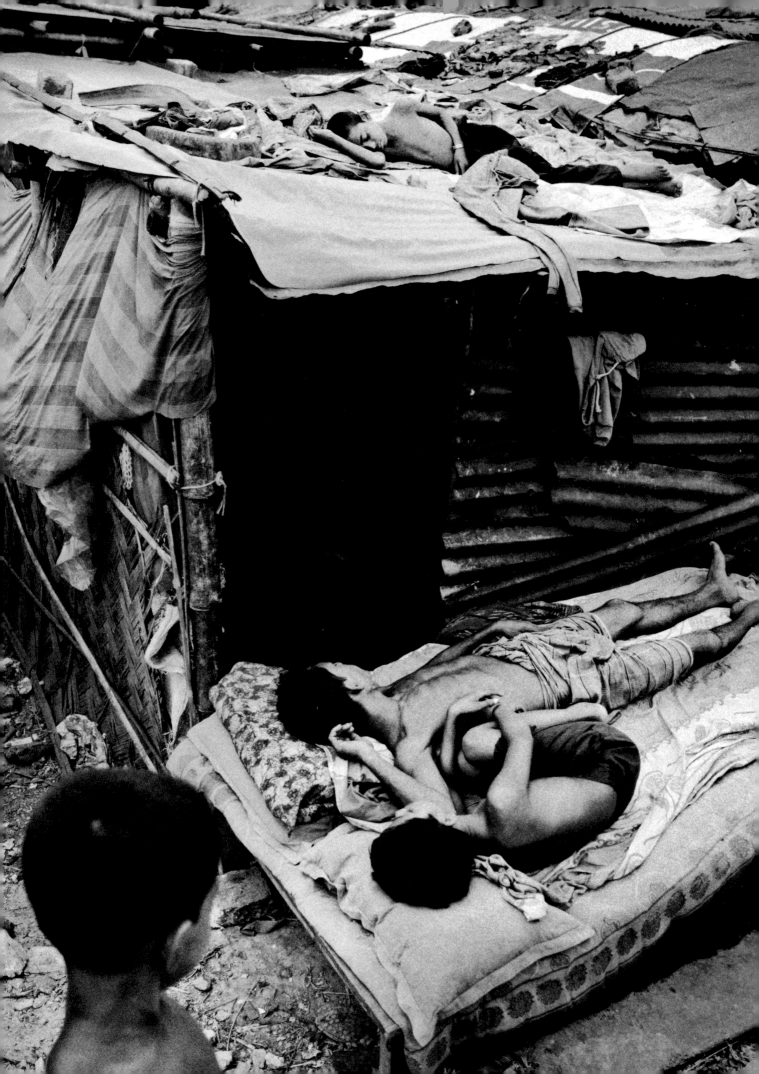

New Delhi, India, 07:27.
Migrant workers from rural India washing at a public water pump before beginning the day at the wholesale spice market in Delhi on Khari Baoli Street. The spice market is the largest one of its kind in Asia, and many shops are family-owned ones, run by the ninth or tenth generation dating back to the seventeenth and eighteenth centuries. People migrate from rural India in their millions looking for jobs in the cities because of the restructuring of agriculture.
Photo: Saurabh Das.

Dhaka, Bangladesh, 07:45.
Many families employed by factories in Dhaka are too poor to afford proper housing and live in shacks along the railway. The urban poor often work in physically demanding jobs, which affect their health, making it even harder to escape poverty.
Photo: Tobias Nørgaard Pedersen.

Dhaka, Bangladesh, 08:40.
In South Asia it is not uncommon to find impoverished settlements alongside transportation arteries. "I had been walking along the railway for nearly three hours and saw many people sleeping along the track. I took nine pictures and the boy never woke up. His mother and brother sat beside. Not far off, a market in the middle of the tracks was selling everything from raw meat to toothbrushes, even though trains passed through every half an hour."
Photo: Tobias Nørgaard Pedersen.

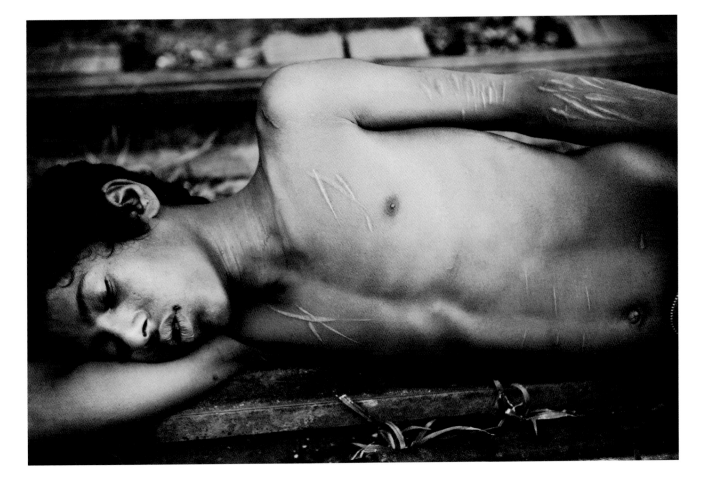

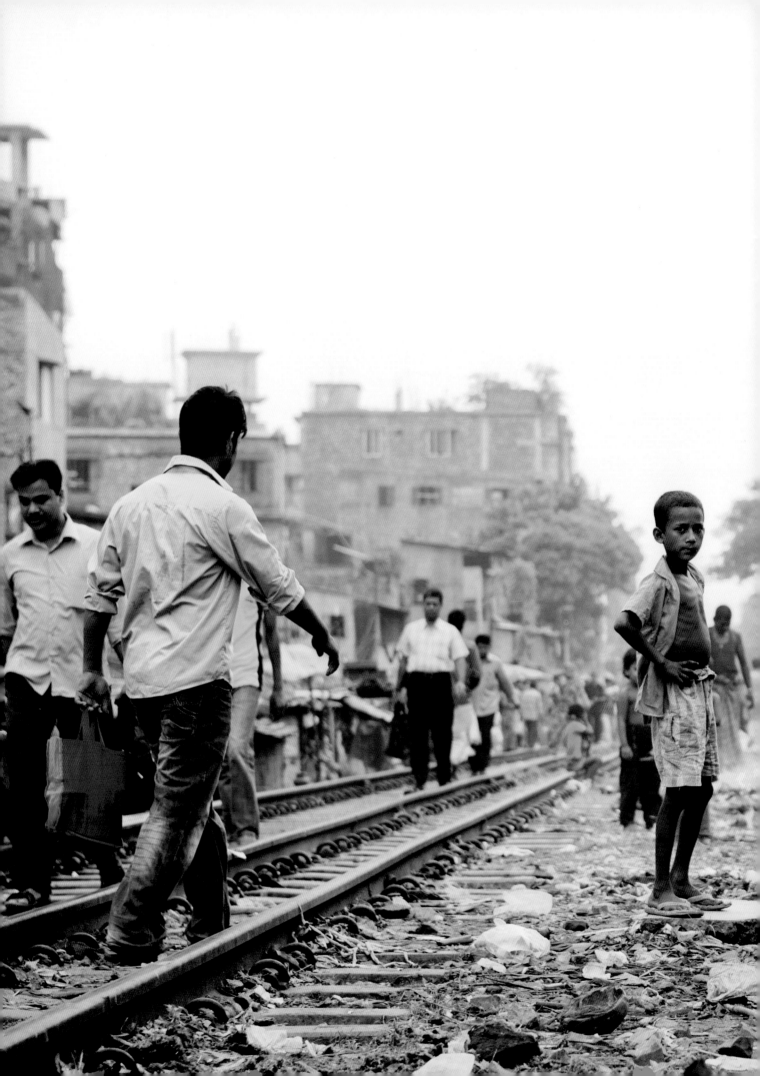

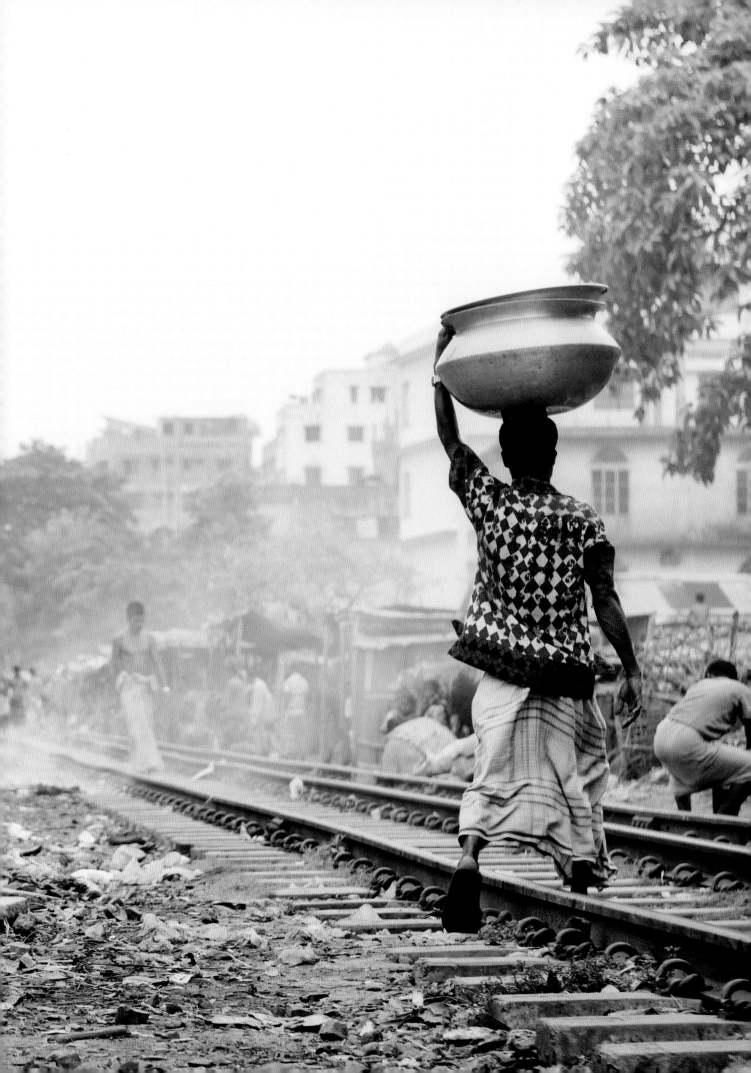

◄◄ Dhaka, Bangladesh, 07:45.
A large train has just passed through.
Most of these people are on their way
to work in factories in the garment
industry. Along this section of the
railroad is a duty-free zone, where
many international companies have
their factories. At least 30 percent of
Dhaka's population of sixteen million
live in slums and about 800,000 of
them are street children.
Photo: Tobias Nørgaard Pedersen.

◄ Fort Collins, Colorado, USA, 09:21.
Out on the Hewlett Gulch trail, a
local man's camp stove blew over in
the wind, starting a brush fire. He told
authorities that he tried to stamp it
out – but failed. The fire continued to
burn for weeks, and it was only one
of several forest fires in Colorado,
resulting in the destruction of many
square miles of forest and hundreds
of homes. Across the state, tens of
thousands of people were evacuated.
Photo: RJ Sangosti.

Karachi, Pakistan, 07:30.
Buses and trucks in Pakistan are
often decorated at vast expense
with what is known as "jingle art".
This bus driver spent approximately
5,000 US dollars on the customized
art. Because chains and chimes
hang from the bumpers of many of
the vehicles, foreigners named them
"jingle" buses or trucks.
Photo: Komal Ghazaali.

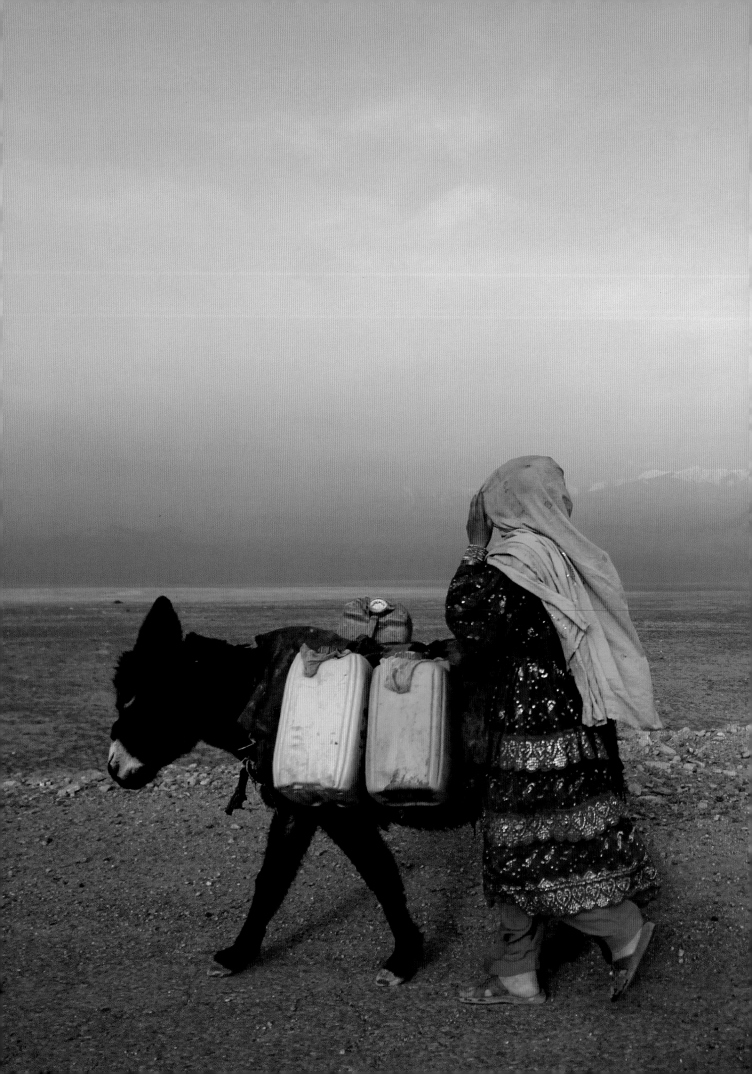

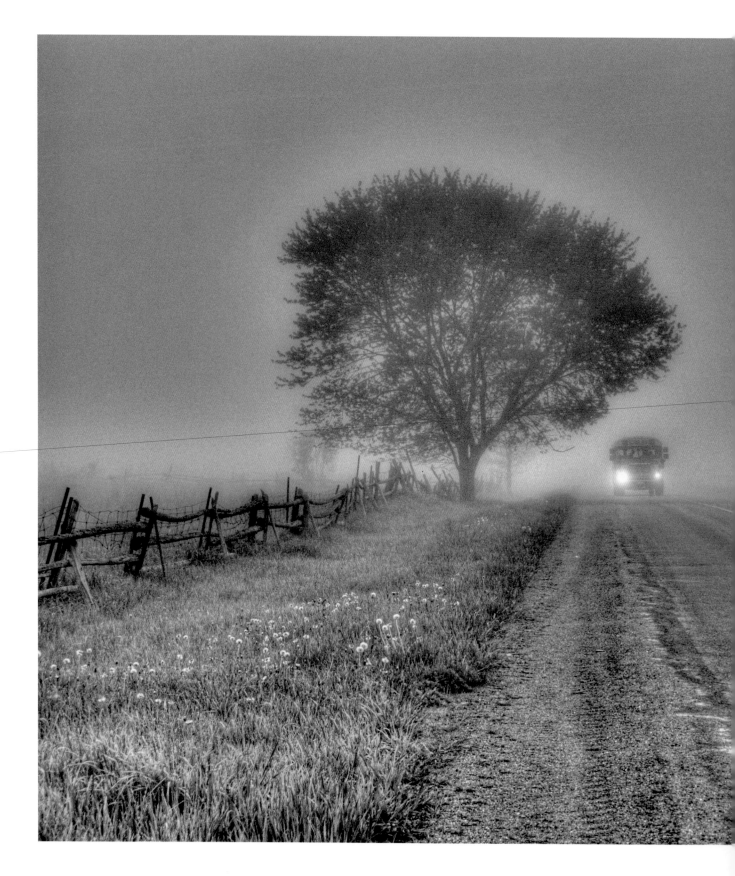

◀◀ Kabul, Afghanistan, 06:45. Women, children and donkeys on their way to get the day's water is a common sight on Afghan roads. As refugees return to Kabul, the water situation is deteriorating. The supply run has to begin at dawn if the plastic jerrycans are to be filled with their precious fluid, which will still have to be boiled before it can be drunk. Afghanistan remains dependent on pack animals, with nearly two million horses, mules and donkeys at work. *Photo: Ismail Mohammad.*

◀ Bucharest, Romania, 08:03. Architecture students Elena Irofte and her tired boyfriend, Laurentiu Astefanoaie, wait for the metro in the morning rush hour. The dorm where Laurentiu lives has five beds, but only he and one other roommate live there full-time, and often Elena stays overnight. Before school, the couple usually eat breakfast together, then watch a movie or a TV show on his laptop. To have time for their morning routine, they have to wake up early. *Photo: Sarah Hoffman.*

Stone Mills, Ontario, Canada, 08:16. "This morning, my half-hour commute from our rural home to my work in Kingston was slowed by the fog. It was also slowed by my glance in the rear-view mirror, where I noticed that the road behind me had disappeared in the mist. When I pulled off onto the shoulder, a vehicle emerged from the fog, which turned out to be a school bus. The fog cleared within the next 10 minutes, and my late arrival at work went unnoticed (I hope)." *Photo: Phil Densham.*

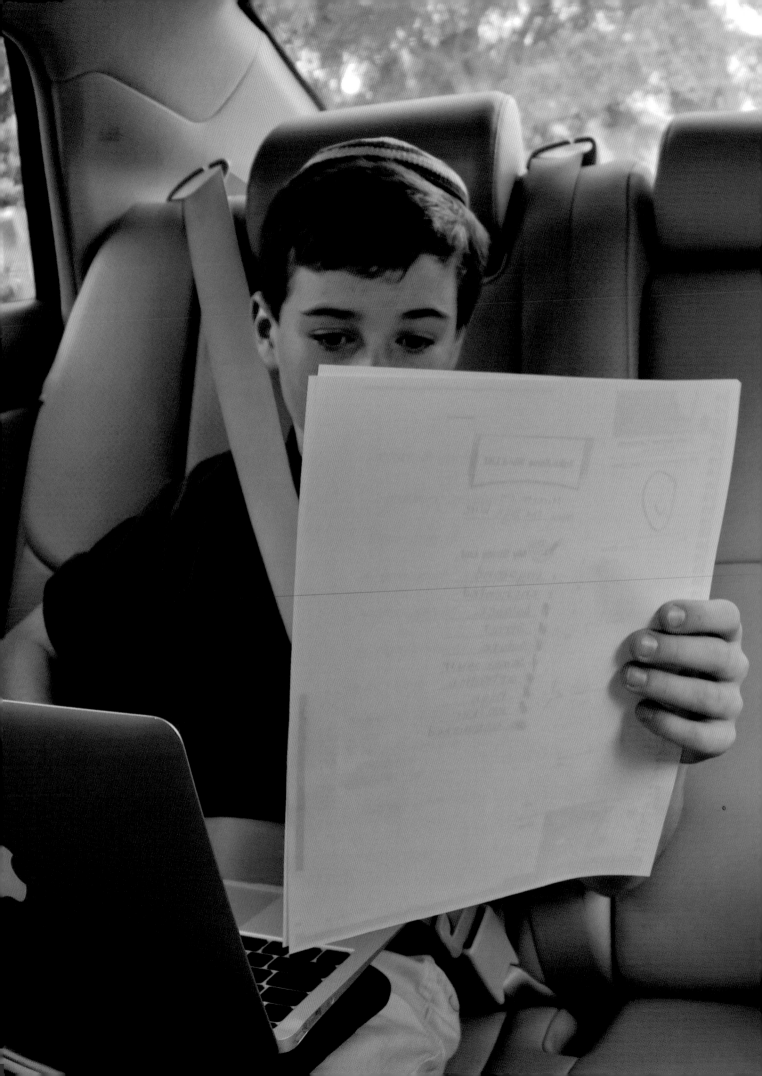

◂ Carrollwood, Florida, USA, 07:39. "With lives already full of demands on their time, my children make the most of their morning commute to a Jewish private school in Tampa, Florida. My 12-year-old son, Ethan, is quizzing my eight-year-old daughter, Miriam, on this week's spelling list. In between words, he debugs the video game he's writing on his Mac. Despite occasional bouts of sibling friction, Ethan and Miriam have a simpatico relationship. They travel together to compete in scholastic chess tournaments around the USA, and Ethan recently won his first national championship."
Photo: Jeffrey Hinds.

Vasasszonyfa, Hungary, 16:15.
A week's worth of underwear washing.
Photo: Balogh Zsolt.

Leiria, Portugal, 20:48.
Time for the day's wash – hoping the colours won't run.
Photo: Karina Alexandra Milheiro.

Tongli, China, 12:00.
In this city of 55 bridges and many canals, washing facilities are often readily available.
Photo: Carolina Johansson.

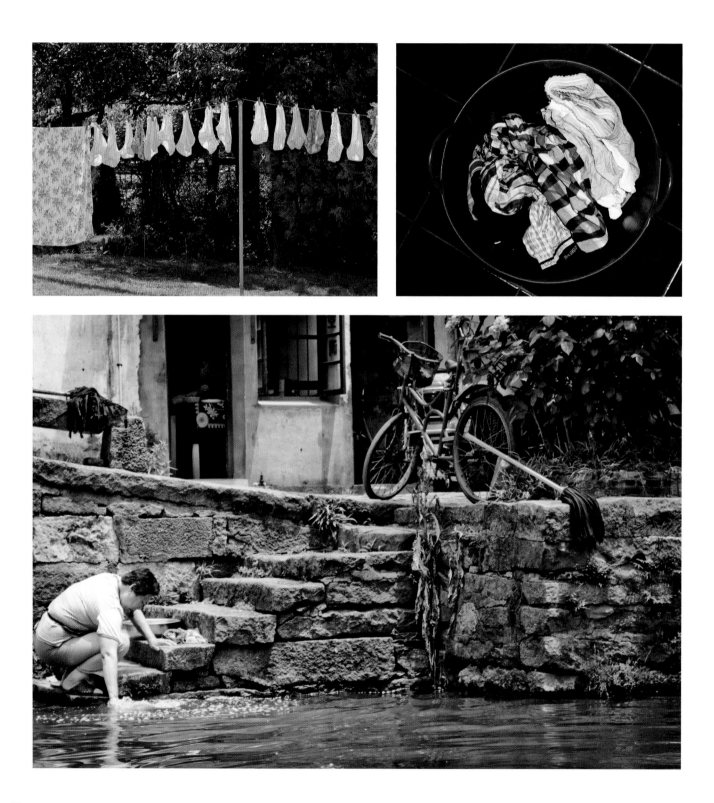

Fundeni, Romania, 11:44.
A family of 10 Roma live in this unfinished house. The washing machine is not connected to a mains supply, but runs instead from a water tank (visible on the left), which is filled several times a day to keep the machine in use for the almost endless family laundry.
Photo: Mugur Varzariu.

Palm Harbor, Florida, USA, 11:57.
"My day consisted of routine household chores. I wanted the photo to be grungy to depict my feelings about chores."
Photo: Michael Jenkins.

Madrid, Spain, 10:54.
"I wash my underwear when I take a shower and I hang them on a clothes rack on the heater. These are my Monday to Friday panties."
Photo: Natalia Quaglia Barrio.

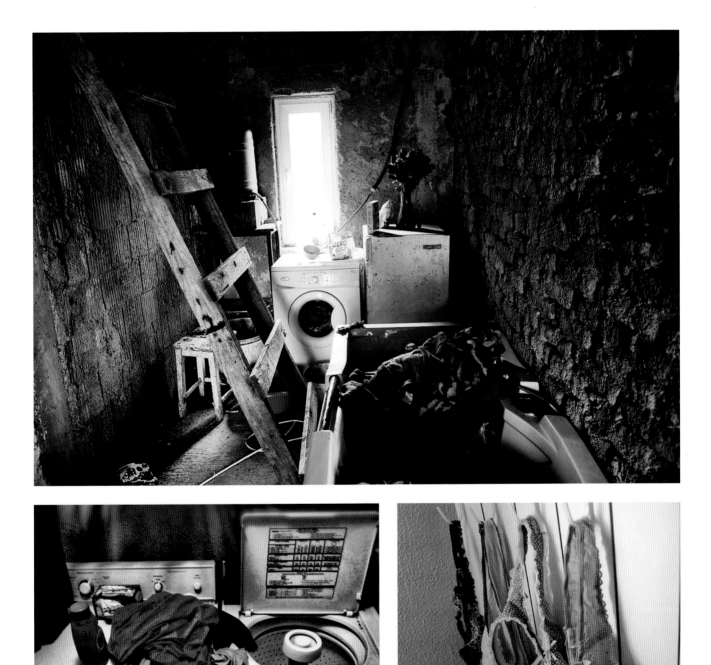

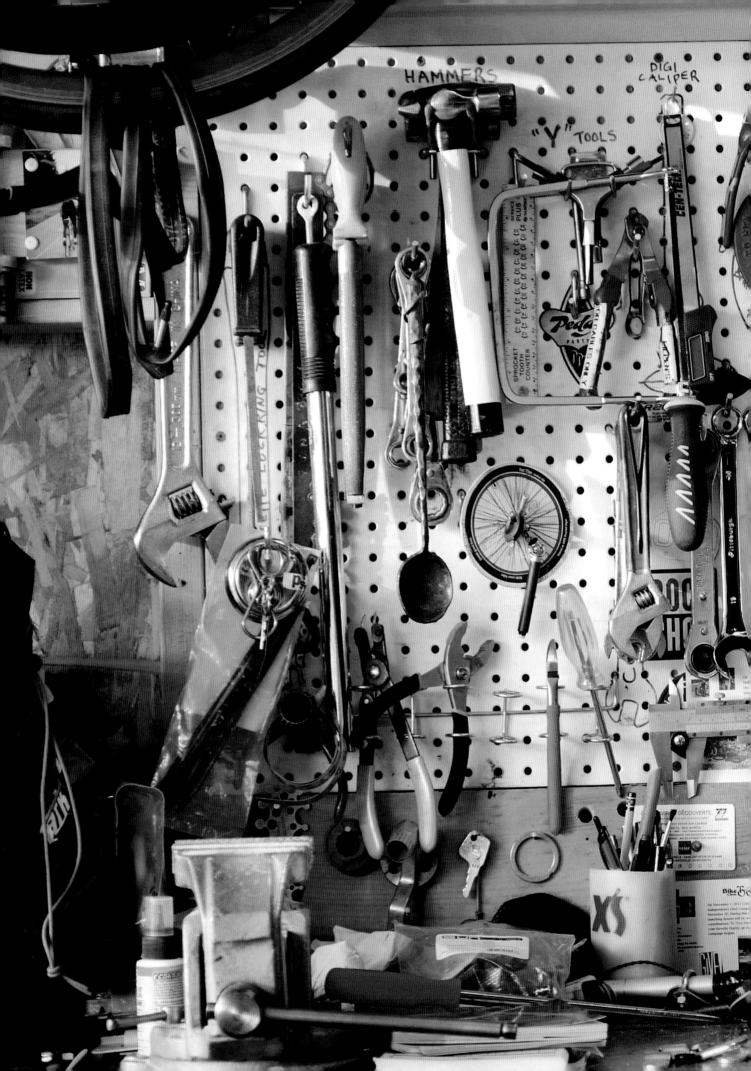

◄ Colorado Springs, Colorado, USA, 05:47.
"I first began fixing bicycles around the age of nine, and had my first job in a shop at age 19. This is my personal workbench at home, a smaller version of benches I used at professional bicycle shops for two decades. There is a love of tools among mechanics, partly for the beauty of the tool, and partly for the precision work they help you do. Now retired from a shop, I can always be found repairing bikes for neighbourhood kids and fixing used bicycles that will go to the homeless. Bringing an old bicycle back to life is very satisfying."
Photo: Eileen Brodie.

Gondomar, Portugal, 07:11.
Luisa Pimenta hugs Ana Júlia, a carer at the Institution Nuno Silveira, a home for socially vulnerable people that was formed by a group of parents and friends of children with disabilities. Luisa has been here five years and her brother, Paulo, is spending all day with her as she follows her normal routine. "Luisa likes to hug people who she really cares about. Because of her condition she has difficulty expressing herself, and hugging can be the most significant way of showing her appreciation to the ones she loves. The day will be in my heart as a special day for being able to photograph my sister and I feel more profoundly than ever how important it is to have her in my life."
Photo: Paulo Pimenta.

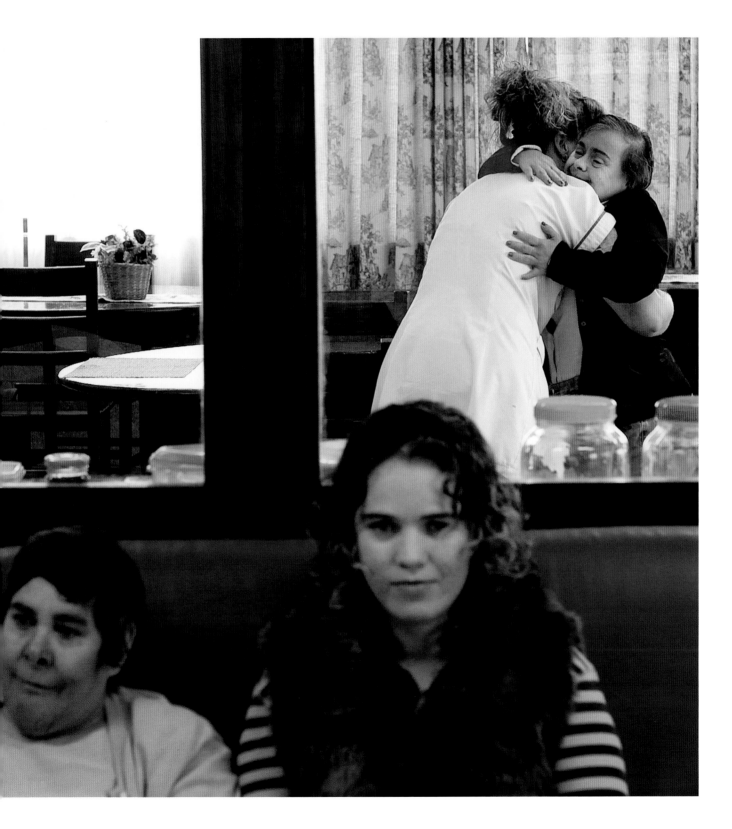

Fundulea, Romania, 07:33.
"Roma sisters Marilena and Florentina wait together at their home, which has neither electricity nor running water. Their father cannot find a job, so these kids don't really know the meaning of breakfast. Florentina, who at 13 is quite shy, helps her smaller siblings and her mother. When she was little, she had a metal rod inserted in her leg to repair a broken bone. The rod should have been taken out years ago, but the family lacked the money, so it remained, preventing normal development of her bone and giving her a limp."
Photo: Mugur Varzariu.

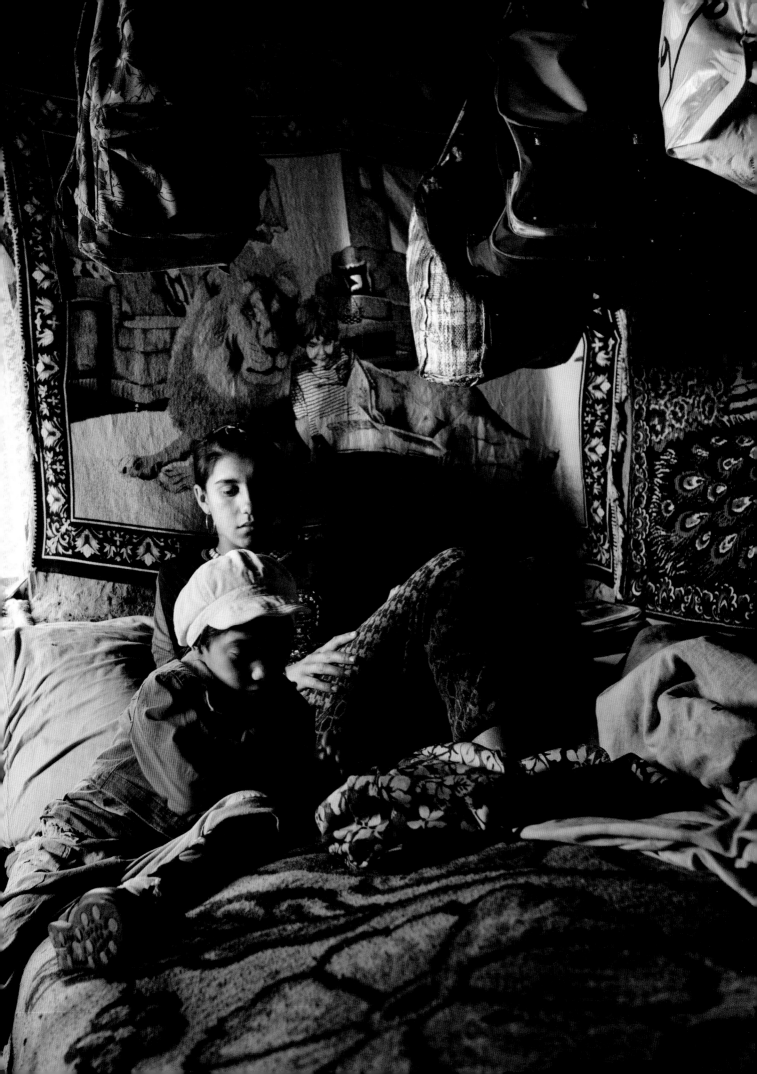

Dhaka, Bangladesh, 07:45.
Dhaka is one of the fastest growing
mega-cities in the world with a popu-
lation estimated at more than sixteen
million. There are about sixty million
children in Bangladesh and half of
them live below the international
poverty line.
Photo: Tobias Nørgaard Pedersen.

London, UK, 07:57.
"Ivy was looking at a Rapunzel sticker
book in her room before she left for
nursery. Her favourite is a nursery
rhyme book. Ivy loves her room and is
often found 'relaxing' (her word) with
books or children's magazines."
Photo: Suzanne Plunkett.

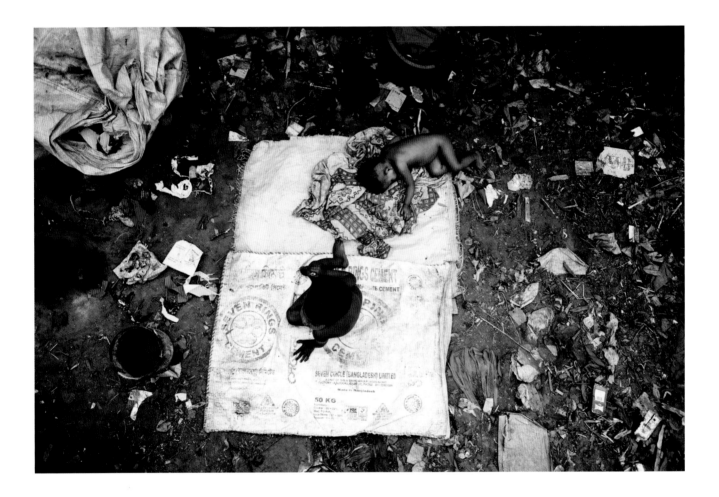

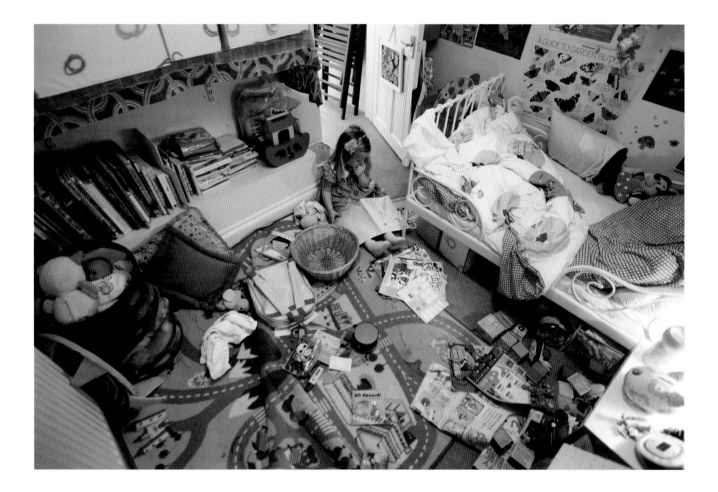

Kuala Lumpur, Malaysia, 15:30.
"The shop where I purchase my baking ingredients is smack in the middle of town. No matter how many times I pass by, I can't *not* look at the Petronas Towers."
Photo: Darna Aminuddin.

Concepción, Chile, 12:30.
Abandoned house on Pedro de Valdivia Avenue.
Photo: Carlos Keim.

Skopje, Macedonia, 17:30.
The Holocaust Memorial Centre.
Photo: Ana Andonovska.

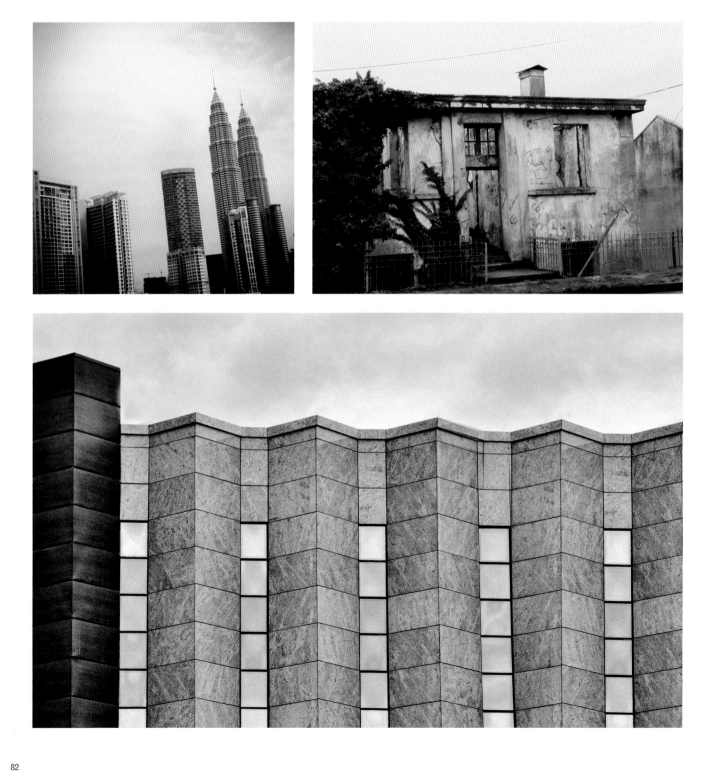

Yekaterinburg, Russia, 14:37.
"On my way to work, I love to study
the old wooden houses."
Photo: Lili M.

Amman, Jordan, 19:15.
"Evening view of Amman
from my neighbourhood."
Photo: Christine Terres.

Newcastle upon Tyne, UK, 20:32.
"The view that greets me from my
front doorstep – I find the lines of
chimneys and roofs a very comforting
sight."
Photo: Barbara Meier.

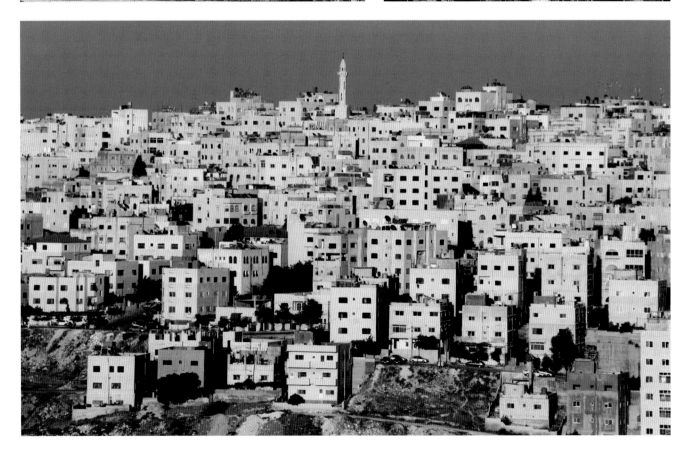

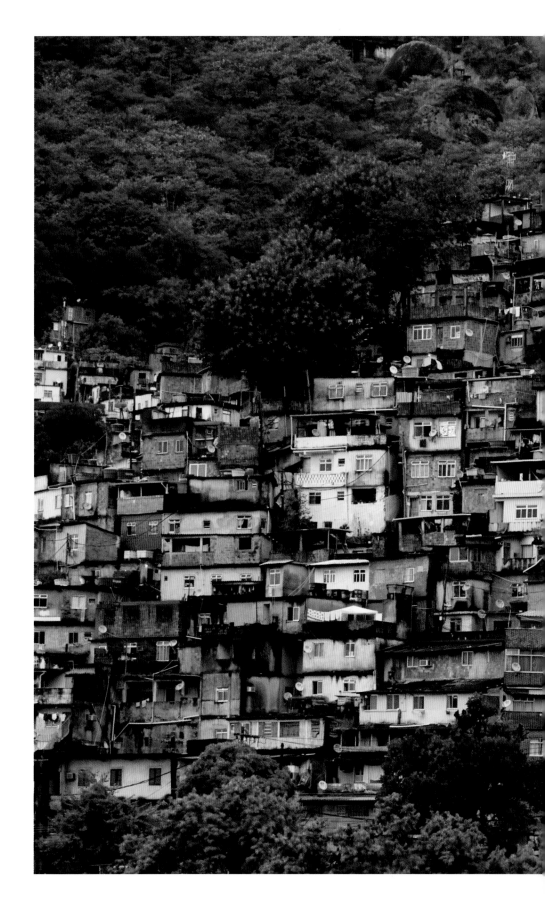

Rio de Janeiro, Brazil, 09:40.
The city has more than a thousand
*favela*s, or shanty settlements, this
one built opposite the Escola
Americana (American School). As
this teacher there observes: "Perhaps
about 20 years ago, poor people
started invading the forest areas
on the other side of the valley. Now
the slum population is estimated
at around 80,000. Some houses are
extremely poor but there are also five-
storey buildings constructed."
A current programme aims to
upgrade the *favela*s by 2020, providing
infrastructure and public services.
Part of the impetus has been the 2014
FIFA World Cup to be staged in Rio
and other Brazilian cities.
Photo: Martha Serra.

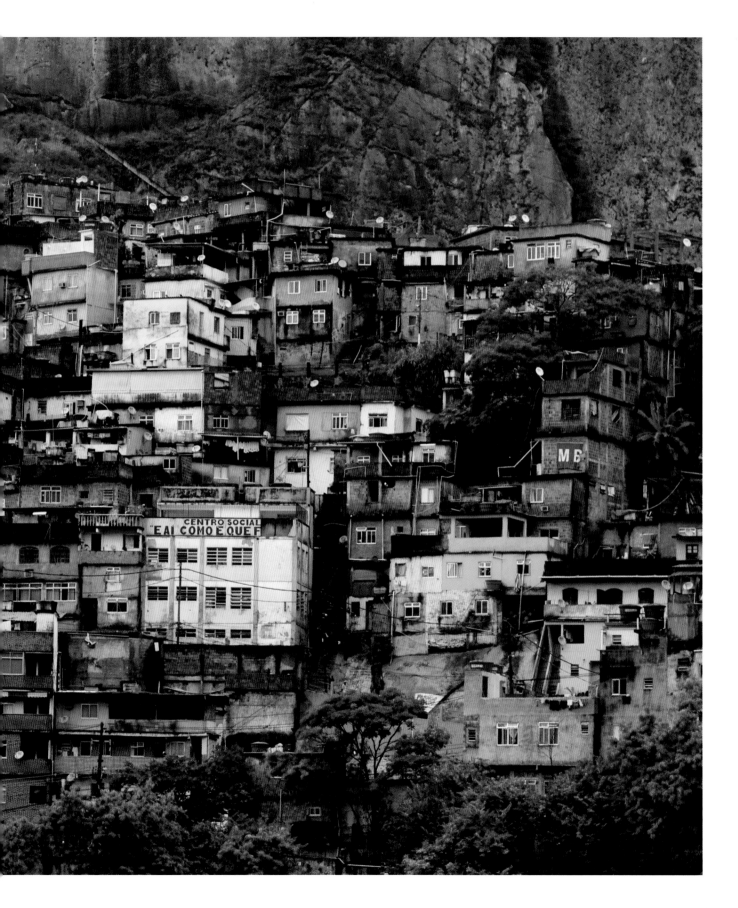

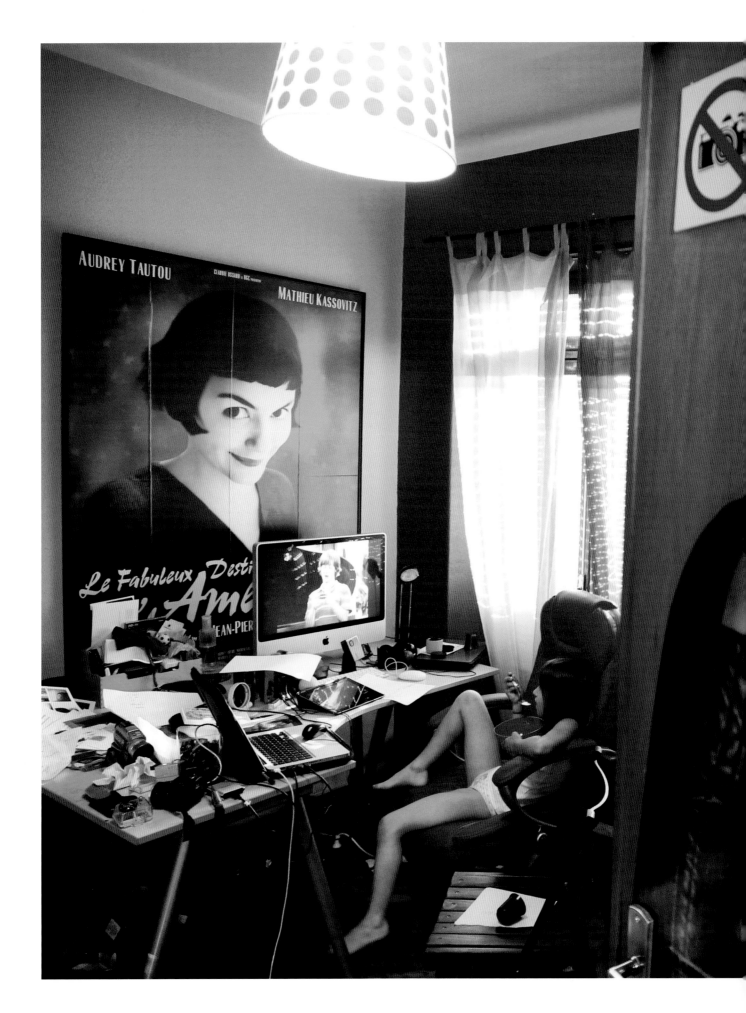

Montijo, Portugal, 08:29.
A distracting world of images
and information keeps seven-year-
old Mariana Lopes amused before
school, when she should be prepar-
ing. Once she gets to school at nine,
her favourite subject is Portuguese.
When summer comes, she'll be
surfing with her older brother. But for
now, there is last-minute homework.
Photo: Miguel Barreira.

◀ London, UK, 08:45.
"In the past 10 years, I have moved house eight times, living in Kabul, in four different flats in New York, briefly in Los Angeles, and finally in London. In each of these places, I always build a memory box corner. A suitcase full of secrets, a time capsule, an alcove, it gives weight and roots to a new place – and for that matter must remain untouched. I never sweep the dust off that shelf. Sometimes I add an object or remove one, but some are central pieces. As an ensemble, they comfort me, express the passage of time, and provide a form of permanence in my vagabond life."
Photo: Claudine Boeglin.

Perugia, Italy, 07:14.
"Breakfast time. Carlo lives in a hospice for AIDS patients in Umbria and has done for 11 years, most of that time in a wheelchair. An early riser, he usually has breakfast alone before the others wake up. Carlo doesn't talk much except to say 'Aloha' every time he sees you; even if the last time you crossed paths was only five minutes previously."
Photo: David deVeson.

St. Moritz, Switzerland, 08:15.
A glamorous resort town in the Swiss Alps, St. Moritz is a prime destination for skiers. "My temporary job, for a month, is helping with the annual cleaning of city parking garages, removing dust and salt from the pipes. Because this is Switzerland, the cleaning of parking garages is quite meticulous."
Photo: Alexis Rousseau.

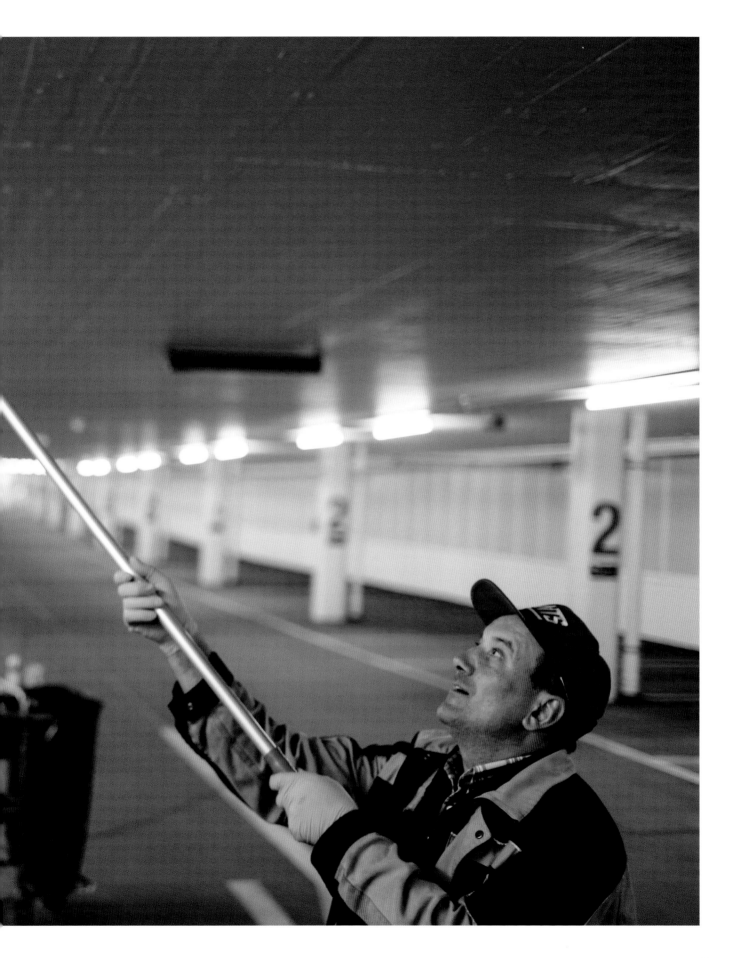

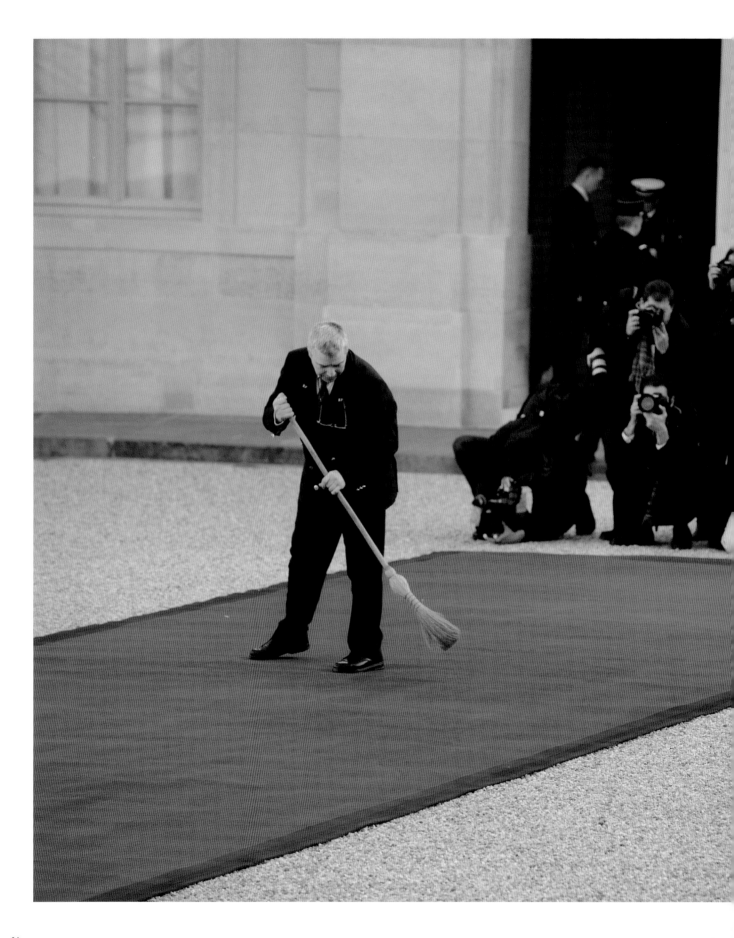

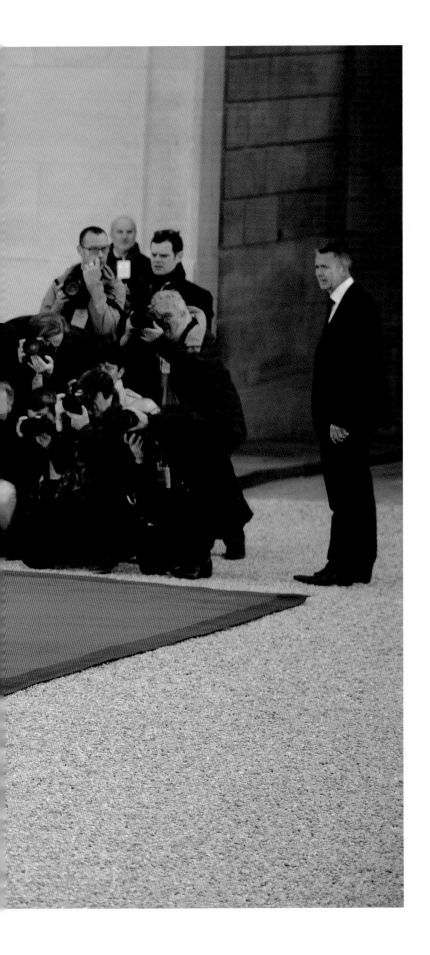

Paris, France, 08:22.
An official from the Elysée Palace prepares for the arrival of François Hollande, the newly elected president of France, on the day of his inauguration. On this particular morning, he will meet behind closed doors with outgoing president Nicolas Sarkozy, to receive sensitive documents and secret codes for France's nuclear weapons.
Photo: Jacques Witt.

Santa Rosa de Copán,
Honduras, 09:15.
Worldwide, millions of waste pickers
brave horrible smells to make a living.
Although they toil under difficult
conditions, they perform a valuable
service to society by collecting,
sorting, recycling and selling the
things others discard. "How often we
complain about life, not realizing that
we have more than so many others
who have only dreams."
Photo: Aída Rodríguez Murillo.

Hanoi, Vietnam, 08:34.
Rubbish is increasingly being
dumped all around Hanoi – like here,
along Highway 5. The capital city's
six million inhabitants daily produce
6,000 tonnes of rubbish. Almost all
of it goes to a gigantic tip in the
Son Soc area, which was planned
for use until 2025 but is already full.
Waste is now more than 130-feet
(40m) high over an area as big as
150 soccer fields.
Photo: Nguyen Huy Kham.

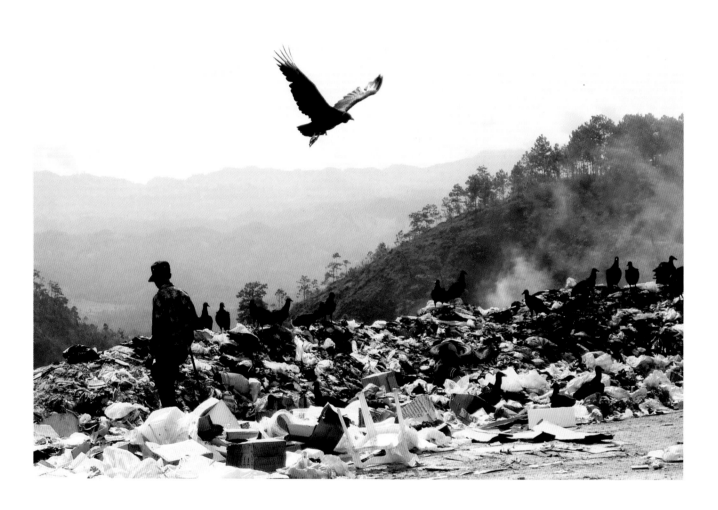

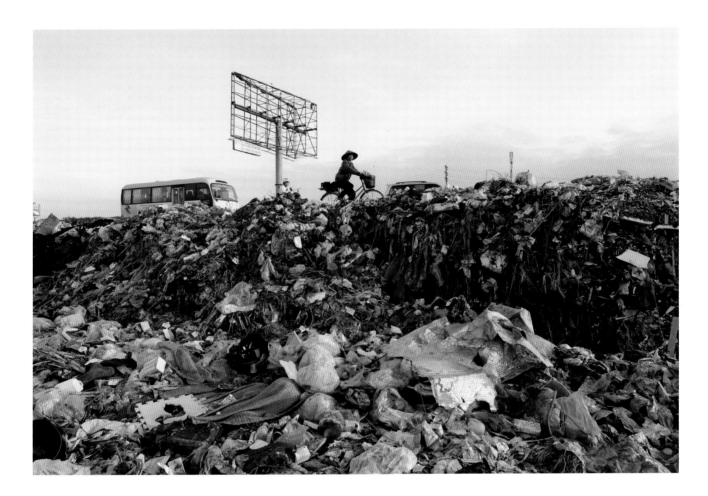

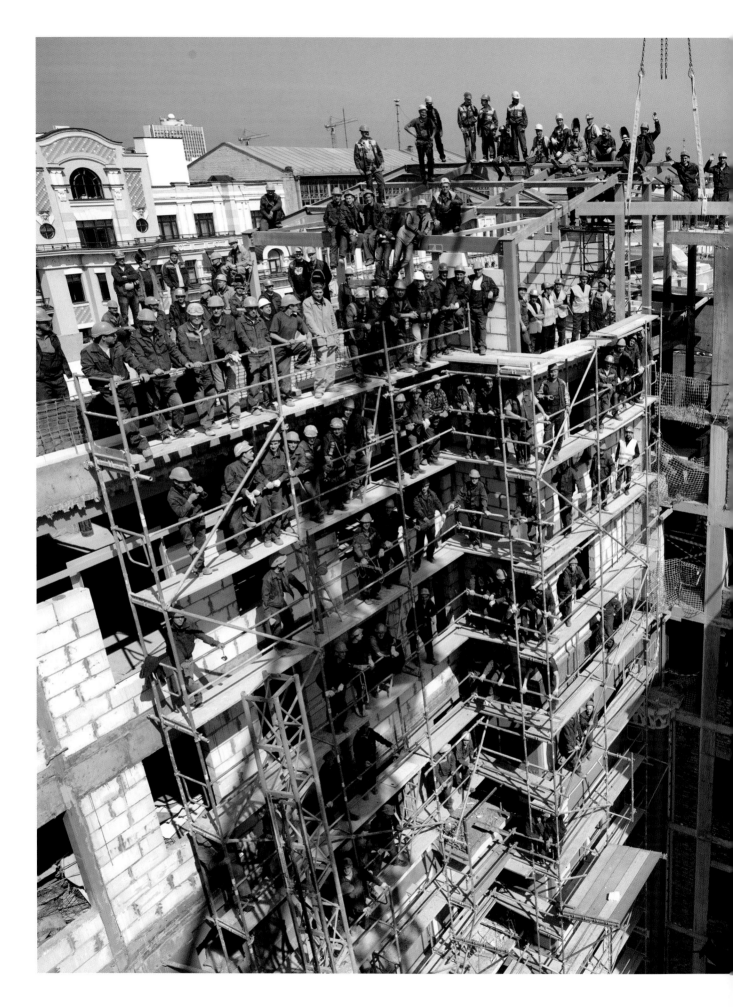

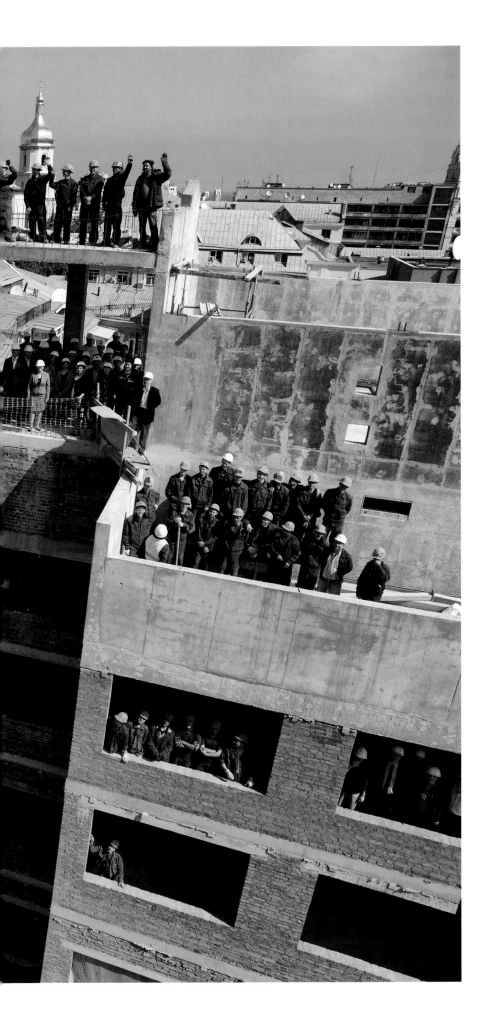

Kiev, Ukraine, 09:30.
The city has many empty building
sites. But close to the Golden Gate
in Kiev's historic centre, the old
Hotel Leipzig, originally built in 1900,
is undergoing total renovation. Here
are the workers on the project, which
could not be completed in time for
the European football championships
in June.
Photo: Igor Gaidai.

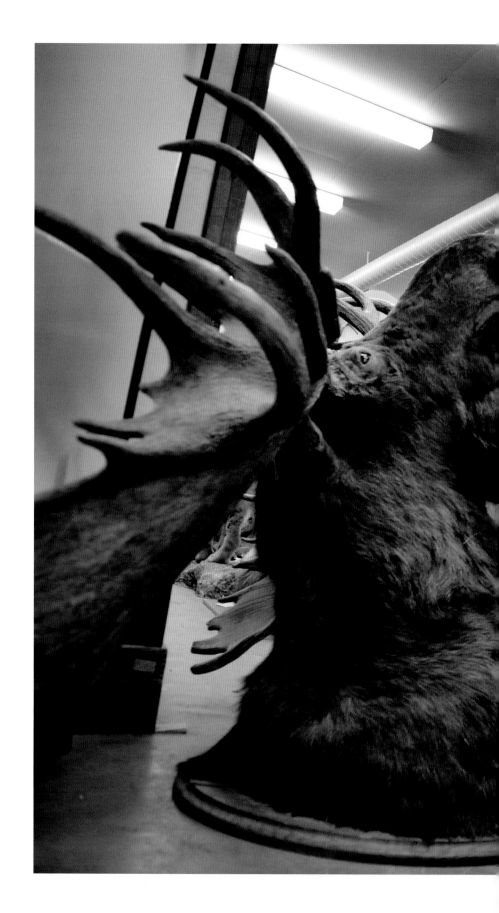

Stockholm, Sweden, 09:45.
Peter Mortensen is a scientific
taxidermist at the Department of
Vertebrate Zoology at the Swedish
Museum of Natural History. He is
storing away stuffed animals that
no longer command a display place.
Photo: Jessica Gow.

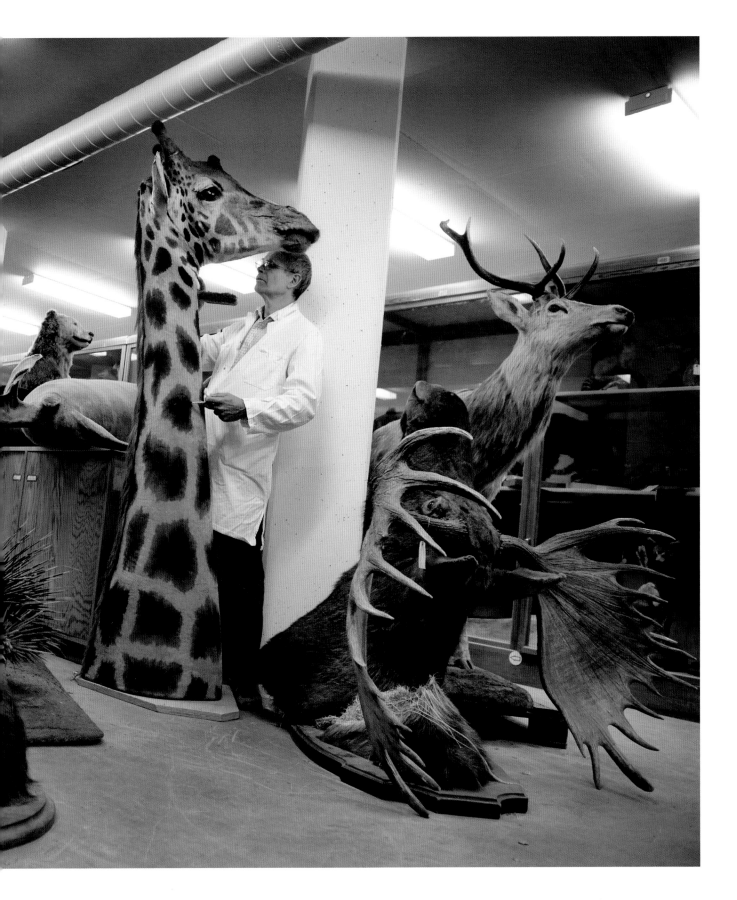

Siem Reap, Cambodia, 13:45.
"An old woman comes out of her home to see what the commotion is about. I had taken photos here two years ago and returned today to give the villagers prints. They were happy and surprised."
Photo: Barend van den Hoek.

Masai Mara, Kenya, 12:45.
Traditional Masai lifestyle is based around cattle. This house is made of a timber lattice structure that is waterproofed with a mud plaster mix that includes cow dung.
Photo: William Cleis.

Örebro, Sweden, 18:00.
With the lighter evenings and warmer temperatures, Emilia, age 10, can stay outside her home playing until late. Today, as the summer solstice approaches, this city in central Sweden basks under 17 hours of sunlight, with the sun rising at 04:14 and setting at 21:16.
Photo: Petter Koubek.

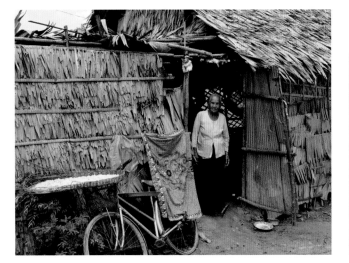

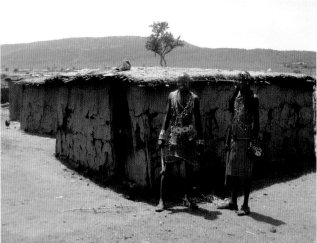

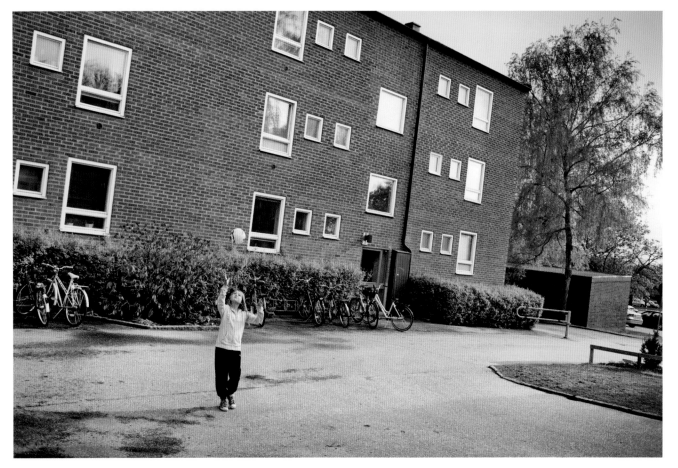

Macao, China, 09:00.
Like Hong Kong, Macao is a former colony now designated a "special administrative region" within China. Macao was under Portuguese control from the 1500s until its handover in 1999. In recent years, Macao has undergone rapid development, spurred by its gambling industry – the city is known as the "Monte Carlo of the Orient". Population density is, by some margin, the highest in the world – nearly 21,000 per square kilometre, almost three times that of Singapore.
Photo: Jay-Jay Cabal.

Maracaibo, Venezuela, 07:13.
"This was once a famous hotel with guests such as the great tango singer, Carlos Gardel."
Photo: Esther Carache.

Pont-en-Royans, Rhône-Alpes, France, 10:31.
A quiet bend in the River Bourne as it runs through this village in Vercors, an area that is officially designated as being of outstanding natural beauty, near Grenoble in the French Alps.
Photo: Roland Pencz.

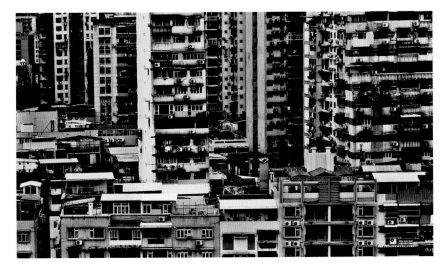

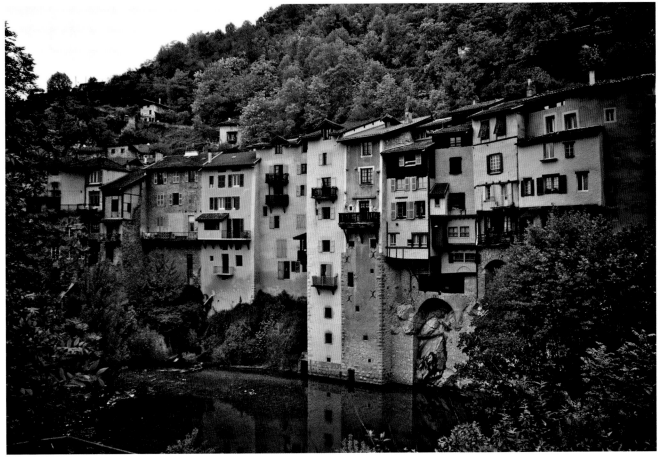

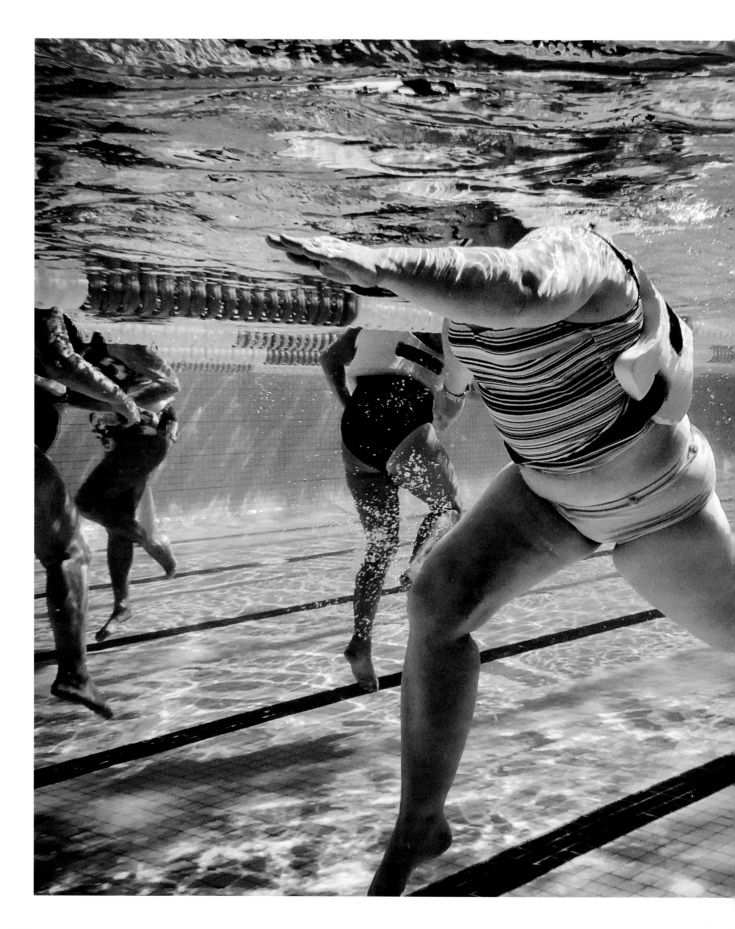

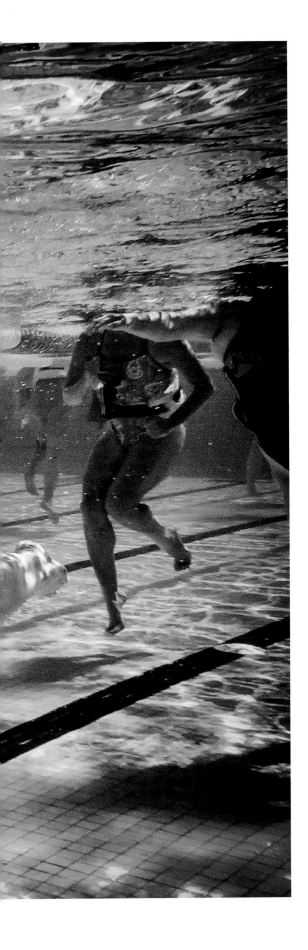

Casuarina, New South Wales,
Australia, 09:02.
"I go to my deep-water running class
every Tuesday. The pool is outdoors
and heated, so we go rain or shine,
winter or summer. You are kept from
touching the bottom of the pool
by the flotation belt. So if you are
very overweight, have bad knees, or
pregnant, it is a safe way to exercise."
Photo: Jillian Merlot.

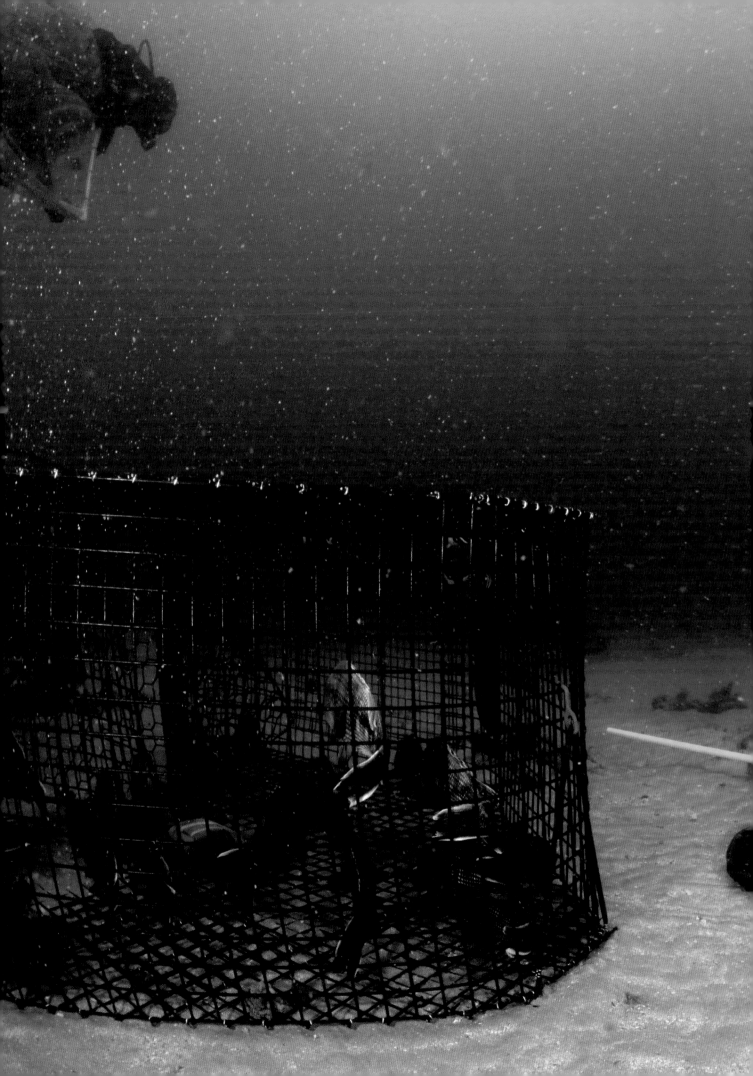

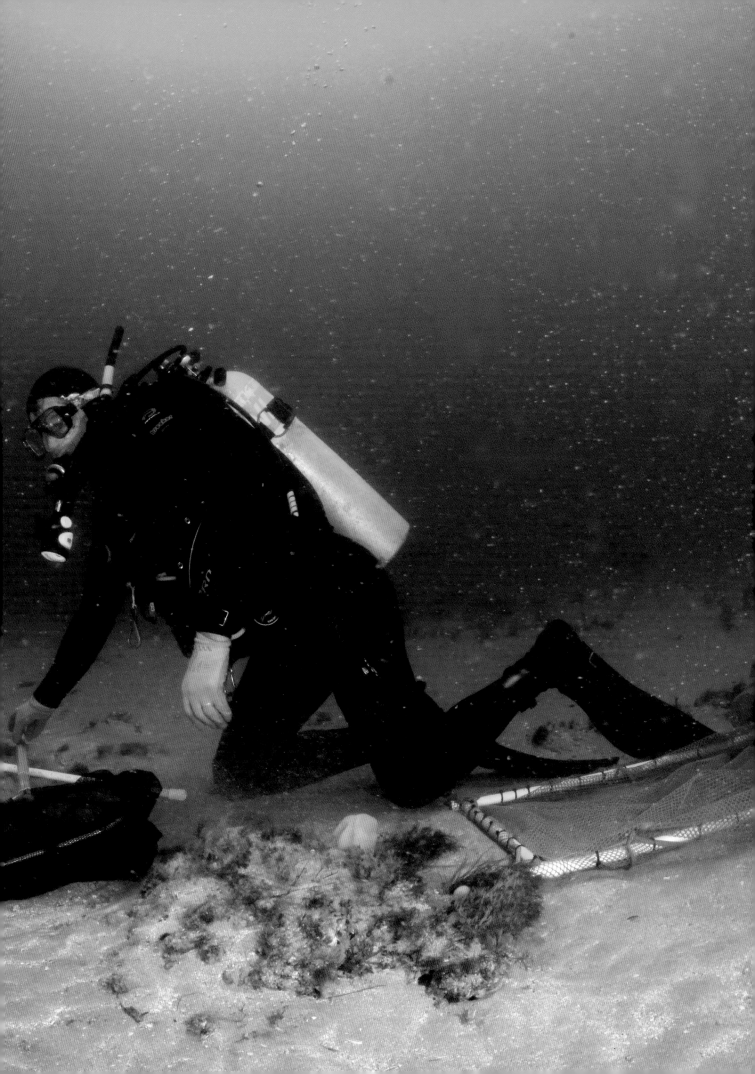

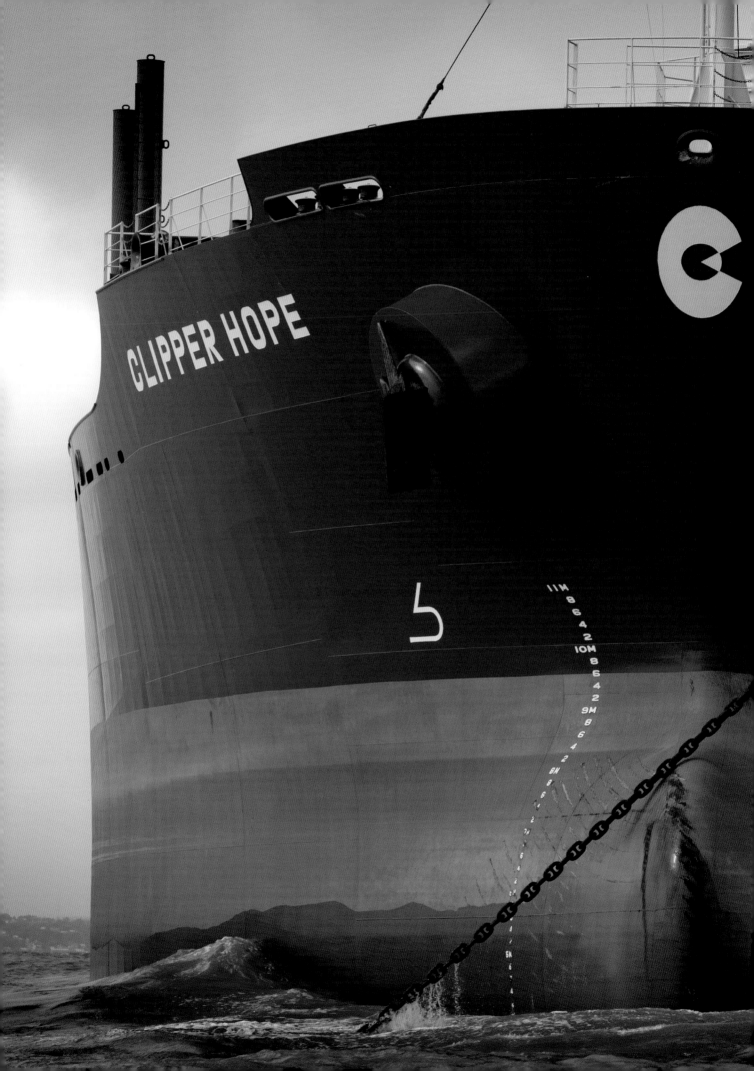

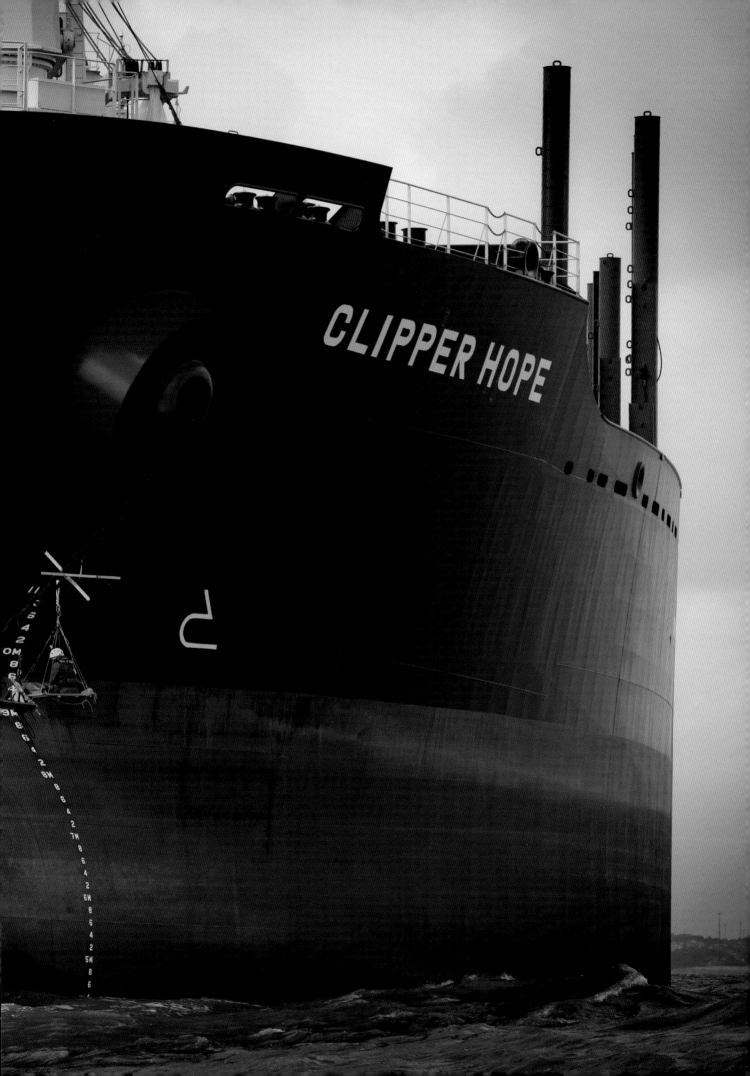

◄◄ Gray's Reef, Georgia, USA, 10:18.
Diver Guy Davenport observes
black sea bass that will have small
acoustic transmitters implanted in
their abdomens, allowing tracking
of their movements within Gray's
Reef National Marine Sanctuary.
By studying the fishes' migration
patterns, scientists hope to make
better-informed decisions about
managing the reef, which is also
open to recreational fishing.
Photo: Greg McFall.

◄ São Luiz do Maranhão, Brazil, 09:07.
Greenpeace activist Leonor Cristina
Silva Souza hangs from the anchor
chain of the freighter *Clipper Hope*,
stopping it from leaving port with
a load of Brazilian pig iron for the
USA. She and her fellow activists on
the *Rainbow Warrior* are protesting
industry practices, which they believe
worsen deforestation through the
heavy burning of charcoal. The pig
iron is exported to make steel for
American carmakers. So far, Souza
and her colleagues, dressed in orange
security uniforms, have delayed the
ship for 10 days.
Photo: Marizilda Cruppe.

Gorey, Wexford, Ireland, 09:51.
"This is Lodger. She is staying with
us for a little while, hence her name.
Already I have fallen in love with her.
She has captured my heart with her
gentle ways. I will be so sad when
the time comes for her to go away.
When Lodger lies on our doorstep
it is the greatest compliment because
it shows how much she loves and
trusts us. She feels at home, relaxed,
and never wants to leave."
Photo: Heather Cody.

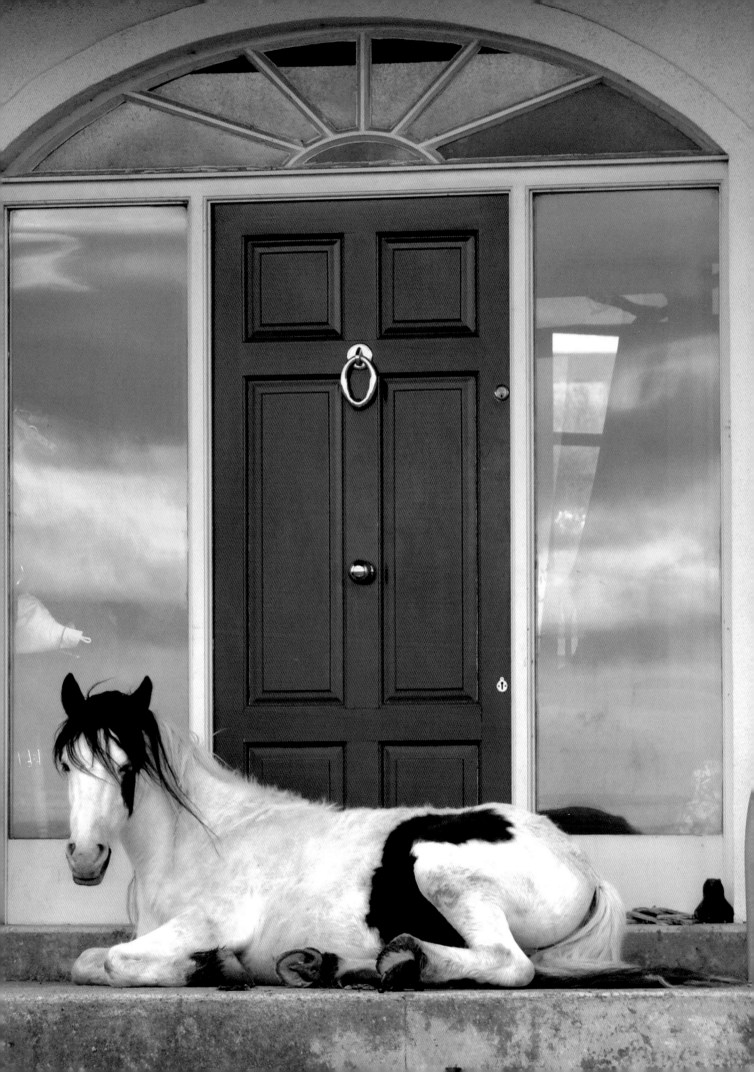

Sulligent, Alabama, USA, 09:07.
"I'm 23 years old and recently moved into my own home after my dad and I fixed it up. I live with my toy poodle Angel and sleep with my .380-calibre pistol close, for protection. I love the outdoors, hunting and shooting my pistol, and work as a company service rep. I speak with people all over the United States. Although at times I get frustrated, I have laughed and at times cried with my customers. They are why I love my job. I'm a preacher's daughter. I aspire one day to be a professional photographer who travels all over the world capturing the beauty God has created."
Photo: Megan Price.

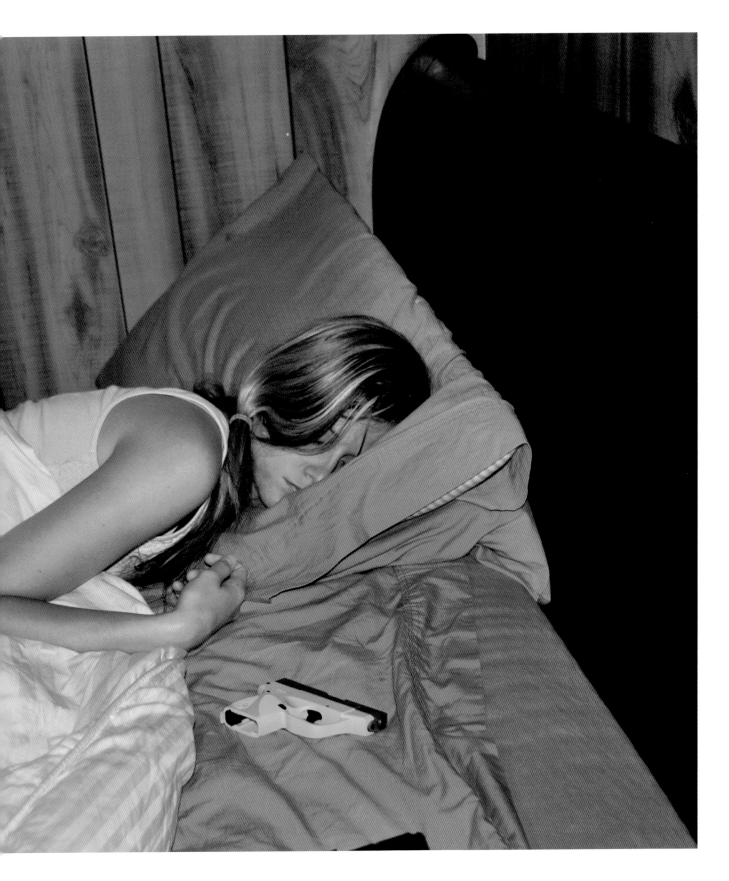

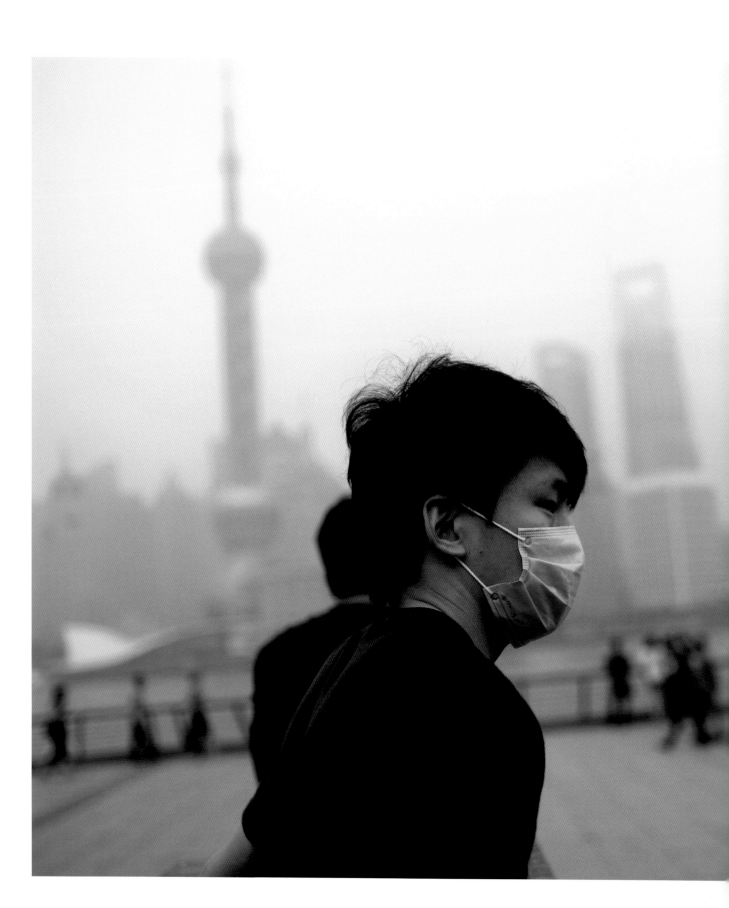

Shanghai, China, 09:15.
A traveller from Sichuan shields himself from Shanghai's pollution. The city is China's most populous, has the highest cancer mortality rate in the country and is still heavily dependent on coal for industrial energy and residential heating. Shanghai's underground rail system now comprises more than 270 miles (430km) of track but passenger car density, and coal use, are still greater than in any other Chinese city. Masks are also commonly used in China to avoid spreading germs. There was a huge upswing in sales and usage of masks during the avian flu epidemic.
Photo: Aly Song.

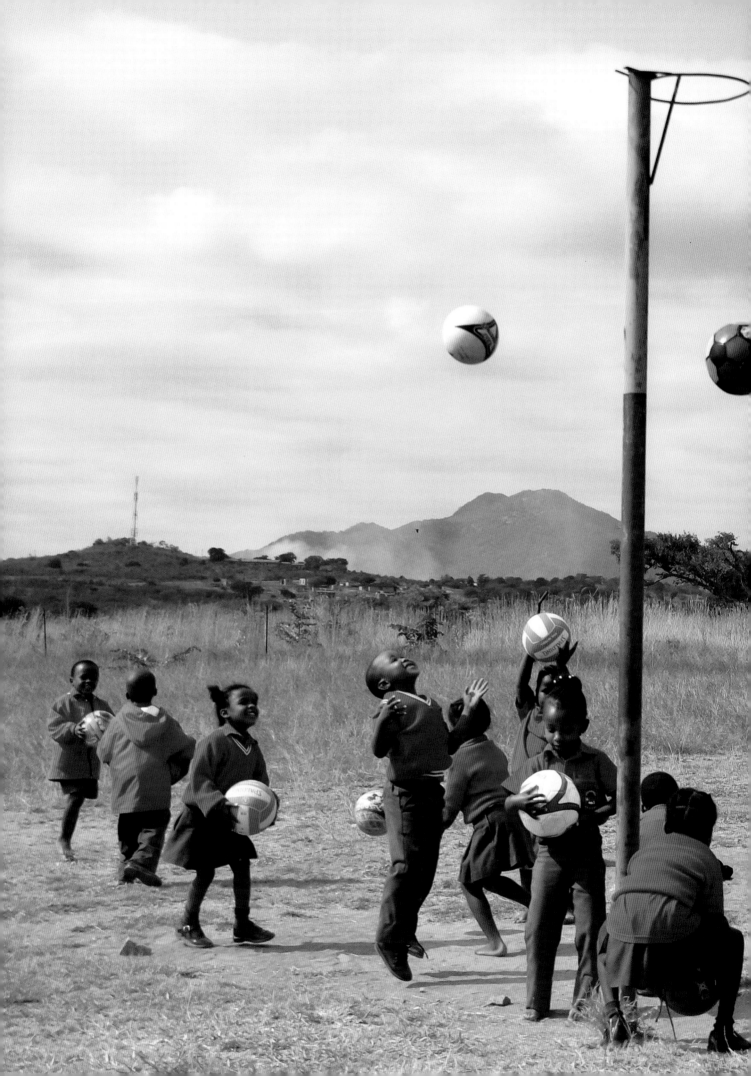

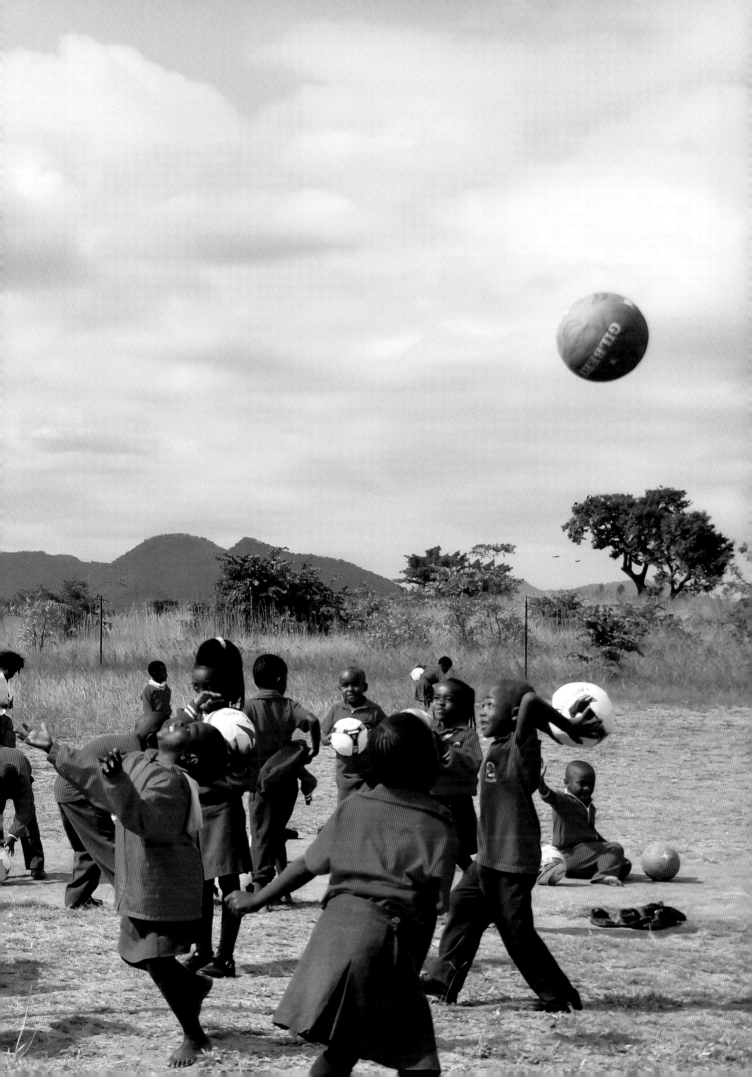

◄ Sasekani, Limpopo, South Africa, 10:25.
Corneli du Plessis had given up teaching more than two decades previously when, three years ago, at the age of 64, she suddenly felt a Christian calling to fulfil a special mission. "These children are having a free-play session. They are four to five years of age, come from the poorest of families in the rural areas and can only speak Shangaan and Northern Sotho. The first six months we spend communicating by hand signals and pictures. Their capacity for learning is just amazing. To see a small child developing intellectually and emotionally is such a satisfaction. Every day feels like a new beginning – to know that I am making a difference in children's lives. It leaves me humble."
Photo: Corneli du Plessis.

San Juan Texhuacán, Veracruz, Mexico, 09:56.
It is Teachers' Day in Mexico so young Samuel is not in school. He caught the rooster on top of the chicken coop and tied his leg to a small copper pipe with twine. When set free, the rooster heads to the freshly planted cornfield, with the hens following him to scratch the earth for edible seeds.
Photo: Denise Aulie.

Tehran, Iran, 12:37.
These women are on their way home after shopping. The stairs connect a housing area and a business district in northern Tehran. About two or three years ago, the municipality of Tehran started a policy of brightening up the city, creating new murals or replacing old ones.
Photo: Morteza Nikoubazl.

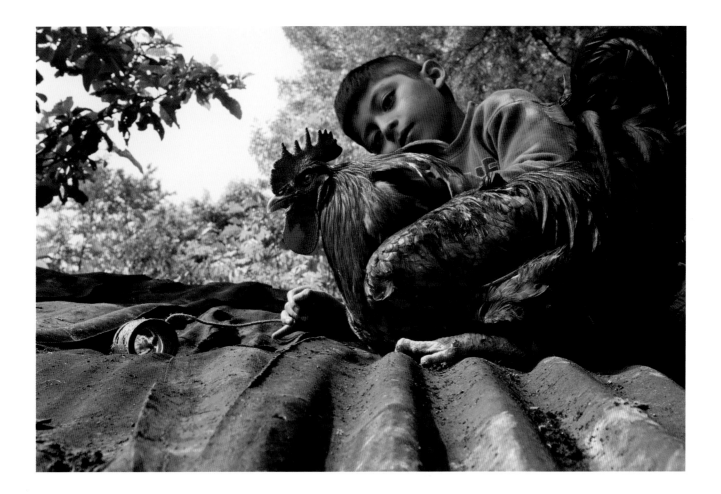

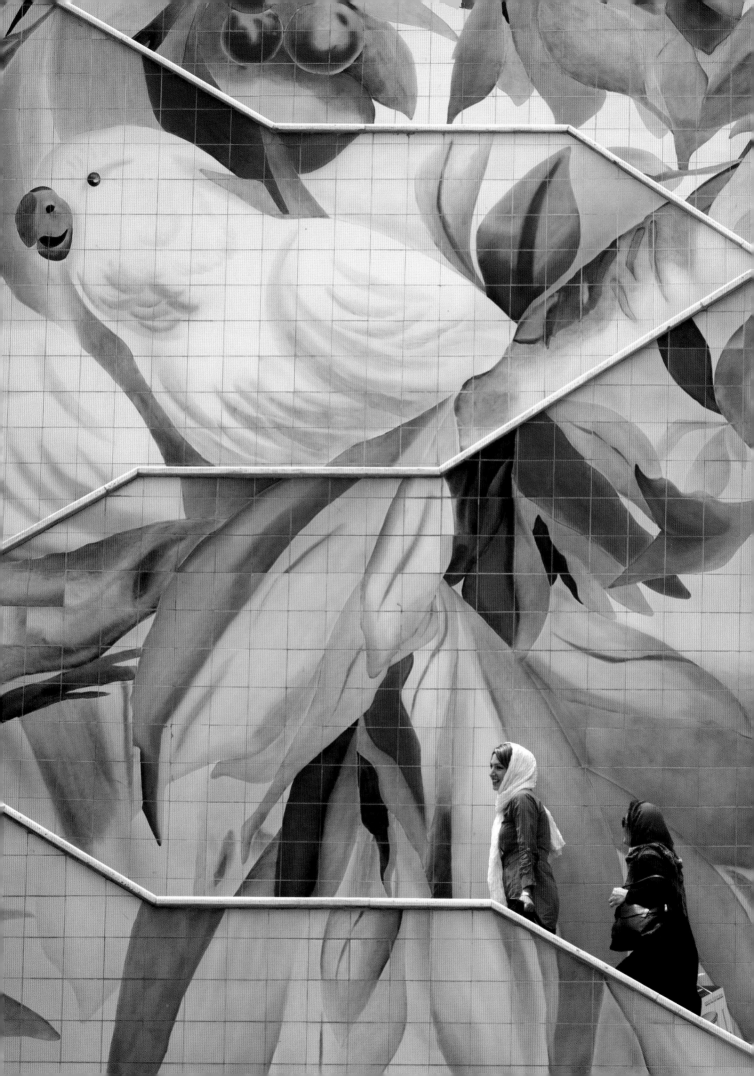

◂ Starokonstantinov, Ukraine, 10:00.
"My daughter Vladislava at the
kindergarten where she spends her
days between eight o'clock and five.
She is five-and-a-half years old. The
25 children usually rest for a couple of
hours a day in this room."
Photo: Mykola Velychko.

Miami, USA, 16:15.
When work pressures mount, it helps
to stay hydrated. In the USA, bottled
water sales have reached their
highest level ever, amounting to some
100 bottles of water per year for every
person. The increase is somewhat
surprising given environmentalists'
efforts to condemn bottled water as
wasteful, with sales banned in some
national parks and college campuses.
Still, convenience is winning out –
and many people still believe that
water in a bottle is healthier than it is
from a tap.
Photo: Julio Alvarez.

Kiev, Ukraine, 08:45.
"I love my job and my workplace.
I like feeling comfortable, so I have
decorated my desk with plants and
nice things that give me positive
feelings."
Photo: Inna Glushchenko.

Annapolis, Maryland, USA, 09:00. "One of my colleagues at the Maryland Department of Natural Resources has his own way of organizing the paperwork for his projects. His work involves invasive species, aquatic surveys of streams, and so on. He says people periodically give him calendars and he enjoys them." *Photo: Paul Genovese.*

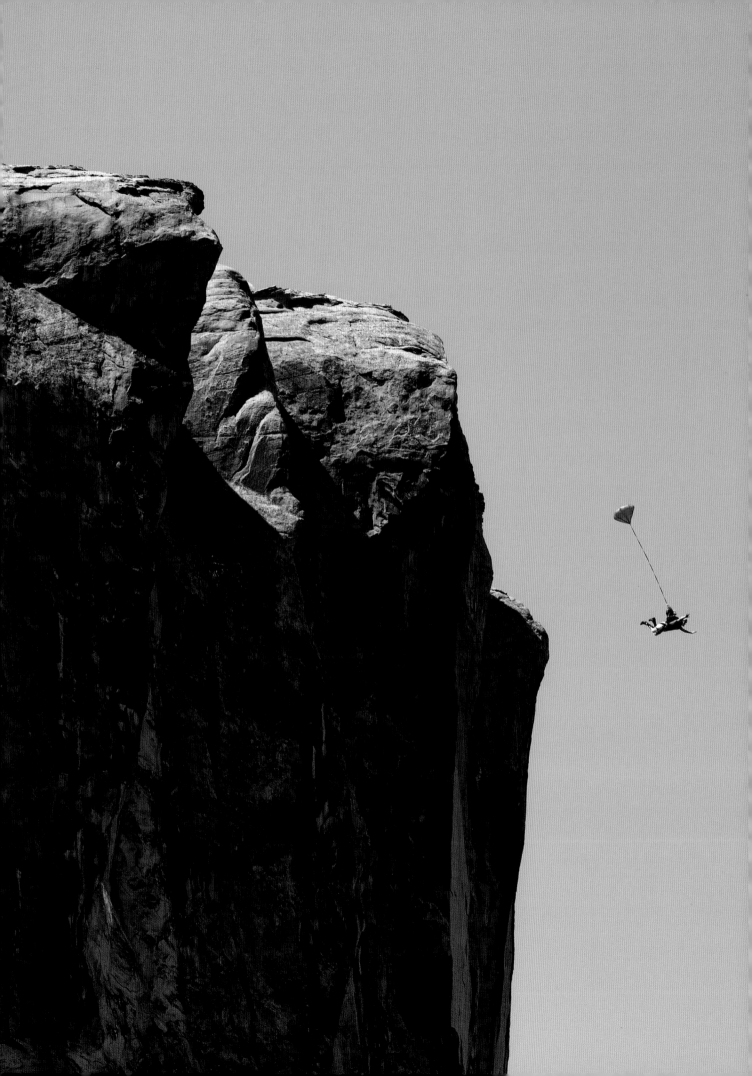

◄ Moab Desert, Utah, USA, 10:12.
BASE jumping is an acronym for
four types of jumping-off points:
Buildings, Antennas, Spans (bridges)
and Earth (cliffs). Here, BASE jumper
Kerry Lofy is leaping off a cliff called
"G-spot". In this extreme sport,
people jump from very low altitudes,
allowing them only seconds to open
the parachute that breaks their
fall – and his has not yet deployed.
"G-spot" stands just 400 feet (120m)
tall, less than five seconds from the
ground for someone in free fall.
Photo: Krystle Wright

Kawasaki, Japan, 10:00.
"My girlfriend started losing her
connections to the outside world
because of depression. She is being
treated at a hospital for her illness,
trying to confront the trouble inside
herself. She is afraid to get a job,
because she would have to quit if
her condition got worse. Somehow,
she has found comfort in taking care
of this little plant."
Photo: Daichi Koda.

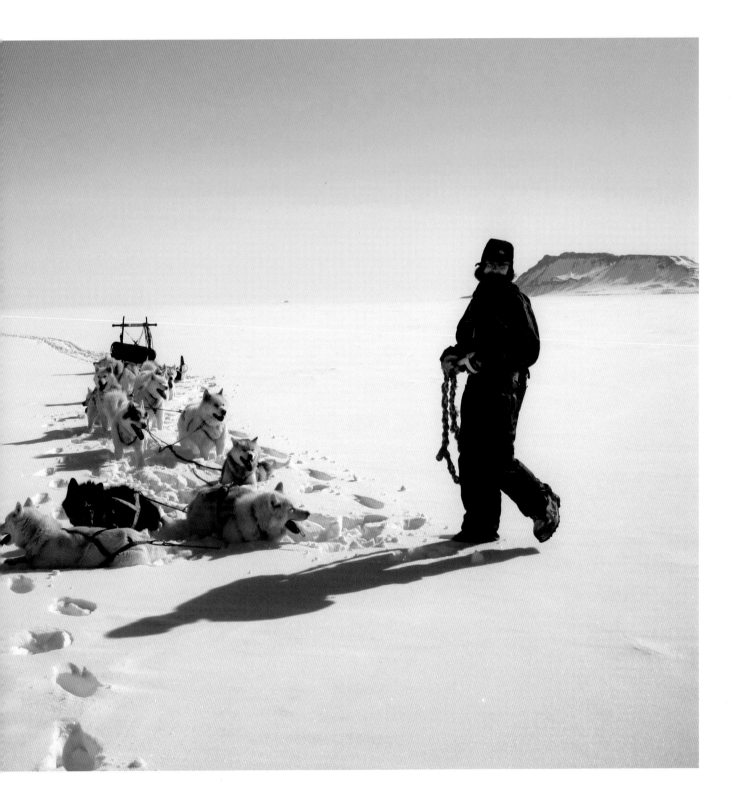

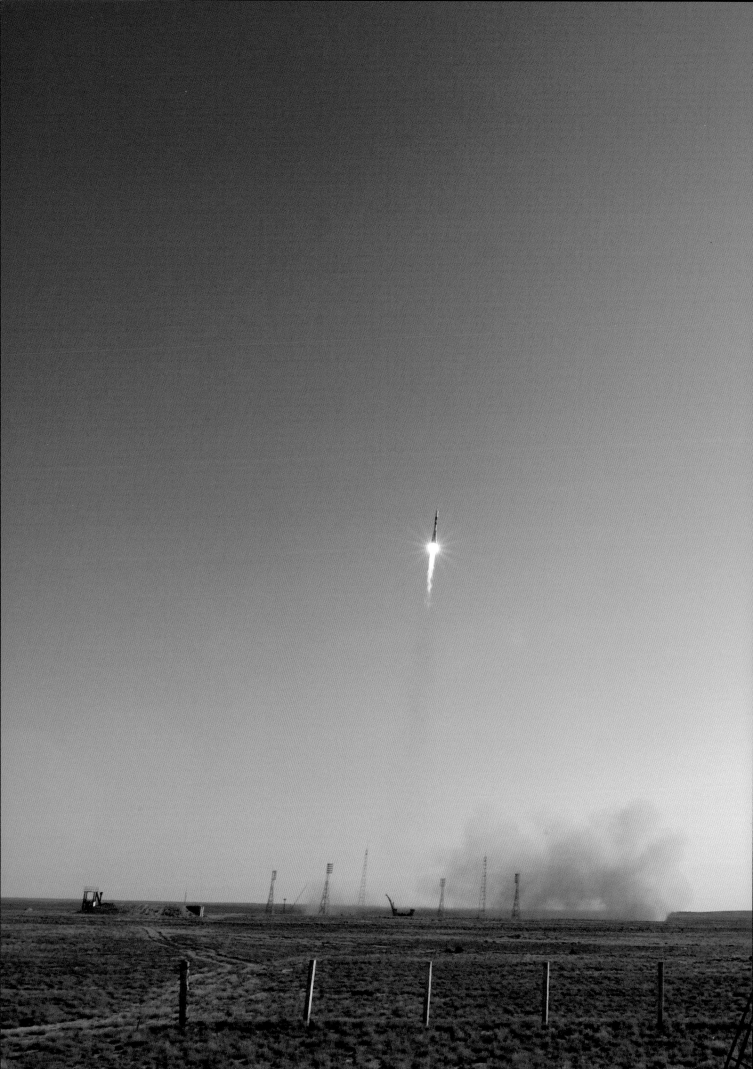

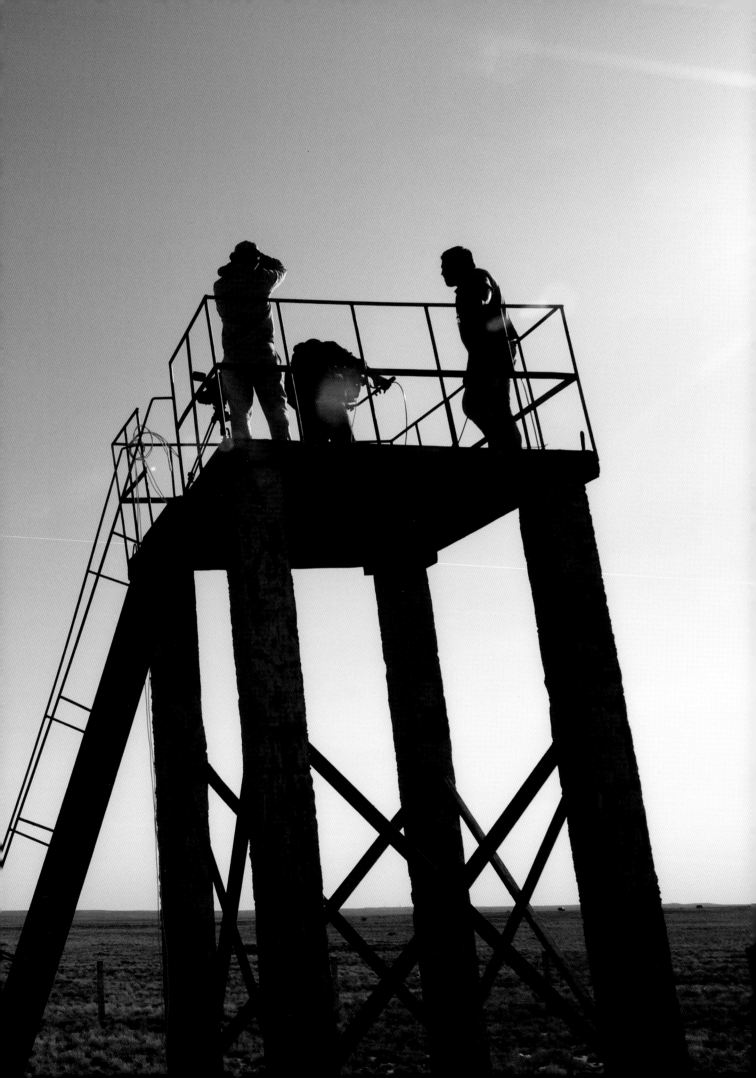

◄ Baikonur, Kazakhstan, 09:05. From their tower, TV cameramen film the blast-off of the Soyuz TMA–04M spacecraft, carrying replacement crew for the International Space Station (ISS). "After the Soviet Union collapsed, Baikonur cosmodrome, the core of the Soviet space programme, became the property of Kazakhstan. Now, Russia leases it to carry out its space programme, especially manned flight. I have been photographing Baikonur for almost 10 years. Coverage of each flight includes many events: the Soyuz rolls out from its hangar and is set up on the launch pad, the crew holds a news conference, an Orthodox priest blesses the Soyuz. But the culmination of the whole story is blast-off day, of course. I set up a second camera, to show photographers working in the vast steppe, which I triggered with a radio-remote held in my left hand."
Photo: Shamil Zhumatov.

Bingie, New South Wales, Australia, 08:15.
Me in the mirror.
Photo: Christine Whitelaw.

Tehran, Iran, 10:30.
Bubbles in the bathroom.
Photo: Yasaman Tamizkar.

Superior, Colorado, USA, 09:15.
Waking up.
Photo: Tyler Tenorio.

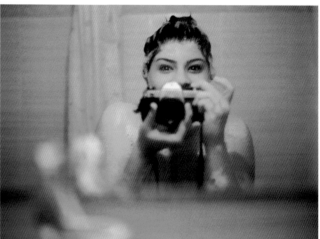

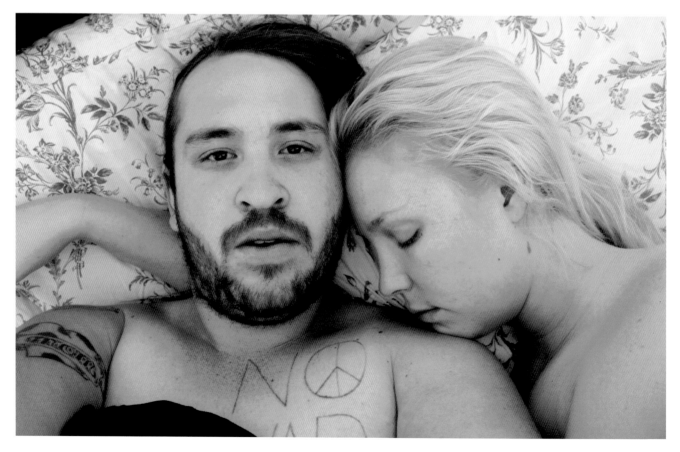

Seattle, Washington, USA, 05:59.
"This is my family: my wife, my son
and myself. We are taking pictures
of our cameras and ourselves. The
mirror was my grandfather's, given
to me by my mother. It was as many
generations as we could gather in
one photo."
Photo: Paco Jones.

Prague, Czech Republic, 07:15.
In the lift.
Photo: Elisa Zampieri.

Byron Center, Michigan, USA, 09:14.
Spontaneous shot.
Photo: Alex Karel.

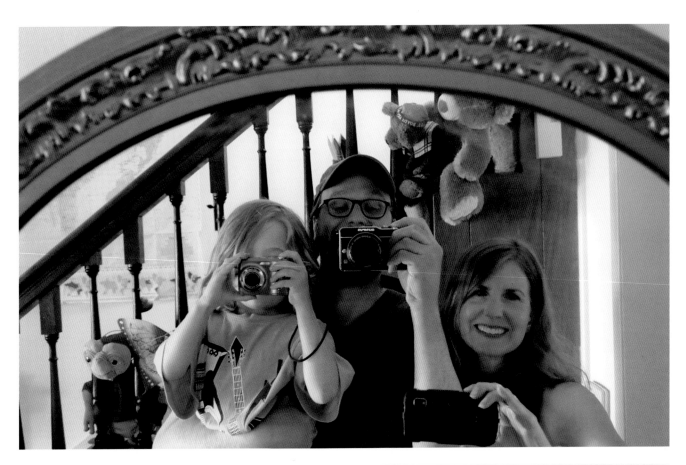

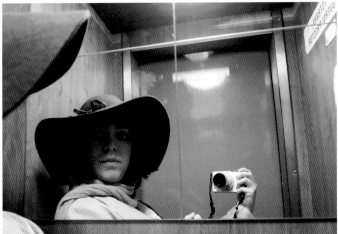

1. Istanbul, Turkey, 08:15.
Turkish coffee. *Photo: Sinem Özmen.*
2. Budapest, Hungary, 11:15.
Cloudy sky. *Bence Ferenczi.*
3. Qom, Iran, 06:15.
Commuting from work.
Mehdi Teimory.
4. Haarby, Denmark, 03:00.
Houseleek in the garden.
Mette Hansson.
5. Connah's Quay, Wales, UK, 11:15.
Oasis "fan wall". *Alex Catton.*
6. Lima, Peru, 07:45.
Morning traffic. *Said Guerra.*
7. Copenhagen, Denmark, 10:00.
My lovely earrings.
Michelle Bonita Madsen.

8. Istanbul, Turkey, 09:30.
Bouquet of flowers.
Alberto Guiliani.
9. London, UK, 07:30.
Liverpool Street Station. *Ian Good.*
10. Istanbul, Turkey, 09:00.
Checking the traffic. *Sinem Özmen.*
11. Budapest, Hungary, 11:00.
My legs. *Kérges Dániel.*
12. Lent, the Netherlands, 12:00.
Flowers. *Marije Brouwers.*
13. Sydney, Australia, 09:15.
Local café. *Gretchen Chappelle.*
14. Tajrish, Iran, 09:45.
Selling on the street. *Mehdi Teimory.*
15. Munich, Germany, 11:30.
Love letters. *Jan Sonnenberg.*

16. London, UK, 07:29.
Starting my day. *Stefan Wermuth.*
17. London, UK, 08:15.
Follow the yellow brick road.
Sophie Wharmby.
18. Pilisvörösvár, Hungary, 05:40.
Spanish donkey. *Patrícia Nádas.*
19. Udine, Italy, 11:00.
Debugging Java apps. *Paolo Agati.*
20. Cascais, Portugal, 08:15.
Hygienic art. *Patricia Rosindo.*
21. Santa Rosa, Guatemala, 09:00.
Dental check-up. *Diana Garcia.*
22. Mexico City, Mexico, 12:00.
Tourist attractions. *Mario González.*
23. Paris, France, 10:00.
Moulin Rouge. *Melanie des Monstiers.*

24. Lisbon, Portugal, 10:15.
Brief encounter. *Sonja Valentina.*
25. Munich, Germany, 10:45.
Power towers. *Jan Sonnenberg.*
26. Debrecen, Hungary, 06:00.
Sunrise. *Ákos B.*
27. London, UK, 08:33.
Information display. *Pierpaolo Lai.*
28. Munich, Germany, 10:30.
Graffiti on the wall. *Jan Sonnenberg.*
29. London, UK, 12:00.
Here comes the sun.
Rebekka Scheller.
30. Paris, France, 09:30.
My view – rooftops and sky.
Melanie des Monstiers.

1.

2.

3.

4.

5.

6.

7.

8.

9.

10.

11.

12.

13.

14.

15.

16.

17.

18.

19.

20.

21.

22.

23.

24.

25.

26.

27.

28.

29.

30.

1. Budapest, Hungary, 08:00.
Whipped cream and Windows.
Photo: Kérges Dániel.
2. Chicago, USA, 08:30.
Students lining up. *Christa Lohman.*
3. Merzouga, Morocco, 10:05.
Crossing the Sahara Desert.
Tiago Costa.
4. Munich, Germany, 07:45.
A baby's bug-mobile. *Jan Sonnenberg.*
5. Tommerup, Denmark, 06:45.
Enjoying dessert. *Sidsel Nordbo.*
6. London, UK, 08:42.
My workplace in Belgravia.
Pierpaolo Lai.
7. Mexico City, Mexico, 11:00.
View from the office. *Mario González.*

8. Budapest, Hungary, 06:15.
Morning breaks over the Danube.
Bence Ferenczi.
9. Setúbal, Portugal, 10:00
Fisherman. *Maria Emilia Matos.*
10. Utrecht, the Netherlands, 08:15.
Canoe near the house.
Marleen Huijing.
11. Tajrish, Iran, 10:15.
Hard times. *Mehdi Teimory.*
12. Isfahan, Iran, 10:00.
Watermelons. *Ehsan Amini.*
13. Mexico City, Mexico, 11:13.
Lucha libre, a Mexican form of
wrestling. *Ladxidua Perea.*
14. Rome, Italy, 06:30.
Waking up. *Antonella Porfido.*

15. Mexico City, Mexico, 07:30.
Waiting is a part of life. *Mario González.*
16. Niort, Deux-Sèvres, France, 10:30.
My workspace. *Eric Chauvet.*
17. Munich, Germany, 09:00.
Painted heart on my daughter's wall.
Jan Sonnenberg.
18. Istanbul, Turkey, 09:45.
On the Bosporus. *Levent Kopuz.*
19. Almeria, Spain, 08:45.
On my way to university. *Deni Cabañas.*
20. Lima, Peru, 07:15.
Waiting for transport. *Said Guerra.*
21. Svendborg, Denmark, 10:15.
Sex education. *Lotte Zarlang.*
22. Istanbul, Turkey, 08:00.
My hotel bed. *Cyrill Abramov.*

23. Setúbal, Portugal, 09:30.
A fisherman. *Maria Emilia Matos.*
24. Tehran, Iran, 07:00.
Waiting for luggage. *Mehdi Teimory.*
25. Lisbon, Portugal, 08:12.
Ready for a new day. *Sonja Valentina.*
26. Ampang, Malaysia, 08:45.
Stripes and plaid. *Darna Aminuddin.*
27. Tehran, Iran, 10:15.
Cars, cars, cars. *Mehdi Teimory.*
28. Coimbra, Portugal, 11:45.
Embroidery. *Paulo Abrantes.*
29. London, UK, 08:30.
Rainy morning in Pimlico. *Edda Detter.*
30. Montijo, Portugal, 11:00.
Watching "Smash". *Rui Alves.*

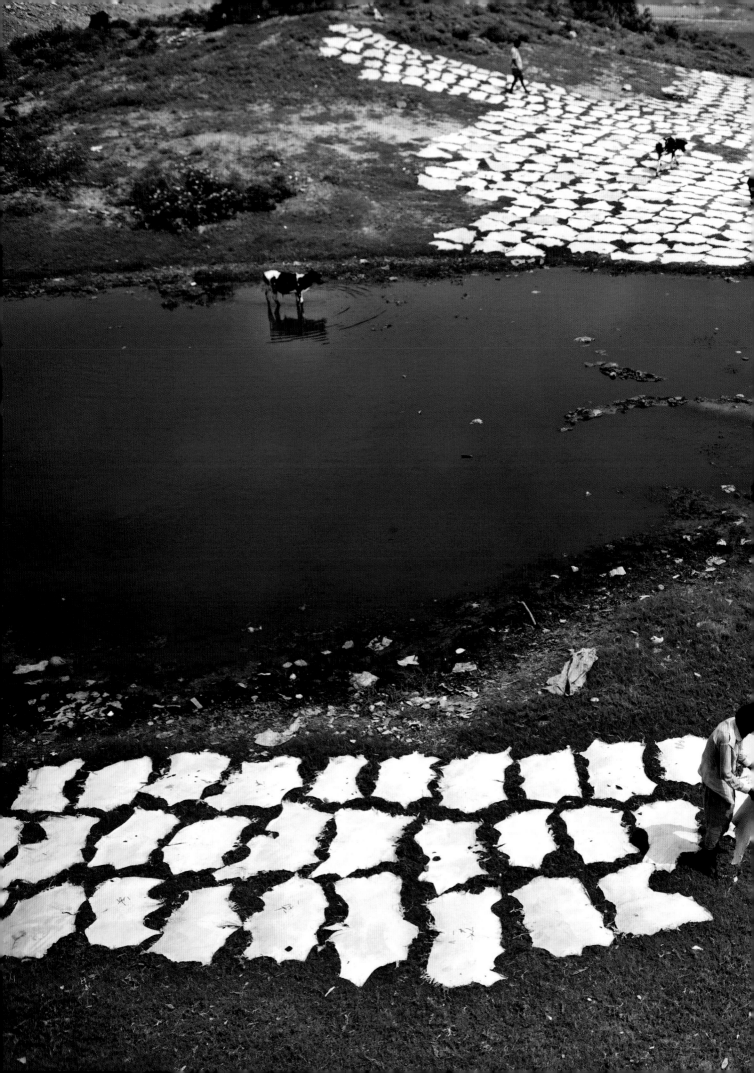

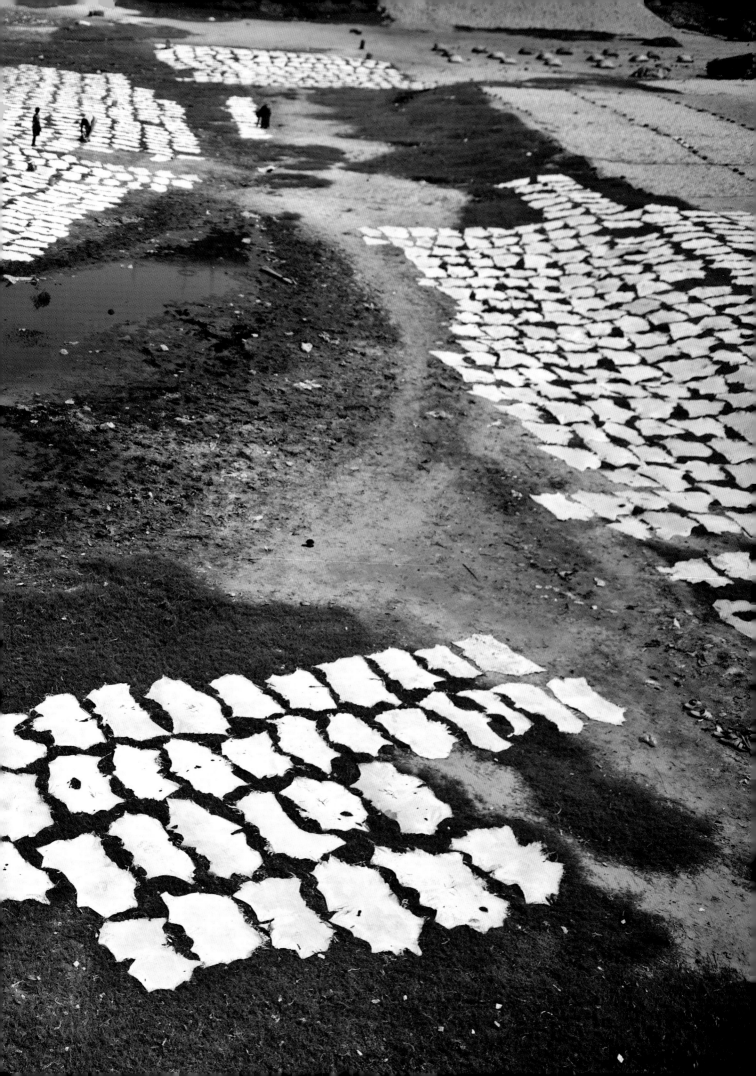

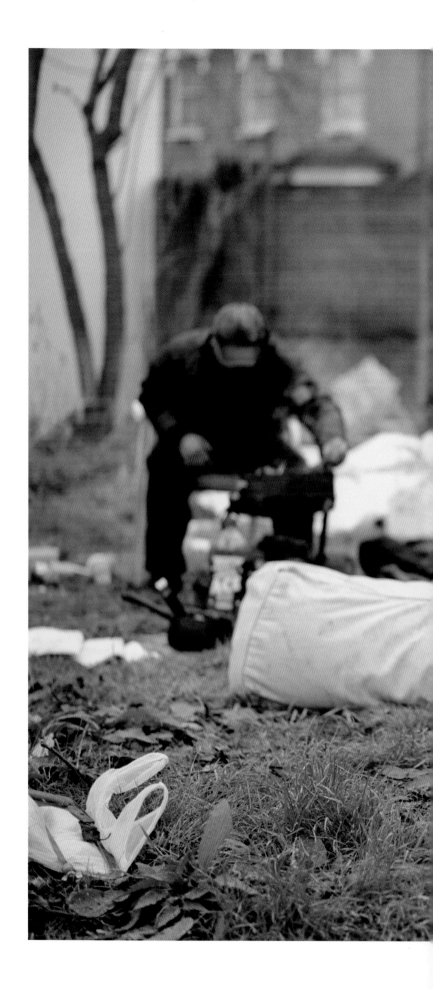

◄ Dhaka, Bangladesh, 09:54.
Bangladeshi workers dry leather
hides on the banks of the River
Buriganga. "About 90 percent of the
workers at the Hazaribag tannery die
before they reach the age of 50, due
to the toxic environment. Some 58
percent suffer from ulcers, 31 percent
have skin diseases, 12 percent
have high blood pressure, and 11
percent suffer from rheumatic fever."
Untreated runoff from the tannery is
a major source of river pollution.
Photo: A.M. Ahad.

London, UK, 10:20.
"This man and his dog are 'squatters'
in a disused council-owned building
on the edge of London Fields. The
weather was bad that day, but he
had built a small barbeque in the
garden. Next door there is a newly
built, architect-designed, white,
modernist, minimalist house with a
roof garden. While I was there the
owners complained about the smoke
from the fire."
Photo: Zed Nelson.

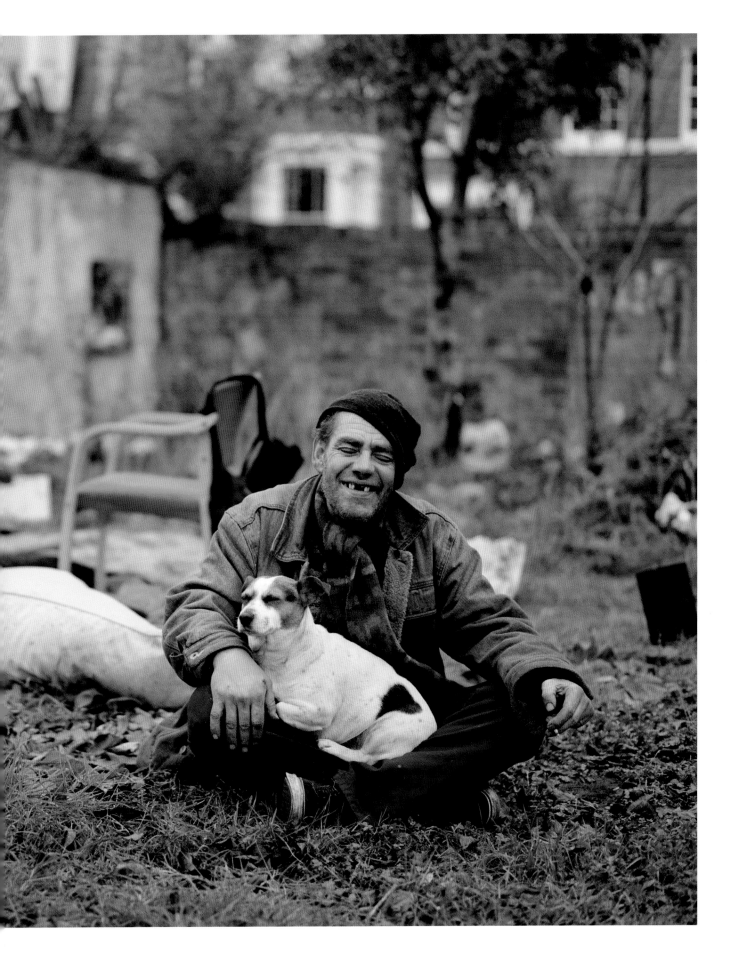

Eslöv, Sweden, 14:50.
"This is from my workplace, my Cat 232 DLC. I am taking out concrete from steel, making it into a ball, then loading it. Many believe that demolition is just pulling buildings down, but this is far from the truth. In Sweden everything is sorted and very little wasted. As much as 95 percent is recycled. I love my work – great workmates and great bosses."
Photo: Malcolm Clarry.

Beijing, China, 11:28.
"From the conference room, I suddenly caught sight of another kind of work and people living a completely different kind of life. Our office is on the eleventh floor in Haidan district. It takes a week to wash the windows in our building. The window cleaners have to use both hands and their lives hang by two ropes. This man recently saw a co-worker fall."
Photo: Lei Shi.

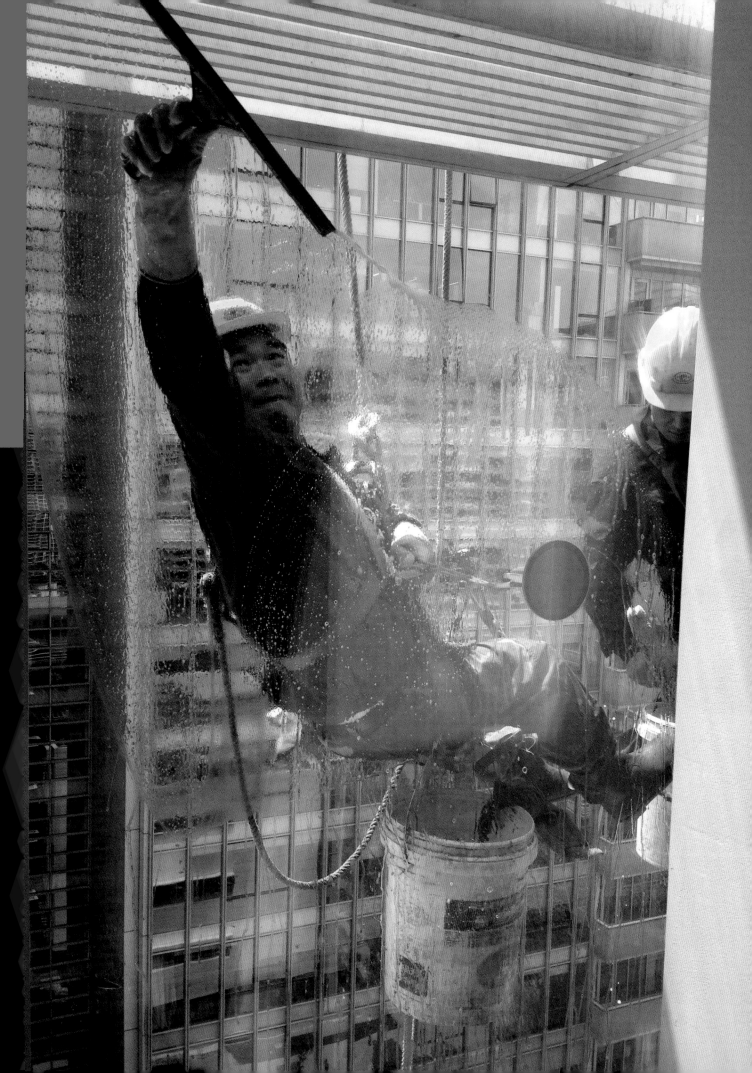

1. Kirkkonummi, Finland, 17:40.
1976 computer game.
Photo: Mikko Karikytö.
2. Bogotá, Colombia, 17:56.
My office.
Photo: Jose Rafael Luna Lopez.
3. Moscow, Russia, 21:30.
At the Abai monument.
Photo: Alexander Simakin.

4. Areosa, Portugal, 09:00.
My workstation. *Photo: Aline Flor.*
5. Rewalsar, India, 15:58.
What's in my purse?
Photo: Nyondo Nadi.
6. Keuruu, Finland 08:08.
Work tools.
Photo: Saku Ikäheimo.

7. Heves, Hungary, 08:30.
Mobile phones.
Photo: Zoltán Szalkári.
8. Singapore, 22:30.
My computer.
Photo: Eddie Leong.

1.

2.

3.

4.

5.

6.

7.

8.

1. Temirtau, Kazakhstan, 18:21.
My job. *Photo: Jergenij Melnik.*
2. Plano, Texas, USA, 18:30.
My three-year-old son Ashwin.
Photo: Ranjith Dharmarajan.
3. Rebild, Denmark, 14:30.
Playing Nintendo.
Photo: Signe Lindberg.

4. Kolkata, India, 23:30.
My shrine. *Photo: Soham Gupta.*
5. Singapore, 16:45.
My work. *Photo: Cassidy Wetzell.*
6. Arizona, USA, 21:06.
This is how we interact.
Photo: Brittany Gorsich.

7. Taguig, the Philippines, 15:49.
Video-conferencing.
Photo: Aiza Tanedo.
8. Ito, Usami, Japan, 08:30.
I watch Major League Baseball each
morning.
Photo: Jack Beasley.
9. São Paulo, Brazil, 13:14.
My desk. *Photo: Eduardo Pedro.*

1.

2.

3.

4.

5.

6.

7.

8.

9.

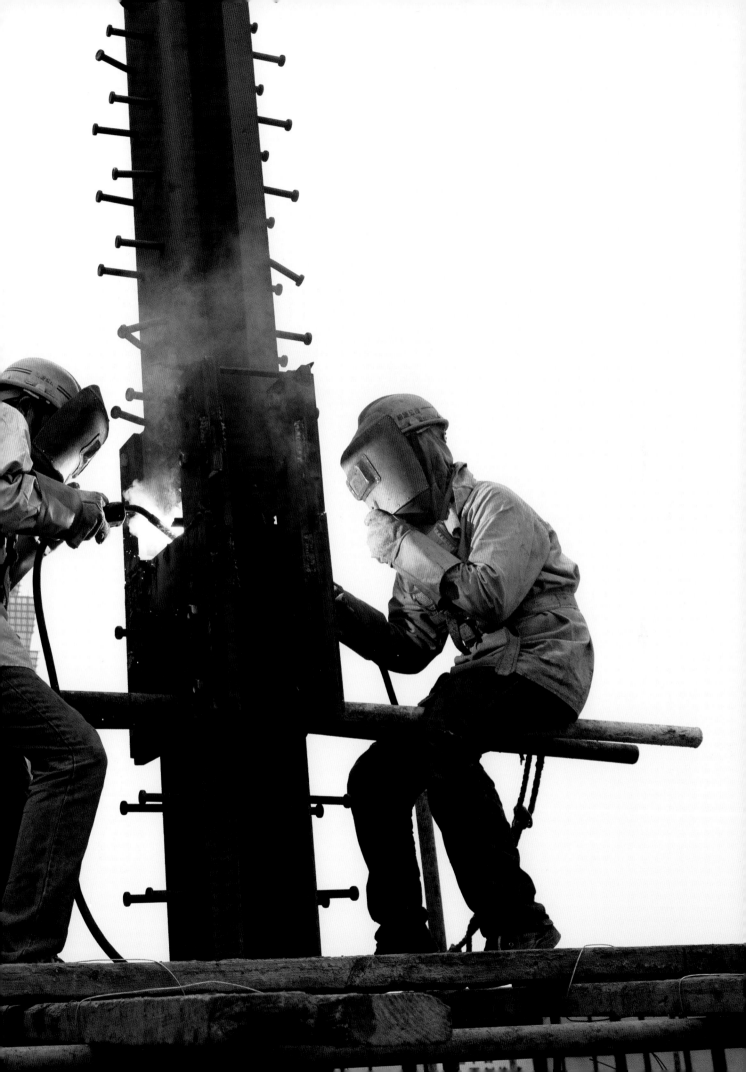

◂ Shanghai, China, 11:40.
Soaring 2,073 feet (632 metres) and with 121 storeys, the Shanghai Tower will be the tallest building in China once completed. But the previously overheated property market in the country's largest city has cooled as China's economic growth has slowed. Visible in the background is the Jin Mao Tower, completed in 1999 and China's tallest building until 2007 when the Shanghai World Financial Center was erected next to it.
Photo: Zhang Chunhai.

Lima, Peru, 10:31.
The Villa Maria del Triunfo fish market ranks among the largest in South America. Close to the Pacific Ocean, the Peruvian capital enjoys a great diversity of fish and seafood. A popular Peruvian dish is *ceviche*, raw fish marinated in citrus juice, and sometimes with hot peppers.
Photo: Mariana Bazo.

London, UK, 11:55.
"Gary Arber is my local printer and stationer in this East End shop, opened by his grandfather back in 1897. Gary's grandmother, Emily Arber, was a suffragette who insisted that the shop print handbills for her friend Mrs Pankhurst free of charge. The same presses still sit in the basement." In the early twentieth century, Emmeline Pankhurst led the British suffragette movement with toughness and charisma.
Photo: David Hoffman.

Hong Kong, China, 12:15.
A spice shop owner using an abacus. These traditional calculating tools, commonly made of bamboo, are now seldom used outside Asia. They were in use centuries before the adoption of our modern numerical system. They can be used for multiplication, division, subtraction, addition and even square root and cube root operations. Adapted models are used, even in the West, by blind people.
Photo: Roy Lee.

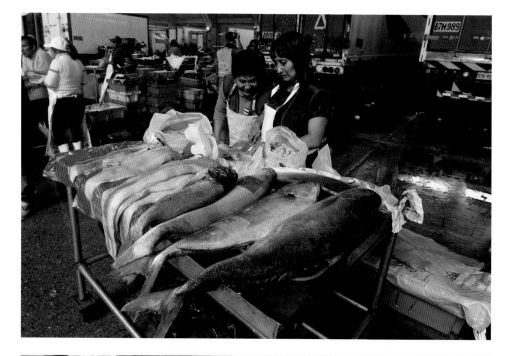

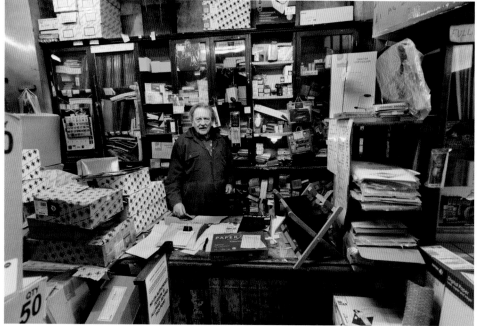

Casablanca, Morocco, 10:30.
Every morning, Omar sets up his stall
to sell eggs in the traditional market
at Lahjajma. The market's labyrinth of
passages forms a colourful mosaic of
vegetables and spices.
Photo: Leila Ghandi.

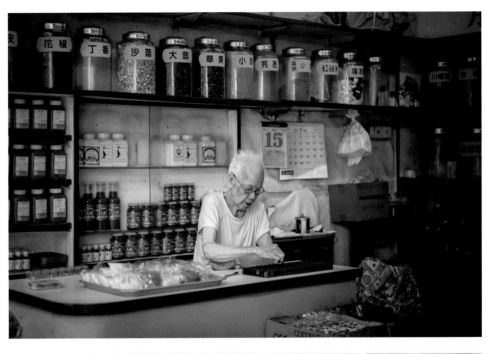

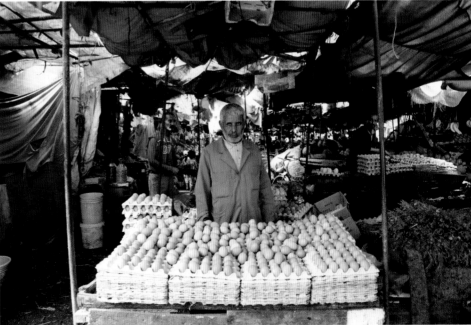

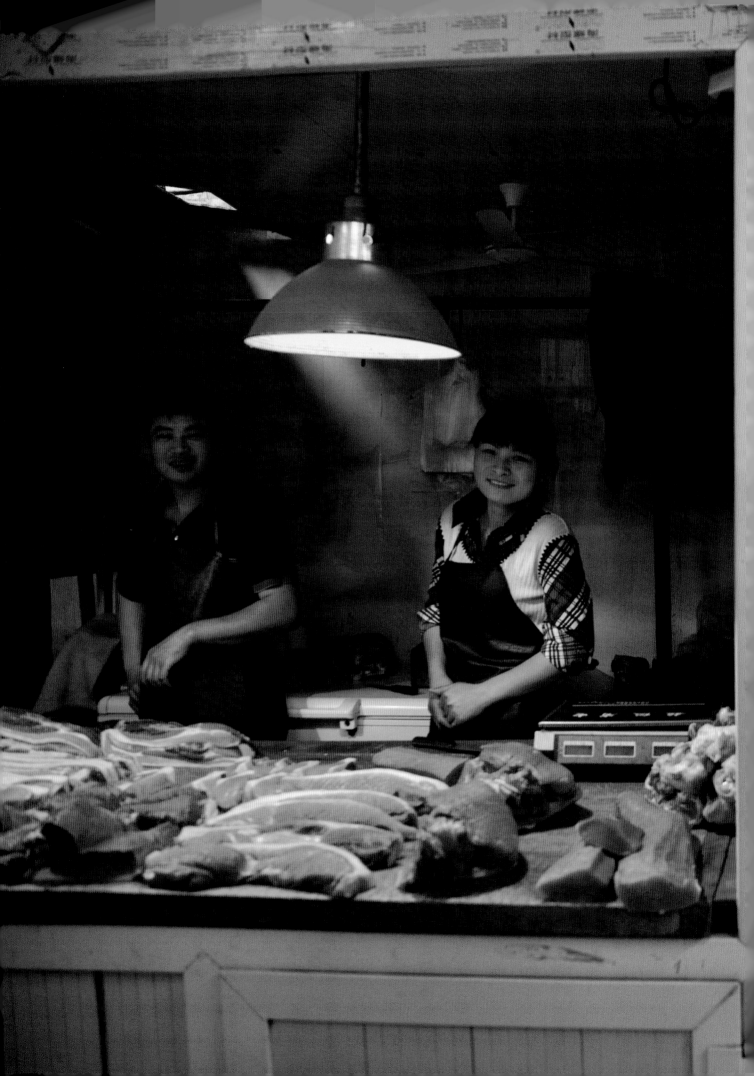

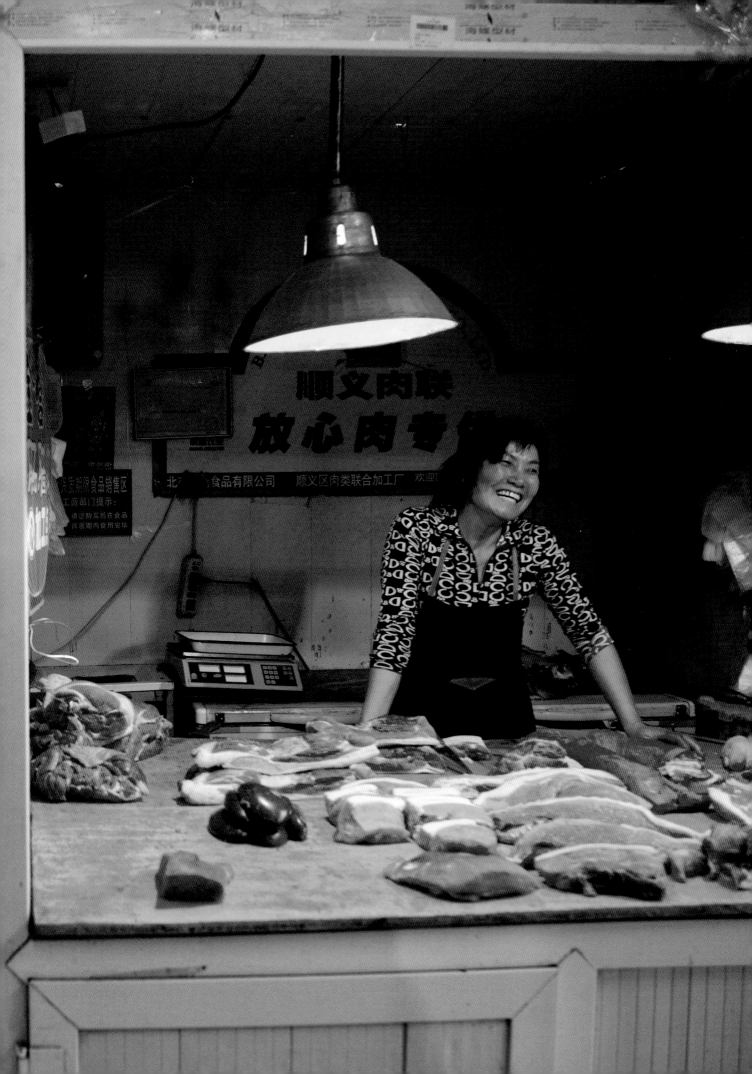

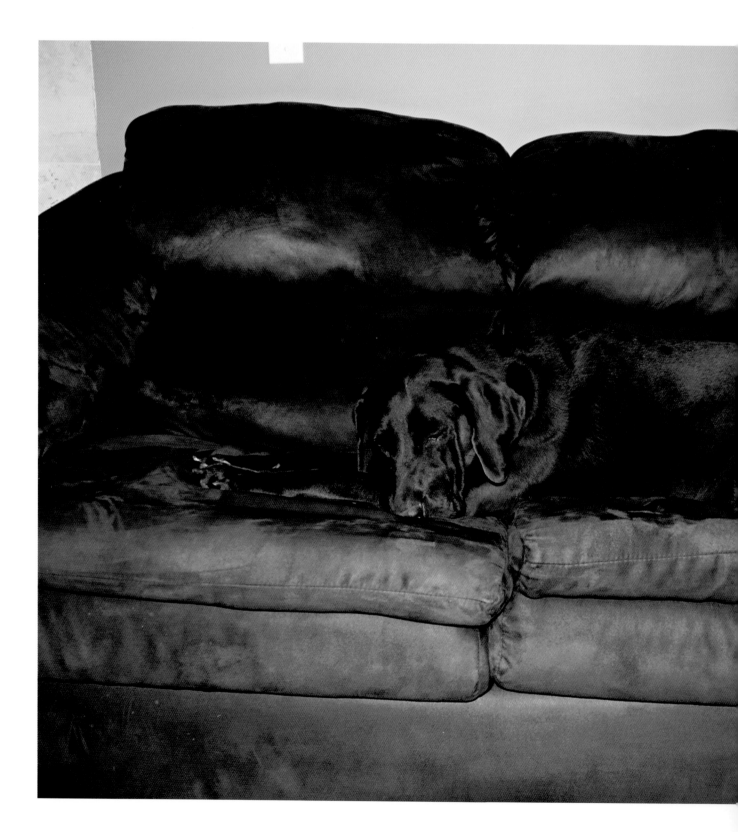

◄◄ Beijing, China, 10:05.
Butchers' shops in Beijing's markets
illustrate one of China's fastest
growing industries. In the 1970s,
Chinese ate an average of nearly
9 pounds (4kg) of meat a year. Annual
consumption is now more than 130
pounds (60kg) per person. Pork is
most popular – half the world's pigs
end up on Chinese plates.
Photo: Peikwen Cheng.

◄ Fundeni, Romania, 11:57.
"Ilona, a Roma girl, eats ice – instead
of ice cream her family cannot afford
– from the 30-year-old, second-hand
freezer her parents received. Her
father works as a night guard at a
car service, but still two of her seven
siblings had to give up school to
help support the family. The mayor
gave the family a little piece of land,
where they built their first house.
But because they didn't have central
heating, last winter everyone had to
sleep in one room."
Photo: Mugur Varzariu.

Lawrence, Kansas, USA, 11:29.
"Allison is our four-year-old brown
Labrador retriever, adopted six
months ago from the animal shelter
in town. She loves to take long walks,
bark, play with kids, meet other dogs
in the neighbourhood, and chew
on everything possible. She is not
allowed to sit on this couch – except
today, for her portrait."
Photo: Danny Unz.

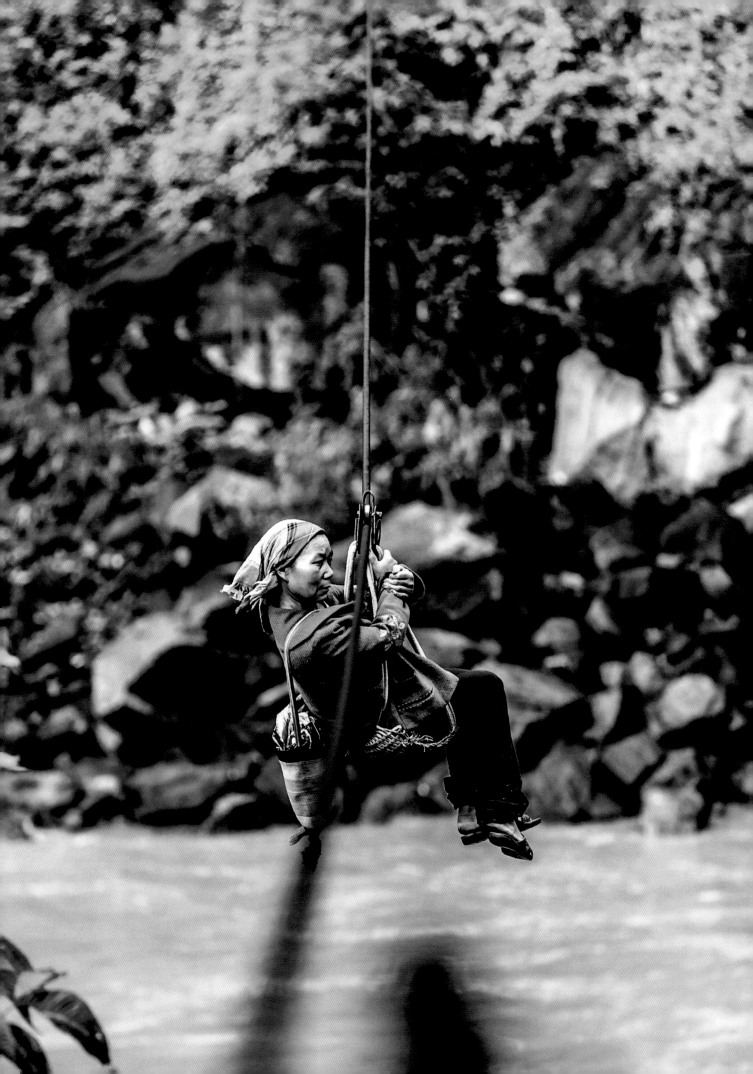

◄ Amsterdam, the Netherlands, 12:01.
"I wash my dishes once a week.
My girlfriend's got a house of her
own, and I live alone, so all I do in
the apartment is have breakfast. If I
need a cup a coffee, I'll wash one
cup. There's no space for a kitchen
table, because my apartment is only
23 square metres – it's like living in
a dollhouse."
Photo: Roger Cremers.

Yunnan, China, 12:45.
In China's Yunnan province, rope
bridges were the traditional way to
cross the angry River Nujiang as it
flows on to Burma. Throughout the
province, the government is replacing
such rope bridges with modern
suspension bridges, improving local
infrastructure and accessibility.
This woman is on her way to the
Lishadi village market. She belongs
to the Lisu people, a Tibeto–Burman
ethnic minority. The Lisu build their
villages near running water, which
they revere.
Photo: Yereth Jansen.

Fugong, Yunnan, China, 13:30.
Rice paddies in Nujiang Valley in
southwestern China. Paddy cultiva-
tion is an intricate skill, involving
precise levels and elaborate water
management. The valley is populated
by ethnic minorities: Nu, Lisu,
Durong and Tibetans. Many of them
are Catholics, ever since French
missionaries visited the valley in the
nineteenth century.
Photo: Yereth Jansen.

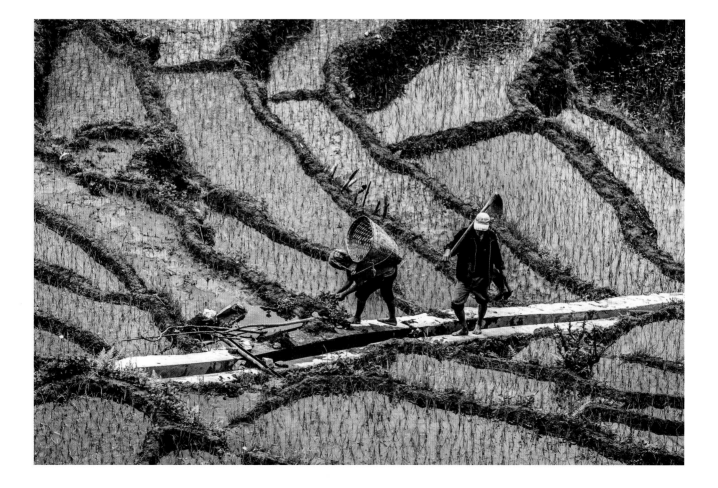

Dhaka, Bangladesh, 12:30.
She makes about 1.50 US dollars a
day crushing bricks with a hammer.
Photo: Asif Mahmud.

Tokyo, Japan, 13:00.
Media workers exchange business
cards at a meeting.
Photo: Kazuhiro Yokozeki.

Rangoon, Burma, 11:09.
When the harvests are good, Burma
is one of the world's biggest rice
exporters. Much of it goes to West
Africa. *Photo: Nay Aung Khine.*

Saltillo, Mexico, 13:30.
Operating on a slipped disc.
Photo: Jesus De la Peña.

Edmonton, Canada, 15:43.
Grinding a part for a veteran car.
Photo: Scott Bruck.

Dar es Salaam, Tanzania, 13:30.
An artisan and his chisel. Working
on a relief of elephants.
Photo: Aika Kimaro.

Baião, Portugal, 12:06.
Nurse Alexandra Ferreira is calling
for an ambulance to take her patient,
Benjamim Vieira, to hospital because
he is in severe pain after recent hip
surgery. Nurse Ferreira is 31 years
old and a rehabilitation specialist.
She visits six patients a day in one of
Portugal's poorer districts. Benjamim
was back at home after a week.
Photo: Antonio Pedrosa.

Lisbon, Portugal, 12:50.
A single mother, Sofia will soon lose her job in this office, where she has worked for two years. "We are in the midst of an economic crisis here, and unemployment is growing fast."
Photo: Céu Guarda.

Lisbon, Portugal, 13:05.
Sofia lives with her 11-year-old daughter Laura. Sometimes they have lunch together. In the evenings, Sofia makes dinner and helps her daughter to do homework.
Photo: Céu Guarda.

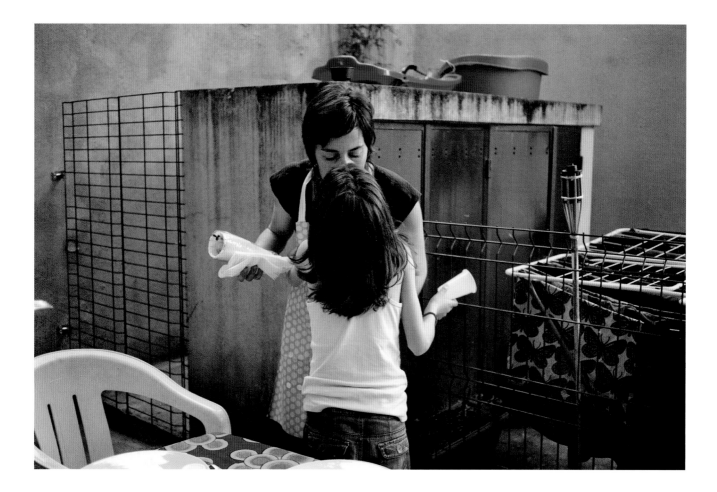

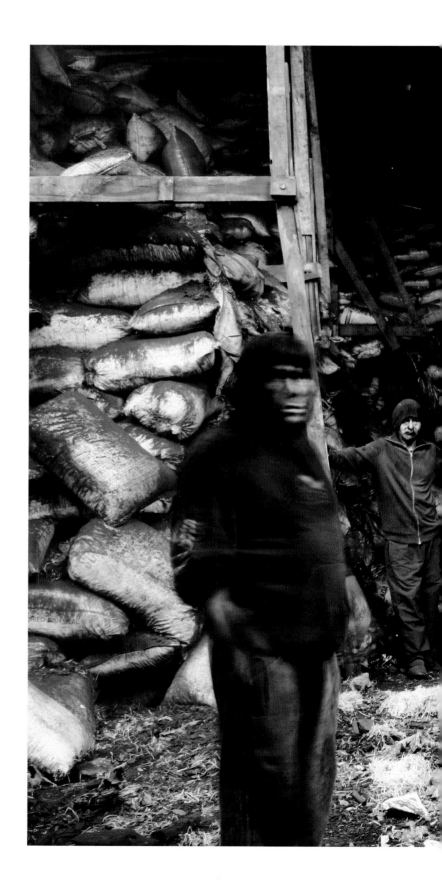

Santiago, Chile, 11:40.
"This is a former coal warehouse in the centre of Santiago which is being emptied because the plot has been sold. The grimy workers seem to be from a different age."
Photo: Claudio Ponce Orellana.

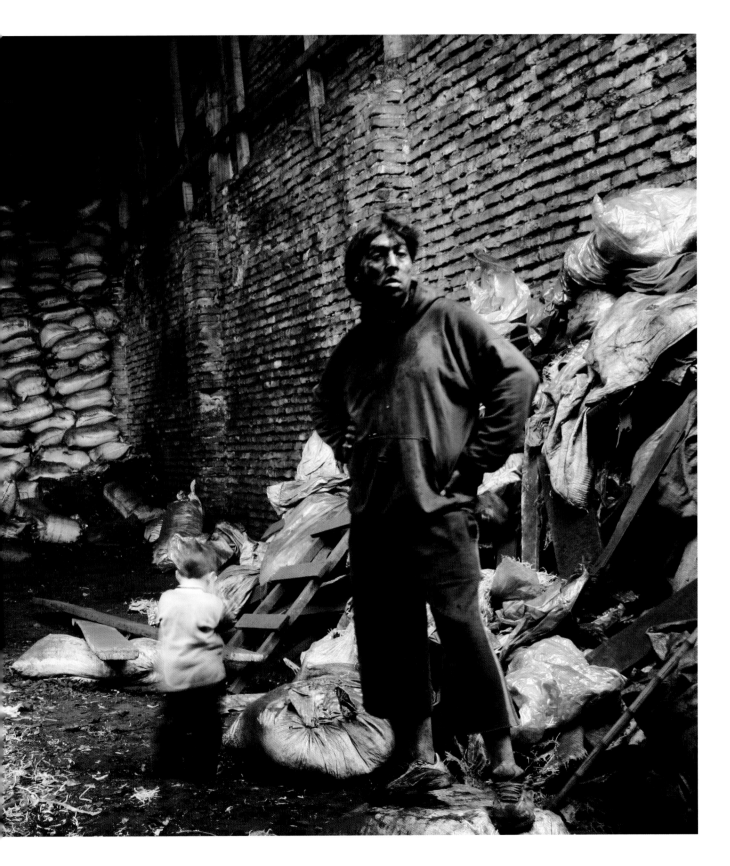

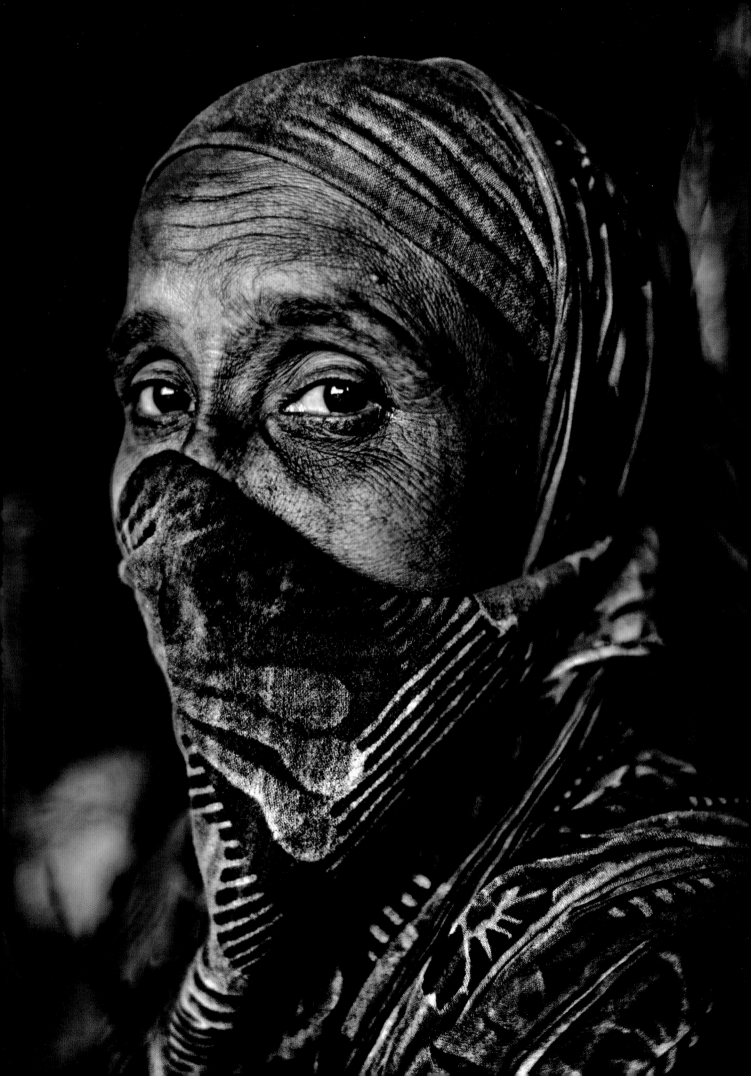

Dhaka, Bangladesh, 10:47.
Rahela has developed terrible asthma
because of her job: sweeping dust in
an incense factory.
Photo: K.M. Asad.

Keller, Texas, USA, 12:45.
Member of the motorcycle club
Ramblin' Gamblers.
Photo: Roy Gunnels.

Colombo, Sri Lanka, 14:14.
An officer in the Sri Lankan army
protects his face against swirling
sand during rehearsals for a military
pageant in the island's major city,
Colombo. The army was celebrating
the anniversary of victory over the
Tamil Tiger separatists, who admitted
defeat in 2009 after 25 years of armed
struggle. More than 70,000 people lost
their lives in the war.
Photo: Gemunu Amarsinghe.

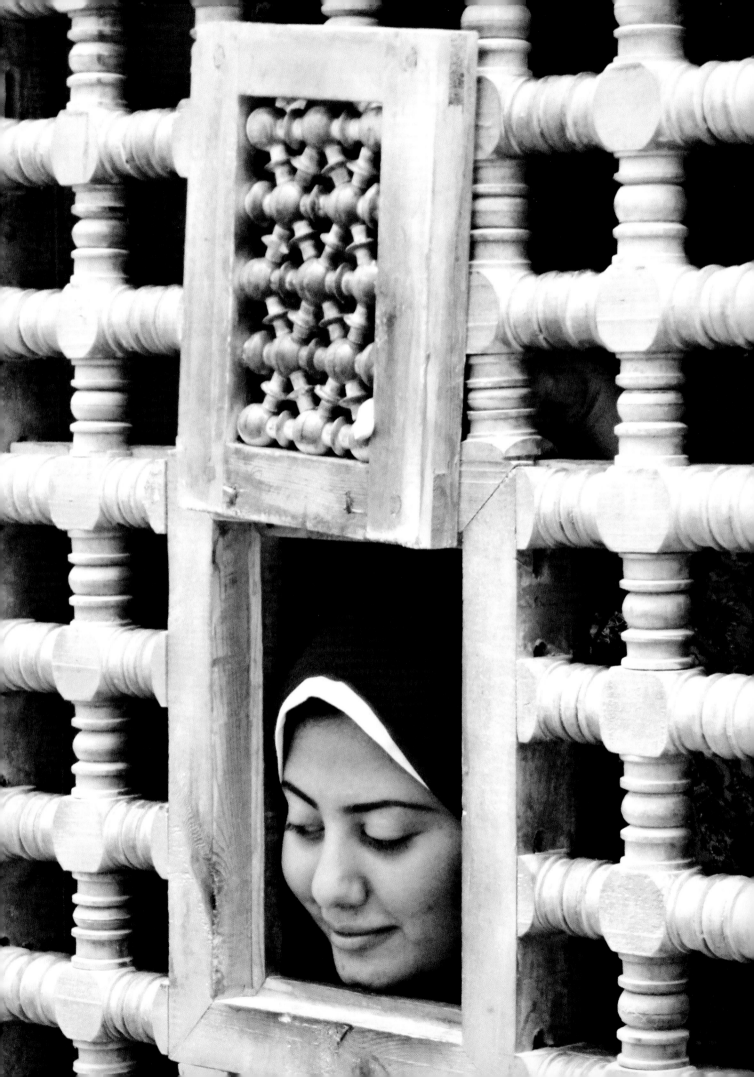

Alexandria, Egypt, 12:00.
A woman peers through a traditional window grille in Alexandria. The city has re-established its reputation as a centre for scholarship following the opening of the Bibliotheca Alexandrina in 2002, a library with space for eight million books in Arabic, French and English. The new building pays homage to the Royal Library of Alexandria, built in the third century BCE, which was the largest and finest collection of the ancient world. Historians believe it was accidentally burned down in the year 48CE by Julius Caesar.
Photo: Jala Yousry.

Vällingby, Sweden, 10:55.
Raising a circus tent takes four hours for a team of 40 people. Ion Sarbu from Romania is tying together tent sheets. Cirkus Maximum is Sweden's largest, with 85 employees. Those who are not circus artists sell tickets, look after props, provide security or manage the stables. Animals include elephants, camels, zebras, lamas, Friesian horses and ponies.
Photo: Niklas Larsson.

Bangalore, India, 10:00.
Deliveries ready to go.
Photo: Tina Nandi.

Mexico City, Mexico, 16:18.
Construction workers slot a beam
into place on a building on Avenida
Reforma. *Photo: Eric Castaneyra.*

Dhaka, Bangladesh, 12:44.
Twice a month, two teams of five
wash the glass roof of a shopping
mall. The mall is modern but the
method is traditional.
Photo: Dominic S. Halder.

Moscow, Russia, 22:52.
A street musician trying to raise money to help pay his wife's medical bills. *Photo: Demis Ru.*

Kista, Sweden, 16:30.
A new heating system for Sweden's IT hub, Kista.
Photo: Anders Österberg.

Puebla de Zaragoza, Mexico, 15:00.
The profession of shoe-shining lives on in this Mexican city.
Photo: Juan Salvador Fernández Tamayo.

Wolfville, Nova Scotia, Canada, 12:25. Canadians love rugby but more for participation than as a spectator sport. The size of the country makes inter-provincial competition difficult and because of the climate, the season is often split. In some provinces schools and universities have strong teams.
Photo: Jayden Shea.

Johannesburg, South Africa, 12:10. A police officer tries to maintain order during an angry protest by union members, who are chanting slogans and blocking the streets. The action is a counter-demonstration during a march by supporters of a government plan to subsidize wages of young people, in a bid to ease unemployment. Soon afterwards, the confrontation between the two groups turned violent, and police had to break up the crowds by firing tear gas.
Photo: Siphiwe Sibeko.

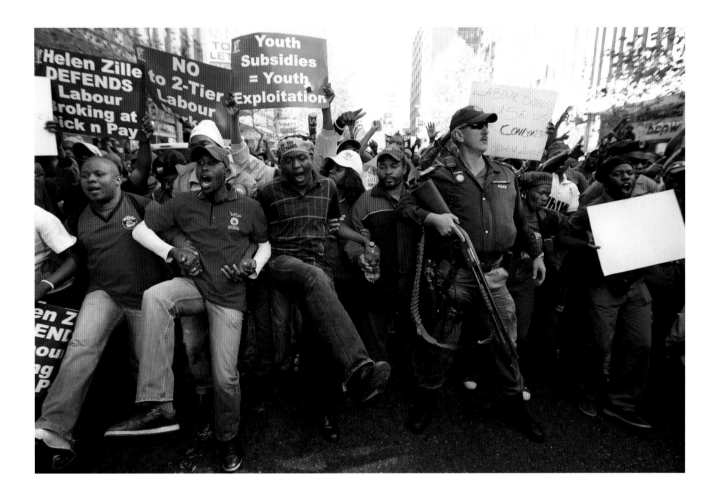

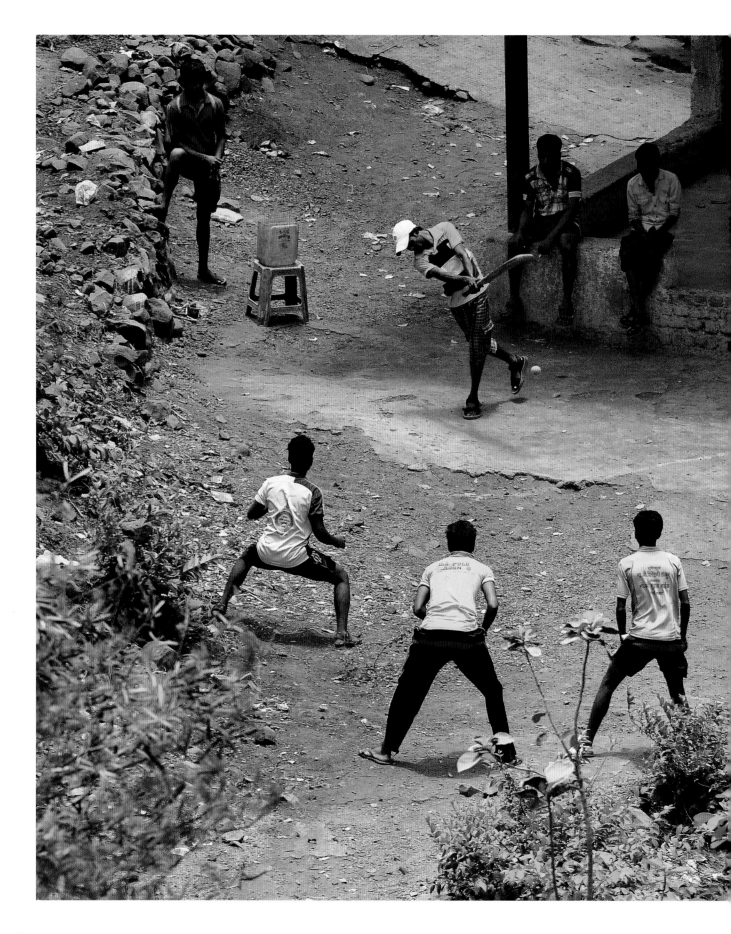

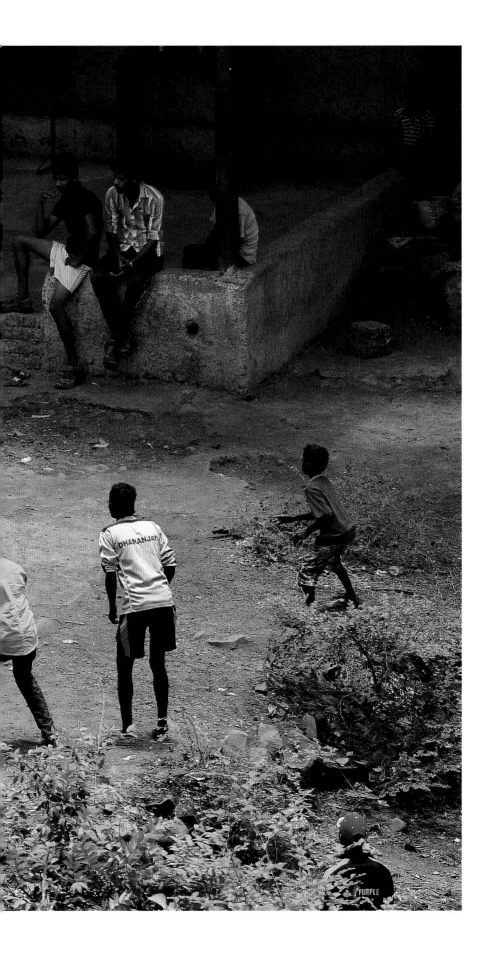

Jogeshwari East, Mumbai, India, 12:13.
A passion for cricket is something that unites Indians, whether rich or poor. A lack of proper facilities and equipment has never stopped children from practising the sports they love. These enthusiastic players are the children of dairy farmers, imitating their sporting heroes, such as fellow Mumbaian and legendary cricketer, Sachin Tendulkar. It has been said that in cricket the individual not only plays against the opposing team but also fights his or her own destiny – a theme that Indians in particular adore.
Photo: Anil Tulsi.

Kirchberg, Luxembourg, 13:15.
School pupils throng the pavement
by the bus stop, heads full of fresh
knowledge. The photographer is a
teacher at their school. She wonders:
"Did we contribute today to their
lives? Did we talk about the core
values of our world, such as peace,
solidarity, respect, freedom? What are
their hearts filled with as they wait?"
Photo: Barbara-Ziadé.

Scherpenheuvel, Belgium, 11:16.
A funeral procession at Scherpen-
heuvel, the most sacred site in
the country for Belgian Catholics.
Pilgrims flock to the basilica here.
Legend has it that miracles have
occurred where an ancient oak tree
once stood.
Photo: Joren De Weerdt.

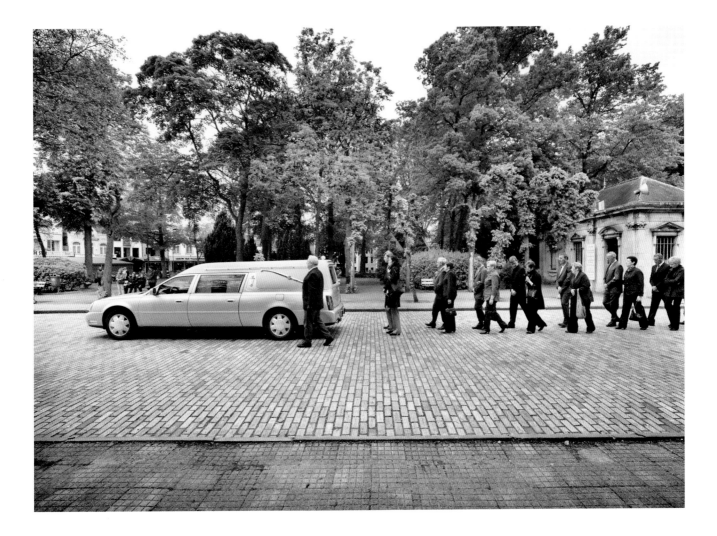

Moscow, Russia, 17:58.
Clutter. *Photo: Nadia Radaeva.*

Guelph, Ontario, Canada, 11:30.
"My room is filled with quotes and
pictures that inspire me."
Photo: Margery Thomas.

Raleigh, North Carolina, USA, 22:45.
"We don't normally do dinner in bed,
but we had just washed our laundry,
and therefore our little dining table
was taken over by clothes. When you
live in a small space, you make do with
what you have." *Photo: Lydia Raines.*

Tehran, Iran, 09:00.
"From my window..."
Photo: Mohammad Baghban.

London, UK, 10:00.
Journalist Barry Neild works from home.
Photo: Suzanne Plunkett.

Veracruz, Mexico, 09:15.
"The house where I live with my family is very old, built for my great-grandfather Charles and his delicate and beautiful wife Sofía. Her name remains on the front of the house, which has been passed from generation to generation. Although we have kept the original architecture, we have modernized it in some ways, such as replacing the traditional laundry method with a washing machine. (In my great-grandmother's time, Sofía boiled clothes in metal cans.) I often think I would like to sit in a corner of the house and see what happened during a day in the life of my great-grandmother."
Photo: Maricarmen Garcia.

Jammu, India, 12:31.
A quick shower at a railway station in Jammu and Kashmir. The few taps here are often turned off and the only water available is for sale in bottles. Little has changed since this junction was inaugurated in 1972. But the number of passengers has grown 50 times since then and traffic will increase further when the new Kashmir line is finished.
Photo: Channi Anand.

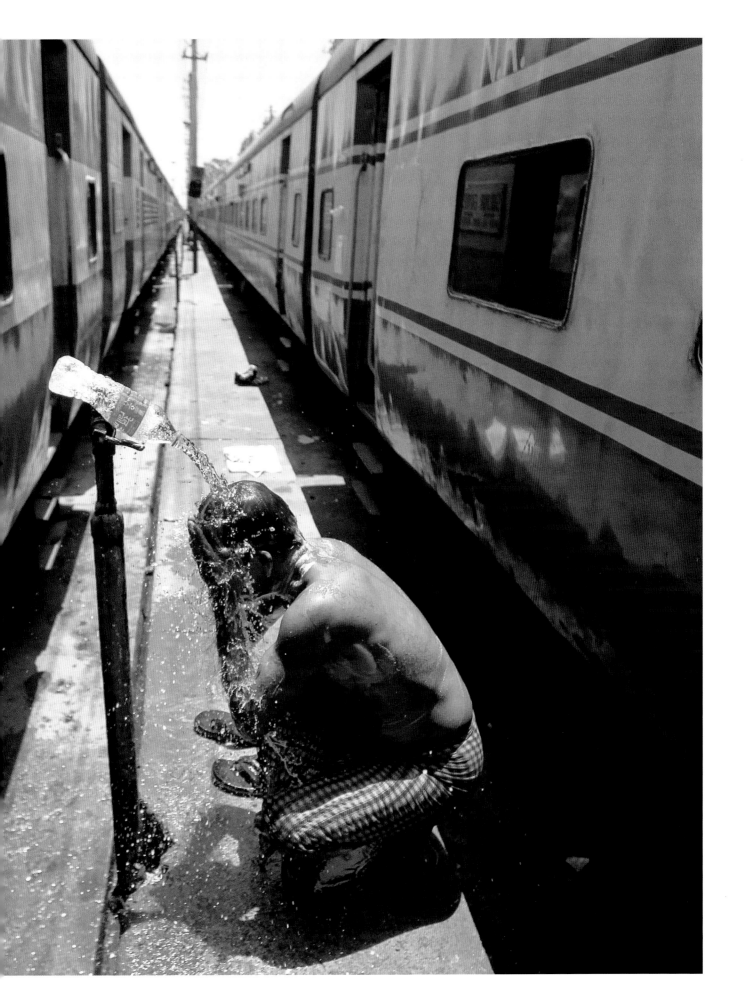

Askim, Norway, 11:30.
"My family likes fresh rolls, and I like to make them."
Photo: Tove Andrea Omvik Aune.

Guangzhou, China, 18:45.
Preparing fried noodles and *chòu dòufu* – "stinky tofu", made from fermented soybeans – in the open market at Beigang village.
Photo: CS Owsley.

San Juan Texhuacán, Veracruz, Mexico, 08:30.
Clemencia rises early to make coffee and *memela*s, toasted cakes made out of corn dough and salt.
Photo: Denise Aulie.

Sydney, Australia, 15:00.
"A trainee chef prepares sushi at our favourite lunch bar."
Photo: Claudio Raschella.

San Juan Texhuacán, Veracruz, Mexico, 11:15.
Victor Tepole shaves the hair off a hog's foot before it goes into the soup pot.
Photo: Denise Aulie.

Randers, Denmark, 18:30.
"My lovely partner making dinner."
Photo: Lene Martine Jensen.

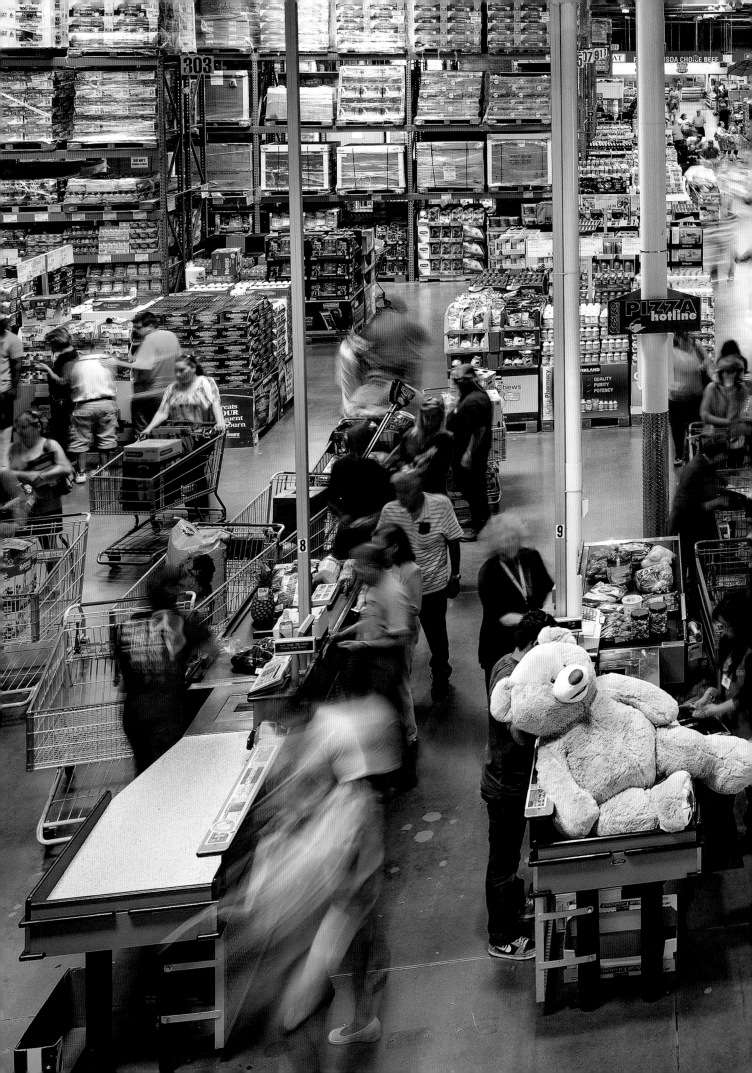

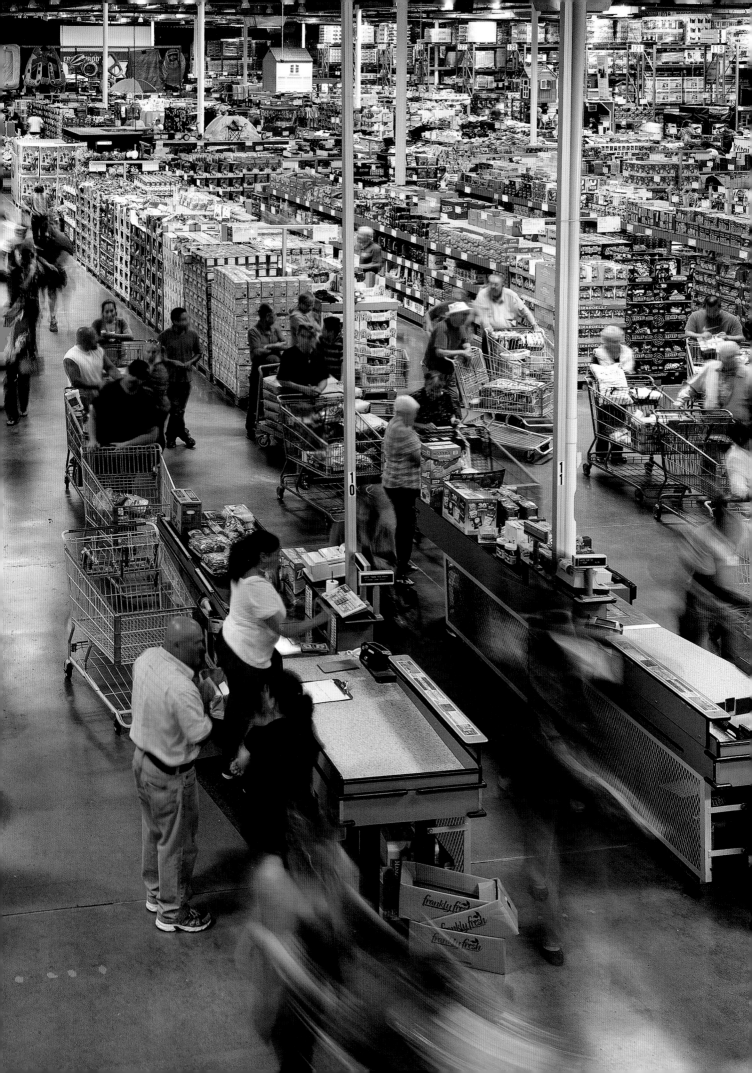

◀ Oxnard, California, USA, 12:52.
Enormous superstores dominate the
American shopping landscape, led by
Walmart, the world's largest retailer
and private employer. In the USA,
there are thousands of these stores,
designed for shoppers who arrive
by car. In addition to Walmart, other
major superstore retailers include
Target, Best Buy, and this members-
only warehouse club, Costco.
Photo: Stephen Schafer.

Tokyo, Japan, 12:34.
Shibuya Crossing is a famous spot
for youth culture and fashion, with its
high-end boutiques, crowds and mul-
tiple pedestrian crossings surrounded
by giant TV screens. A "Shibuya Girl"
is a term for a Japanese fashionista,
but these teenage schoolgirls at the
crossing are restricted to wearing
their uniforms.
Photo: Keith Crowley.

1. St. Petersburg, Russia, 12:45.
Bakery storefront.
Photo: Tanja Ottestig.
2. Port Coquitlam, British Columbia,
Canada, 17:48.
Quick spaghetti dinner.
Photo: Michelle Chong.
3. Welwyn Garden City, UK, 22:00.
Bacon sandwich.
Photo: Nicholas Ford.

4. Warsaw, Poland, 13:15.
My lunch. *Photo: Maria Medynska.*
5. Stockholm, Sweden, 19:52.
Dinner with my relatives.
Photo: Robyn.
6. Moscow, Russia, 16:45.
Café at lunchtime.
Photo: Oksana Shapiro.

7. Kuala Lumpur, Malaysia, 12:30.
Village-style fried noodles.
Photo: Richard Humphries.
8. Doonfoot, Scotland, UK, 18:21.
Just teatime! *Photo: Phillip Gamble.*
9. London, UK, 20:10.
Dinner. *Photo: Zhivko Dimitrov.*
10. São Paulo, Brazil, 13:55.
Lunchtime! *Photo: Claudia Aparicio.*

11. Voorburg, the Netherlands, 09:23.
Breakfast on my balcony.
*Photo: Thi-Thanh-Tam Maramis -
Nguyen.*
12. Chisinau, Moldova, 20:15.
The fruits of our labours.
Photo: Leo Stolpe Törneman.
13. Makati City, the Philippines, 18:45.
Beef *mami. Photo: Luar Joy Dela Cruz.*

1.

2.

3.

4.

5.

6.

7.

8.

9.

10.

11.

12.

13.

1. Markham, Ontario, Canada, 15:49. Afternoon snack. *Photo: Jhoan Torres.*
2. Budapest, Hungary, 10:00. My breakfast. *Photo: Alfred Strabel.*
3. Caparica, Portugal, 12:58. My lunch. *Photo: Leandro Guardado.*
4. Nyíregyháza, Hungary, 13:15. Lunch for my brother. *Photo: Szabolcs Tompa.*

5. Alstonville, New South Wales, Australia, 18:51. Delicious stir-fry with lots of chili. *Photo: Samantha Newnham.*
6. Brampton, Ontario, Canada, 20:00. Cream of mushroom soup. *Photo: Lat Leger.*
7. Richmond, British Columbia, Canada, 13:00. This is my late lunch. *Photo: Leah Pirani.*
8. Bussum, the Netherlands, 20:08. Dutch snack. *Photo: Martijn de Valk.*

9. Fehérgyarmat, Hungary, 17:15. Italian ice cream. *Photo: Ádám Molnár.*
10. Wong Tai Sin, Hong Kong, 15:45. Lunch at home. *Photo: Kelvin Lee.*
11. Budapest, Hungary, 16:00. Pickled cucumber. *Photo: Virág Szűcs.*
12. Vienna, Austria, 13:00. A traditional surschnitzel. *Photo: Philipp Ruesch.*

13. Rangoon, Burma, 12:58. My lunch. *Photo: Ye Lay.*
14. Harrisburg, Pennsylvania, USA, 11:30. My daughter's lunch. *Photo: Tavia Flanagan.*
15. Struer, Denmark, 19:00. Dinner at my father's house. *Photo: Martin Kurt Haglund.*
16. Melbourne, Australia, 22:19. A quiet night at home with a friend. *Photo: David De Roach.*

1.
2.
3.
4.
5.
6.
7.
8.
9.
10.
11.
12.
13.
14.
15.
16.

◄ Cape Town, South Africa, 13:43.
One advantage of being shipwrecked
near a major city is pizza delivery.
When the Japanese tuna trawler
Eihatsu Maru ran aground near
Cape Town, its 90 tonnes of fuel oil
were a potential threat to the area's
beaches. With a tugboat working
to pull the ship free, a local radio
station took pity on the crew of 28
Taiwanese and sent them the pizzas.
Photo: Nic Bothma.

Krimpen aan den IJssel,
the Netherlands, 12:48.
"Rotterdam has always been full
of industry, and as the biggest port
in Europe this is often directly
related to water and shipping. These
men rent a workshop inside an old
factory building. The place reeks of
steelworking from a bygone era:
a bit messy, roll-up-your-sleeves,
no-nonsense, proud, ambitious, rough
and tough. In short: Rotterdam-ish."
Photo: Patrick Lecarpentier.

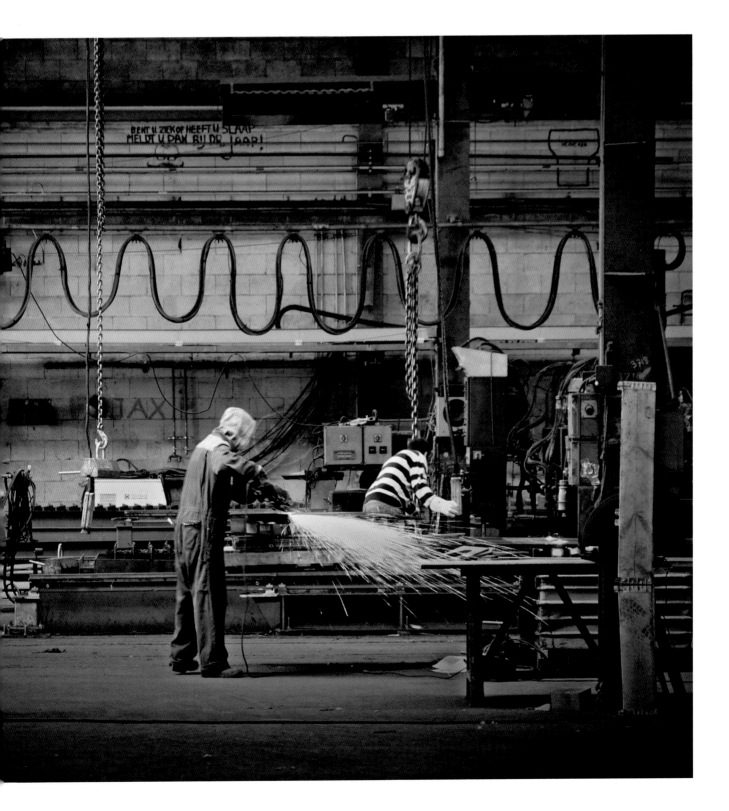

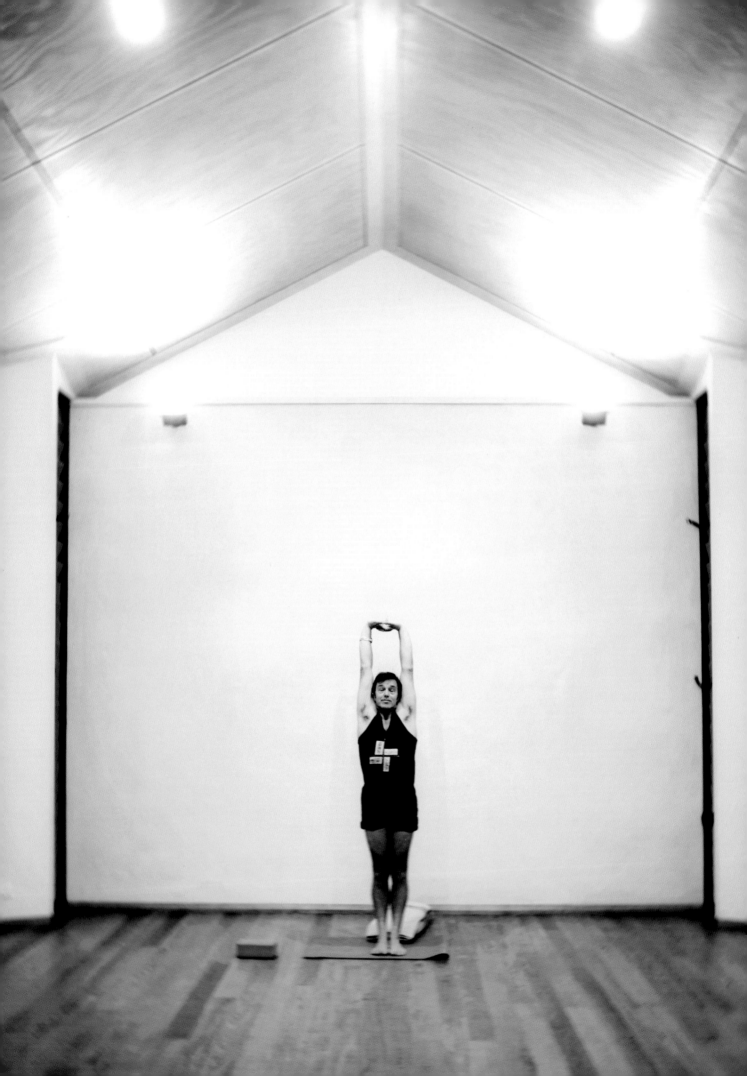

Yallingup, Western Australia, 18:00. Tuesday night yoga class is about to begin. Teacher Shane Moody uses the Iyengar method, which pioneered the use of props such as cushions, minimizing strain and the risk of injury. *Photo: Freedom Garvey-Warr.*

Chittagong, Bangladesh, 10:30. A little heavy rain doesn't deter these young footballers. Nor does the mud. *Photo: Wahid Adnan.*

Chiapa de Corzo, Mexico, 14:15. The River Grijalva in Chiapas province effectively slows down a young cyclist. Formerly known as the Tabasco, the river is one of Mexico's major waterways. *Photo: Jonathan Look, Jr.*

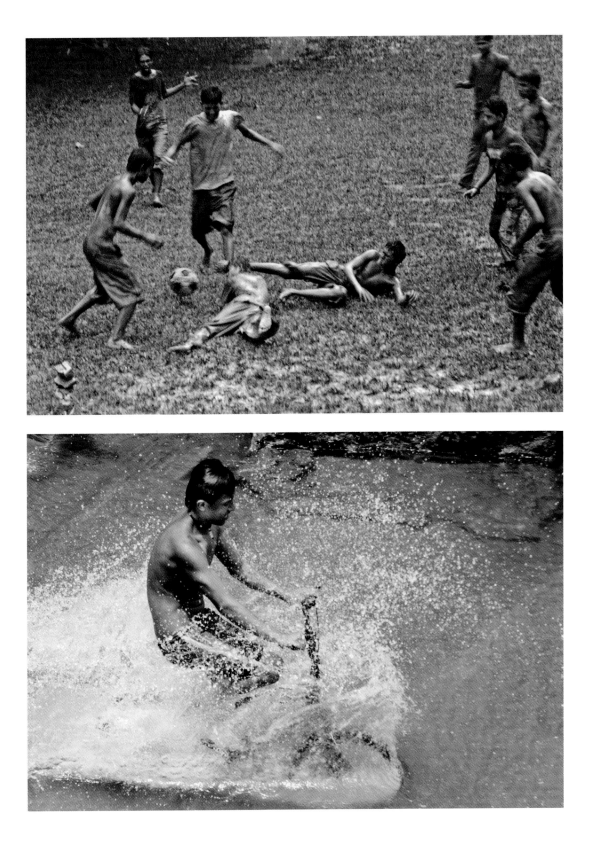

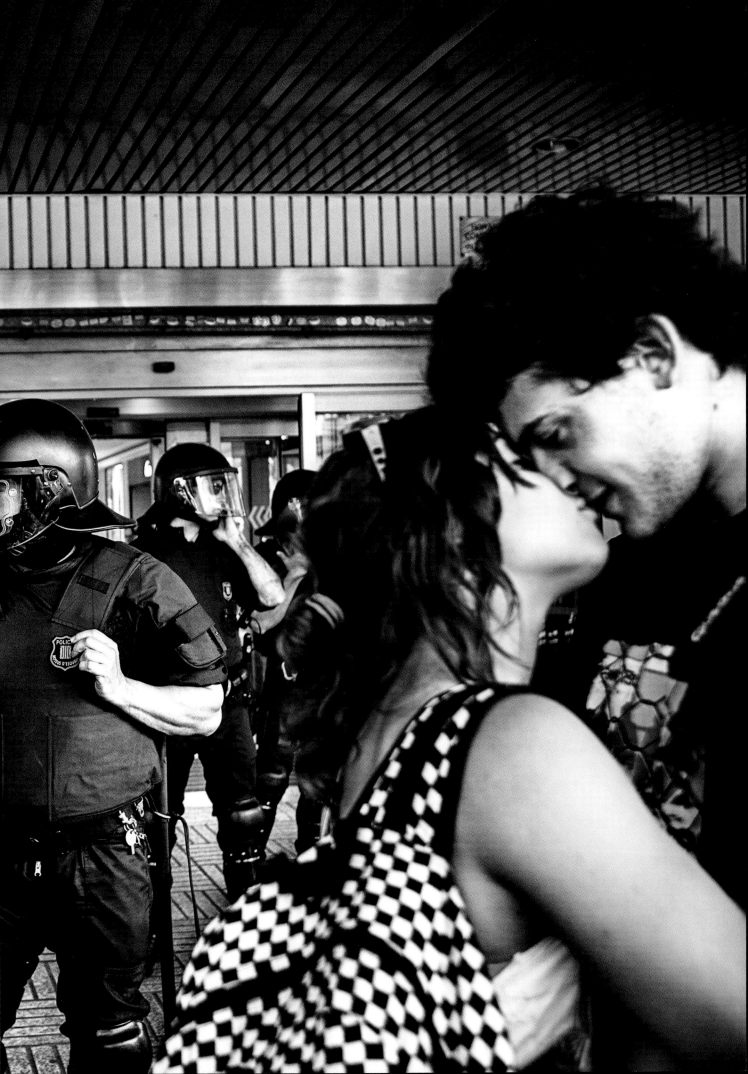

◀ Barcelona, Spain, 13:03.
The Catalonia police are maintaining order outside the headquarters of Caixa Bank during demonstrations against what the protestors say is financial greed for the few while there is government austerity for the many. This young couple are momentarily oblivious to the tension on the street.
Photo: Giuliano Camarda.

Dale i Sunnfjord, Norway, 12:33.
Josef Dinis packs away his lunch box while some of the other Slovakian workers doze before returning to work on the new bridge over Dalsfjord in western Norway. Some of the men spend the break fishing for salmon. After 50 years of planning, the bridge and connecting tunnels will link two communities across a fjord. Schoolchildren in Askvoll will no longer need to take a half-hour ferry ride to reach the school in Dale.
Photo: David Zadig.

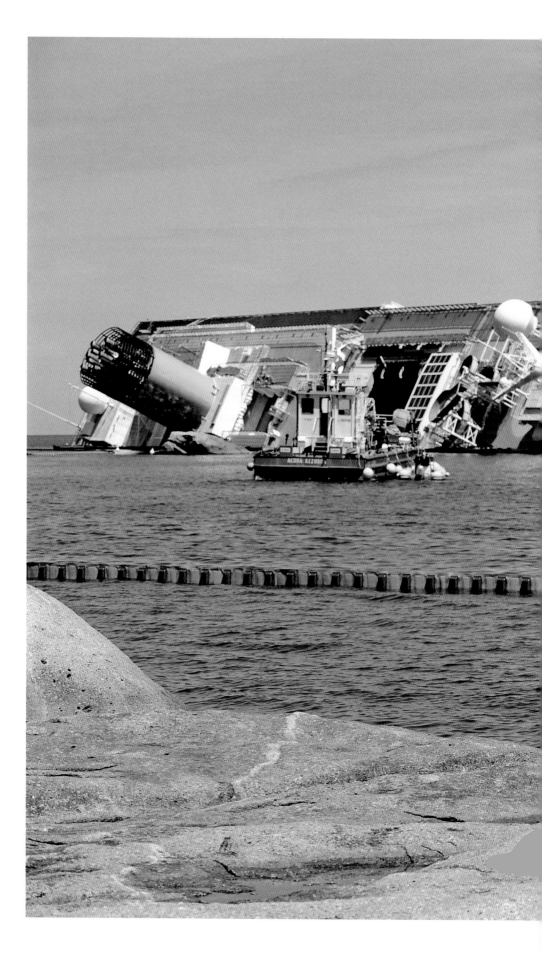

Giglio Porto, Italy, 12:58.
When the *Costa Concordia* ran
aground on 13 January 2012, the tiny
island of Giglio suddenly found itself
at the centre of a crisis. The islanders
rose to the challenge, helping to
rescue people at sea, then taking
drenched and terrified survivors into
their homes. Perhaps their kindness
counterbalanced the infamy of the
ship's captain, Francesco Schettino,
who faces trial on charges of multiple
manslaughter, causing a shipwreck,
and abandoning ship. Of the 4,252
passengers on the cruise ship, 32
died. Somewhat uncomfortably,
Giglio now finds itself a focus for
disaster tourism.
Photo: Jack Mikrut.

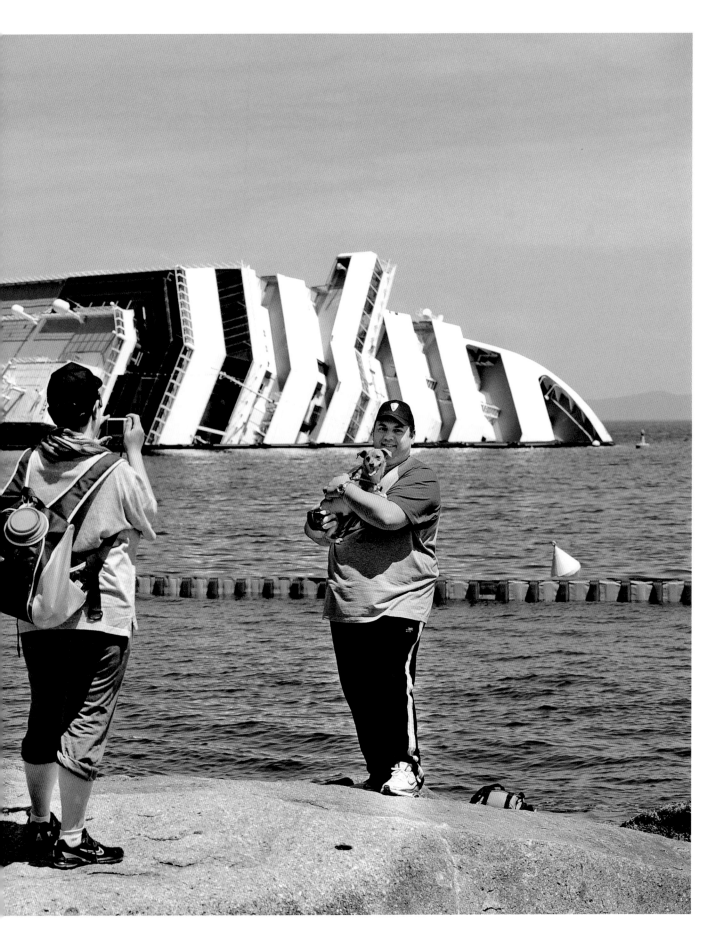

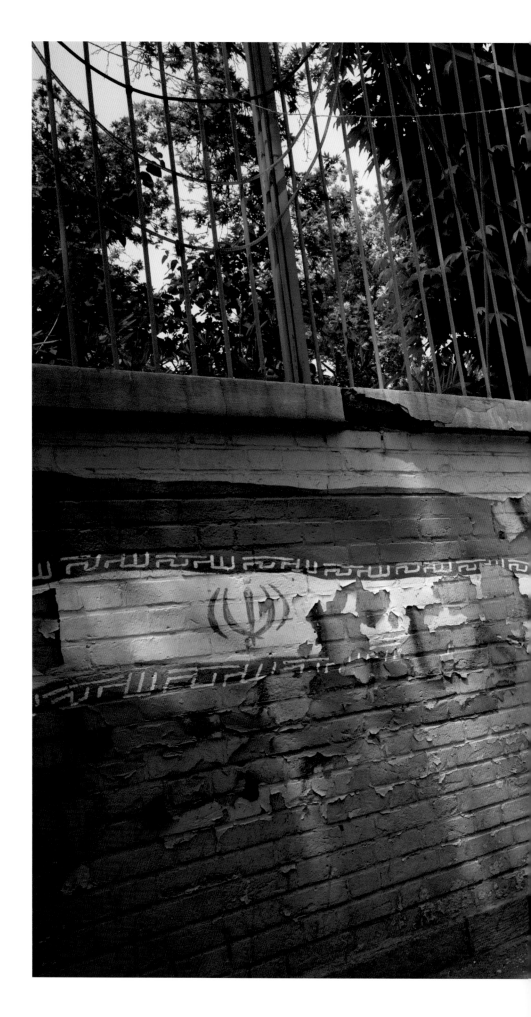

Tehran, Iran, 13:04.
The former US embassy compound is now a cultural complex recalling the occupation in 1979 and the taking of hostages by Iranian students. The inscription on the flag reads: "With 'Down with America' in our minds, there is no chance of American domination." The woman hides her face from the camera, as Iranians often do.
Photo: Morteza Nikoubazl.

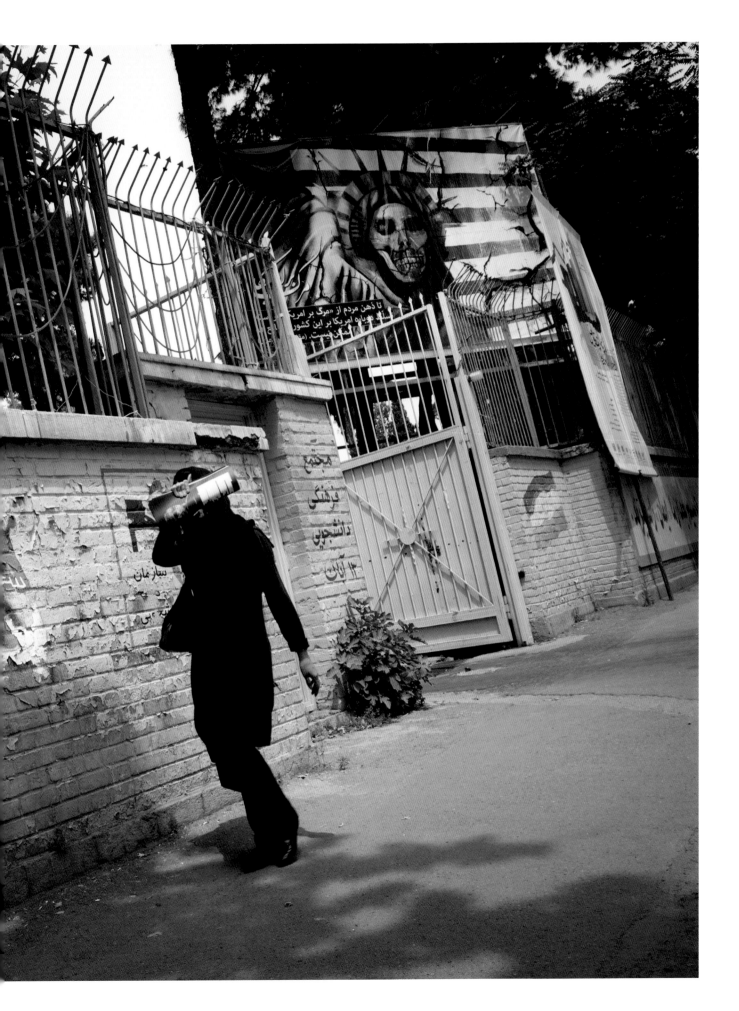

Tokyo, Japan, 22:00.
With other passengers occupying
the priority seats, a young mother
must stand.
Photo: Isti Winayu.

Krasnodar, Russia, 21:45.
Public transport in many places can
be quite trying, with often fierce
competition for spaces. In Krasnodar,
a city spread out on the River Kuban,
cheapness makes such a form of
travel even more popular. There is no
metro but there are trams, city buses,
trolleybuses and minibuses like this
one, which are called *marshrutka*.
Photo: Ilya Panov.

Kolkata, India, 09:15.
Train commuters squeezed together.
More than fourteen million people
live in the city's metropolitan area.
Photo: Aniket Jana.

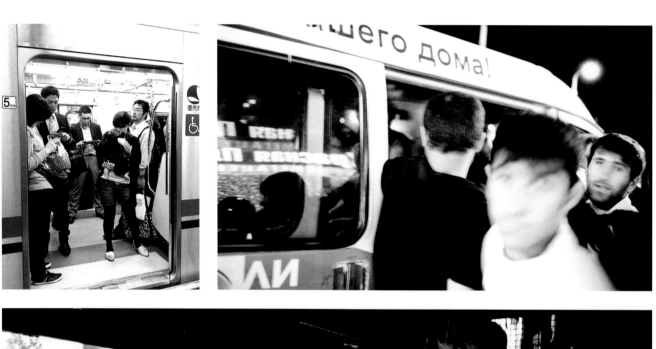

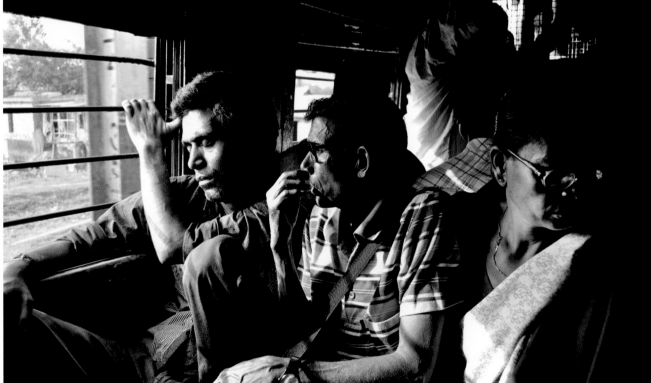

Kuala Lumpur, Malaysia, 13:11.
Office workers shield themselves not
from rain, but from the midday sun.
Photo: Richard Humphries.

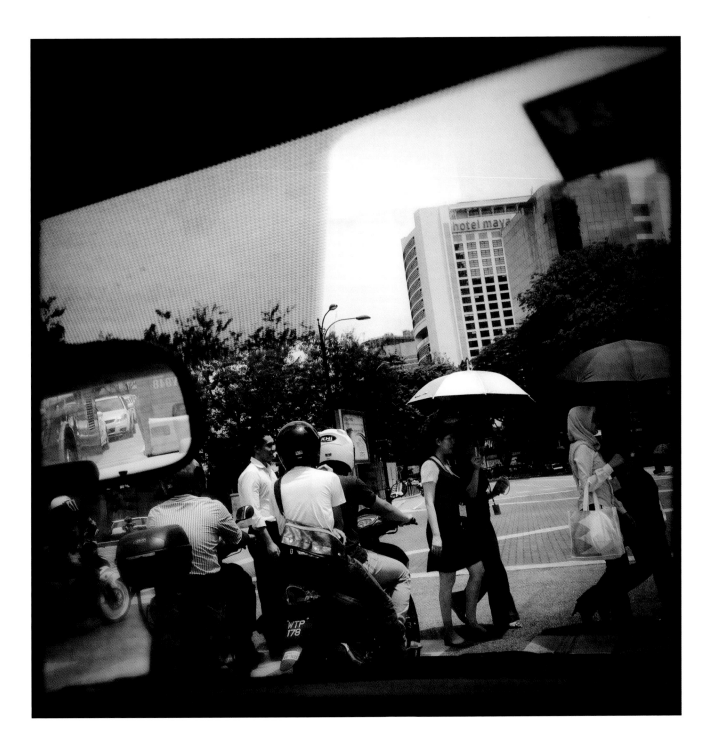

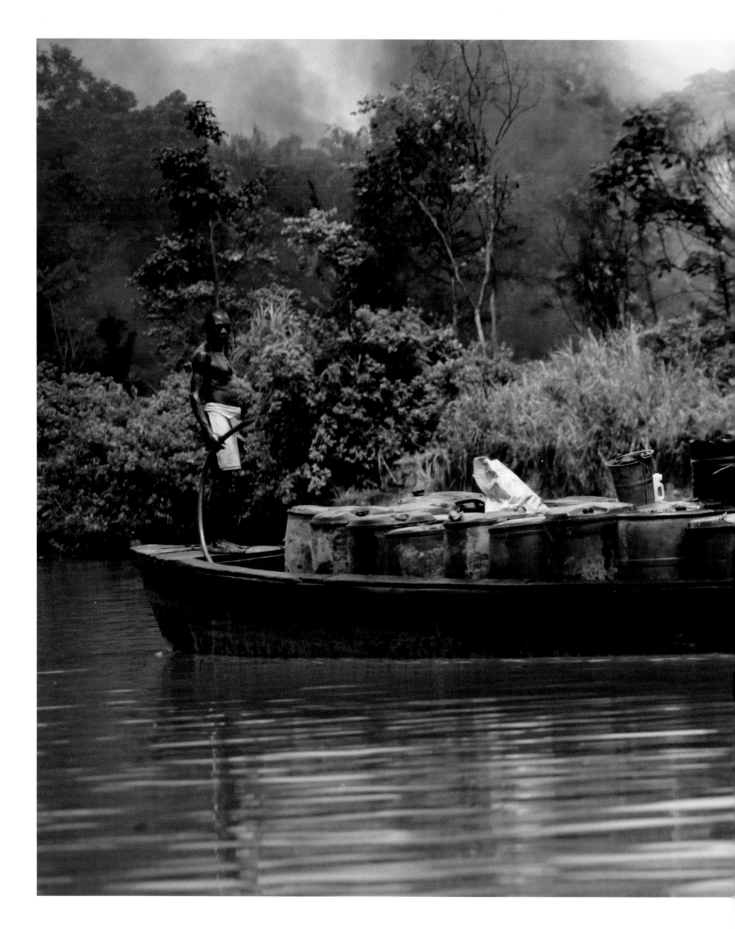

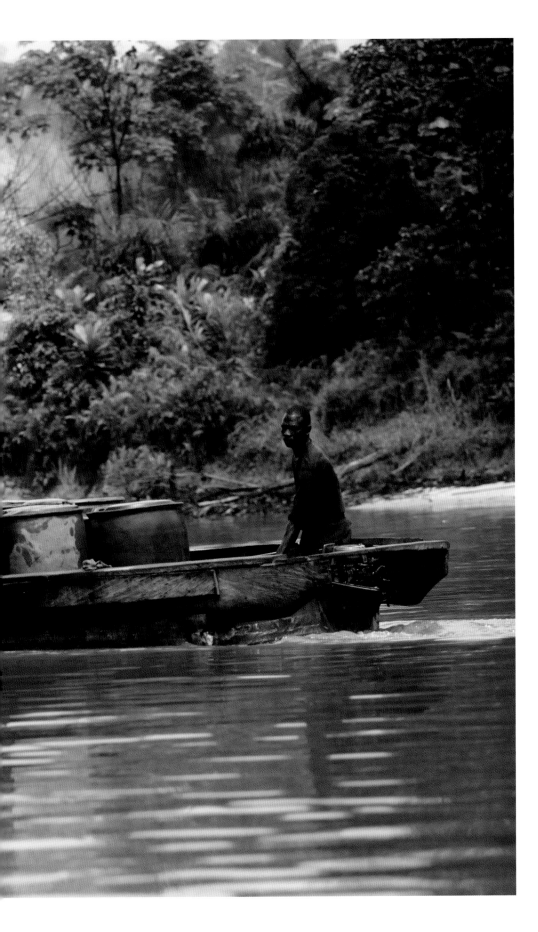

Bayelsa, Nigeria, 13:15.
Men ferrying stolen crude oil to an
illegal refinery, revealed by the smoke
in the background, along Diebu
Creek. Oil production in Nigeria has
been reduced by thieves siphoning off
supplies from unguarded pipelines.
The illegal industry is estimated to be
worth hundreds of millions of dollars
a year.
Photo: Akinleye Akintunde.

Ramallah, Occupied West Bank, 13:18.
Palestinians in uproar on Nakba Day
("Catastrophe" Day), commemorating
the exodus of more than 700,000 Arabs
who were displaced or fled from their
homes during the fighting that accom-
panied the declaration of statehood
for Israel on 14 May 1948. "My camera
equipment still stinks from the chemi-
cal 'skunk water' the Israeli security
forces sprayed on the demonstrators.
I was wearing a gas mask and helmet
against the soldiers' rubber bullets
and the demonstrators' stones, but I
was drenched with the water. You have
to strip before getting into your car,
otherwise you'll never get the stench
out. You have to throw the clothes
away or wash them repeatedly."
Photo: Heidi Levine.

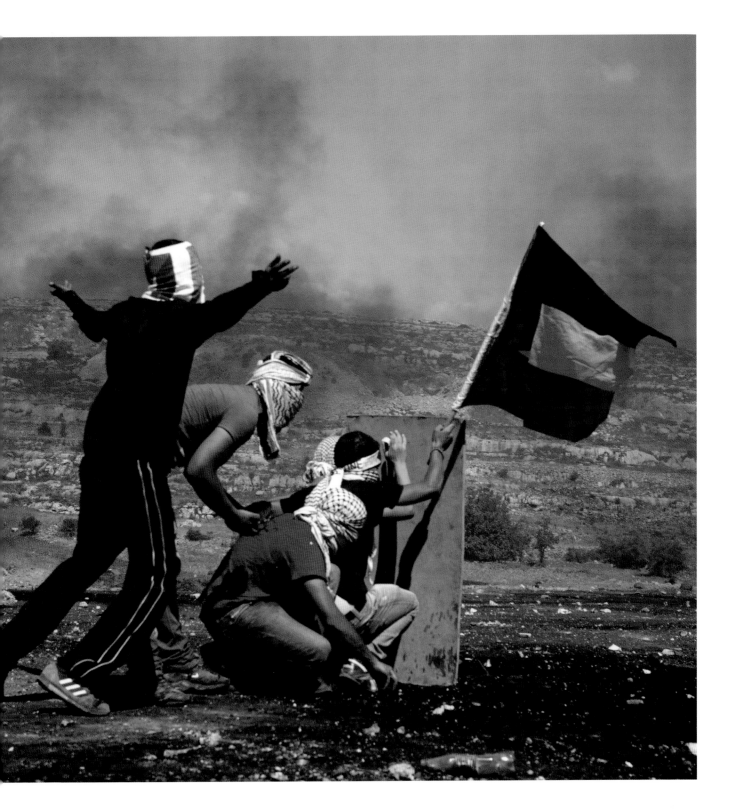

Fontes, Santa Marta de Penaguião, Portugal, 09:37.
Olga and Rosa work for a charity called Fundação Dr. Carneiro de Mesquita in the village of Fontes in an inland region of northern Portugal, one of the poorest parts of Europe.
Photo: Nelson d'Aires.

Fontes, Santa Marta de Penaguião, Portugal 11:20.
Olga Pereira is 35 and Rosa Morais 44. They help with the hygiene needs of people recovering from illnesses and also do general housework for the deprived and infirm.
Photo: Nelson d'Aires.

Paredes de Chã, near Fontes, Portugal, 14:26.
The work is hard, but it's a job Olga Pereira and Rosa Morais both enjoy. Portugal has many similar organizations dedicated to helping the poor and sick. The country's precarious financial situation has led to cuts in public funding for the unemployed and others dependent on charity, while donations have dropped at about the same rate. Eighteen percent of the population is believed to live below the poverty line.
Photo: Nelson d'Aires.

Fontes, Santa Marta de Penaguião, Portugal 20:03.
In the evening, after work, Olga and her family – mother Isolina, son Afonso and husband Luis Filipe – start their dinner with vegetable soup, listening to news about Hollande and Merkel. An extra place was set for the photographer.
Photo: Nelson d'Aires.

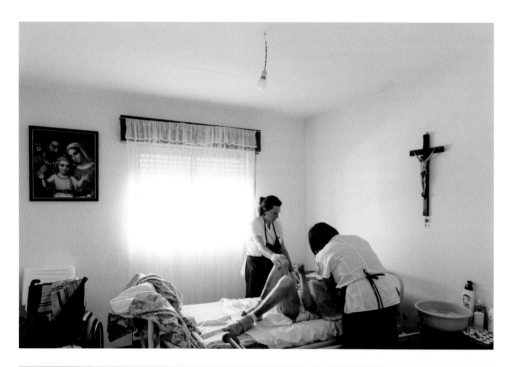

Laem Mae Phim, Thailand, 14:43. Bhumpen has been a monk for 11 years at a temple north of the beach resort of Laem Mae Phim. Every day he treats villagers with back or joint problems. They talk about personal issues and get a half-hour's treatment on his vinyl mat. The 20-*baht* fee goes to the temple. Many of the monks are soccer fans – 43-year-old Bhumpen's team is "Manjo" (Manchester United).
Photo: Björn Larsson Ask.

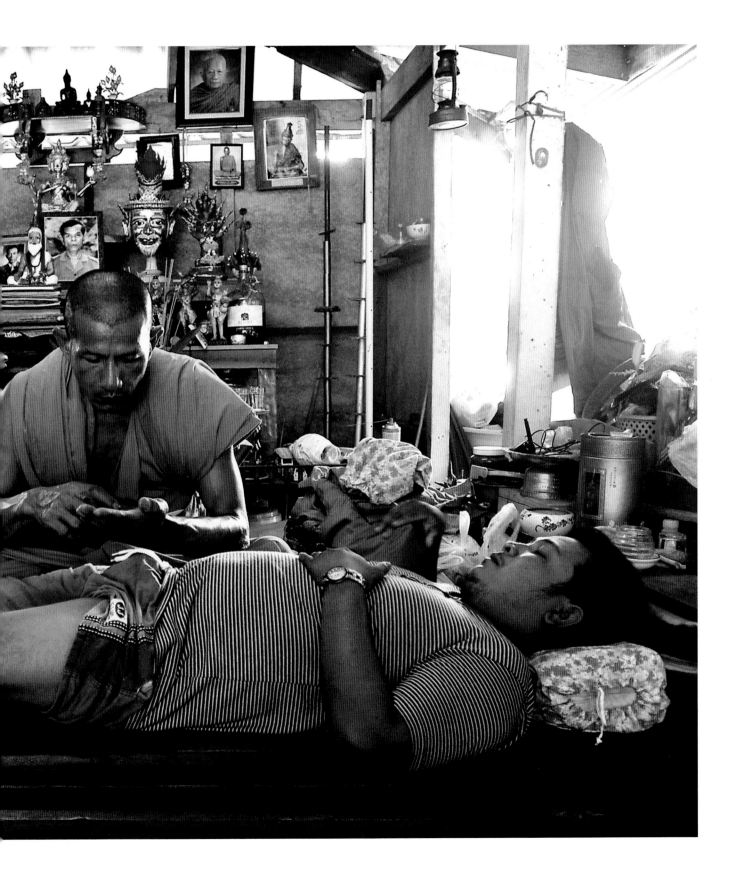

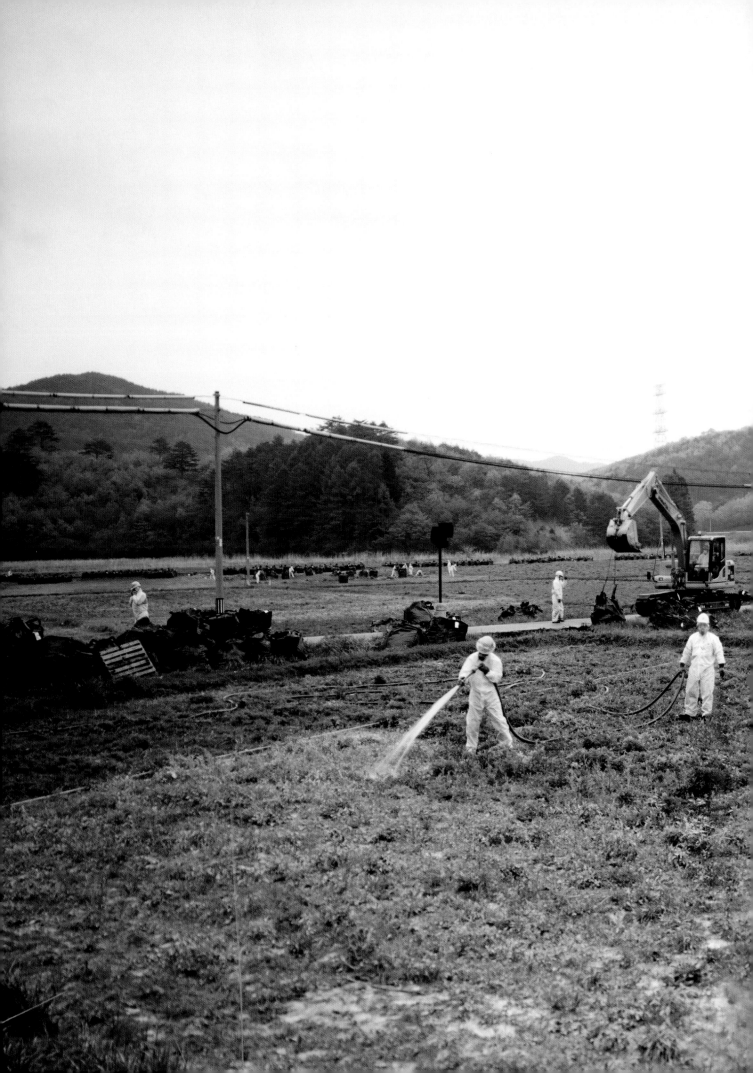

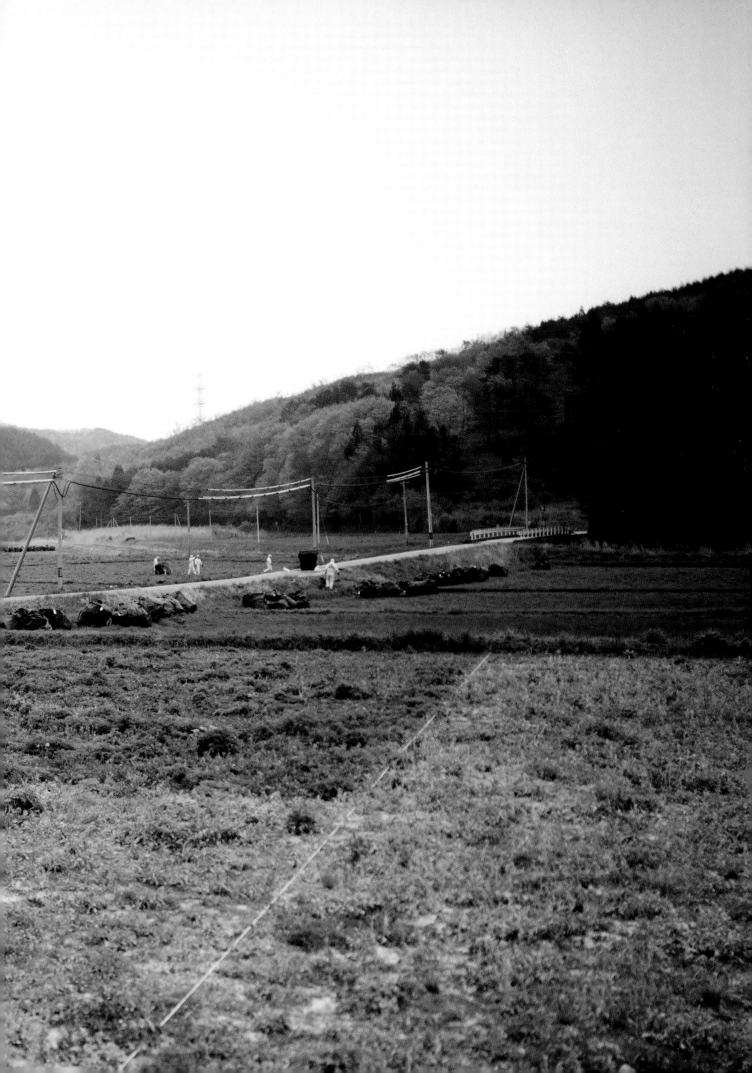

◂ Iitate, Fukushima, Japan, 12:00.
Decontamination workers spray lime
on a rice field. Potassium fertilizers
and lime can reduce the level of
uptake of radioactive materials by
plants. This is a farming community
not far from the Fukushima Daiichi
nuclear power complex that was dev-
astated by the major accident in 2011,
which followed the tsunami. Parts of
the village will be uninhabitable for
decades. Villagers burning leaves in
the region have unknowingly been
spreading radioactive fallout to Tokyo,
about 150 miles (240km) south of here.
Photo: Peter Blakely.

Naples, Florida, USA, 13:17.
"My father, Doug Kelbaugh, stretch-
ing at my grandmother's home in
a retirement community in Naples,
Florida. This exercise helps loosen
his sore lower back by stretching
thighs and hamstrings at the same
time. He cycles 100–150 miles a week
and is currently training for bike trips
in Glacier National Park and wine val-
leys in the San Francisco Bay Area."
Photo: Casey Kelbaugh.

Kiev, Ukraine, 14:15.
Do I have a fever? Oles Danys
doesn't feel well, and Kateryna
Gladka checks his forehead. It's
not hot. She is a journalist and he
is an opposition parliamentarian.
The two friends are on their way to
a café after a protest rally against a
proposed law that would weaken the
status of the Ukrainian language.
Photo: Alex Zakletsky.

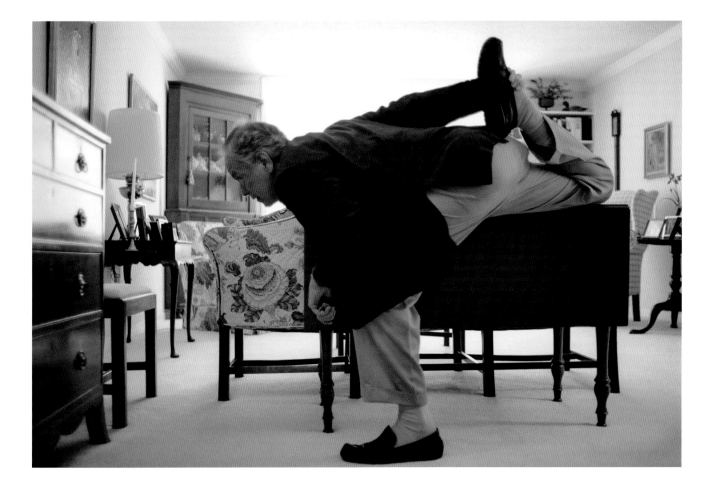

224

Twickenham, UK, 13:31.
"I live in the countryside over an hour away from my daughter, Lucie. She rang early in the morning as her baby was coming, already five days late. Lucie and her husband Simon Mellodew live in Twickenham, London, in a flat with their two-year-old little boy Freddie. The plan was to go to the hospital with Lucie and Simon and be there for the birth. My youngest daughter, who lives nearby, would stay with Freddie. As the contractions increased, Lucie phoned the hospital. They told her a midwife was in the area and she called in at midday to see how things were progressing. The midwife advised us to get ready to go to the hospital but we all realized it was too late to leave the flat, walk down two flights of stairs, get in the car and drive four miles to the hospital. My eldest daughter arrived from Germany just 20 minutes before Jude was born at home at 13:10, weighing 8 pounds and 11 ounces. We were amazingly lucky to have the midwife there as it all happened so very quickly. A beautiful happy ending, for me especially, to have my three daughters there and for us to witness the birth of my fourth grandchild."
Photo: Esther Gallimore.

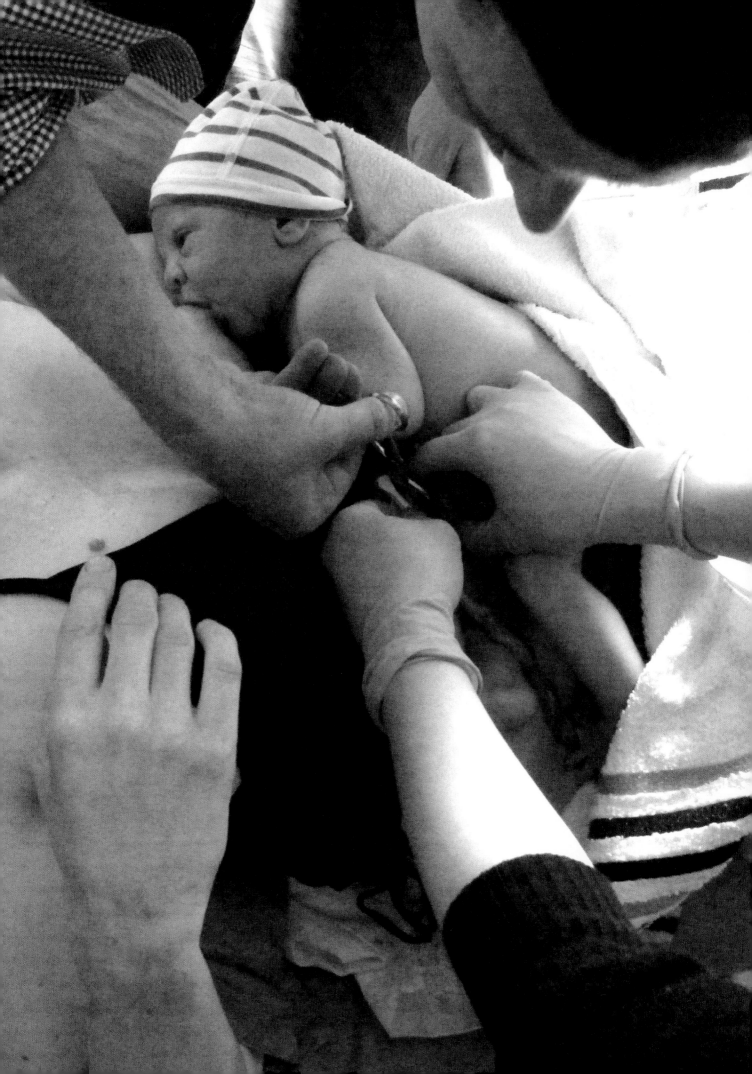

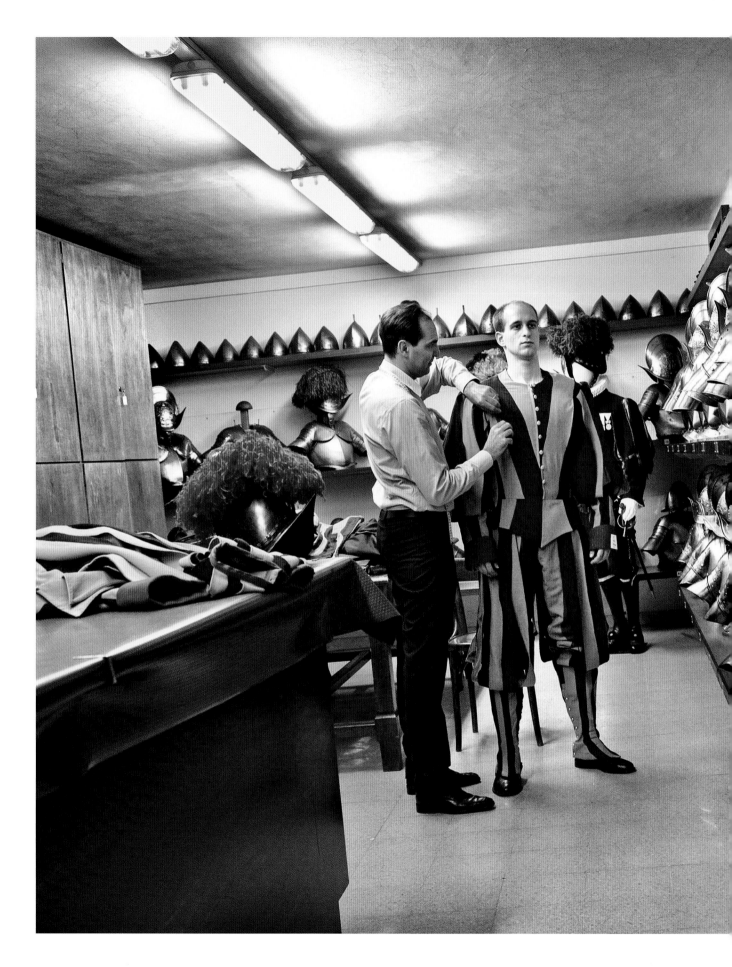

◀ Buenos Aires, Argentina, 13:46.
In the skyscraper shadows of Buenos
Aires' bank district at lunch hour,
the street's regular cleaner waits to
cross. It is an unusually warm autumn
day. The light is reflected from one of
the glass-fronted office buildings.
Photo: Maria Plotnikova.

Vatican City, 13:56.
A Vatican tailor, Ety Cicioni, takes
measurements for a Swiss Guard's
summer uniform. After 15 years at
the job, he has made thousands of
them. Andreas Burkhard's costume
is in the original family colours of
Pope Julius II, who established
the Pontifical Swiss Guard in 1506.
The metal morion helmet, worn on
ceremonial occasions, has coloured
ostrich-feather plumes.
Photo: Stefano dal Pozzolo.

Dhaka, Bangladesh, 14:26.
A woman cooks her lunch of curry with aubergine and potato, called *aloo baingan* in Bengali cuisine. More potatoes rest on top of a row of traditional, hand-built, clay ovens. "Taken in a Jurain slum, this picture shows the daily life of a lower-middle-class family."
Photo: K.M. Asad.

Robertsport, Liberia, 14:37.
A woman in the village of Latia, near Robertsport, expresses her happiness over the energy-saving wood stove that her sister-in-law has constructed for her. The photographer explains: "Such stoves reduce the need for firewood by up to 20 percent compared to the traditional 'three-stones' method, meaning that she does not need to spend so much time collecting fuel."
Photo: Markku Vesikko.

Homs, Syria, 16:00.
For now, the street is calm. A lone
Syrian rebel walks by an undetonated
mortar shell in the war-ravaged
Khalidiyeh district of northern
Homs. From the spring of 2011,
the city has been one of the hardest
hit places in the bloody rebellion
against President Assad.
Photo: Fadi Zaidan.

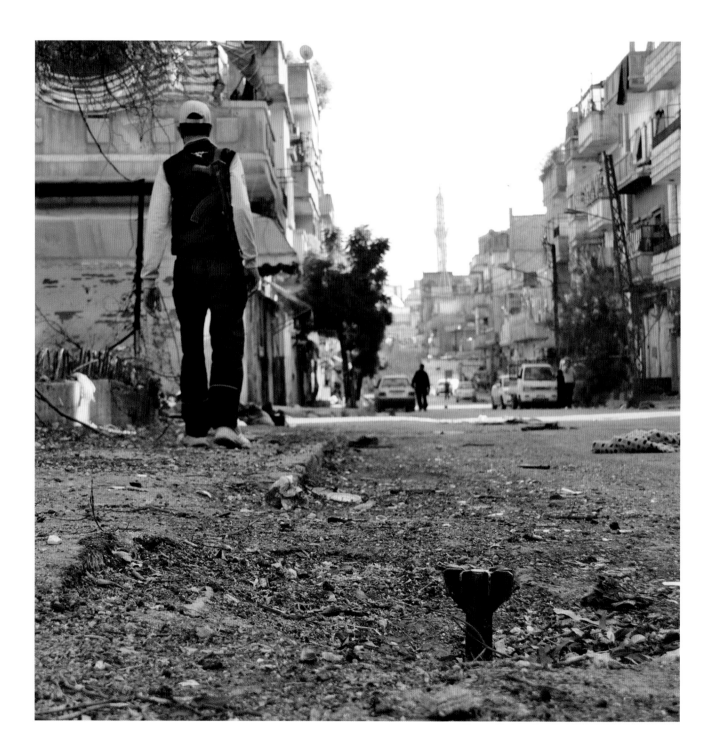

Damascus, Syria, 11:00.
Two friends, playing in a poor neighbourhood. "When I asked them to pose for the photo, he was shy, but she begged him to do it. Then he went off, and she came to look at the photo. She saw it and smiled. Then she laughed, played with her hair and ran away. Although there are no conflicts yet in this neighbourhood, I think the childhood innocence of these two was ruined by the sounds of the bombing not far away."
Photo: Rawad Bara.

Damascus, Syria, 12:45.
Although Syria implemented a nationwide smoking ban in 2010, smokers are still able to enjoy their *argillah* waterpipes in outdoor cafés. The ban, which is rare in the Arab world, carries a modest fine for offenders. In traditional cafés like this one, old men may spend the morning discussing the day's news and drinking tea.
Photo: Rawad Bara.

Ariha, Syria, 12:07.
Muatiz Bezmawi has been bedridden for three months at his parents' house. It is unlikely that he will ever leave his bed. On his way to work in Ariha in northwestern Syria, he was shot at without warning from a guard post manned by government forces. Bullets struck his kidneys and spine, and Muatiz is paralysed. His parents care for him as well as they can, but he is becoming thinner and his muscles weaker. Muatiz accepts that he will die from his injuries. Hospital care is no alternative. If soldiers find men with bullet wounds in hospital, they assume they have been involved in anti-government fighting or demonstrations. The wounded are arrested, or sometimes even killed on the spot.
Photo: Niklas Meltio.

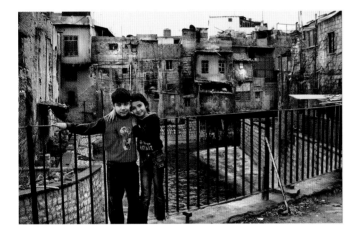

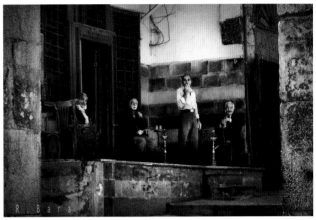

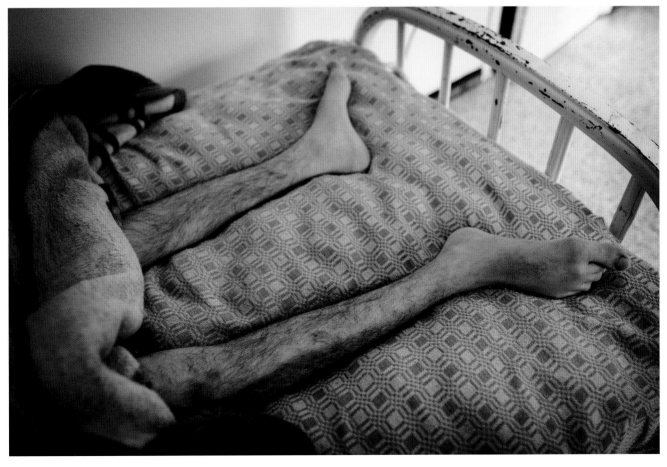

Samara, Russia, 14:00.
A sunny afternoon in a Samara backyard. *Photo: Irina Voronkova.*

Tongli, China, 12:15.
Tongli, near Suzhou, is sometimes known as the "Venice of the East" because of its many canals. *Photo: Carolina Johansson.*

Dhaka, Bangladesh, 13:15.
Many Bangladeshi textiles have delicate floral patterns and are most often used for long saris. *Photo: Arifur Rahman.*

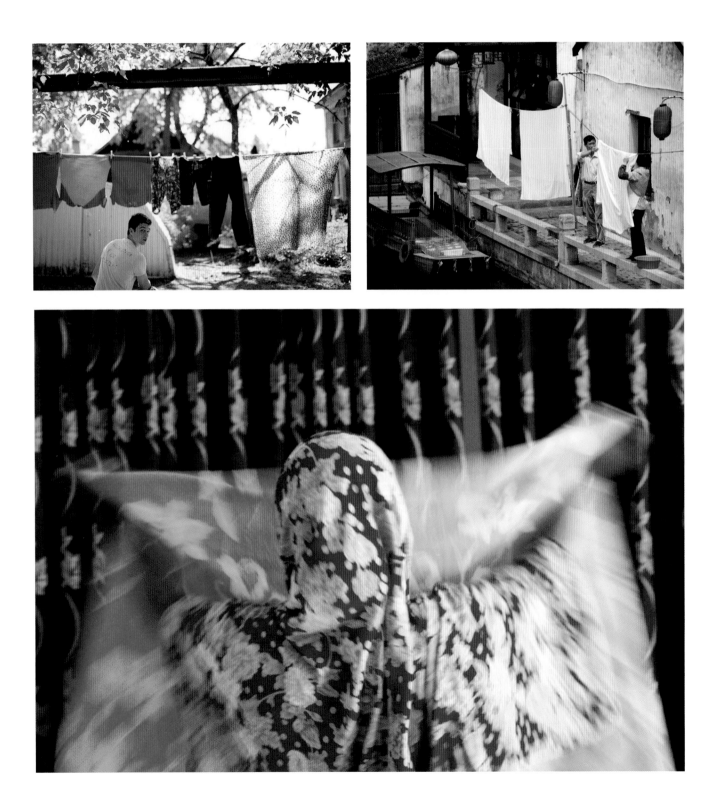

Marina Gorka, Belarus, 15:45.
"I visit Marina Gorka once a month, going to see disadvantaged families for a charity." This is the backyard of a mother who has four girls.
Photo: Yuliya Matskevich.

Lagos, Nigeria, 12:05.
"A friend doing her laundry at noon."
Photo: Omolara Aluko.

Mexico City, Mexico 15:15.
"This is part of a series of photos I'm doing for a stop-motion animation. In the animation my clothes slowly invade my room. It's part of an autobiographical project I'm doing, and although it leaves out my face, I am everywhere: in my room, in my bed, in my clothes, in the pile, in the mess, in the colours."
Photo: Aimee Suarez.

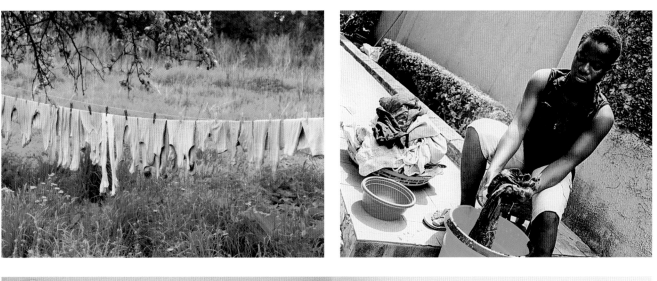

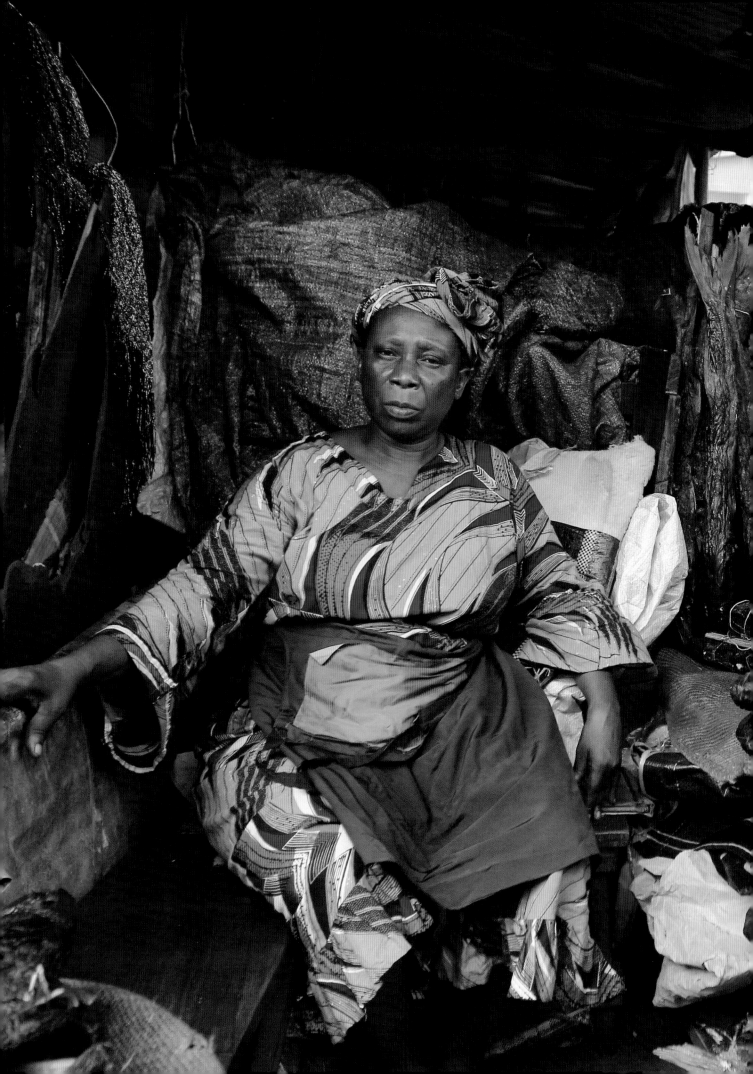

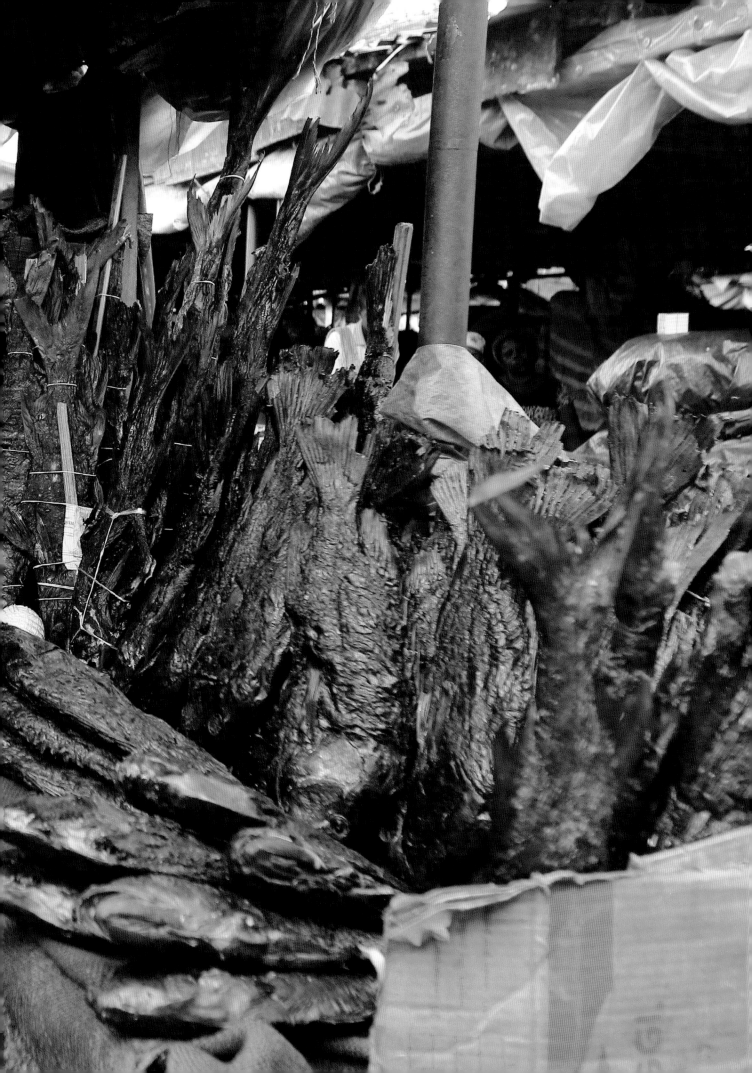

◀ Port Harcourt, Nigeria, 15:19. Salome Manuel has worked for 15 years at the Creek Road Market, selling *okporoko* (stockfish) caught in the creeks and rivers that flow down through southern Nigeria to the Atlantic. The dried fish – red snapper and more – are a popular feature of Nigerian cuisine, prepared by soaking and softening in stew. "She buys large fish in bulk, already dried in the sun and smoked under a charcoal fire. Every night, she smokes the fish again under charcoal to keep them preserved. Although she wishes she could earn more money, she has been able to use her profits to send one of her sons into higher education."
Photo: Jide Odukoya.

Ogresgals, Latvia, 17:30. One of the best moments of Juris Osokins' day is when he feeds the calves. On their farm east of Riga, Juris and his wife Inese Grisane have about a hundred milk cows. They have 14 farmhands and belong to Latvia's biggest dairy cooperative. They also grow rapeseed, grain and caraway.
Photo: Aivars Lurens.

Matsumoto, Japan, 14:45. For more than a century, this company in the Nagano area has been preparing *miso*, a traditional seasoning paste used for soups and pickling vegetables. The mixture consists of soya beans, rice, rice malt, water and sea salt. The two men are mixing the *miso* smooth as possible and speeding up fermentation by breaking up air pockets.
Photo: Michio Endo.

Ockelbo, Sweden, 15:25.
Inga-Lill Lundqvist has done the day's baking and is letting her Apple Braids cool on the kitchen table at her home in Gästrikland county. Cloths cover her *Mazarin* almond tarts: "They're my special recipe, using almonds and potatoes instead of almond paste. I love to bake and sometimes bake for the whole village, often flatbreads. My husband Knut is my back-up, washing up and finding ingredients. When we lived in town, the teenage boy next door used to teach my daughters, Lisa and Linda, to play golf. He was a lovely boy and I tried to match him up with my sister. But Daniel chose Crown Princess Victoria, and now he's Prince Daniel of Sweden. She got the best husband in the world."
Photo: Lisa Lundqvist.

Hong Kong, China, 15:30.
Tailoring of suits and dresses is still
a major industry in Hong Kong, and
there are countless shops selling
fabrics. When business is slow, a
nap usually refreshes.
Photo: Roy Lee.

Hong Kong, China, 14:15.
China is facing a blood shortage in some parts of the country, as more people undergo surgery, but blood donation has not kept pace. The rate of giving is higher in Hong Kong (30 people per thousand) than on the mainland (only nine per thousand), in part because foreign nationals have been encouraged to supply blood for rare blood types.
Photo: Raymond Choi.

Dniprodzerzhynsk, Ukraine, 10:33.
"This little [Ukrainian] Orthodox
church near our house was set on
fire last night for the fourth time
by unknown vandals. A temporary
structure, the little corrugated metal
church – the only one I have ever
seen in the Ukraine – stands on the
site where the new Orthodox Prince
St. Yaroslav the Wise Cathedral is
supposed to be built. The two
churchgoers were very sad."
Photo: Iurii Serzhanov.

Ciudad Juárez, Mexico, 15:51.
This city lies on the Mexico–USA
border and is one of the world's
most violent places. Organized
extortion gangs routinely terrorize
small businesses, burning shops or
even killing the owners. The stubborn
owner of this premises, a carpenter
in his late 60s, is now left without
means to support his family.
Photo: Carlos Gutierrez.

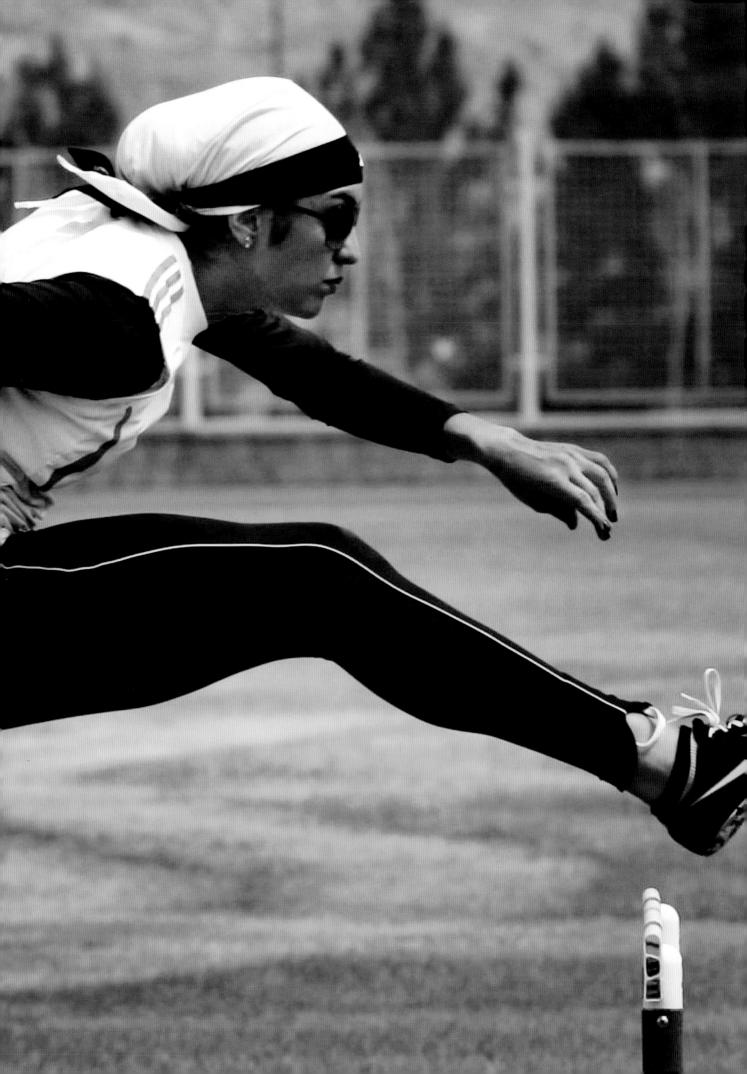

◀ Tehran, Iran, 14:51.
Sepideh Tavakoli Nik in training at the city's Aftabe-Enghelab complex. She wears the Iranian female athlete's outfit to comply with the Islamic dress code. Sepideh is studying industrial engineering at Tehran Azad University and has been a member of the Iranian Women's Track and Field team since 2005. A holder of three national records, in 2010 she won two gold medals at the West Asian Track and Field Championship, held in Aleppo, Syria, and hopes to qualify for the London 2012 Olympic Games.
Photo: Maryam Majd.

Krasnoyarsk, Russia, 14:11.
Firemen instructing school pupils from Krasnoyarsk in Siberia how to winch down people from high buildings. In this simulated rescue operation they are using wooden dummies. The participants also practise treating severe burns.
Photo: Ilya Naymushin.

Krasnoyarsk, Russia, 15:38.
Every year, teams of Siberian teenagers compete in fire drill and rescue. Organizer Pyotr Petruch, who has experience of being in charge of rescues in earthquakes, floods and plane crashes, wants the younger generation to know how to react in a catastrophe.
Photo: Ilya Naymushin.

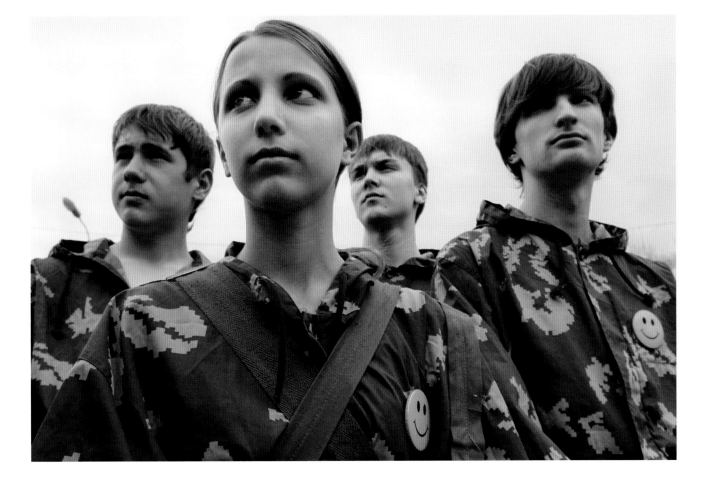

Moscow, Russia, 15:15.
"On the wall is assembled everything that is most beloved, important and dear to the heart! The wall is the story of our little family!"
Photo: Nadia Guseva.

Paris, France, 15:15.
France was calm as the first socialist president of France in a generation, François Hollande, was sworn in. Although he had never previously held a ministerial portfolio, in a riveting tussle with incumbent president Nicolas Sarkozy, Hollande proved to have greater appeal to voters. This homely looking scene was actually recorded at the photographer's office.
Photo: Sophie Zénon.

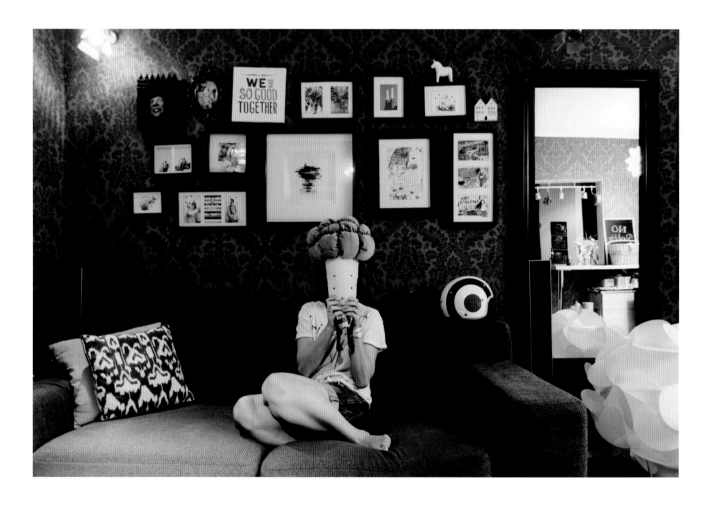

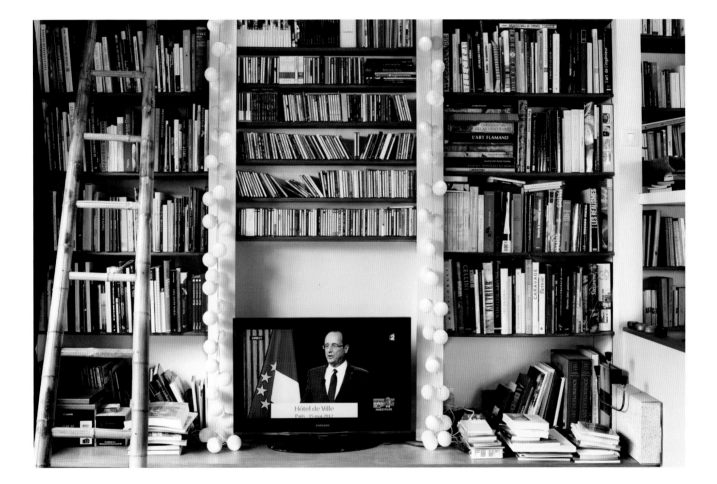

◂ Queenstown, South Island,
New Zealand, 15:00.
"Heading south from Queenstown
along Highway 6, the scenic main
tourist road, to Milford Sound. The
scene changes with every turn."
Photo: Reggie Lee.

Marbella, Spain, 13:30.
"When we got to the apartment,
we couldn't find a baby bed."
Photo: Nikolai Linares.

Lonco, Chile, 13:15.
Siesta. *Photo: Alvaro Lagos.*

Lisbon, Portugal, 11:30.
"Paula chose to be a personal trainer,
stunt woman, vegan and lesbian."
*Photo: Tiago Miguel Semião Carvalho
de Miranda.*

Bear Lake, Michigan, USA, 14:15.
An afternoon nap on the couch – in
front of her grandson's mess, created
by his PlayStation 3 games.
Photo: John Feyers.

Pfäffikon, Schwyz, Switzerland, 16:30.
"My son was worn out after playing
hard." *Photo: Lamielle Lincke.*

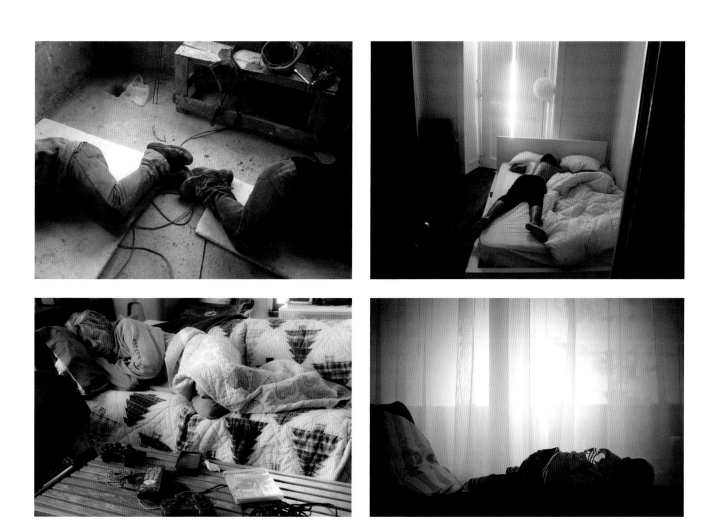

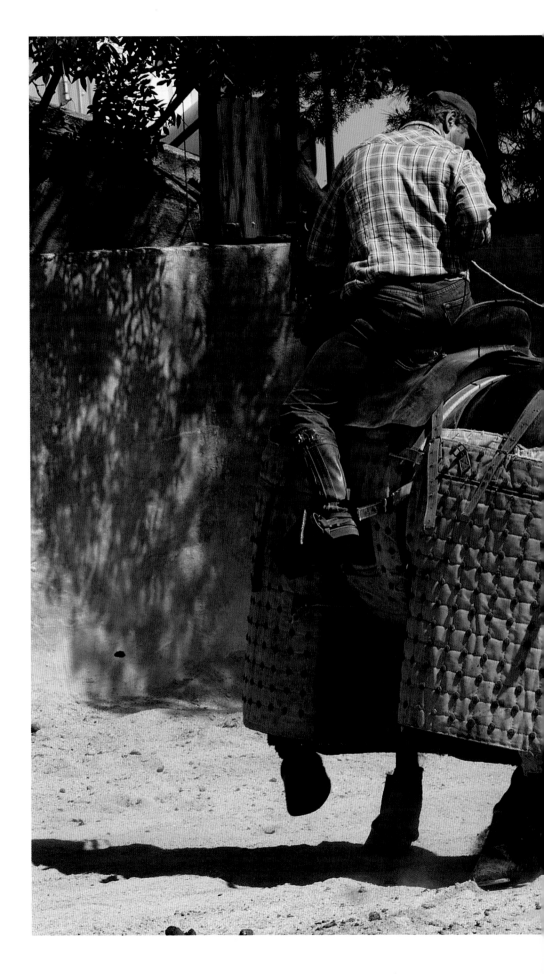

Franquevaux, France, 15:38.
On his farm near Nîmes in southern France, Alain Bonijol trains horses for picadors in bullfighting. The farm's only bull, Desgracidado, is brought into the round pen to run around and buffet the blindfolded horse – today, Rital – to accustom it to a charging bull. The protective padding developed by Alain for bullfights in France and Spain is made of Kevlar, also used for bulletproof vests.
Photo: Claes Löfgren.

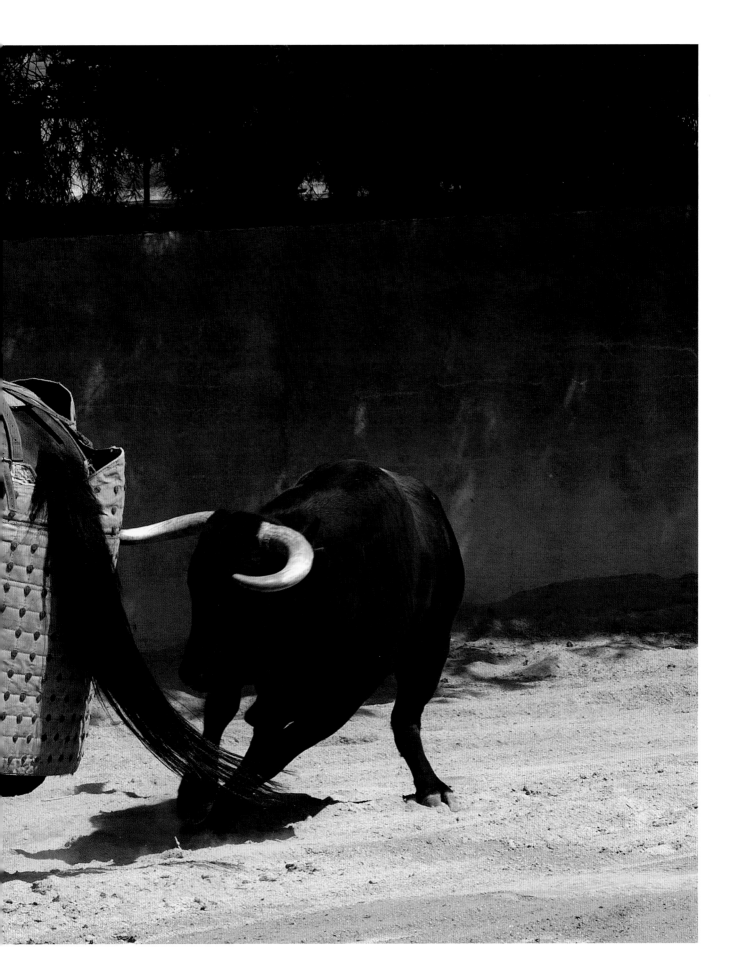

262

Ouagadougou, Burkina Faso, 22:09.
"At the home of my friend, after the music festival."
Photo: Ulrika Walmark.

Ocala, Florida, USA, 19:01.
"Each cross on this wall represents a country the Lord Jesus Christ has sent me to. The small, plain wooden cross is from Romania. The black-and-cream striped cross is from Honduras. The large grey-stone lighthouse cross is from Trinidad. The bamboo cross with the clay flowers is from Ecuador. The red wood hand-carved cross is from Nicaragua. And the red and brown, curly cross is from my hometown of Ocala, to remind me that God's Word is needed at home as well as at the ends of the Earth."
Photo: Regina Huffman.

Loch Garman, Ireland, 23:30.
"All the people in the photos live in different parts of the world, but I like to have them close to me on my wall. My mam and dad, my husband's mam and dad, my son with his cousins, me and my husband on our first holiday nearly 12 years ago. The clock says another time and another place. It links to my photos, because they were all taken in another time and place."
Photo: Michelle O'Kane.

Nottingham, UK, 17:00.
"My wall." With an image by Banksy, the famous British graffiti artist.
Photo: Paul Bryant.

Kungsbacka, Sweden, 15:52.
"The long, cold winters on Sweden's
west coast make it necessary to stock
lots of firewood to keep homes warm.
This old house is deep in the forest
outside Kungsbacka."
Photo: Aline Lessner.

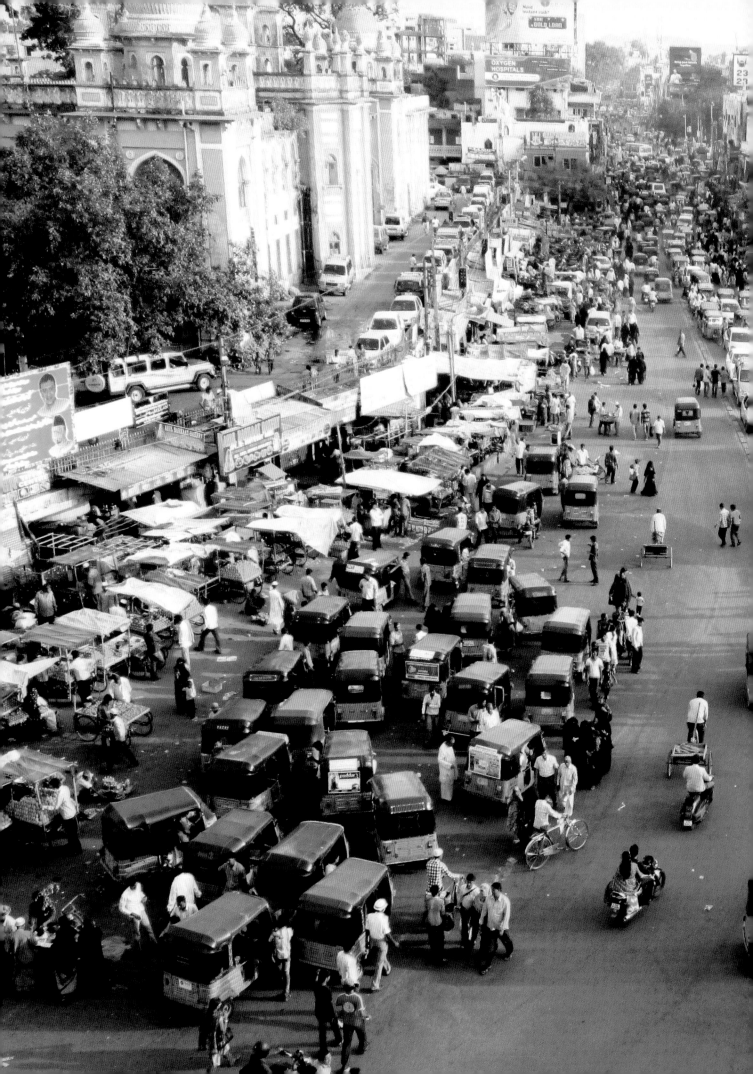

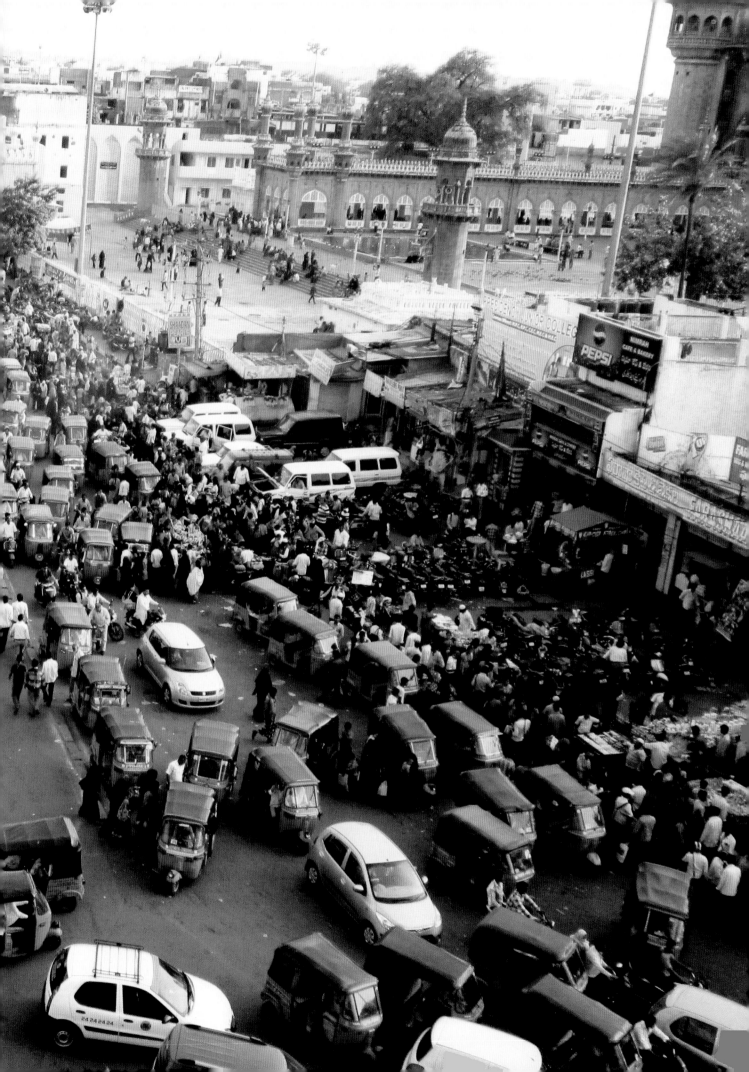

◀ Hyderabad, India, 15:15.
The auto-rickshaw is both a boon and a curse for traffic in Hyderabad. While it moves vast numbers of commuters, at times it keeps them immobile in traffic jams. Here, at the city's principal attraction, the Charminar, congestion is intense but somehow fluid. New auto-rickshaws run on compressed natural gas, but the old, black and yellow, two-stroke engines still run on petrol. Most can carry four passengers. *Photo: Ramakanth Venukanti.*

Berlin, Germany, 21:37.
Evening in Berlin. Construction workers have returned to their homes. *Photo: Anton Corbijn.*

Santa Cruz de Tenerife, Spain, 13:45.
"This is my office. Beige and grey. This is where I work every day. It tortures me, it puts me to sleep, it sustains me. Like a voyeur, I observe my colleagues from my desk." *Photo: Roberto Goya.*

Tunis, Tunisia, 14:15.
The new entrance for the Bardo National Museum in Tunis, the city's main collection of historical treasures. *Photo: Sameh Arfaoui.*

Minato, Japan, 22:30.
"This is the landscape I see on my daily commute home. In a city of artefacts, it looks as if the plants are intentionally illuminated by the street lamps."
Photo: Tetsuya Higashikawa.

Cape Town, South Africa, 12:36.
"The safest way to manage mail in Cape Town is to use a post office box." *Photo: Antonella Ragazzoni.*

Hannover, Germany, 18:45.
Everybody moved out of this building months ago. The plants were left to die. They have been removed, but their dry leaves remain.
Photo: Dietlinde Bamberger.

Accra, Ghana, 14:47.
"I helped coordinate a training
programme in management skills
for the Ghana branch of the company
I work for. After an intense morning,
we took a break and strolled down
to the beach, where Alex Ntale, who
is from Uganda, balanced on a rock.
When a wave surged in his direction,
he decided to save his polished
shoes and neatly ironed trousers."
Photo: Debra-Jane Nelson.

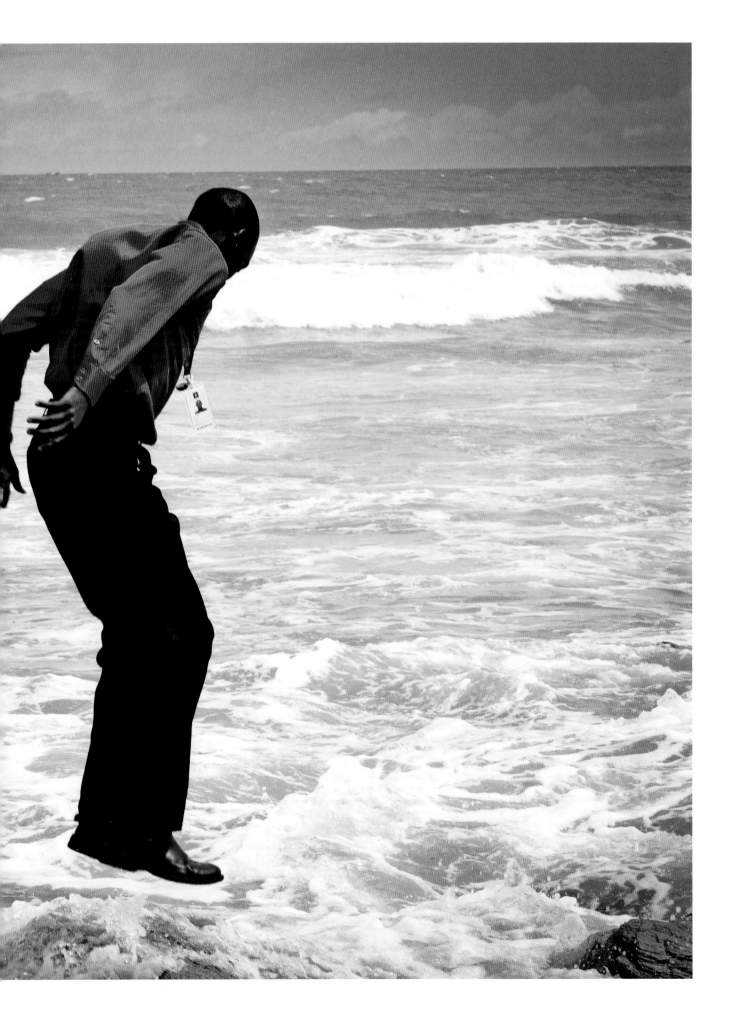

Bogotá, Colombia, 16:31.
Bus passengers in Bogotá's business
centre stare at the devastation where
a bomb has just exploded. Terrorists
were targeting former Colombian
interior minister Fernando Londoño
Hoyos, now a journalist. Two of his
bodyguards were killed, while he
and more than 30 other people were
wounded in the blast.
Photo: Fernando Vergara.

Stockholm, Sweden, 16:14.
"Me and my boyfriend Ludvig went out for a walk and laid down on a football field. He told me I should upload a picture of when we kissed each other, and so I did." The two, who are 18 and study sciences together at school, were best friends for two years before they started dating a month ago. Ludvig lives in Näsbypark, a Stockholm suburb.
Photo: Amanda Tolj.

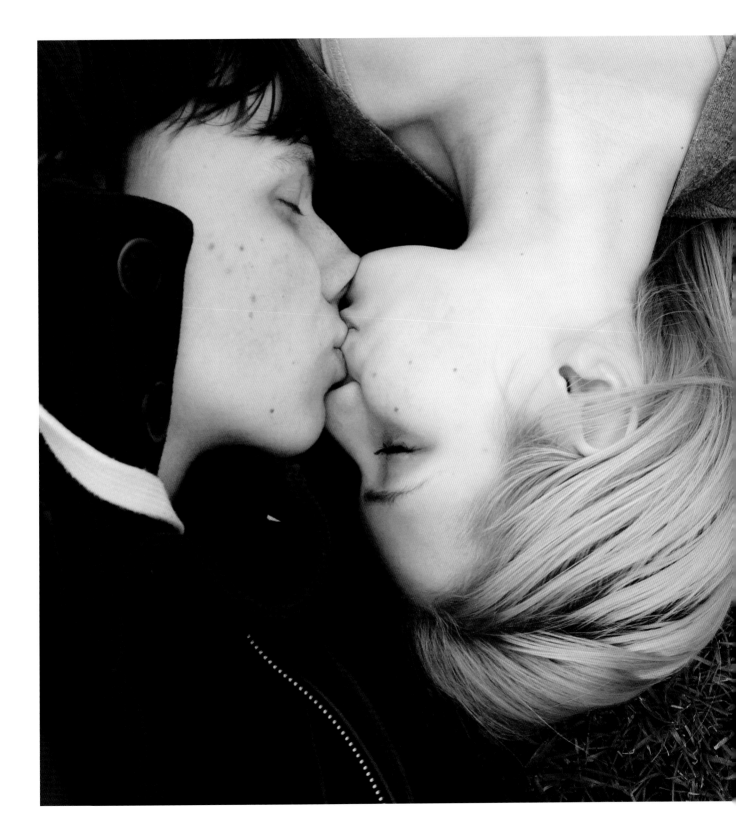

1. Fredericton, Canada, 11:15.
Baby feet – "heart of my heart".
Photo: Allison Taylor.
2. Papagayo, Puerto Rico, 09:41.
Winding down in the water.
Photo: Anders Erlandsson.
3. Sydney, Australia, 08:28.
Cinema carpet. *Photo: DJ Paine.*
4. Muang Phuket, Thailand, 13:30.
My son's feet.
Photo: Jackeline Ooijevaar.

5. Rydal, Pennsylvania, USA, 22:30.
The end of a long day.
Photo: Neil Bookman.
6. Brisbane, Australia, 07:15.
Shoes. *Photo: Eric Imbs.*
7. Porto, Portugal, 19:41.
Strawberry dress.
Photo: Beatriz Filipe.
8. Nottingham, UK, 17:15.
Bicycle shoes. *Photo: Chris Hill.*

9. Moscow, Russia, 23:34.
Sleeping feet. *Photo: Basil Furt.*
10. Richmond, Canada, 13:15.
Feet on the bathroom floor.
Photo: Leah Pirani.
11. Nantes, France, 14:00.
Tattooed legs. *Photo: Efe Zita.*
12. Messery, Rhône-Alpes,
France, 19:00.
Big shoes. *Photo: Pierre Vassellerie.*

13. Morayfield, Queensland,
Australia, 13:20.
New shoes. *Photo: Chris Robinson.*
14. Cali, Colombia, 22:45.
Slippers. *Photo: Juan Carlos Vargas.*
15. Singapore, 08:55.
Nail polish. *Photo: Lauren Beck.*

1.

2.

3.

4.

5.

6.

7.

8.

9.

10.

11.

12.

13.

14.

15.

1. Lisbon, Portugal, 17:30.
Legs. *Photo: Ana Silva.*
2. Kecskemét, Hungary, 13:45.
Feet in the sand. *Photo: Tivesz Pintér.*
3. Ottawa, Canada, 20:15.
Stained shoe. *Photo: Pauline Pilon.*
4. Singapore, 00:30.
A favourite place.
Photo: Stefanie Chan.

5. Bangkok, Thailand, 10:15.
Shower. *Photo: Hon Keong Soo.*
6. Várpalota, Hungary, 09:00.
Slippers. *Photo: Erika Váradi.*
7. Santiago, Chile, 19:08.
High heels. *Photo: Diego Candia.*
8. Sydney, Australia, 07:32.
Feet under blanket.
Photo: Tim Wimborne.

9. Burnaby, British Columbia,
Canada, 08:45.
Therapeutic exercise.
Photo: Heather Bould.
10. Lusaka, Zambia, 08:15.
Morning walk to work.
Photo: Miriam Nkhungulu.

11. Geneva, Switzerland, 06:00.
On crutches after hip surgery.
Photo: Kaisamaija Valimaki.
12. Bury, Lancashire, UK, 09:00.
Last trip to the doctor for the
all-clear. *Photo: Ian Butler.*
13. Bangkok, Thailand, 15:45.
Waiting for the train.
Photo: Hon Keong Soo.

1.

2.

3.

4.

5.

7.

8.

9.

6.

10.

11.

12.

13.

London, UK, 15:00.
City of London special constables shepherd a demonstrator from a clothes retailer, which is being targeted for allegedly avoiding paying taxes. The protesters had been putting "Occupy" stickers on clothes, cash registers and counters. The almost worldwide Occupy movement, protesting social and economic inequalities, is reacting to the 2007–2012 global financial crisis.
Photo: Darren Johnson.

◄ Ahmedabad, India, 14:30.
"Walking with my camera, I saw a barber inside a plastic hood cover – a small shop with a few shaving and hair-cutting implements. Many poor people in India live from hand to mouth, saving nothing. Every day is a challenge and a new start."
Photo: Umang Ojha.

London, UK, 17:45.
Liverpool Street station, thick with rush-hour commuters – some of the fifty-five million entries and exits the station experiences in a year. It's London's third biggest rail terminus.
Photo: Ciarán O'Gallagher.

Cape Town, South Africa, 12:24.
South Africa has one of the highest road accident fatality rates in the world. The most recent data reveals there were 13,802 fatalities in the previous year. The photographer recalls: "I took this shot through the window of the car as I was passing the scene. The emergency services had just arrived and a person was being treated on the ground. I don't know what happened and couldn't find a newspaper report later, though these incidents are quite frequent and don't make big news items."
Photo: Raphael Helman.

Johannesburg, South Africa, 19:30.
Watching his older brother play.
Photo: Jeanette Verster.

Tongli, China, 13:00.
Two by two.
Photo: Carolina Johansson.

Horta, Portugal, 16:39.
Shyness. *Photo: Marco Nascimento.*

284

◂ Rio de Janeiro, Brazil, 17:15.
Laurentia has lived in Copacabana
for 50 years after moving to Brazil
from Portugal when she was 21. For
40 years she and her husband have
run this Copacabana shoe repair
store, which they bought from
another Portuguese immigrant.
Photo: AC Junior.

Southampton, UK, 16:26.
"My lovely neighbour, Margaret Hill,
will be turning 90 soon. She lives on
her own, walks to the shops, does
her own meals and washing. She
sometimes sits on her porch so she
can watch people walk by. If you stop
to chat, she'll tell you she hasn't
spoken to anyone all day but that
she mustn't keep you."
Photo: Susan Dixon.

◄ Lod, Israel, 16:18.
Just released from his fifth term in prison, this man has been convicted of robberies and other small- to medium-scale crimes. A Bedouin from southern Israel, he moved to Lod many years ago. Located south of Tel Aviv, Lod has a mixed population of Jews and non-Jews, with long-neglected neighbourhoods where the crime rate remains high.
Photo: Nir Elias.

Kolkata, India, 17:34.
"Munto hails from Orissa and migrated to Kolkata in search of opportunity. He has been my aide for a long time and helps me in my work as a photojournalist. I keep saying, 'Quit smoking for the sake of your family'. One day, Munto may burn away just like the cigarettes he smokes, leaving behind scattered memories in the nooks and crannies of the metropolis."
Photo: Soham Gupta.

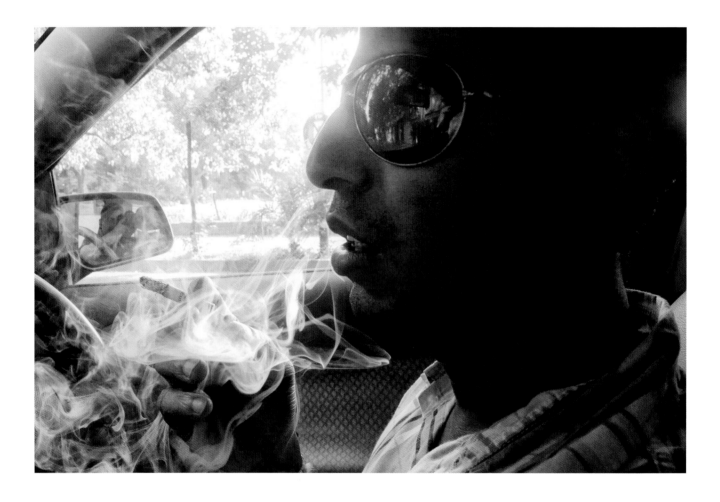

New York City, USA, 23:23.
"Brent got a weed delivery. Usually
how it works is you text your service,
then they call you back and someone
arrives with your order. Most times
you get it within the hour. Oh yes, the
quality is very good." This delivery
was made outside the Mercury
Lounge, a club with live music
located on the Lower East Side.
Photo: Eric T. White.

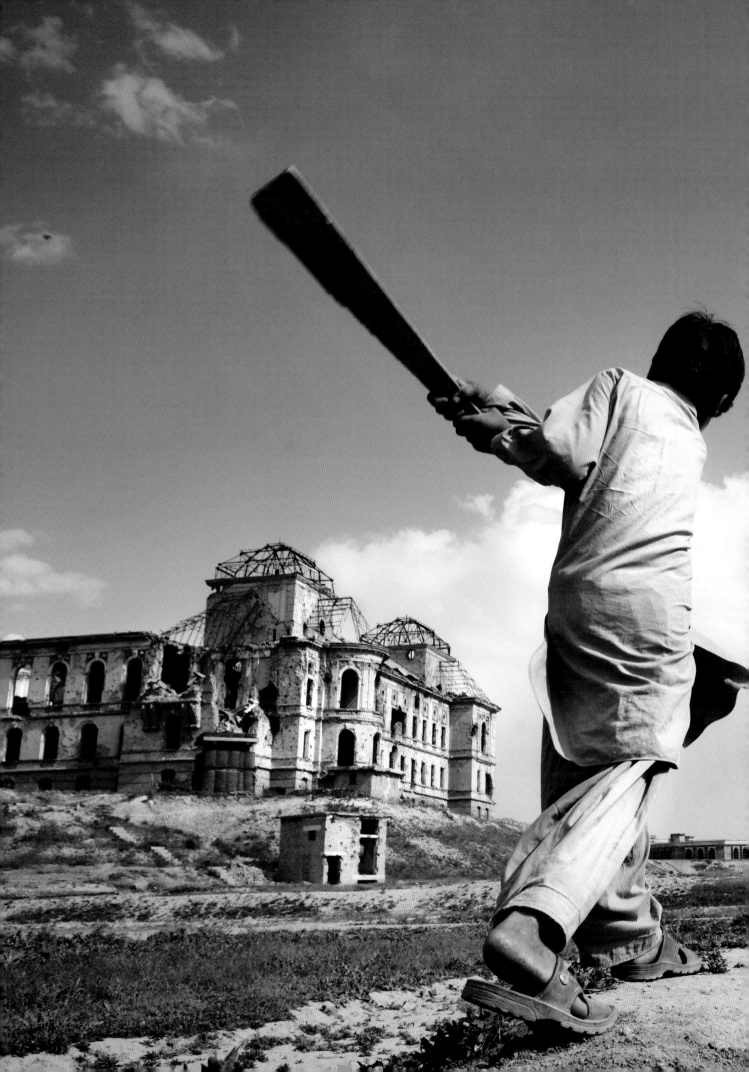

◄ New York City, USA, 15:55.
Big city commuters have their
unwritten codes of behaviour, most
of which seem to involve discon-
nection from their neighbours. More
than five million people every day
ride the subway in New York. On this
mid-afternoon train on Line 7, which
connects Queens with Manhattan,
there are meditators, text mes-
sengers and window-gazers. One of
the best-known sights on this line is
5 Pointz, a former warehouse that is
now divided into artist studios and is
decorated outside with famous and
novice graffiti art.
Photo: Q. Sakamaki.

Kabul, Afghanistan, 15:39.
Cricket practice in front of Kabul's
abandoned Darul Aman Palace,
built by King Amanullah Khan in the
1920s (Darul Aman means "Abode
of Peace"). British soldiers were
playing cricket in Afghanistan in
the mid-nineteenth century, but the
game became popular with Afghans
only in the 1990s when refugees from
Pakistan brought it back. Cricket
was the only sport permitted under
the Taliban regime. Afghanistan's
national team almost qualified for the
2011 World Cup.
Photo: Kuni Takahashi.

Hung Yen, Vietnam, 15:30.
Assembling trucks at the Truong Hai
Dongfeng factory.
Photo: Kham Nguyen.

Ukmerge, Lithuania, 17:30.
"The second floor of our house. The
builders are gone and my husband is
cleaning up the mess."
Photo: Asta Inciute.

London, UK, 15:13.
Excited Cub Scouts and Rainbows
(junior Girl Guides) wait in rain and
a sudden burst of painful hail to see
the United Kingdom's Queen Eliza-
beth II arrive to visit an exhibition in
Richmond Park, west London. In 2012
the queen is celebrating 60 years on
the throne.
Photo: Suzanne Plunkett.

Saratov, Russia, 16:45.
The youngest members of the
Saratov Ensemble rehearsing
Russian folk songs for a forthcoming
concert. They are playing single-row
accordions with two bells, called
Saratovskaya garmonicas after the
city. At the piano is the ensemble
director, Yevgeny Jarkin. The boys
are aged between five and seven
and have been playing for a year.
Photo: Yuri Mamulin.

Dublin, Ireland, 14:57.
Cormac O'Brien at the Science
Gallery to test himself as part of an
experiment to measure happiness.
Photo: Mary Robinson.

Pusan, South Korea, 19:45.
Skyscrapers loom over a rooftop
car park.
Photo: Kyunghee Lee.

Budapest, Hungary, 05:30.
"Every day I go to work next to this
building. It reminds me of the power
of nature."
Photo: Jànos Ott.

London, UK, 19:15.
With rush hour over, this walkway in
Canary Wharf in London's Docklands
is almost deserted.
Photo: John Angless.

◄ Haukadalur Valley, Iceland. 15:46.
The English word "geyser" comes
from Geysir, whose dormant pool
appears in the foreground. Sadly,
it stopped erupting regularly in the
early 1900s. These days, Strokkur
gets most of the attention, as it
reliably shoots boiling water some
70 feet (20m) into the air every four
to eight minutes.
Photo: Andreas Carlsson.

Chicago, USA, 16:15.
Crown Fountain consists of two tall
towers divided by a very shallow
pool, a low area of the patio where
the water from the fountain collects.
Each tower displays rotating video
images of giant faces of men, women
and children representing the cultural
diversity of Chicago. When the faces
disappear, water cascades down
the front of the towers. Occasionally
water spits from the faces' mouths.
The fountain was designed by Spanish
artist Jaume Piensa to encourage
interaction and play.
Photo: Stephen N. Garrett.

Paramaribo, Suriname, 08:15.
A porter bringing bananas to the
Waterkant Street market.
Photo: Ertugrul Kilic.

Kabul, Afghanistan, 06:30.
Women bringing home dried shrubs
to be used in cooking and as fuel.
Photo: Ismail Mohammad.

Hanoi, Vietnam, 09:45.
Long Bien wholesale market.
Bustling, despite Vietnam's slowing
economy. *Photo: Kham Nguyen.*

Malé, the Maldives, 16:45.
Immigrant workers in the building
industry. *Photo: Martin Whiteley.*

Kabul, Afghanistan, 17:45.
At a brick factory on the outskirts of
Kabul. *Photo: Omar Sobhani.*

Catalina, Peru, 10:30.
Lionel Messi, football hero, inspires a
workman in Peru. *Photo: Engui GZ.*

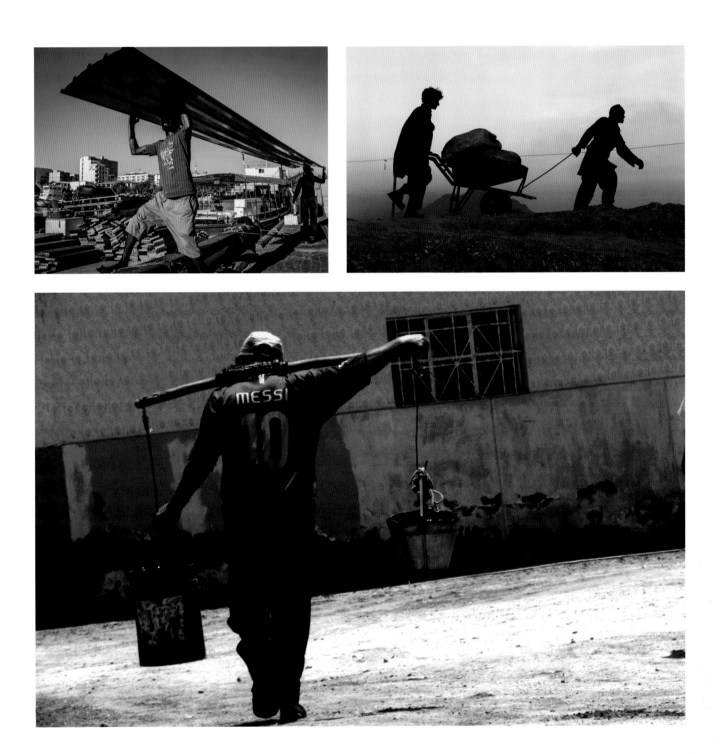

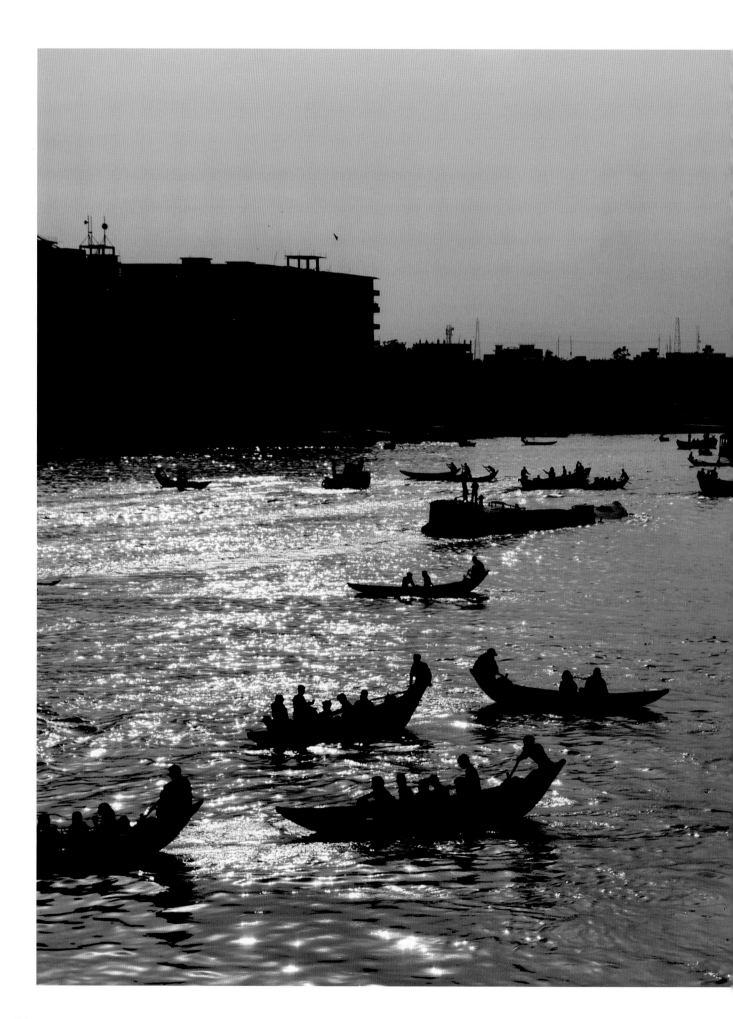

◄ Pyongyang, North Korea, 16:55.
A newly married couple pose for photographs with their families before the reception at the Kyonghung restaurant. Family connections are important. Marrying into a family that is out of favour with the ruling clique will automatically bring dishonour, implying future problems for education, housing and employment.
Photo: Kim Kwang Hyon.

Dhaka, Bangladesh, 16:51.
The port of Sadarghat, where small boats called *dingi* are crossing the River Buriganga. "There is a hidden story in the picture", explains the photographer. "The Buriganga has become so polluted that it is now dead – nothing lives in the water – and urbanization is causing the river to become narrower day by day. But the golden past may remain in our minds, through this picture. Someday, looking at this photograph, someone may say, 'Once there was a river named Buriganga...'"
Photo: Abu Saleh Mohammod Ziaul Hoque Raihan.

Florianópolis, Brazil, 16:16.
Dominoes doesn't get less serious
just because you're retired. These
dedicated players – under impartial
supervision – meet regularly near the
Catedral Metropolitana, one of the
city's most attractive buildings.
Photo: Caio Cezar Nascimento

Dakar, Senegal, 15:49.
"This street scene is from my
residential neighbourhood of
Fann Hock, which is close to the
University of Dakar but has become
run-down because of poverty and
youth unemployment. Housing is
difficult to find. These workers, who
are not from the area, are building
a five-storey block of offices and
apartments. The woman is from
nearby Cité Claudel district,
returning after a shopping trip."
Photo: Sylvain Cherkaoui.

◄ Beijing, China, 18:08.
A mass wedding in Beijing. A Chinese company treated 140 couples from the business to a Western-style wedding. The setting was St. Peter's Plaza at the city's Hotel Chateau Laffitte, a multi-million dollar copy of a French castle and a favourite venue for weddings. Copies of European architecture and even towns are not unusual in China, an economy second only to the United States but still a culture curious about European traditions. Near-perfect replicas exist of French, Dutch and Swedish streets – and an almost entire English village. Mass weddings are common in China, partly to offset cost. China also claimed a world record for marriages on a single day when more than 300,000 couples tied the knot on the opening day of the 2008 Olympics: 8 August. Eight is an auspicious number in China.
Photo: Rui Xia.

Huishui, China, 07:28.
In springtime, women of the Miao ethnic minority pick tea in Guizhou province, whose subtropical climate suits the plant, *Camellia sinensis* (*sinensis* meaning "from China" in Latin). Better teas are plucked by hand, using thumb and index finger to remove the tender top leaves. One story says that the first tea plants sprang from the eyelids of the fifth-century monk Bodhidharma, who, having arrived in China from India, tried to ensure that his eyes would never again close during meditation. His teachings gave rise to China's Ch'an school (known in Japan as Zen) and, according to legend, he trained the first Shaolin monks in their famous martial arts.
Photo: Ou Dongqu.

Vauvert, Languedoc-Roussillon,
France, 16:25.
Jean Clopes and his horse Phoulane
ploughing a vineyard in Domaine
Scamandre. Many vineyard owners
prefer this method over tractor
ploughing, which tends to pack the
soil too hard, and is unsuitable if the
vines are growing on a steep hillside.
Each row is worked in turn with two
different types of plough, one to cut
the soil, one to rake it.
Photo: Claes Löfgren.

Ponta do Sol, Cape Verde, 18:07.
Water is scarce in the Cape Verde
Islands off the west coast of Africa.
On the volcanic island of Santa
Antão, many have to fill their
plastic jugs from village pumps and
reservoirs. Hot and dry summers,
increased tree harvesting and the
growing number of tourists worsen
the situation. Up in the mountains,
people sometimes put up nets to
capture the moisture in fog and dew.
Photo: Finbarr O'Reilly.

◀◀ Geographic South Pole,
Antarctica, 16:58.
This shimmering aurora is over the
ICL, or IceCube Lab. IceCube is a
huge neutrino detector (1 cubic kilo-
metre in size) that looks deep into the
ice to detect neutrinos from space
interacting. The hope is that this may
reveal more about our universe. Sven
commutes on foot from the Amund-
sen–Scott South Pole Station less
than a mile away. "It is normally too
cold to use any vehicles", says Sven.
"That day it was minus 60 degrees C
on average. The landscape is very flat
but the wind creates big *sastrugis*,
or snow 'waves', so it reminds me of
being out on the ocean. Because the
night is six months long at the South
Pole, the only natural light comes
from the moon and auroras. We are
getting closer to a solar maximum
and we see more – and nicer, bigger –
auroras than average."
Photo: Sven Lidström.

◀ Over Baja California, 15:58
(21:58 GMT/UTC).
The International Space Station
(ISS) appears to have Earth – about
220 miles (355km) away – as a tem-
porary ceiling. Inside the spacecraft,
without gravity to impose itself,
the astronauts had to designate an
arbitrary ceiling and floor. Outside,
to the left, is a Japanese robot arm
construction for maintenance. Two
cooling panels point homewards to
Earth while the large solar panels
soak up energy. The ISS orbits Earth
16 times every 24 hours.
Photo: André Kuipers.

Fort Langley, British Columbia,
Canada, 19:00.
"Looks like a lot of food for two adults
(me and my mum) and one child
(my nine-year-old son). We eat mostly
vegan/vegetarian when at home.
When we're away, all rules are gone."
Photo: Amie Stafford.

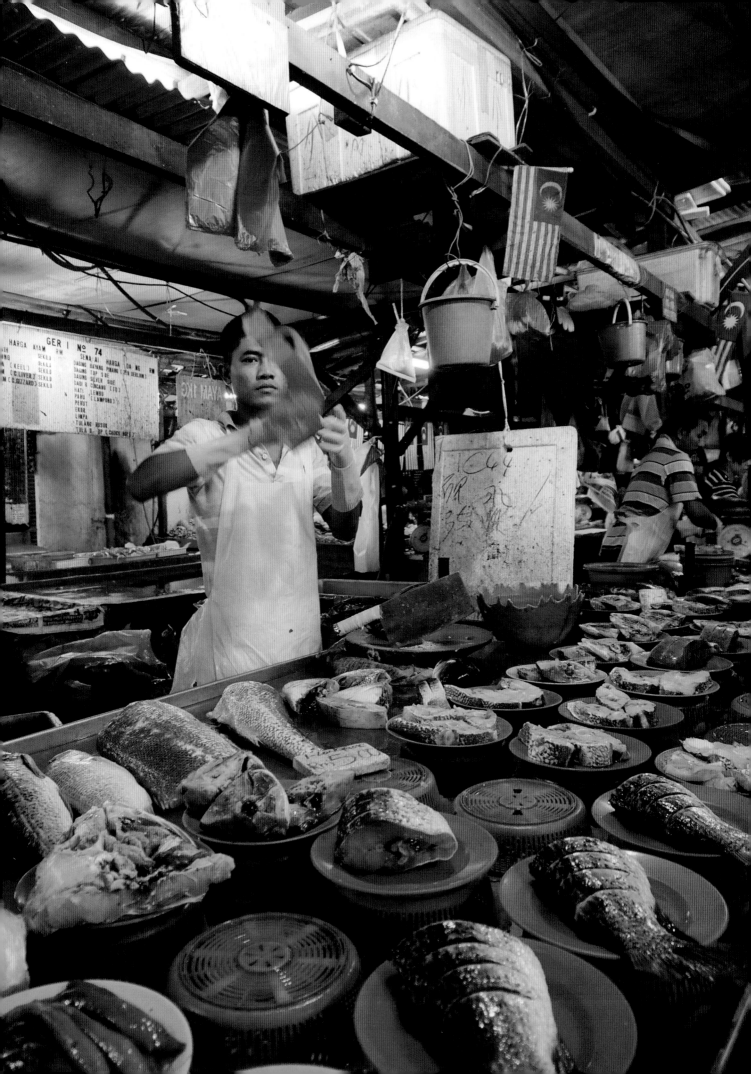

Kuala Lumpur, Malaysia, 10:01.
Fresh fish on sale at the city's Chow
Kit market. *Photo: Suzailan Shoroyo.*

Hanoi, Vietnam, 11:30.
A portable shop and its proprietor in
Hanoi. *Photo: Nam Long Nguyen.*

Ybycui, Paraguay, 11:30.
A load of stevia plants, a Paraguyan
plant that is 400 times sweeter than
sugar. *Photo: Margarita Duarte.*

Fugong, China, 15:30.
A woman from the Lisu ethnic
minority in Yunnan, on her way
home with young rice plants to be
replanted elsewhere.
Photo: Yereth Jansen.

Nîmes, Languedoc-Roussillon,
France, 05:45.
As protection against mildew,
Costières de Nîmes winemaker
Yvon Gentes sprays his vines with
environmentally friendly copper
sulphate. *Photo: Claes Löfgren.*

Molina, Chile, 11:07.
An agricultural student harvesting
grapes for wine.
Photo: Guillermo Vergara.

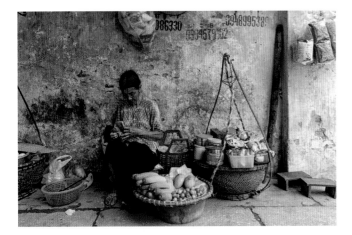

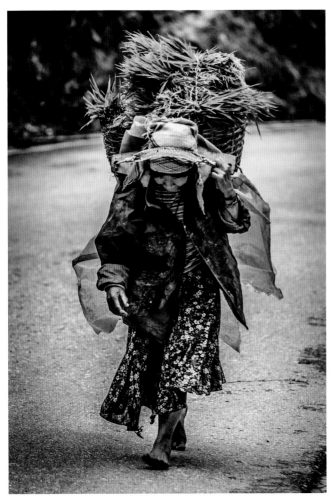

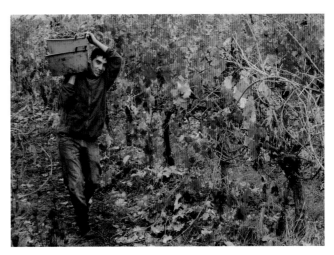

1. Irish Sea, UK, 12:00.
Vegetarian airplane food.
Photo: Robert Harding Pittman.
2. Chongqing, China, 19:29.
My dinner. *Photo: Ying Zhang.*
3. Moscow, Russia, 08:08.
Fried eggs. *Photo: Maria Petrova.*
4. Sliema, Malta, 17:15.
Freshly picked lemons.
Photo: Katarina Lennmarker.

5. Wentworthville, New South Wales,
Australia, 19:06.
Roasted pumpkin.
Photo: Bronwynn Rhodes.
6. Johor Bahru, Malaysia, 13:00.
Fresh meat at the supermarket.
Photo: Boon Kua.
7. Dhaka, Bangladesh, 02:37.
In the middle of the night.
Photo: Noor Ahmed Gelal.

8. Toamasina, Madagascar, 12:30.
Two students eating lunch.
Photo: Colin Radford.
9. Spokane Valley, Washington,
USA, 20:39.
Cooking bacon! *Photo: Thomas Riley.*
10. Lisbon, Portugal, 13:45.
Lunch with my family.
Photo: Pedro Pinheiro.

11. Dhaka, Bangladesh, 10:15.
Preparing cake.
Photo: Mohammad Anisul Hoque.
12. New Mexico, USA, 18:00.
Strawberry shortcake.
Photo: Art Zest.
13. Curridabat, Costa Rica, 18:55.
Breakfast with fruit and coffee.
Photo: José Pablo Porras Monge.

1.
2.
3.
4.
5.
6.
7.
8.
9.
10.
11.
12.
13.

1. Keelung, Taiwan, 20:07.
Ru Rou Fan. *Photo: Johnson Ng.*
2. Porto, Portugal, 17:26.
Beans.
Photo: Manuela Matos Monteiro.
3. La Paz, Bolivia, 13:10.
Selling in the street.
Photo: Claudia Dorado Sánchez.

4. Petaling Jaya, Malaysia, 12:45.
Lunch at work. *Photo: Clara Soon.*
5. Helsinki, Finland, 09:23.
Breakfast. *Photo: Tuuli Holttinen.*
6. Amsterdam, the Netherlands, 18:30.
Soup. *Photo: Femke van der Valk.*
7. Ipoh, Malaysia, 17:58.
First meal of the trip.
Photo: Tang Wai Yung.

8. Boulogne-Billancourt, France, 07:15.
Good breakfast. *Photo: Ferit Düzyol.*
9. Kathmandu, Nepal, 10:05.
Salad for lunch. *Photo: Nabin Baral.*
10. Toronto, Canada, 19:30.
Korean stew. *Photo: Jessica Wilczak.*
11. Malmö, Sweden, 15:00.
My daily dose of pills.
Photo: Petra Li Larsson.

12. Frankfurt am Main,
Germany, 14:26.
Lunchtime.
Photo: Tiago Loureiro.
13. Sant'Angelo Lodigiano,
Italy, 12:30.
Trash can be art.
Photo: Simona Malattia.

1.

2.

3.

4.

5.

6.

7.

8.

9.

10.

11.

12.

13.

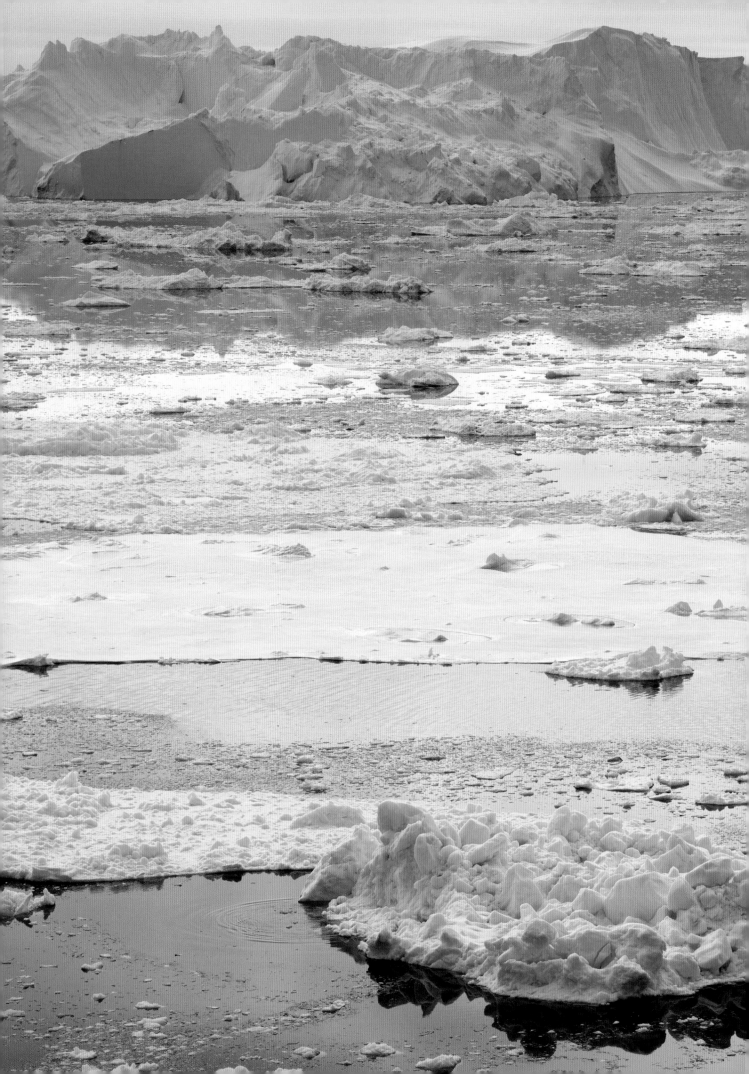

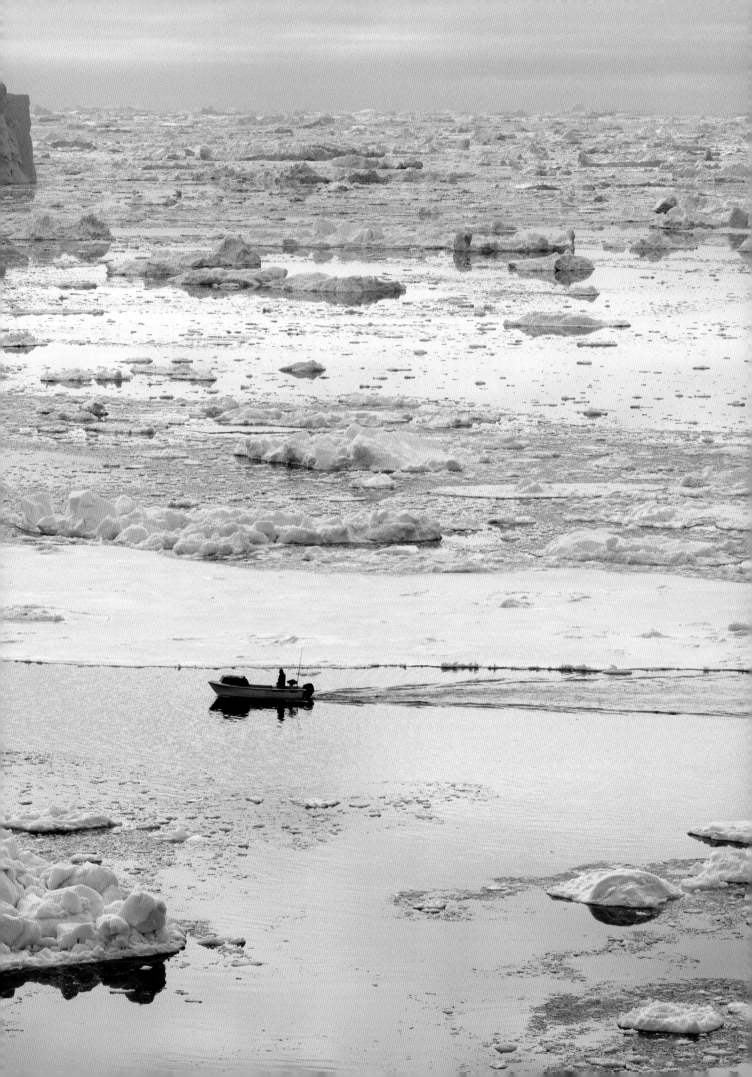

◂ Disko Bay, Greenland, 15:37.
Nowhere in the world are glaciers
spawning icebergs as fast as in Disko
Bay on the west coast of Greenland.
This Inuit fisherman in a plastic-
hulled boat, longline fishing for
Greenland halibut, must beware
of icebergs rushing out of Ilulissat
Fjord. The catch goes to the two
packing factories in Ilulissat, a
coastal town about 125 miles (200km)
north of the Polar Circle with 5,000
inhabitants and as many sledge dogs.
The town's name means "iceberg" in
Greenlandic (Eskimo–Aleut).
Photo: Hans Strand.

Miami Beach, Florida, USA, 17:05.
"When I took this photo, I was five
days past due in my pregnancy. The
scene seemed to hold such mystery,
because the woman was fully dressed
and looking out to the horizon. She
told me that the tattoos on her back
– Solomon and Isaiah – are the
names of her future children."
Photo: Kristen Ashburn.

Braga, Portugal, 17:08.
Natalia Rocha is a self-employed dentist. She is eight months pregnant but needs to work until the last possible day to get paid. She is relaxing with a joke after a patient's treatment.
Photo: Tommaso Rada.

Siófok, Hungary, 01:15.
"My colleague, Istvan, doing maintenance on a cutting machine."
Photo: Sándor Végh.

Algiers, Algeria, 09:30.
An apprentice in the old Kasbah learning to carve wood.
Photo: Zohra Bensemra.

Brogueria, Portugal, 02:45.
Paulo Dinis dusts his bread with flour before baking.
Photo: Henrique Calvet.

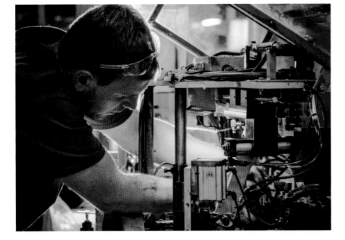

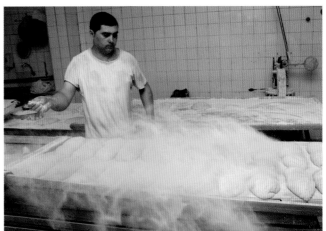

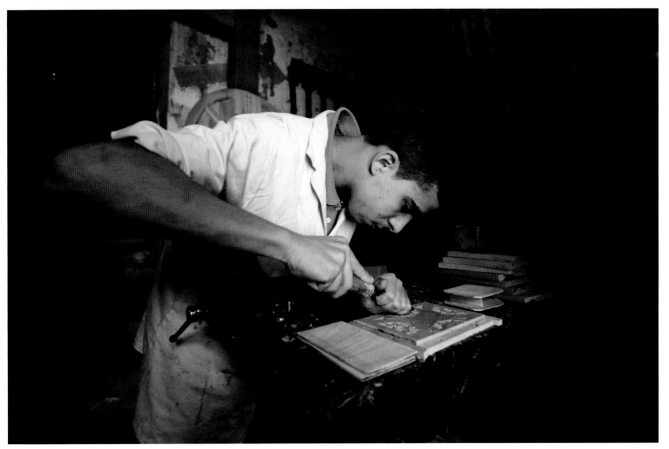

Geographic South Pole, Antarctica, 17:16.
In the IceCube laboratory, hundreds of computers collect data from 5,400 detectors in the ice.
Photo: Sven Lidström.

Dhaka, Bangladesh, 16:14.
A workday with no breaks. One preferred way to renew energy is with yet another cigarette.
Photo: Rozer Gomes.

Pietà, Malta, 16:30.
Policeman Kurt Bugeja Coster tries to put out a grass fire in a pine plantation outside Valletta.
Photo: Darrin Zammit Lupi.

Waterford, Ireland, 10:13.
Bike stunts. *Photo: David Clynch.*

Beijing, China, 19:40.
Pensioners dance in the park.
Photo: Yi Xiao.

Dakar, Senegal, 16:30.
Mbaké and "Little Joe", both six
years old, practise Senegalese
wrestling, one of the country's most
popular sports. To win, one boy must
knock the other off his feet or onto
all fours.
Photo: Sylvain Cherkaoui.

El Tunco, El Salvador, 17:45.
Surfing on the Pacific Ocean at
El Sunzal beach, one of the region's
best spots for riding the waves.
Photo: Francisco Garay.

Paris, France, 18:15.
"The man who stole the show",
near the basilica of Sacré-Coeur.
Photo: Marie Cloupet.

Vyshgorod, Ukraine, 16:00.
Hitting tennis balls against a
wall at an elementary school.
Photo: Constantin Brejak.

Uppsala, Sweden, 17:00.
A new mobile coffee shop in town.
Only five other countries in the world
drink more coffee per capita than
Sweden – they are the other four
Nordic countries (Iceland, Finland,
Norway, Denmark) and the
Netherlands.
Photo: Anders F. Eriksson.

New Delhi, India, 17:00.
"This entrepreneur, Bittoo, has a
team of photographers around the
park taking pictures of people. Under
the shade of a tree, Bittoo has set up
a number of photo printers connected
to car batteries. A camera is linked to
a printer via USB and – voilà! – within
minutes a beautiful colour print
emerges. So innovative!"
Photo: Fatima Pais.

Rio de Janeiro, Brazil, 16:13.
Work can wait. In mid-afternoon,
two office workers find space to
weave and sway amid the clutter
of files, shelves and tables.
Photo: Ana Cláudia Rohloff.

◄ Ulan Bator, Mongolia, 17:06.
"I pop by the office of *AVSF*, or
Agronomists and Veterinarians
Without Borders, a French NGO for
whom I do voluntary photographic
assignments. I really appreciate
their work with nomadic herders.
This is Mongo, their interpreter, at
her desk, with a mighty fine view of
downtown Ulan Bator."
Photo: Pearly Jacob.

Casablanca, Morocco, 17:15.
Playing football on their way to the
beach, with the country's largest
mosque – the Hassan II – as their
backdrop.
Photo: Leila Ghandi.

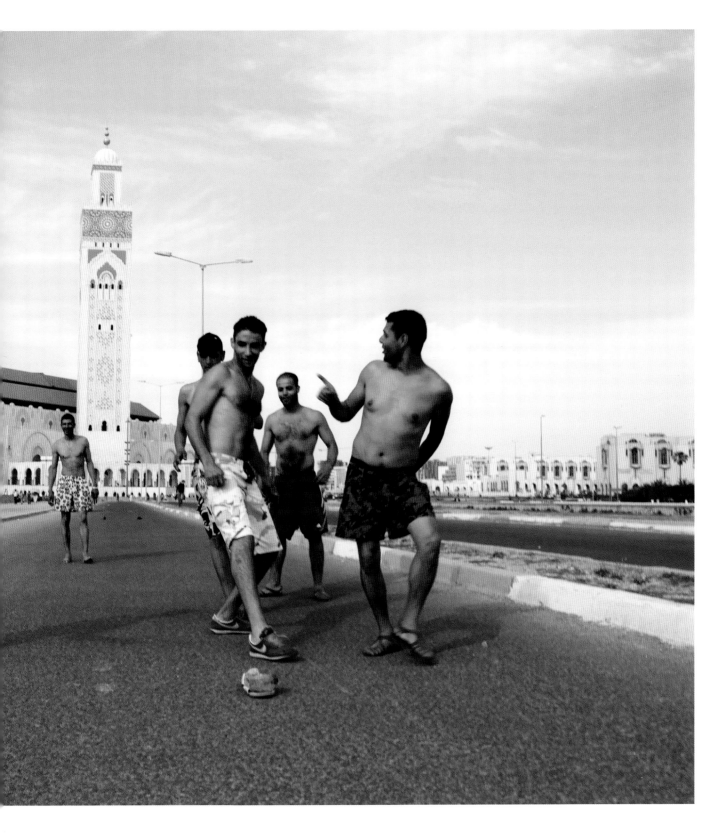

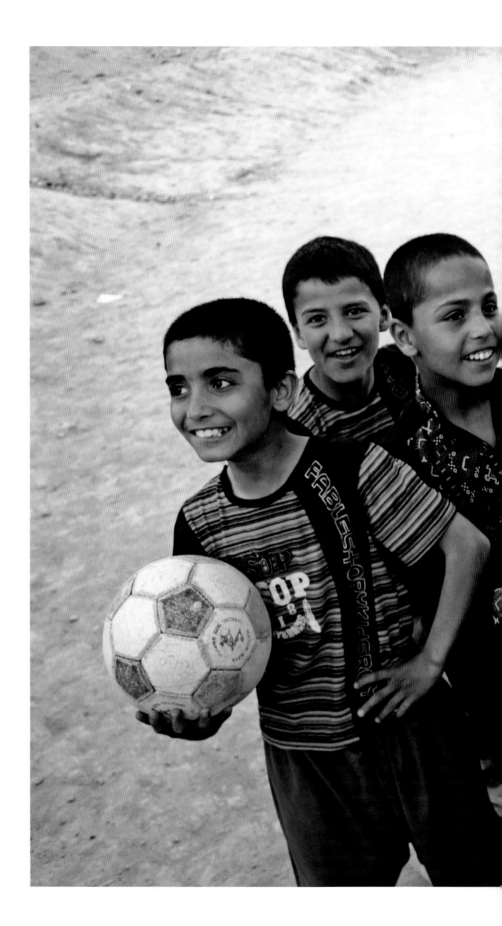

Kabul, Afghanistan, 18:15.
"In a poor part of Kabul, some boys
were playing soccer. I showed them
my magnifier and they got excited.
I realized that we can make people
happy anywhere, using anything."
Photo: Ali Zare.

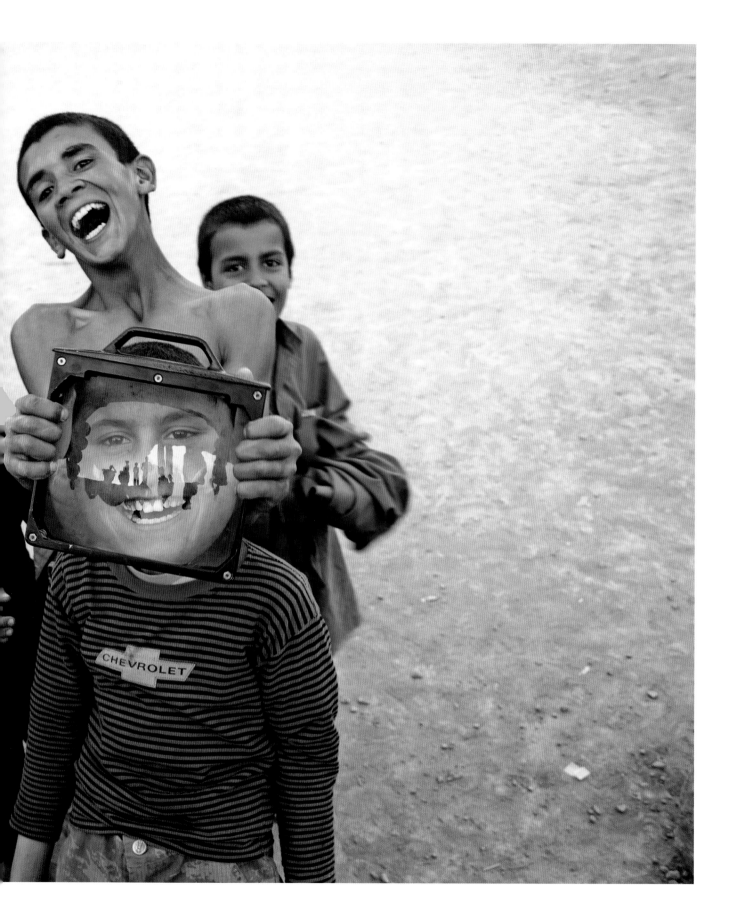

Los Angeles, USA, 21:24.
"I had to travel to LA and got back late to my room at the Hilton Garden Inn. This self-portrait came together as I was trying to show how I felt – away from home, tired and alone. I'm holding the camera trigger in one hand. In my other hand is the light meter, like a pretend TV remote."
Photo: Ben Reeve.

Cologne, Germany, 17:31.
With central Cologne bathing in afternoon sun, an old man slips into the Rex am Ring cinema to watch the vampire comedy "Dark Shadows" all alone. The cinema was built in 1927 and is the city's oldest but now also shows 3D movies.
Photo: T. Fitzler.

Lisbon, Portugal, 22:41.
"Bruno has been in his workspace
for days, painting."
Photo: Rita Delille.

Porto, Portugal, 10:00.
Crutches lean on a wall while
their user, an old woman, is visiting
her doctor.
Photo: José Pedro Limão.

Medan, Indonesia, 18:06.
"My mother is making a dress
for her sister."
Photo: Samson Ariel Salim.

Dhaka, Bangladesh, 15:59.
"People working in a smoky,
unhealthy place. Metalworking
provides them with food, shelter
and more, but at the same time it
takes away the beautiful essence
of their lives."
Photo: Rozer Gomes.

London, UK, 13:56.
"These are the lovely, shiny tools I use at work in my role as an anatomical pathology technologist."
Photo: Zoe Rutherford.

Meinedo, Portugal, 20:15.
"Something came loose in my car. All I had to fix it with was my trusty knife and a piece of plastic string. It worked like a charm!"
Photo: Tiago Pereira.

Puebla, Mexico, 13:15.
In Mexico, 15 May is Teachers' Day and a public holiday. In Puebla, demonstrators gathered to protest against the government. "I found this street photographer, looking like a lost tourist searching for a souvenir photo."
Photo: Juan Salvador Fernández Tamayo.

Caparica, Portugal, 17:30.
Someone's mouth is waiting for these dentures to be completed.
Photo: Leandro Guardado.

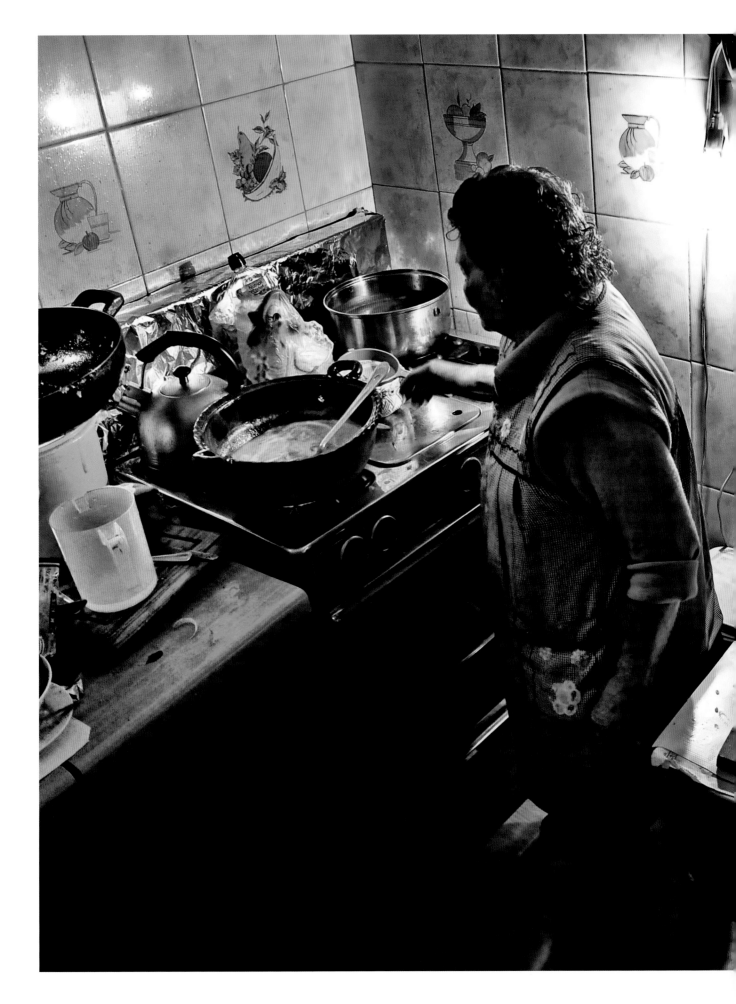

Mexico City, Mexico, 16:35.
Delicious aromas fill the kitchen
as Rufina García García, age 86,
cooks *chilaquiles*, a dish made with
tortillas, tomatoes, *epazote* herb
and onions. She is the photographer's
grandmother. "In Mexico, it is
common to see older ladies go
shopping at the markets and return
home to cook, sharing or selling
their secret flavours to everyone
who passes by."
Photo: Carlos Omar Rosas García.

1. Merzouga, Morocco, 18:00.
Camels in the Sahara Desert.
Photo: Tiago Costa.
2. Dublin, Ireland, 21:30.
Dessert after dinner. *Lin Lee.*
3. Lisbon, Portugal, 13:30.
Rest and recharge. *Claudia Andrade.*
4. Niort, Deux-Sèvres, France, 18:45.
My friend's daughters' room.
Eric Chauvet.
5. Isfahan, Iran, 22:45.
My dinner. *Ehsan Amini.*
6. Porlamar, Venezuela, 16:00.
Playing a *cuatro. Ricardo Gomez-Perez.*
7. Haarlem, the Netherlands, 18:30.
A female commuter. *Maarten Koets.*
8. Ikgomotseng, South Africa, 17:23.
Windmill and water tank. *David Larsen.*

9. Brighton, UK, 13:30.
Tuesday cake shopping. *Leila Grayling.*
10. Milan, Italy, 15:08.
Maggie. *Chiara Oggioni Tiepolo.*
11. Edinburgh, UK, 16:15.
Chloe and her pet rat. *Lynne Jefferies.*
12. Singapore, 23:48.
Airport trolley. *Cassandre Stapfer.*
13. Kingsbridge, Devon, UK, 18:45.
Bedtime. *Michelle McQuinn Farrand.*
14. London, UK, 17:15.
Busy escalator. *Gayle Gander.*
15. Catherine Hill Bay, New South
Wales, Australia, 12:45.
The wave. *Rachel Pether.*
16. Amsterdam Muiderpoort, the
Netherlands, 14:15.
Amazing clouds. *Marleen Huijing.*

17. Haarlem, the Netherlands, 18:32.
Bicycle stairs. *Maarten Koets.*
18. Boshof, South Africa, 15:22.
Harnessing the horses. *David Larsen.*
19. Tehran, Iran, 15:00.
Emptiness in Golestān Palace.
Mehdi Teimory.
20. Udine, Italy, 19:00.
Pavement shadow. *Paolo Agati.*
21. Fredriksberg, Denmark, 19:34.
A bath for a digger. *Tilde Wolffbrandt.*
22. Budapest, Hungary, 13:30.
Cables and clouds. *Bence Ferenczi.*
23. London, UK, 13:00.
The Strand after showers. *Ben Smith.*
24. Moscow, Russia, 22:45.
Bright lights of the theatre.
Anastasia Mitina.

25. Koh Samet, Thailand, 16:14.
Exotic Beaumontia murtonii.
Gustav Lidén.
26. Porlamar, Venezuela, 16:00.
Stretching by the seaside.
Ricardo Gomez-Perez.
27. Marseilles, France, 12:00.
The flag of Europe. *Loraine Falconetti.*
28. Athens, Greece, 20:45.
Wheels mean freedom.
Grigoris Iosifellis.
29. Rome, Italy, 20:10.
Bedtime stories. *Giovanni Del Brenna.*
30. Singapore, 19:12.
Contentment. *Cassandre Stapfer.*

1. 2. 3. 4. 5. 6.
7. 8. 9. 10.
11. 12. 13. 14. 15.
16. 17. 18. 19. 20. 21.
22. 23. 24. 25.
26. 27. 28. 29. 30.

1. Amsterdam, the Netherlands, 13:46. World Press Photo Exhibition, Oude Kerk. *Maarten Koets.*
2. Elsinore, Denmark, 18:38. Dinner on our balcony. *Pernille Helsted.*
3. Merzouga, Morocco, 13:00. Sahara travel leader. *Tiago Costa.*
4. Singapore, Singapore, 17:45. Boots on the go. *Cassandre Stapfer.*
5. Mexico City, Mexico, 11:00. My office view. *Mario González.*
6. Melbourne, Australia, 13:15. Luca's play tunnel. *Remedios Linden.*
7. Warsaw, Poland, 14:43. Plac Wilsona station. *Piotr Turecki.*
8. Rome, Italy, 18:41. We love pasta. *Giovanni Del Brenna.*
9. Athens, Greece, 20:30. Staring at you. *Grigoris Iosifellis.*

10. Selangor, Malaysia, 13:15. Lunch often means "15-minute food". *Mohd Shahrul Azmani Mohd Appandi.*
11. Porto Salvo, Portugal, 22:18. Our first anniversary. *Goncalo Vieira.*
12. Milan, Italy, 13:00. Commute. *Alberto Giuliani.*
13. New York City, 23:45. My wife checking her email before bed. *Lash Ryan.*
14. Lisbon, Portugal, 20:00. Benfica, one of Lisbon's many neighbourhoods. *Joao Nicolau.*
15. Krakow, Poland, 14:30. An umbrella can make a rainy day look brighter. *Jake Williams.*
16. Singapore, 18:50. Young couple boxing on the rooftop. *Cassandre Stapfer.*

17. Karachi, Pakistan, 23:51. I was thinking of my dad and how his last days were filled with medicine. *Raheel Lakhani.*
18. Hong Kong, China, 13:00. Lunch break at Terminal 4. *Kevin Leung.*
19. Budapest, Hungary, 18:00. A climbing wall. *Peter Szatmari.*
20. Dresden, Germany, 20:09. On my way to an indoor swimming pool. *Anne-Kathrin Gericke.*
21. Lisbon, Portugal, 17:45. Mother and daughter sunbathing. *Goncalo Vieira.*
22. Franca, Brazil, 15:45. A cold and rainy day. *Bruno Camargo.*
23. Richmond, British Columbia, Canada, 20:00.

My son running at the dyke during sunset. *Andy Tam.*
24. Sydney, Australia, 17:15. Evening commuters heading home. *Kate Walton.*
25. Ampang, Malaysia, 12:00. Hammy – the youngest of our eight cats. *Darna Aminuddin.*
26. London, UK, 18:13. Regent's Canal. *Media Eghbal.*
27. Istanbul, Turkey, 17:00. A grey view from the meeting room. *Sinem Özmen.*
28. Birmingham, UK, 17:45. Broad Street. *James Ridgway.*
29. Tehran, Iran, 12:00. The Supreme Leader. *Mehdi Teimory.*
30. Hong Kong, China, 19:00. End of the road. *Kevin Leung.*

1. 2. 3. 4.
5. 6. 7. 8. 9.
10. 11. 12. 13. 14. 15.
20. 21. 22. 23. 24.
25. 26. 27. 28. 29. 30.

16. 17. 18. 19.

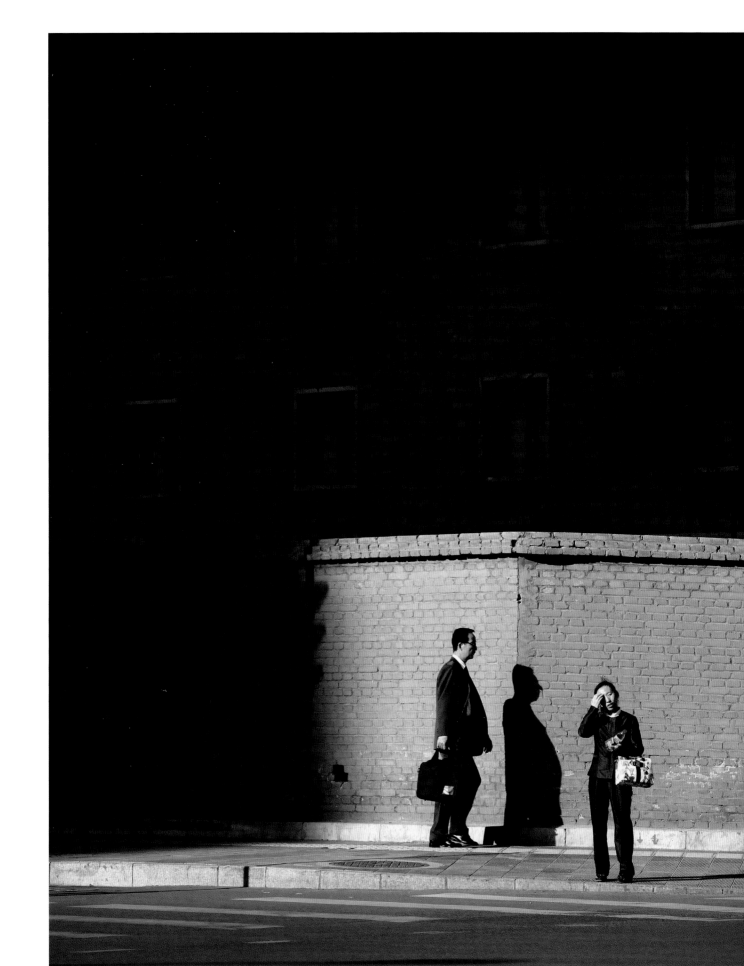

Beijing, China, 16:58.
Here, a woman waits for the light
to change at the intersection of You
Fang and Xirong Xian, two *hutongs*
(alleys), as the traditional streets
of Beijing are called. Although the
name *hutong* remains in use, most
of the old narrow alleyways of Beijing
have given way to busy, modern
thoroughfares.
Photo: David Gray.

Tampa, Florida, USA, 16:49.
"My wife Cynthia Ann has suffered from depression for the past 30 years, and she sleeps on the living-room couch for days at a time. Medications, counselling and regular visits to the psychiatrist are part of her routine." According to recent studies, nearly thirty million Americans take anti-depressants.
Photo: Raul E. Sanchez.

Nesodden, Norway, 15:30.
"Ellen, Linn and my son Milo started screaming and yelling at something they saw inside the playhouse at their schoolyard. When I went over to see what the noise was about, they showed me a spider. It was not quite as big as one would have thought – maybe 1 centimetre. A normal, generic Norwegian spider. There are no poisonous spiders in Norway."
Photo: Jonas Bendiksen.

Moorefield, Ontario, Canada, 17:10.
"Today is my nephew Hayden's ninth birthday. Free to roam around his grandparents' organic farm and go wherever his curiosity takes him, he has just been checking the tank where the cows get their drinking water. Here Hayden slips under the live electric fence, which keeps the 70 cows from escaping the pasture where they feed in spring and summer. If he touches the fence, it would not do any harm but would feel really uncomfortable."
Photo: Elske deGroot.

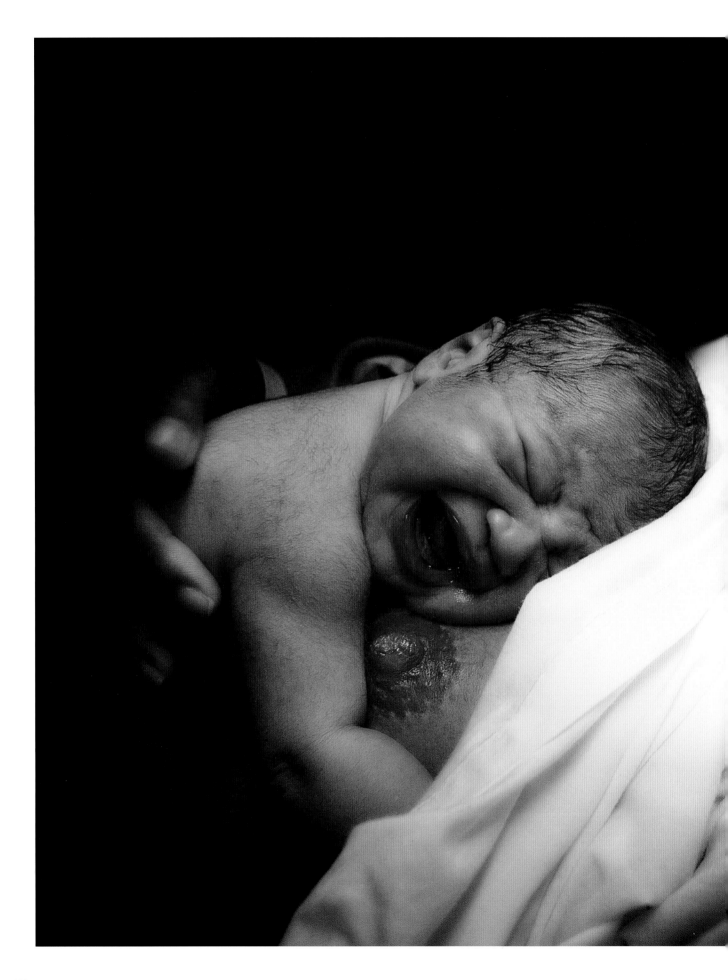

San Fernando City,
the Philippines, 17:15.
Rhea Monis cradles her first child,
a boy, moments after giving birth
at the Lorma Medical Center in
northwestern Luzon – the first of four
deliveries that day. The obstetrician
had detected the baby's heart rate
decreasing with every contraction
and elected for emergency surgery.
It was a good call, because the umbili-
cal cord had become wrapped around
the baby's neck. Eye surgeon Rey
Espinueva witnessed the dramatic
moment: "I was just finished with my
operation in the adjacent room when
I saw through the glass window that
an expectant mother was about to
undergo Caesarian Section. I then
asked the expectant mother permis-
sion to take her photos while the
procedure was ongoing." Mum called
her son Giordie Monis.
Photo: Rey Espinueva.

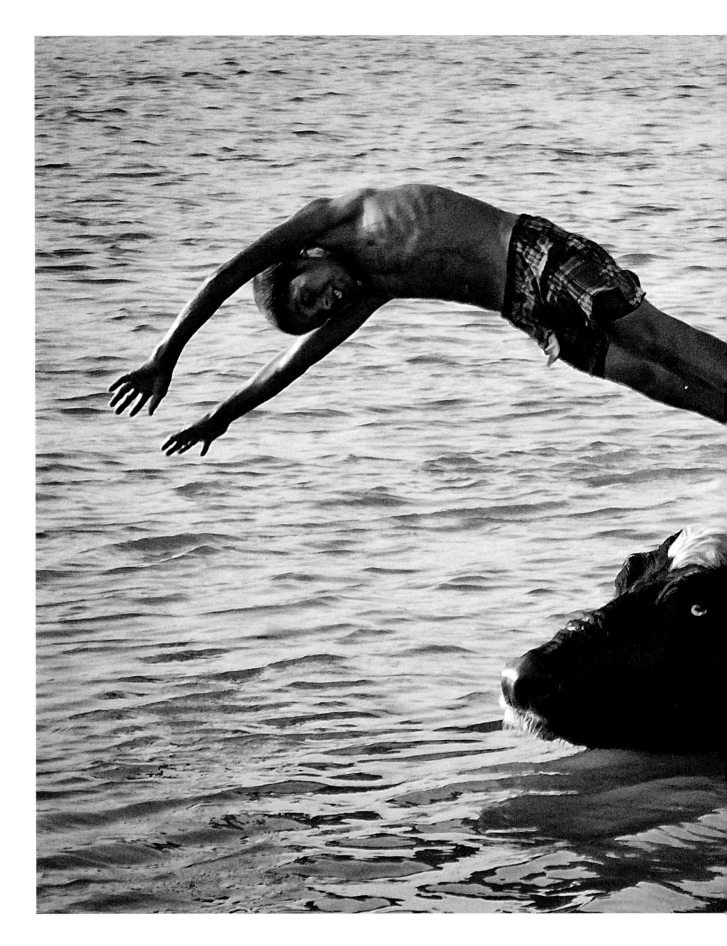

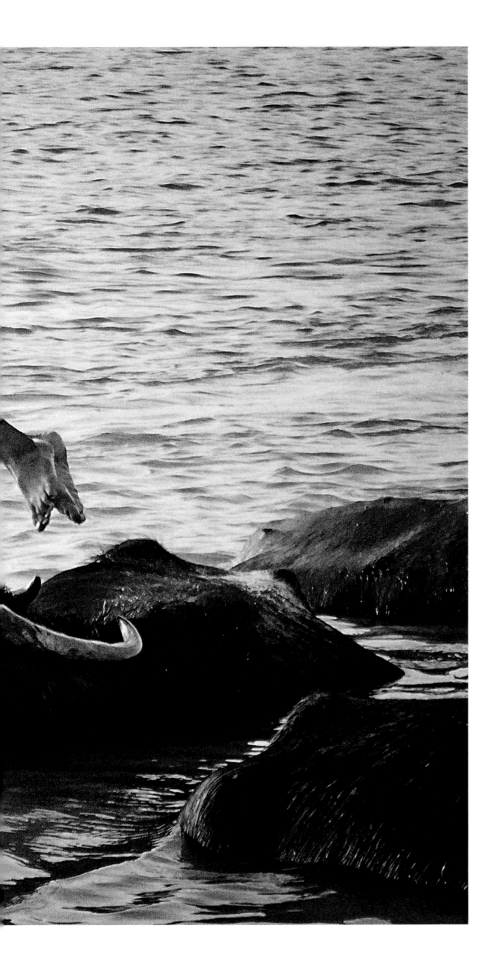

Ahvaz, Iran, 17:15.
What to do when you want to dive into the River Karun and there is no rock or jetty handy? One solution is to climb onto the back of a water buffalo. In the long summers in Ahvaz in southwestern Iran, the temperature can hover at 46 degrees C for more than a month. Together with Kuwait City, Ahvaz is the hottest city in the world. The photographer recalls: "I think the boy's name was Ghasem or Reza, I'm not sure. These 'cowboys' are poor people and they come to the river with their animals to escape the heat and play in the water."
Photo: Mehran Hamrahi.

Calgary, Alberta, Canada, 17:19.
"My six-year-old daughter Jenna
spends every waking moment on our
trampoline, except when we pack it
away in the dead of winter. This was
one of the first warm days of spring,
and we were out in our backyard
after school enjoying the beautiful
weather. I took the photo because
I was amazed how her tricks had
improved since last season."
Photo: Karen Williams.

Malé, the Maldives, 17:27.
A migrant Bangladeshi labourer
grabs a much-needed and well-
deserved five minutes of rest, using
the time to text a friend. Private
space is rare in Malé, the main island,
which is one of the most densely
populated in the world.
Photo: Martin Whiteley.

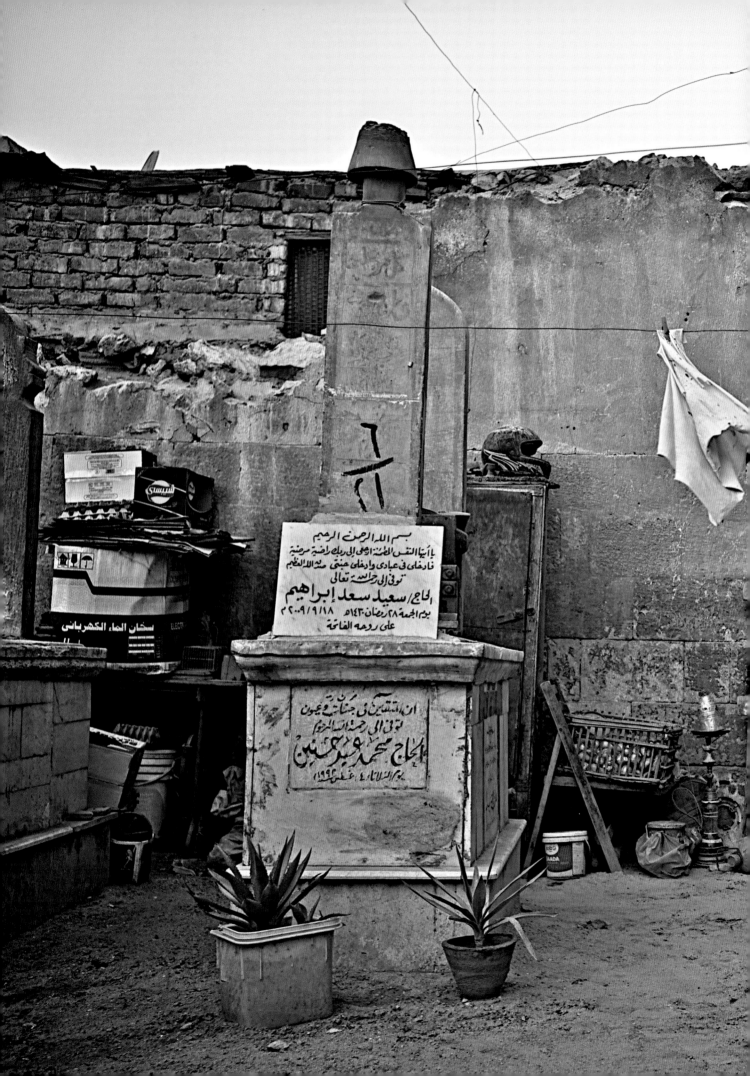

◄ Cairo, Egypt, 18:18.
"In Cairo there is a city within the city, a huge ancient cemetery known as the City of the Dead. Some say it is a slum, but there is no degradation of desperation. It is a shelter offered by the departed to the forgotten. There is life, too, in the kingdom of the dead. "
Photo: Luka Rocco.

Kabul, Afghanistan, 18:31.
Brick-making is one of Afghanistan's most flourishing industries. Since most brick factories are coal-fired, they have had to move outside urban centres. The tools used are spades, buckets and wheelbarrows, and the work is hard on hands. To supplement family incomes, many workers have found jobs for their children as brick-making assistants.
Photo: Omar Sobhani.

Nouakchott, Mauritania, 11:21. About 30 of Mauritania's one and a half million dromedaries at rest just outside the capital, Nouakchott. Because of constant drought, the Saharan Desert is spreading south-wards. Nouakchott, now with a million inhabitants, is threatened by dunes and experts predict that the water table will dry up by the middle of the century.
Photo: Conrad Duroseau.

Ruwais, United Arab Emirates, 17:27. In recent decades, Ruwais has developed into one of the biggest industrial centres in the Middle East. To attract workers to the oil refineries and factories west of Abu Dhabi City, the state oil company ADNOC built a model city with air-conditioned hous-ing, shops, schools, banks, mosques, hospitals, sports complexes and a television station. But there is no escaping the drifting desert sands.
Photo: Sharon Harper.

◄ Middelburg, South Africa, 17:25.
"Taking a shortcut through the veldt between two townships, Deon Lombart delivers a borrowed paraffin stove to his girlfriend's home. Winter is almost in full swing, and with no money to buy prepaid electricity the little stove will have to heat the house for the night. The local electricity supplier has raised rates sharply over the last three years, and many poor and unemployed people suffer greatly."
Photo: Altus Pienaar.

Burleigh Heads, Queensland, Australia, 16:45.
"A stunning autumn sunset was happening around these two and all they could focus on was their phones. It made me smile." The men are sheltering by a wall from a cool sea breeze. In summer, the beach is one of the best swimming, surfing and body-boarding Gold Coast beaches, not far south of the glitz of Surfers Paradise, but hotel development is encroaching even here.
Photo: Cath Murphy.

Barcelona, Spain, 20:38.
"It's the First Holy Communion
of Marta, my seven-year-old god-
daughter, and we are celebrating it in
the garden at her house. One of her
cousins is trying to burst a balloon,
which has a prize inside. He is about
to pop it and the other cousins are
very nervous."
Photo: Iñaki Fernández.

Carro exclusivo para mulheres

Segunda a Sexta, das 6h às 9h e das 17h às 20h.

Exceto feriados Lei Estadual nº 4733/06

Women exclusive car

londay - Friday, 6 am - 9 am and 5 pm - 8 pm. Except holidays.

Almaty, Kazakhstan, 21:15.
Homemade fries.
Photo: Erken Shakhmukhambetov.

Leicester, UK, 19:25.
"Cooking my dinner: *paneer* and
vegetable stir-fry. Yum." *Paneer*
is a South Asian fresh cheese.
Photo: Amy Jane Barnes.

Yaoundé, Cameroon, 20:00.
"Madame Claire Kepseu, the woman
of the house."
Photo: Jean Pierre Kepseu.

Siem Reap, Cambodia, 13:45.
"I take her photo and return in the
afternoon to give her a print – this
is the first time she has seen a
photograph of herself."
Photo: Barend van den Hoek.

Mexico City, 16:04.
"Here, there is no retirement, only
day after day of work, and hands like
these that support an entire people."
Photo: Carlos Rosas García.

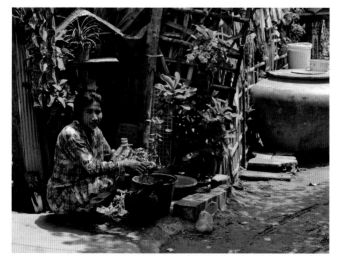

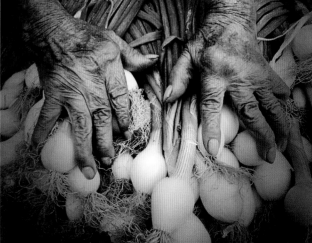

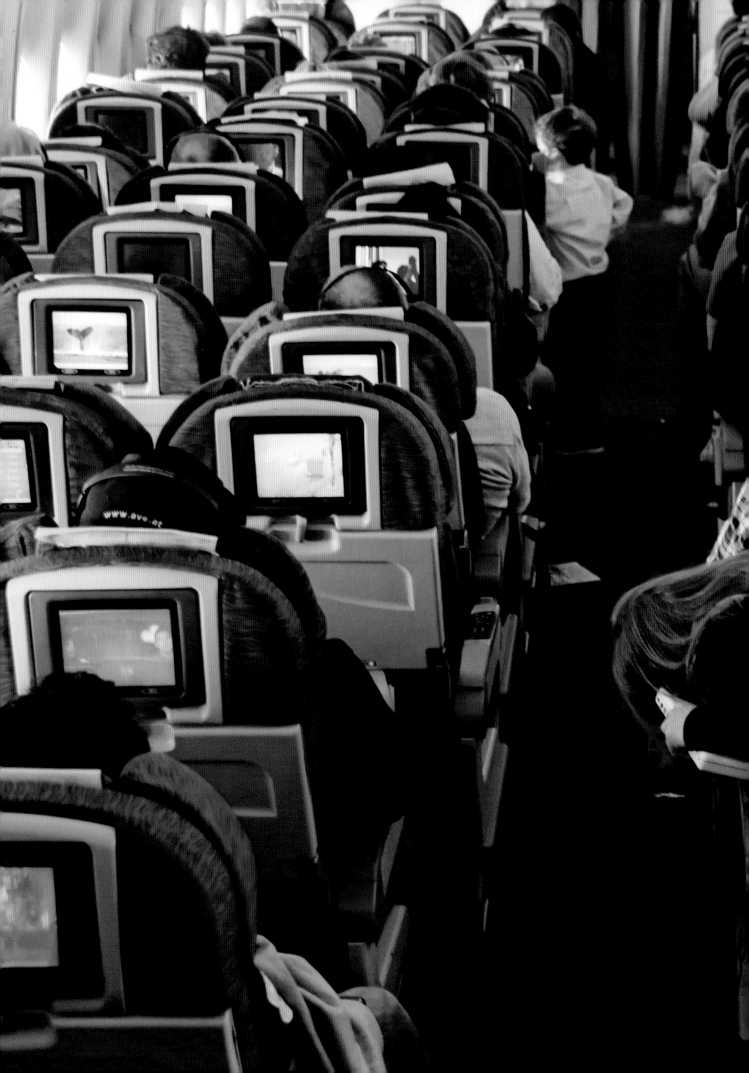

◀ Above London, UK, 19:58.
At this time of day there are more than a million passengers in the sky worldwide. Air travel is cheaper than ever but it has lost its glamour. The upside is the variety of inflight entertainment now available.
Photo: REZA.

San Francisco, USA, 17:50.
"I prepared a Burrata salad – Burrata cheese on arugula, olive oil, salt, black pepper and a touch of balsamic vinegar. We had some olives, and spaghetti as a main dish. It was only my boyfriend and me. We usually watch a movie or just a TV programme when we eat. That night we had candles because the fog was illuminating the city in a beautiful way."
Photo: Erika Castaneda.

Rio de Janeiro, Brazil, 18:04.
Five minutes ago, the sky was blue,
and now the rain pours down on the
beach, the high-rises and the traffic
jam. The month of May marks the end
of the rainy period. It's normal to see
the weather changing fast as a cold
front comes in. This neighbourhood,
Leblon, is the most affluent in Rio.
Photo: Roberto Arantes.

Lund, Sweden, 20:48.
Cancer surgery on the second breast.
"I don't worry. I feel certain I will live."
Photo: Kerstin Rassner.

Stockholm, Sweden, 16:37.
From too much stress at school.
Photo: Elsa Leo.

Lisbon, Portugal, 20:00.
A self-portrait. "Hold me tight."
Photo: Cristina Prat Mases.

Ponta do Sol, Cape Verde, 17:22. Like so many others in the fishing village of Ponta do Sol this woman has to leave home to get water. The former Portuguese colony of Cape Verde, 280 miles (450km) out in the Atlantic, has few natural resources. Ninety percent of all food-stuffs are imported. Electricity is also in short supply, and investments are being made into wind and solar power. *Photo: Finbarr O'Reilly.*

Ganderbal, India, 18:07.
A Muslim girl strolls through a field
of grain near Ganderal, northeast of
Srinagar, the summer capital of the
Indian state of Jammu and Kashmir.
Agriculture is the main industry in
this region, which is one of the
poorest in India. Literacy is only
22 percent.
Photo: Dar Yasin.

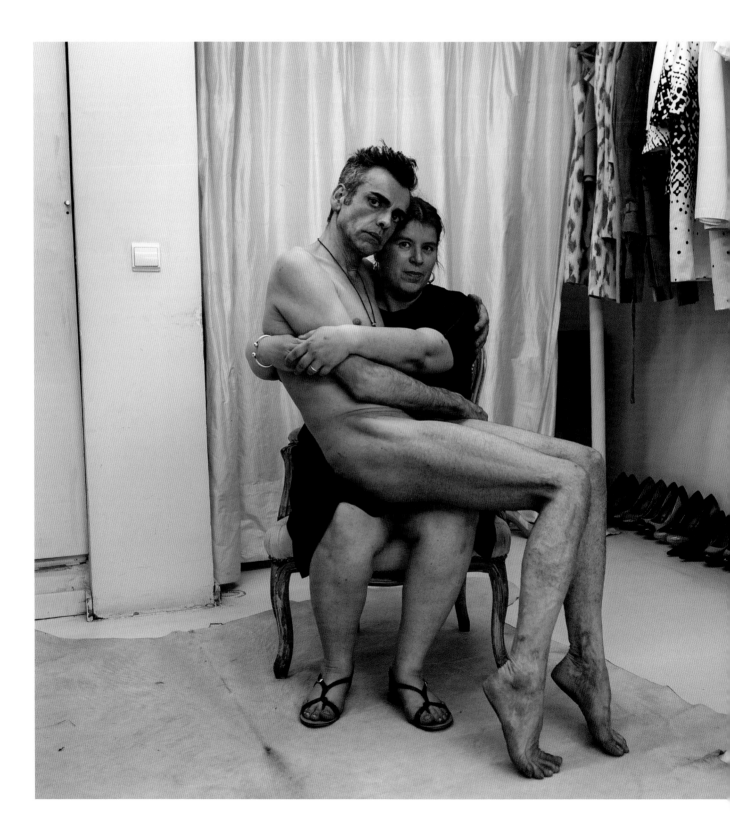

Lisbon, Portugal, 18:30.
Sculptor Joana Vasconcelos, with an upcoming major exhibition of her works at the Versailles palace near Paris, was trying on a dress for the exhibition dinner when her friend, fashion designer Filipe Faisca, playfully stripped and jumped into her lap.
Photo: Luís Vasconcelos.

Kiev, Ukraine, 19:15.
"My room and my little world", with
icons on the top shelf.
Photo: Mykhailo Radzievskyi.

Bergisch Gladbach, Germany, 08:30.
"Breakfast, the best time of day."
Photo: Britta Kuth.

Augusta, Georgia, USA, 06:48.
"My living room, complete with toys
and exercise equipment."
Photo: Jimmy DeKalb.

Dhaka, Bangladesh, 13:13.
"When there is nothing to do, this
is the place where I find peace ...
although it happens only once a day."
Photo: Asheque Mohammad Ahsan.

Kazan, Russia, 15:14.
"The usual dinner with family!
Delicious food, interesting
conversations!"
Photo: Lilya Kashapova.

Quezon City, the Philippines, 06:56.
"Our old hound, Johnny, asleep in the
corner." *Photo: Raffy Paredes.*

◄ Colombo, Sri Lanka, 18:15.
Sundown over the Indian Ocean,
at Galle Face Green beach. "What
is everyone looking at? The view of
the horizon was magnificent, and for
many of these people, this gathering
– this beautiful sunset – is their only
entertainment. I could almost feel the
happiness floating in the air. Positive
energy everywhere! "
Photo: John Simitopoulos.

Islamabad, Pakistan, 18:40.
Almost two million Afghans live in
Pakistan, most of them having arrived
since the 1980s. One nameless young
Afghan refugee pours water on a boy
called Doost Hamid. The water point
is in a slum area on the outskirts of
the Pakistani capital, Islamabad.
Water shortages in Pakistan have
increased as the levels have dropped
in the country's dams, and as
Himalayan glaciers disappear.
Photo: Muhammed Muheisen.

Sylhet, Bangladesh, 18:33.
Small, wild-caught fish provide a crucial source of protein in poor rural households. This fisherman makes a bare living catching perch, barbs and other freshwater fish that swim in the local *beel*s, or oxbow lakes.
Photo: Mohammed Akhlas Uddin.

Yerevan, Armenia, 18:46.
"The children are playing hide and seek – *paghkvotsi*, in Armenian. If one of the hiders reaches the wall before the seeker, he or she taps on the wall three times and yells: *'tou-tou-tou'*, which is also often exclaimed by adults to ward off bad luck."
Photo: Karen Mirzoyan.

Bogotá, Colombia, 19:00.
"My beautiful girlfriend's insecurity
makes her stuff her bra."
Photo: Santiago Martínez.

Kabul, Afghanistan, 19:15.
The sun has just set but it is still 21
degrees C on the outskirts of Kabul.
Nights in the Afghan capital are no
longer pitch black; the hills are
necklaced by electric light. Ravaged
by war, it is still one of the world's
least electrified cities but in recent
years the proportion of inhabitants
with power for most of the day has
more than quadrupled. The result
has been a surge in demand for TVs,
DVD players – and taking hot baths.
Photo: Kuni Takahashi.

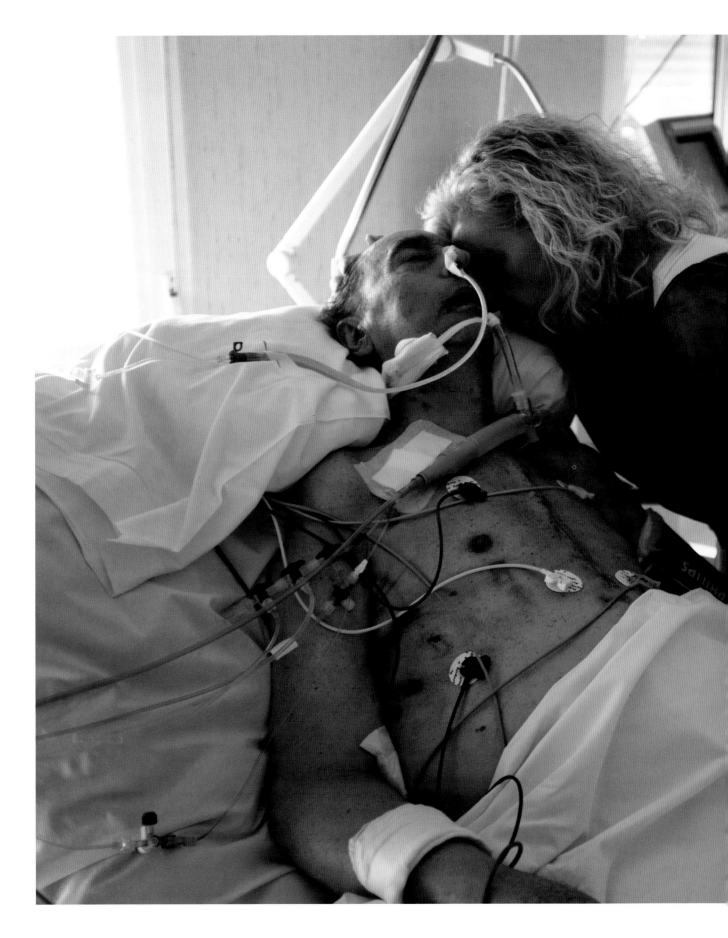

Seville, Spain, 19:13.
"In April, my 74-year-old father, Jesús Ramírez, was rushed to the Infanta Luisa Hospital due to problems caused by a dislodged metal heart valve. For the third time in his life he underwent open-heart surgery. After the valve was successfully fixed, several post-operative complications weakened his condition, and one required further surgery, this time to his lungs. During his nearly two months in hospital, my mother Carmen was able to say her farewells before her husband passed away, less than two weeks after this photo."
Photo: Carlos Cazalis.

Tokyo, Japan, 19:16.
Shiho and her infant son, Atlas, live with her parents. Grandma Tsuneko is 74, and Grandpa Hiro is 78. "They are very helpful, whenever I am working or need a break. Every night, they put the baby bathtub in their kitchen, both of them holding Atlas because he is active and slippery."
Photo: Shiho Fukada.

Cape Town, South Africa, 19:44.
"My niece Nura is profoundly disabled due to brain damage at birth. She is unable to walk, talk, sit or feed herself. My sister Razia cares for her 24 hours a day."
Photo: Sumaya Hisham.

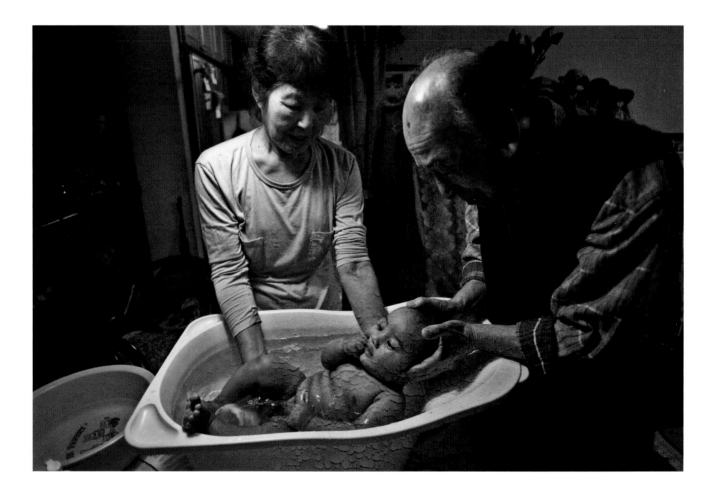

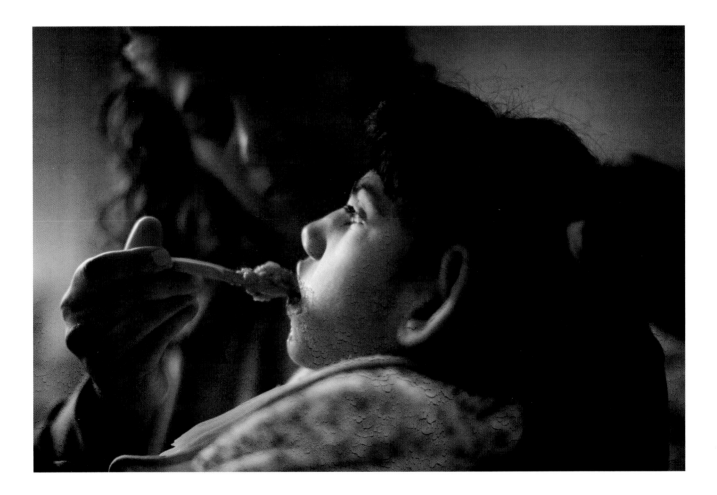

Las Vegas, USA, 19:37.
"The place was filled with tourists enjoying the evening and alongside the joyful crowd I found these two sorrowful faces in the sea of celebration. She is Clarice Schlegel, 43 years old and from southern California. Robert is not a regular on the street. Clarice moved to Las Vegas three years ago, right after her parents died. She thinks she might have a brother in Las Vegas. When I met Clarice again, she did not know where Robert had gone. Clarice is one of those people who live in the street, sunrise to sunset. When their bodies are almost giving up from the day's challenges, a shaded corner will be a resting place. I will be back in that same place where I found them. But the next time I meet Robert and Clarice, or see people like them, I will remember to appreciate what I have in life, every simple thing that I have that others do not enjoy or possess."
Photo: Arnold Despi.

United Nations Headquarters, 12:46.
Keeping in touch with world leaders,
listening to the voices of the people
across the globe
Photo: Ban Ki-moon.

Utrecht, the Netherlands, 14:29.
"We just moved with our department
to another floor at Utrecht University.
We have not yet really unpacked all
our stuff. Jumpers for our weekly
running appointment are ready,
though!"
Photo: Romi dePomi.

Abingdon, Oxfordshire, UK, 17:15.
"As soon as I'm done for the day and
on my way home, my tie is discarded.
I usually have five or six ties kicking
around in my car where I have thrown
them after work, and every couple
of weeks I have to find them all and
hang them back up in my wardrobe."
Photo: John Whittle.

Karlskrona, Sweden, 23:10. Ideas in Swedish and English mix as participants brainstorm at a Swedish branch of Hyper Island, where people are trained to rise to the challenge presented by transformative technology.
Photo: Anton Heestand.

Utrecht, the Netherlands, 14:07. "A cabinet in our office. We share a room with five to seven PhD candidates in educational studies – all women, hence Hello Kitty on top of the cabinet."
Photo: Romi dePomi.

Raleigh, North Carolina, USA, 17:39. "A common sight behind the SPCA (Society for the Prevention of Cruelty to Animals). These are cleaned pet carriers ready to be used to save lives at a moment's notice."
Photo: Darci VanderSlik.

1. Stockholm, Sweden, 21:30.
Espresso machine.
Photo: Anders Källén.
2. Oceanside, USA, 18:00.
Partial denture.
Photo: Mary Van Essen.
3. Stockholm, Sweden, 18:57.
Thimble. *Photo: Halewijn Bulckaen.*

4. Pontypridd, UK, 19:17.
Cooking knife. *Photo: Ben Pitcher.*
5. Visby, Sweden, 13:46.
Dala horse. *Photo: Sonja Nagy.*
6. Porvoo, Finland, 19:45.
Wooden clock. *Photo: Ville Juurikkala.*
7. Worcester, UK, 07:45.
A fairy queen doll I made for my
granddaughter.
Photo: Deidre Leeming.

8. Lynnfield, USA, 21:00.
Gnome. *Photo: Maureen Hannon.*
9. Honolulu, USA, 20:46.
My Batman wallet is my favourite.
Photo: JB-Clarke Velasco.
10. Boling, USA, 9:40.
Hats. *Photo: Bobby Crabb.*

11. Sollentuna, Sweden, 19:44.
Juggling balls.
Photo: Sonja Karwacka.
12. Moscow, Russia, 21:00.
Born in the year of the dragon.
Photo: Elena Lyadova.
13. Ust-Kut, Russia, 16:45.
Love peace and understanding.
Photo: Alexandra Isakova.

1.

2.

3.

4.

5.

6.

7.

8.

9.

10.

11.

12.

13.

1. Cambridge, USA, 17:17.
Medal. *Photo: Mike Law.*
2. Kuopio, Finland, 10:00.
Plectrum. *Photo: Mona Myllynen.*
3. Rovaniemi, Finland, 14:41.
We collect reindeers.
Photo: Sirpa Tiensuu.
4. Vora, Finland, 19:00.
Trophies. *Photo: Gote Granholm.*

1.

2.

3.

4.

Benghazi, Libya, 19:58.
Libyan soldiers direct parachutists
landing in a military parade in the
country's second largest city. The
Libyan National Army numbered
only a few thousand trained soldiers
at the end of the 2011 uprising,
although many militias have not
disarmed after the fall of Muammar
Gaddafi's regime.
Photo: Esam Al-Fetori.

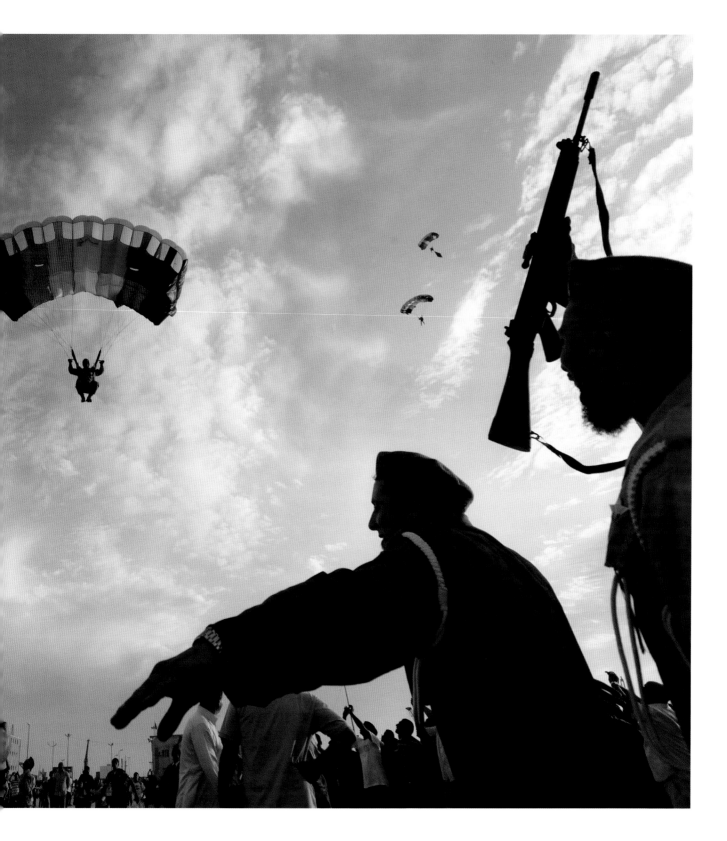

Yaoundé, Cameroon, 20:42.
Homework before dinner. The older
two, Nefieu Aurelienne, 17, and
Derrick Pileuk, 15, in red, are
students at the Lycée d'Ekounou
secondary school. The younger two,
Mambou Kepseu Pierre Junior, age
nine (in orange), and Wélako Kepseu
Astride Mégane, eight, are enrolled
at elementary school Les Pyramides.
In Cameroon, education is compul-
sory until the age of 14.
Photo: Jean Pierre Kepseu.

Kiev, Ukraine, 19:05.
Exiting from the underground railway at Universitet station after a day at the office in Kiev. The city's underground network was inaugurated in 1960 and now has three lines and 50 stations. In central Kiev, the stations were built deep enough for use as bomb shelters. One of them, Arsenalna, was for a long time the world's deepest underground rail station, at nearly 345 feet (105m) below ground.
Photo: Diana Olifirova.

Edmonton, Alberta, Canada, 20:38.
"Edmonton is an industrial city with a bad rap for being not the most beautiful, but the river valley is a little hidden gem. In the warm spring air with the buckbrush shrubs in full bloom, my boyfriend Zac climbed up for a view of the sprawling Alberta countryside. He and I were introduced by a mutual friend, and after only two weeks of enjoying each other's company we decided we could take on the world together. Almost a year later, we love each other more than life itself. We push each other to our limits and never stop experiencing life to its fullest."
Photo: Monikah Wiseman.

◄◄ Yekaterinburg, Russia, 20:01.
"My girlfriend Alina is 26 years old and is an office manager in Yekaterinburg. We have been together for four years. On weekends, she makes our dinner, which is usually scrambled eggs with black tea. This evening we were just staying at home, in the kitchen. Alina likes to dream about freedom – and Goa."
Photo: Evgeniy Pribavkin.

◄ Tver, Russia, 17:48.
"One year ago, we got married. And a month ago we moved from St. Petersburg to Tver. My husband's parents still live in the house where he grew up. I started to look closely at the place and shot some details. All of them are treasures for me. They help me understand my husband and his relatives better."
Photo: Inga Bugaeva.

Chicago, USA, 18:23.
"I love this hat shop because it is reminiscent of a different era. The shot turned out to be a happy accident." Optimo Hats is in downtown Chicago in what was said to be the world's largest office building at the time of its construction in 1893. The photographer was in the building but looking through the closed shop window to Dearborn Street.
Photo: Jessica Garrett.

Brussels, Belgium, 17:30.
"On my way home from work on a train from Brussels to Ghent, a trip of about 30 minutes. The train is filled with commuters like me. Spring has been particularly grey and wet this year, and the sight of rain on the windows is not promising for the rest of the evening."
Photo: Bruno De Cock.

Minsk, Belarus, 19:45.
Tanya and her little sister are playing after school in their backyard. Tanya is going to her dancing club later. She's wearing her new watch. The girls' home is in an industrial area of Minsk, near a huge tractor factory.
Photo: Alexander Kladov.

Minsk, Belarus, 19:45.
The boys are schoolmates. Marian is holding a pack of roasted sunflower seeds (*semechki*), a traditional snack food that is a favourite with children. Marian has had heart surgery and had to miss a year of school.
Photo: Alexander Kladov.

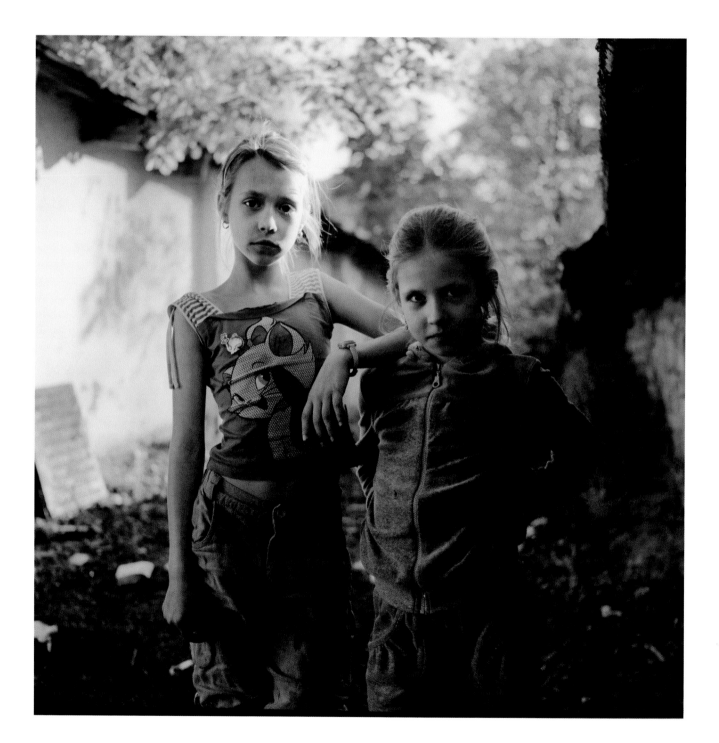

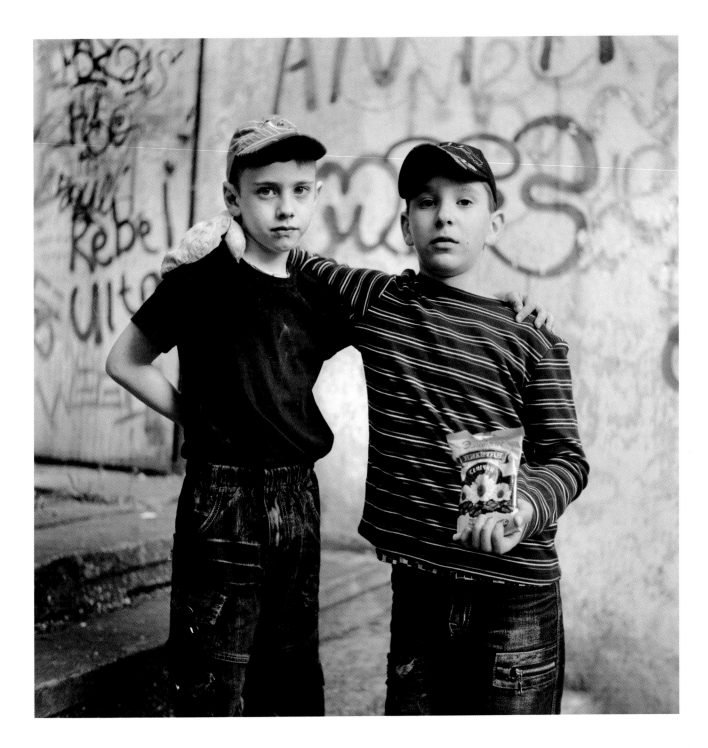

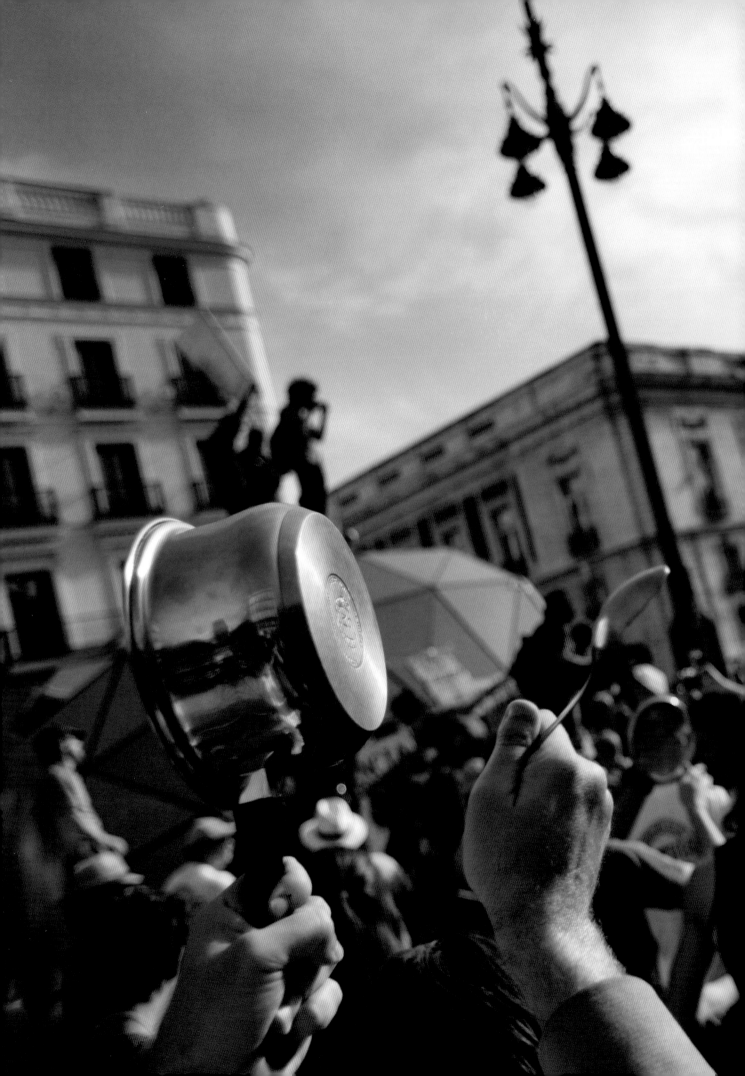

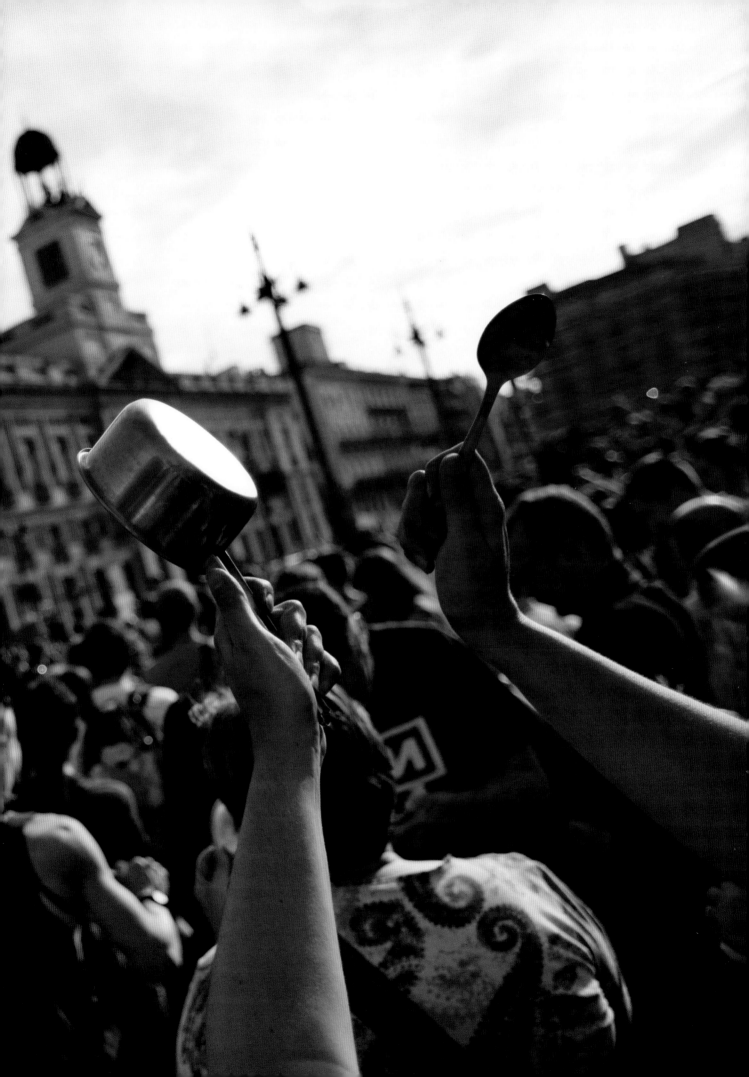

◂ Madrid, Spain, 19:15.
Spoons banging on pots, angry
shouts and burning euro banknotes
underscore the demonstrators'
demands for sturdier democracy,
while ventilating their fury at the
government, corruption, the banks
and high unemployment. The protests
on Puerta del Sol in the heart of
Madrid are taking place on the
first anniversary of the birth of the
Indignados ("outraged") movement
in dozens of Spanish cities, inspired
by the events of the Arab Spring in
North Africa and the Middle East in
2010–2011.
Photo: Juan Medina.

Karachi, Pakistan, 20:26.
Free food – biryani rice with meat or
lentils with rice, depending on the
donor – is distributed to people from
all faiths who bring plastic bags for
cooks to fill at the shrine of Abdullah
Shah Ghazi, considered by many to
be Karachi's patron saint.
Photo: Sohail Osman Ali.

Ankara, Turkey, 19:29.
"I had a ticket for a modern dance
performance ("A Midsummer Night's
Dream") at the Ankara Opera House.
While I was parking my car, it started
pouring down. I spotted an elegant
lady getting out of a taxi and running
towards the building. The rain was
lighter now, but she had no umbrella
and didn't want her hair to get wet.
She was holding her purse over her
head as she ran!"
Photo: Tuba Korhan.

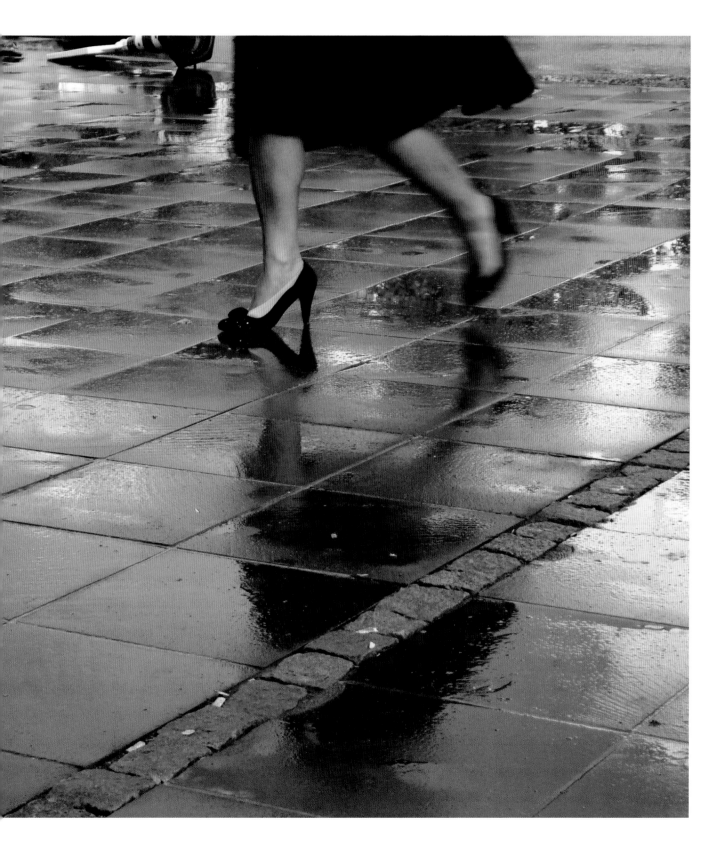

Lisbon, Portugal, 20:45.
Family memories: travel and good times. *Photo: Joao Sa Leao.*

London, Ontario, Canada, 13:14.
"My whole bedroom is covered. Just by looking at my walls you can get a good idea of my beliefs and my history." *Photo: Emilia Wilson.*

Bethlehem, Georgia, USA, 16:15.
"The bookshelf in my home office: cluttered. Full of various types of multimedia – books, CDs, DVDs, magazines – and printed photographs, collected rocks and other items of interest to me."
Photo: Matt Fulkes.

Vaasa, Finland, 08:30.
"The first night in a 'big-boy bed' for my son Cedric, aged one year and seven months. Gone is the crib, away the bars." The town where Cedric sleeps is Vaasa, which has a population of 60,000 and sits on the Baltic Sea. Once under Swedish control, the city remains bilingual: three-quarters of the population speaks Finnish as its first language, and one-quarter speaks Swedish.
Photo: Lasse Mäkynen.

Porto, Portugal, 10:27.
Fridge magnets celebrating Porto and Portugal. And the shrine at Fatima. *Photo: Jorge Castro.*

Bogotá, Colombia, 20:01.
"My wall in my bedroom is like a sanctuary of some of my most valuable objects, and helpful material for my studies." *Photo: Angel Acosta.*

Asunción, Paraguay, 19:00.
A mural in Asunción depicting a Paraguayan "Wonder Woman". *Photo: Julia Duarte.*

Berlin, Germany, 11:09.
"This is my living room. I started furnishing it two days ago after months of painting. The calendar on the wall is from 6 December 1990, the day my great uncle moved out of his house and left lots of his stuff. The bookshelf is a temporary solution and eventually the frames will be hung on the wall. I like it like this, so there's no hurry."
Photo: Sandra Juto.

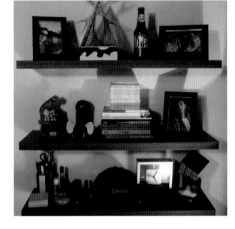
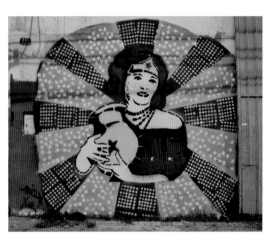

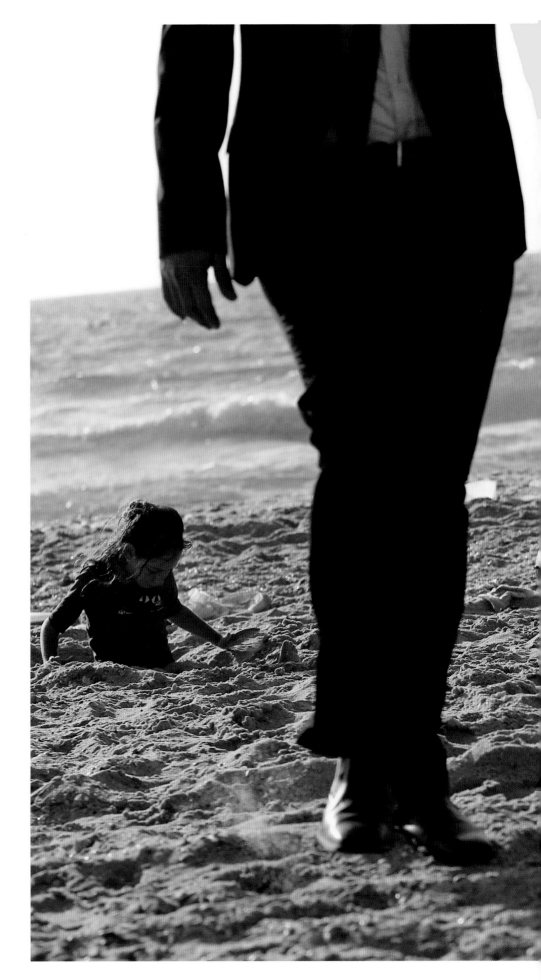

Ashkelon, Israel, 19:33.
An Israeli bride and groom stop by
Zikim Beach before their wedding
ceremony, seeking to be photographed
alone in an exotic place. "This beach
is wild. It forms the border with Gaza,
and here you see soldiers, swimmers,
couples, fishermen – and people like
me who come to relax. You cannot
find a beach like this anywhere else
in the world – with a conflict zone on
one side, and on the other, a leisurely
life of its own."
Photo: Tsafrir Abayov.

Fryksås, Orsa, Sweden, 18:44.
"The table is an old butcher's bench of pine. Underneath, someone has etched the date: '1600'. I sleep on the kitchen bench. Above it is an embroidered elk and a picture of a grouse hen, both bought at flea markets. My great-great-grandmother owned the china on the shelf. I live here on my own and enjoy my solitary, contemplative dinners."
Photo: Göran Boardy.

Hayes, Middlesex, UK, 19:40.
"My wife Alison loves jigsaw puzzles. This one is slightly more challenging in that the completed jigsaw is a scene as seen from the perspective of a person highlighted on the box. There are only clues as to how the completed puzzle will look."
Photo: Peter Stefanovic.

◀ Tehran, Iran, 18:00.
The availability of heavy clay
has encouraged building with
bricks, which can offer architects
a remarkable degree of flexibility
– even after the building has been
completed.
Photo: Sahar Arjmandi.

Iowa City, USA, 11:45.
"This is a makeshift light switch
cover that has been there since I
started working here in 2001. I work
with weird people. The Charles
Manson carving in the forehead is…
interesting."
Photo: Lee Madison.

Buenos Aires, Argentina, 19:30.
"This is my boyfriend, Sebastian.
We like to hang out at this shopping
centre called Bond Street, where the
different 'tribes' – the punks, heavies,
rockers, skateboarders, and so on
– of young people go because of the
clothes shops, record stores and tat-
too parlours. The centre is actually in
one of the wealthiest neighbourhoods

in the capital, called Recoleta. It has
a unisex bathroom, with urinals and
cubicles with toilets. Like the centre,
it is filled with graffiti. The writing on
the floor says 'SLASH' – the Guns N'
Roses guitarist, I think. Apart from
the graffiti, they're not that dirty."
Photo: Cecilia Gil.

Ipswich, UK, 18:00.
"My younger sister wearing a wedding dress, looking quite mature. I wanted to show a young girl waiting for her dream partner to come into her life."
Photo: Adrianna Keczmerska.

Dniprodzerzhynsk, Ukraine, 19:25. In Ukraine the official figure for those living on the streets is 15,000, although independent charities put the total at closer to 600,000. By spring it may become warm enough for a cooling ice cream, but the winter can be severe. The most recent one was particularly hard and more than 130 people froze to death on the streets in just 10 days during February.
Photo: Sergei Muzyka.

Kabul, Afghanistan, 17:45.
A worker at a brick factory.
Photo: Omar Sobhani.

Taguasco, Cuba, 18:30.
Farm chores.
Photo: Beatriz Dal Col.

◄ New Taipei City, Taiwan, 18:37.
Banqaio district in the heart of
New Taipei. Hundreds of thousands
of workers hurry home at dusk by
underground rail, bus or motorcycle
– or detour to restaurants or other
evening entertainment. This is
Taiwan's largest city and together
with the capital, Taipei, the two form a
megacity of six million inhabitants.
Photo: Gary Chen.

Srinagar, India, 18:49.
By Dal Lake in Srinagar, Kashmir
Valley, a group of students light
candles in symbolic protest at
widespread corruption in India. More
than 18 billion US dollars annually
is estimated to find its way into the
pockets of civil servants. Candles
are being lit across the country to
put pressure on India's parliament
to finally pass its anti-corruption law.
Photo: Farooq Khan.

◄ Düsseldorf, Germany, 22:23.
Away fans throw flares before the
home fans storm the field. The
referee finally abandoned the game,
a decisive qualifier between Fortuna
Düsseldorf and Hertha Berlin. The
home team, Düsseldorf, finally won
by an aggregate score of 4–3 and
was promoted to the first division
of the Bundesliga. Hertha was
demoted, making Berlin the only
major European capital without
a top division football team.
Photo: Sascha Schuermann.

Toronto, Canada, 21:05.
"My balcony faces south and I have
a perfect view of Canada's National
Ballet School. I'm on the eighteenth
floor. I was intending to get some
photos of the skyline when I saw how
perfectly lit the ballet school was."
Photo: Alexandra French.

Jerusalem, Israel, 19:39.
Jerusalem's population is strongly
religious so orthodox Jews can be
found among most professions –
including that of street musician.
This is Ben Yehuda Street, a pedes-
trianized thoroughfare named for the
founder of modern Hebrew.
Photo: Sasha Lee.

Melbourne, Australia, 21:37.
The Purple One thrills a sold-out
concert at the Rod Laver Arena. In
high heels, he struts the stage to
belt out one of his classic tunes.
The arena, in central Melbourne, is
where the Australian Open tennis
Grand Slam is played in January.
Photo: Jess Lomas.

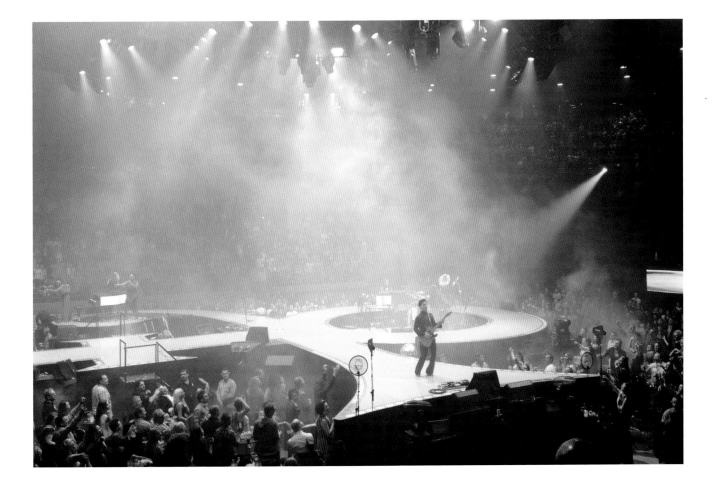

Cabo San Lucas, Mexico, 21:30. "This is my girlfriend Yoli. She is a 21-year-old single mum with two baby girls, and she works at her father's ice cream and coffee shop. She loves to bake. She is getting her first tattoo, of an ice cream cone." *Photo: Luzan Quintero.*

Paris, France, 22:52. "I am speaking with my little sister, who lives in my hometown of Sfax in Tunisia, discussing life after the revolution. When I'm abroad, I often speak with my family on Skype, so I can get their news and be reassured. I told her about my day in Paris, with power passing from Sarkozy to

Hollande, and we talked about the news from Tunisia being discussed on Facebook. I am very close to my sister, and I worry about her future, especially given the country's post-revolutionary situation. She, in turn, worries about me in my job as a photojournalist." *Photo: Ons Abid.*

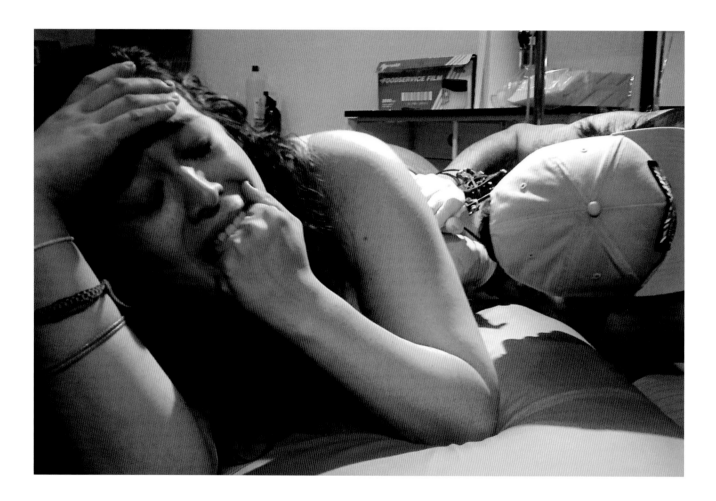

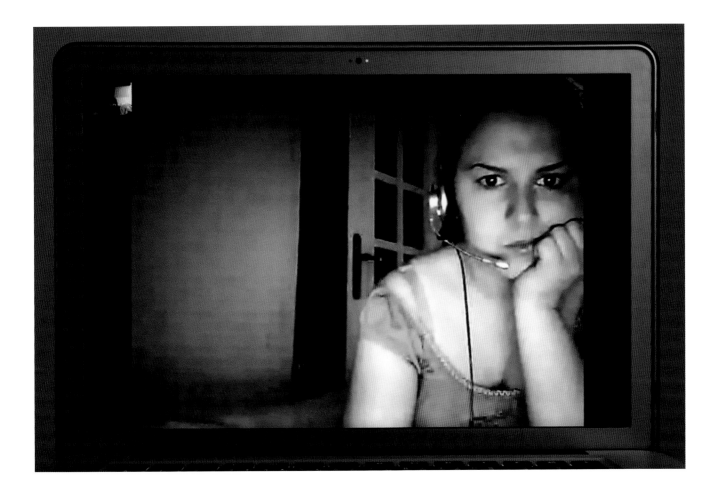

Halmstad, Sweden, 23:03.
"I've been following the rock band Scary Mary for almost a year now, as a staff photographer at the local newspaper in Halmstad (on the coast of southeast Sweden). Three band members live together in this one room. They're broke, and sometimes one of their mothers sends a box full of food. They party almost every night, but at the same time they're devoted to their music and are working on recording their first album." Here, Phil Dizzy enjoys the sofa with friend Jenna Källqvist, while Will Wild is "chilling". "Of course makeup is not just for women", says Will. "Guys also want to look beautiful. I love my pink lipstick!"
Photo: Roger Larsson.

Winchester, Hampshire, UK, 20:09.
"Mark and Marie are my housemates. They are engaged to be married, and their baby, Amelie, is four months old. I guess at first I was a little worried, and thought the baby crying would keep me up all night, but actually it has been absolutely fine. When I get home from work, I can take her off her parents' hands for a while, to give them a break. I'm sure it's all preparing me for one day having children of my own, which can only be a good thing. The household may currently be an unconventional setup, but we all find it works really well."
Photo: Alick Cotterill.

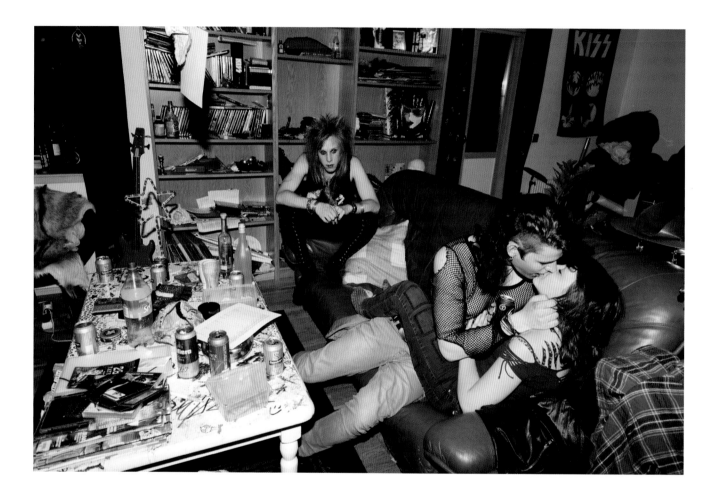

◄ Kawasaki, Japan, 21:30.
Japan's impressive structures encompass far more than ancient temples, hyper-modern skyscrapers and imperial palaces. On its list of picturesque sights for tourists, the local authorities in Kawasaki include the city's oil refinery. This dazzling plant can produce more than 330,000 barrels of oil a day.
Photo: Keith Crowley.

Dhaka, Bangladesh, 22:45.
Rezia Begum surrounded by her two daughters and their families. "Her husband was a freedom fighter who died after a terrorist attack in 1972. Rezia was only 26 but never married again. With granddaughter Soma at home after studying three years in London, today is a happy day."
Photo: Mohammad Anisul Hoque.

Edmonton, Alberta, Canada, 19:30.
"My nieces and nephew live over 500 kilometres away. I talk to them every few weeks using Skype or FaceTime. On this particular evening, my six-year-old niece had 'set me down' on her parents' coffee table so she could multitask – she wanted to use her hands to build Lego while telling me about her soccer practice. Some days I get to look at her sweet face; others I spend the conversation looking up her nose. It's the highlight of my evening, either way!"
Photo: Gina Blank.

Halifax, Nova Scotia, Canada, 22:28.
"This is in the basement bedroom
of my parents' house, where my
boyfriend has been living for the past
year. I sleep in my own bedroom two
floors above, since we are unmarried.
We are in our mid-20s and have been
a couple since we were 17, living with
parents to save money for our first
home. My parents are devout Catholics,
but neither my boyfriend nor I are.
Under their roof, I usually respect
their rules – however, most nights
we still get to spend time in private
before I go upstairs to sleep. Here, he
has just gotten out of the shower. He
is a basketball player and has been
working out since he was a teenager.
Contrary to his fit physique, another
one of his night-time routines is to
eat half a bag of chips or a huge bowl
of ice cream. When I had the camera
out, he was a bit shy. In general he
hates getting his picture taken but he
is proud to show off his muscles."
Photo: Claire McIntyre.

◂ Beauvais, Picardie, France, 22:05.
Sebastian Gaulme and Claire
Vidal rehearse their salsa moves
at a Salsapills dance club class,
held in the restaurant Le Touco.
On this particular Tuesday it was
a quiet night.
Photo: Lars Tunbjörk.

Marshfield, Wisconsin, USA, 21:40.
"I make albums for my grandchildren
to give them when they graduate
from high school, looking back on
their 18 years of life. The stacks
here, with photos I took myself,
are for my granddaughter Christina
who graduates in June. When my
grandchildren see my albums, they
especially like the goofy photos
and they say 'Oh, I remember this,
Grandma, it was so much fun.'
I consider these albums the most
significant gift of love that I can
give them."
Photo: Patty Brink.

Masku, Finland, 14:00.
"This is my wall, covered with
dozens of postcards I've gotten
via Postcrossing or my friends."
Postcrossing is a project that
allows members to receive random
greetings from all over the world.
Photo: Jemina Linnama.

Memphis, Tennessee, 21:30.
The Lorraine Motel, where Dr Martin
Luther King was shot dead in April
1968. The building is now the National
Civil Rights Museum. The wreath
marks the approximate place where
Dr King was standing when he was
killed. The 1960s' cars are part of the
museum exhibit.
Photo: Michael Stoughton.

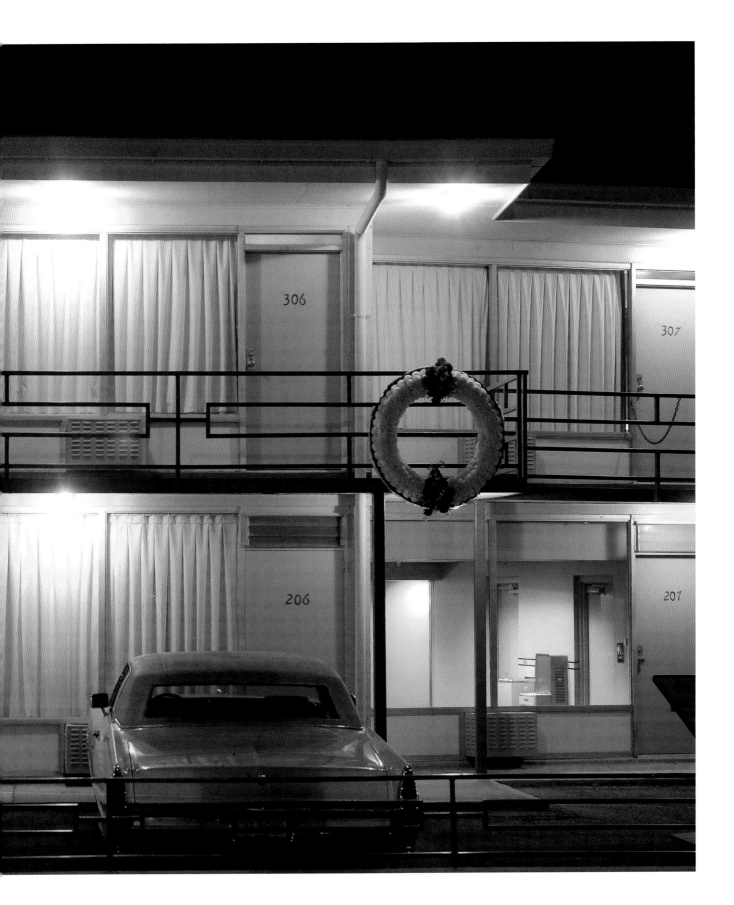

◄ Chicago, USA, 22:31.
"My friend Stan lives with his five dogs on the west side of Chicago. All were rescued from the streets or shelters, and some were saved from being euthanized. The dogs – Bumper, Paladin, Jack, BeeGee and Charlie – are all protective of Stan, and frequently focused on their master. Will he offer a treat?"
Photo: Stephen Garrett.

Yerevan, Armenia, 22:42.
"I don't remember much of my grandmother. I was six when she died. There are many pictures of her in our flat and the one I love most is this portrait. I am always told I look like her, and that we have similar personalities."
Photo: Tatevik Vardanyan.

Lynchburg, Virginia, USA, 06:58.
"My maternal grandmother is the best grandmother and mentor I'll ever have. She's intelligent, wise, beautiful, understanding and loving. Most importantly, she has always been there. I remember vividly taking stubby, wobbly steps behind her through the house just hoping she'd slip off her slippers so I could put them on and be just like her."
Photo: Vannathan Light Sitton.

▸ Estoril, Portugal, 22:45.
"My grandmother Maria José, soon
to be 97, has been living in a hotel
in Estoril for the past 24 years. She
has two rooms and her own furniture.
She takes all her meals in the hotel
restaurant or by the pool, which has
a sea view. Many guests think she
owns the hotel. After a fall four years
ago, grandmother has trouble walking
and is looked after 24 hours a day by
two young women from Brazil, Dina
and Joelma. Maria José has two
daughters, nine grandchildren and 15
great-grandchildren, so she has many
visitors. Evenings often end with her
watching TV until two or three in the
morning."
Photo: Bruno Portela.

▸▸ Tel Aviv, Israel, 23:52.
"I have been photographing the area
near Tel Aviv's central bus station for
a few years, documenting the human
mosaic of prostitutes, drug addicts,
homeless people, migrant work-
ers – and now these asylum-seekers
coming in from Sudan and Eritrea.
Many have been living in Levinsky
Park, where, since last winter, the
volunteer organization Levinsky
Soup has dispensed hot food once
a day. In Israel, there have been
demonstrations both against and
in support of the refugees."
Photo: Nitzan Hafner.

▸▸▸ New York City, USA, 23:12.
For the first time in history, more
people live in cities than in the coun-
tryside. Where millions converge,
anything is possible. Most of us seek
sustenance not from the seasonal
cycles of toil in the fields, but from
the constant buzz of the technology
driven, hyper-modern metropolis.
We inspire, we challenge, we feed
off each other's energy in what the
photographer describes as "a living,
breathing collective of the people
who live and work here". We savour
the chance to glimpse into lives
unimaginably different from our own.
We converge, and we find comfort in
knowing that, whatever happens, we
are all in this together.
Photo: Steven Kelley.

Aday.org, the largest single-day photographic documentation of everyday life, took place on 15 May 2012. People all over the world took part to produce a visual record of humankind, simultaneously sharing their own lives.

The modern narrative has become very direct – think of Twitter, Facebook, blogs. We are experiencing new ways to see the depth of ordinary lives and new means to express and share. The categories we chose – such as home, communications, tools, food, purpose and community – encouraged participants to reflect on the basics in our lives. The profusion of pictures of feet, laundry and domestic scenes indicates an instinctive urge to share.

This has been a gigantic chronicle of our lives, merging countless perspectives. Exactly 63,294 people from more than 190 countries signed up to take part. On the day, millions of pictures were taken for Aday.org – by both professionals and amateurs – and more than half the participating photographers were women. Almost a hundred thousand pictures were ultimately uploaded. One thousand images were chosen for this book. The selection makes no claim to be a complete representation of life on Earth, but is a mirror of what was submitted.

We wanted to highlight the evolution of photography and the value of the simplest images when created with a purpose. The Internet has provided a platform for global reach, and digital technology has changed the way we shoot: for example, only 1 percent of the submitted images were taken with analogue cameras, while 20 percent were taken with mobile phones.

Although Aday.org is the largest global photo project of its kind, capturing life in one day is not a new idea. A single day is a measurable and comprehensible format that has been used successfully before. But previous projects have chiefly involved professional photographers or video.

Aday.org is a kind of self-portrait of humankind. In conjunction with this book's publication, two exhibitions started their international tour. All submitted images will be preserved for future research as time capsules in several institutions around the world – the first to accept this donation was the National Archives of Sweden. All contributing photographers have thus sent a message to the future: this was us, this is what we did, this was our world on 15 May 2012.

Marika Stolpe *Patrick Ståhle* *Jeppe Wikström*

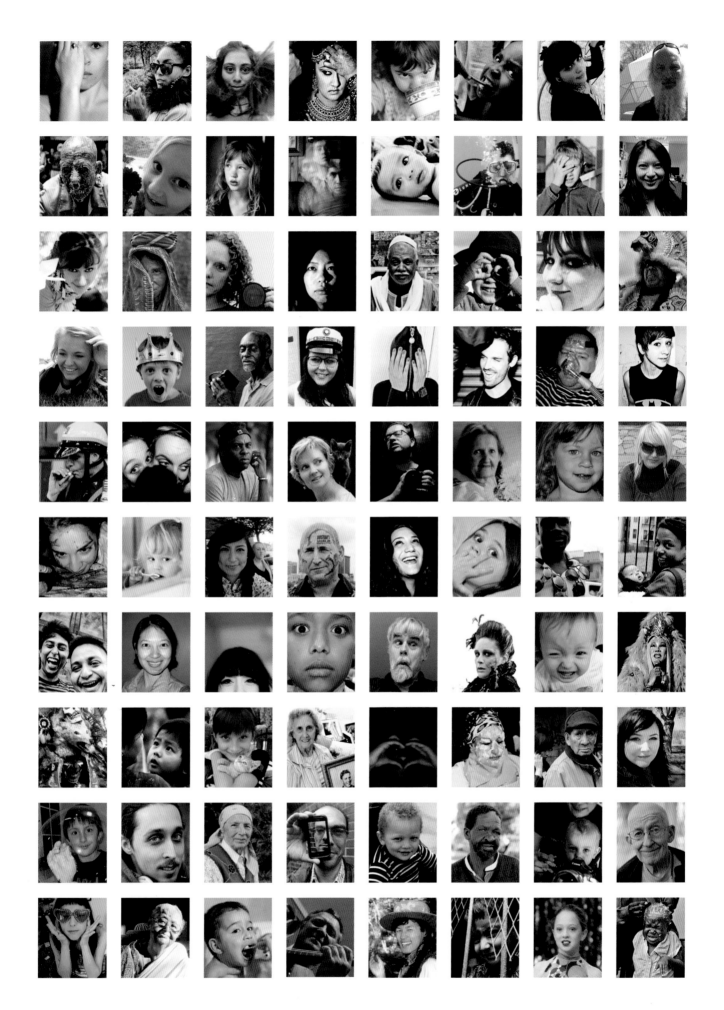

504

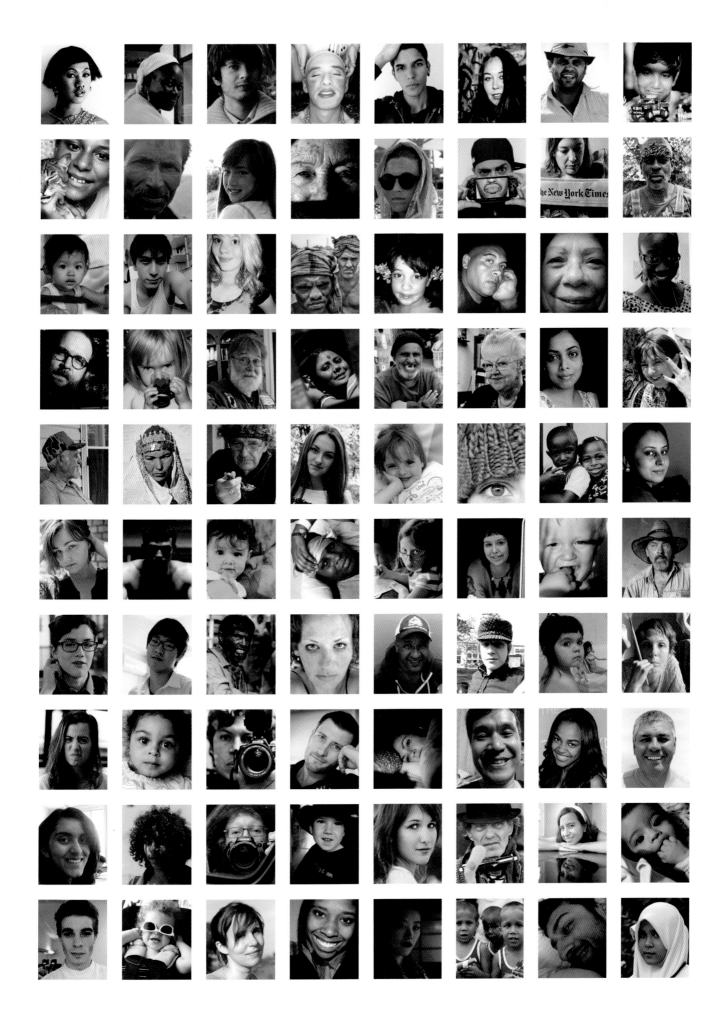

505

▸ Page 502
Row 1
Michaels Timmons
Yunus Prasetyo
Moe-Butch Hannon
Joe Loh

Row 2
Eddie Leong
Javier Nemirc
Shalla Yu

Row 3
Fernando Serra
Liza Rey
Anita Csirkéné Szabó
Oly Juárez Bautista

Row 4
Alexandre da Veiga
Jocke Edberg
Donna Jordan

Row 5
Elisabete Madureira
Tash Hatcher
Piritta Parhi
Tatyana Yudina
David Rothwell

▸ Page 504
Row 1
Maria Khomenko
Shirin Saleh
Maria Aleman
Tanuja Chenna
Evelina Pentcheva
Jean Pierre Kepseu
Catalina Valenzuela
Joel Stolpe Montan

Row 2
Corina Suciu
Sofia Heintz
Anna Rytterbrant
Danilo Urbina Peña
Viktorija Ford-Gorcev Curtright
John Hellman
Alexander Kladov
Susan Lai

Row 3
Stanislava Dementieva
Khaled Hasan
Susana Combina
Kosuke Okahara
Samariya Mekawy
Sif Heida Gudmundsdottir
Ryan Goodwin
Jason White

Row 4
Vanessa Huynh
Ed Olson
Anderson Griffith
Christine Pauliine Sølvsten
Camilla Wikke
Eric T. White
Franck Chezza
Brandy LaVallie

Row 5
Joseph Pritchett
Justine Waterlot
Ricardo Rodriguez
Joseph Frazz
Ulf Bengtsson
Joseph Papeika
Corby Ivey
Liza Rey

Row 6
Ayelén López de Armentia
Monica Renaud
Jocelyn Hernandez
Ana Alves
Eric T. White
Jimmy Majors
Dani Walker
Sandra Alexander

Row 7
Soham Gupta
Syc Cal
Felix Karlsson
Mircea Iordache
Thorbjorn Steiro
Nacho Sraik
Ashley Freeney
John Glines

Row 8
Said Alanís
Dominic S. Halder
Yuri Buts
Amy Connolly
Te'Nya Thomas
Yasaman Tamizkar
Sarkis Baharoglu
Moa Glantz

Row 9
Emi Espinosa Leahy
Maria Redko
Mykhailo Petyakh
Tamas Revesz
Adam Wännman Zetterqvist
Suzy Bernstein
Bengt Wanselius
Lesley Mason

Row 10
Florencia Martinez Ortiz
Soham Gupta
Fernando Lobos Miralles
Micke Löfroth
Jamyang Tenzin
Sumedha Bhattacharyya
Jill Riter
Joey Abrait

▸ Page 505
Row 1
Varinrat Budda-Ard
Mari Pennanen-Kok
Charles Lucke
Wladymir Hermoso
Jamie Alberto Soto
Eric T. White
Amr Miqdadi
Nidhin Nishanth

Row 2
Leigh Bayley
Aniket Jana
Shona Chau
Mario Tellez
Bea Bjørnsten
Joel Villanueva
Julie Simons
Alessandra Migliorini

Row 3
Nicole Klakulak
David Knight
Krysti Sumpter
Khaled Hasan
Spiroula Tsouras
Julio Mazorra
Adriana Sousa
Esther Shittu

Row 4
Milla Eronen
Gabriella Sahlin
Janice Halligan
Sayem Ahmed Chowdhury
Mostafa Dib
Lynn Brooks
Sumi Bordoloi
Staffan Moberg

Row 5
Van Hicks jr
Bayrem Zouari
Christina Fryle
Masha Zhernovnikova
Marie Bouvet
Dominique Barteau
Alessandra Migliorini
Mohammad Anisul Hoque

Row 6
Oleksiy Mironyuk
Dmitry Kirsanov
Dee Lenor
Phred Mosbey
Mike Egan
Bala Muthukaruppan
Martin Andersson
Emir Klepo

Row 7
Patrick Connolly
JeongMee Yoon
A.K.M. Emdadul Islam
Kristina Nierman
Emnet Belew
Michelle Kienast
Rodrigo Gomez
Yaroslav Bozhkov

Row 8
Alexia D'Arconso
Terrance Jackson
Jousé Araujo
Kari Bernardini
Michael Frederiksen
Tsukasa Tada
Deasia Parter
Bernie Sahadi

Row 9
Chuchu Jiang
Thierry Egger
Gerald Sklarow
Stephan Söderberg
Emilia dlP
Linus Karlsson
Edgar Rene Estrada Estrada
Valentina Piriz

Row 10
Xavier Ferreira
Shannon Dodds
Joel Correia
Alyssa Safraj
Julie Glassberg
Helio Eudoro
Sara Benson
Zhiyang Lu

Aday.org has been supported
by the following "connectors"
who helped to spread the word
about the project:

Abir Abdullah
Rolf Adlercreutz
Jassim Ahmad
Akinbode Akinbiyi
Jan Almlöf
Daphné Anglès
Mladen Antonov
Olivia Arthur
Kristen Ashburn
Walter Astrada
David Axelbank
José Azel
Greg Barton
Karim Ben Khelifa
Alban Biaussat
Leopoldo Blume
Claudine Boeglin
Mirjam Boer
Michelle Bogre
Enrico Bossan
Anne Bourgeois-Vignon
Susan Bright
Kim Brunhuber
Micha Bruinvels
Johan Bävman
Dan Calladine
David Campbell
Jim Casper
Paolo Ciuccarelli
D.J. Clark
Paul Conneally
Anton Corbijn
Roger Cremers
Jess Crombie
Marizilda Cruppe
Denis Curti
Lars Dareberg
Serdar Darendeliler
Saurabh Das
Bruno De Cock
Frédérique Deschamps
Agnes Dherbeys
Iñaki Domingo
Sherri Dougherty
Philippe Dudouit
Ferit Düzyol
John Easterby
Angus Easton
Kate Edwards
Ruth Eichhorn
Fred van der Ende
Tina Enghoff
Claude Erbsen
Andrew Esiebo
Wilfrid Estève
Liza Faktor
Renata Ferri
Fred Flade
Per Folkver
Bill Frakes
Melanie Friend
Patrick Fuller
Alice George
Shannon Ghannam

David Gibson
Alberto Giuliani
Susan Glen
Raoul Goff
Julien Goldstein
MaryAnne Golon
Khrisslyn Goodman
David Griffin
Elizabeth Griffin
Tricia Guild
Johan Gunséus
Léonie Hampton
Martin Hampton
Marcus Haraldsson
Brian Harris
Artur Heller
Magdalena Herrera
Claudia Hinterseer
Matias Ibanez
Masaki Ikegami
Kay Itoi
Patrice James
Jon Jones
Meredith Kamuda
Hideko Kataoka
Katherine Kay-Mouat
Casey Kelbaugh
Everett Kennedy Brown
Geert van Kesteren
Eric Kim
Alexander Kladov
Martijn Kleppe
Kent Klich
Nikandre Koukoulioti
Laurie Kratochvil
Elka Krol
Eva-Lotta Lamm
Loup Langton
Brigitte Lardinois
Jonas Lemberg
Lissette Lemus
Volker Lensch
Heidi Levine
Dewi Lewis
Mauricio Lima
Terje Lindblom
Eefje Ludwig
David Magnusson
Eric Maierson
Chris Maluszynski
Maria Mann
Pietro Masturzo
Yann Mathias
Ayako Matsumoto
Stephen Mayes
Donald Miralle
Adriaan Monshouwer
Linda Moritz
Philippa Neave
Johanna Neurath
Swan Ti Ng
Junko Ogawa
Linda Ohama
Silvia Omedes
Arne van Oosterom
Finbarr O'Reilly
Masha Osipova
Laura Pannack
Peter Petermann
Edie Peters

Andrei Polikanov
Marc Prüst
Rima Qureshi
Anil Ramchand
Tina Remiz
Tamas Revesz
REZA
Nada Rezq
Arianna Rinaldo
Manuel Rivera-Ortiz
Inta Ruka
Sara Rumens
Damir Sagolj
Moises Saman
Mats Schagerström
Lotta Schwarz
Laura Serani
Rebecca Simons
Kristina Snyder
Sujong Song
David J. Spear
Juergen Specht
Alnis Stakle
Mike Stanton
Radu Stern
Brian Storm
Joakim Strömholm
Aidan Sullivan
Serita Suman
Mariko Takeuchi
Maris Takk
Monica Takvam
Newsha Tavakolian
Serkan Taycan
Steve Taylor
Dan Torres
Roger Turesson
Luís Vasconcelos
Joe Ventura
Pauline Vermare
Horacio Villalobos
Jim Virga
Dirk-Jan Visser
Ruth de Vries
Rob Walls
Paul Weinberg
Andreas Wellnitz
Irina Werning
James West
Jason Wilson

Organizing Aday.org has been
a huge undertaking. Many people
have helped and we would
especially like to mention:

Kim Ahlström
Ida Almén Lagerwall
Shahidul Alam
Hans-Holger Albrecht
Casten Almkvist
Pär Altan
Josiane Ambiehl
Rebecca Amey
Sten Ankarcrona
David Andersson
Samuel Andersson
Maria Augustsson
Cesare Avenia
Asmahan Aweidah
Amanda Back
Joan Bardeletti
Jim Becker
Molly Benn
Åsa Bergman
Magnus Bergmark
Kristian Bergström
Kevin Billinghurst
Anna Billow
Kristina Billow
Margita Björklund
Fredrik Björnsson
Carl-Johan Bonnier
Hans-Jacob Bonnier
Cecilia Borglin
Richard Brisius
Charlotta Broady
Jan Broman
Per Broman
Mia Brunell Livfors
Jeremy Bryant
Nils Byrfors
Lennart Båge
Ingvar Carlsson
Carlos Cazalis
Ying Chen
Adam Cherry
Michael Cheung
Caroline Cohen
Henrik Conradi
Katy Cronin
Hamish Crooks
Jacob Dalborg
He Dang
Silvana Davanzo
Maya Ecer
Johan Eghammer
Tomas Ek
Therese Ekblom
Emma Ekelund
Roger Eklund
Monica Enecrona
Peter Englund
Charlotte Eriksson
Mathilda Eriksson
Jallo Faber
Lars Fahlén
Andreas Falkenmark
Anna Fornek Bergstrom
John Garewal

Lucien Garin
Madeleine Gaterud
Andrea Gisle Joosen
Wouter Goudsvaard
Marika Griehsel
Dorothea Grimberg
Michael Grimborg
Anna-Lena Grusell
Martin Hagensteijn
Fredrik Hallstan
Henrik Halvarsson
Natela Hanela
Greg Hano
Paul Hansen
Anna Hansson
Stefan Haskel
David Hegetorn
Michael Hellman
Claes Henriksson
John Hichens
Simon Hohn
Stina Honkamaa
Therése Hydén
Kristina Hägg-Blecher
Anna Högberg
Johan Höök
Tero Isokauppila
Per Mikael Jensen
Jim Johansson
Nisse Johansson
Bjørn Johansen
Angelica Johnsson-Gerde
Björn Jordell
Thomas Jönsson
Riz Kahn
Karim Ben Khelifa
Saam Kapadia
Lars G. Karlsson
Nathalie Karnig
Magnus Kennhed
Björn Kjellström
Niklas Kjellström-Matseke
Reinhard Krause
David Kristensson
Erik Kullander
Mikaela Kumlin Granit
Camilla Käller
Gordon Laing
Erik Larsson
K.F. Lee
Miriam Leuchter
Daniel Lezano
Stanislas Liban
Jeremy Light
Tom Lindahl
Amanda Lindén Guinez
Petter Lindholm
Hans-Peter Lindqvist
Svante Lindqvist
Brandon Litman
Dina Liu
Johnny Lo
Monica Lundkvist
Pelle Lundquist
Elizabeth Luu
Viola Luu
Pelle Lydmar
Santiago Lyon
Brita Löfgren Lewin
Kristoffer Malmsten

Evelyn Malzani
Torbjörn Martin
Martin Mellgren
Stefan Mehr
Bert Menninga
James Mole McConnel
Joel Montan
Louise Montgomery
Elin Moritz
Per Mossberg
Turi Munthe
Janken Myrdal
Carl Mårtensson
Edward Negussie
Dmitry Nesterchuk
Filip Nilsson
Hannah Nilsson
Hans-Jacob Nilsson
Victoria Nilsson
Lars Nittve
Lotta Nordfelt Signorini
Lars G. Nordström
Anna Nordström Carlsson
Milla Nummenpää
Eva Nygren
Magnus Nytell
Selina O'Connor
Erik Olsson
Klas Olsson
Johan Othelius
John Owen
Rebecca Oxelström
Jerome Petit
Olle Pettersson
Calvin Phan
Ginny Power
Diana Prelorenzo
Claudio Prestigiacomo
Mario Queiroz
Vanessa Ralli
Susanne Reali
Hanna Rehlin
Julia Reuszner
Annie Rickard
Johan Rockström
Andreas Rondahl
Brian Rose
Stefan Rudels
Morgan Röhl
Cecilia Salén
Maggie Samways
Ulla Sandén
Lasse Sander
Dera Saracevic
Annika Savill
Moa Schalin
Kalle Schröder
Calle Schwerin
Johanna Schäfer
Elio Schöfer
Rob Sharpe
Alexia Singh
Sara Sjögren
Jessica Sjölin
Eric Sjöström
Mikhail Sketin
Christian Skipper
Antonia Solivellas
D. Sriram
Simon Stanford

Jenny Steggo
Richard Steiber
Amelie Stenbeck-Ramel
Olof Stenhammar
Henry Sténson
Ewa Stoch
Jim Stone
Rosita Suenson
Fredrik Sundberg
Emma Sundin
Charlotte Sundåker
Pär Sveen
Axel Söderlund
Eva Tagesson
Rob Taggart
Tuula Tanskanen
Daniel Tarschys
Rowan Thornhill
Edvin Thungren
Erik Tillberg
Anastasia Timoshina
Emma Toft
Francesco Triglia
Susanne Trygve
Burcu Turel
Fredrik Ulfsäter
Joana Vasconcelos
Monique Villa
Bertil Villard
Asko Vivolin
Helena Wallenberg
Robert Wallis
Russell Walls
Munem Wasif
Annie Wegelius
Anna Weiner Jiffer
Michelle Wells
Mats Widbom
Elaine Weidman
My Wiborg
Jeanette Widlund
Tim Wimborne
Michael Wirtberg
Merlin Wulf
Margareta Zetterström
Carina Åkesson
Anders Årbrandt
Cecilia Öhlin
Per Örnéus
Per Österman
Peter Östman

Aday.org is organized by the non-profit foundation Expressions of Humankind, based in Sweden. The foundation supports scientific research and education centred on the photographic image and the written word. The aim is to inspire creative reflections on humanity by experiencing global perspectives.

Editor in Chief
Ayperi Karabuda Ecer

Project director
Sander Goudswaard

Chair and CEO
Patrick Ståhle

Partner director
Fredrik Byrfors

Communications manager
Hannah Gustafsson

Publishing director
Alex Mitchell

Exhibition manager
Marcus Erixson

Technical and Service Design Advisor
Stefan Moritz

PR
Benjamin Webb

Team
Lena Abrahamsson Lund, Rolf Adlercreutz,
Elisabeth Ahlberg, Malin Björnell, Oskar Kihlborg,
Tina Runhem, Henrik Ståhle, Jacob Ståhle,
Lars Einar Engström

Doberman Team
Lisa Lindström, Erik Almenberg, Marith Olsson,
Pär Lindhe, Patrik Berg, Martin Tägtström,
Sebastian Pettersson, Vinh Kha, Olle Svensson

HiQ Team
Gustav Lidén, Jan Brucek, Marios Nikolaou,
Robert Stenbom

Global Advisory Council
Desmond Tutu, Richard Branson,
Martti Ahtisaari, Gro Harlem Brundtland,
Mary Robinson, Jan Eliasson, Robyn

Technical Advisory Council
Mats Alendal, Fabian Fischer, Stefan Moritz,
Mikael Runhem

Scientific Advisory Council
Professor Harriet Wallberg-Henriksson,
Professor Val Williams, Pelle Snickars PhD,
Professor Dr. Sonja de Leeuw,
Dr. Dennis M. Bartels, Craig Venter,
Professor Teruo Okano

Expressions of Humankind Board
Ingvar Carlsson, Matias Palm-Jensen,
Michael Sohlman, Marika Stolpe, Patrick Ståhle,
Bengt Westerberg, Jeppe Wikström

www.aday.org